Joseph Beuys
Actions, Vitrines, Environments

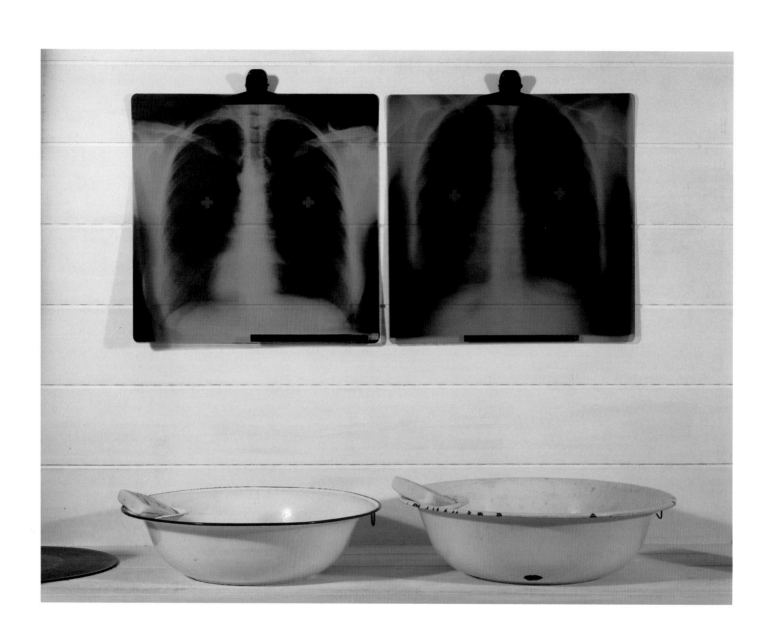

Joseph Beuys
Actions, Vitrines, Environments

Mark Rosenthal With Sean Rainbird and Claudia Schmuckli

The Menil Collection, Houston
Distributed by Yale University Press

This catalogue
accompanies the exhibition
Joseph Beuys
Actions, Vitrines, Environments
presented at
The Menil Collection, Houston
October 8, 2004–January 2, 2005
Tate Modern, London
February 4–May 2, 2005

The exhibition at the Menil is generously supported in part by The Andy Warhol
Foundation for the Visual Arts, Inc., Art Mentor Foundation Lucerne, and
Georges Pompidou Art and Culture Foundation, with additional funding provided
by The Cullen Foundation, Houston Endowment Inc., Fayez Sarofim & Co.,
The Wortham Foundation, and the City of Houston.

The exhibition at Tate Modern is supported by Tate International Council.

Designed by Nathan Garland / Printed in Italy by Amilcare Pizzi
Edited by Susan Braeuer, Clare Elliott, and Jane Watkins

Unless otherwise noted, all works
reproduced are by Joseph Beuys.

Front cover:
The End of the Twentieth Century,
1983–85 (detail)

Frontispiece:
Double Objects, 1974–79 (detail)

Back cover:
I Like America and America Likes Me,
1974, New York

Library of Congress Control
Number: 2004108389
ISBN 0300104960 (Yale University Press)
ISBN 0939594587 (The Menil Collection)

Available in North America through
Yale University Press
P.O. Box 209040
New Haven, Connecticut 06520-9040

This exhibition has been organized by
The Menil Collection, Houston,
in collaboration with Tate Modern, London.

Published by Menil Foundation, Inc.
© 2004 by Menil Foundation, Inc.
1511 Branard, Houston, Texas 77006
Essay by Sean Rainbird © Sean Rainbird 2004

Contents

Foreword

The Menil Collection and Tate Modern take pride in presenting this exhibition of perhaps the most influential artist of the post-World War II period in Europe: Joseph Beuys. For those fortunate in having had firsthand experience with his eloquent body of work, the name of Joseph Beuys signifies a profoundly European sensibility that broke entirely from American domination in the early part of the 1950s and announced an art built on a clear confrontation with history. Notwithstanding his unequivocal stature, Beuys's work has often proved elusive for English-speaking audiences; hence his last retrospective occurred in 1979, during his lifetime, at the Solomon R. Guggenheim Museum, New York. We are honored to introduce this magisterial figure to our audiences in America and Britain.

Both the Menil and Tate have enjoyed a long association with Beuys. In 1954, John and Dominique de Menil founded the Menil Foundation, Inc., and in 1982 made a major contribution to Beuys's *7000 Oaks* project, created for the Documenta VII in Kassel, Germany. A near decade before, their daughter, Philippa de Menil, along with Heiner Friedrich, founded Dia Art Foundation. By 1990, Dia's collection of Beuys's environments formed the basis of the Menils' exhibition, "Joseph Beuys: Works from the Dia Art Foundation." Today, an extension of *7000 Oaks* is installed on the streets surrounding the Dia in New York City, thanks to the de Menils' early recognition of Beuys in America.

Tate's association with Beuys goes back to the early 1970s while also reflecting many of the challenges faced by major museums considering how to collect his art. Concerns about the conservation of fragile works, often objects related to Beuys's actions, thwarted early attempts to acquire sculptures for the permanent collection. However, Beuys was the only artist not based in Britain included in a list of seven contemporary artists invited to make a presentation at the Gallery in 1972. A practical generosity marked his gesture in 1984 to make a third vitrine to add to two already in the collection, when he brought with him two recently cast sculptures to combine with one already in the collection. This triggered the gift from E J Power of a fourth work, to complete the ensemble. The acquisition of *The End of the Twentieth Century* in 1991 finally brought a major installation into the collection. Since 2000 it has been a prominent feature in successive displays of Beuys's works in the impressive double-height gallery at Tate Modern.

At this point in history, it is essentially impossible to organize a true retrospective of Beuys's art because so many crucial works are permanently installed in museums around the world. It might even be fair to add that Beuys's output is so varied it has essentially outlived the retrospective format in the posthumous phase of his career. Though the Tate and Menil exhibitions share the central focus of nontraditional sculpture, they reflect the unique points of view of each curator. Mark Rosenthal, Adjunct Curator of Twentieth Century Art at the Menil, has organized an exhibition with a particular emphasis on three principal areas of Beuys's work: performances, vitrines, and environments. For London, Sir Nicholas Serota, Director, Tate, and Sean Rainbird, Senior

Curator at Tate, have given greater emphasis to an expanded number of Beuys's environments, as well as his vitrines, and approached his actions by looking in detail at Beuys's 1972 lecture at Tate Gallery.

An exhibition of Beuys is a complex undertaking that depends on several partners for its success. We must first express our profound gratitude to the following individuals and institutions whose loans have made this event possible: Richard Calvocoressi, Director, at Scottish National Gallery of Modern Art, Edinburgh; Charles Esche, Director, Stedelijk Van Abbemuseum, Eindhoven, and his predecessor, Jan Debbaut; Ronald and Frayda Feldman, Founders, Ronald Feldman Fine Arts, Inc., New York; Josef Froehlich, co-founder, Froehlich Foundation, Stuttgart; Jan Hoet, Founder and Director, Stedelijk-Museum Voor Actuele Kunst, Ghent; Peter-Klaus Schuster, Director of the Museums of Berlin, and Eugen Blume, Director, Hamburger Bahnhof, Museum für Gegenwart-Berlin; Thomas Krens, Director, and Lisa Dennison, Deputy Director and Chief Curator, Solomon R. Guggenheim Museum, New York; Thomas W. Lentz, Elizabeth and John Moors Cabot Director of the Harvard University Art Museums, and Peter Nisbet, Curator; Robert and Marguerite Hoffman; Marshall and Cynthia Reid, Houston; Malcolm Rogers, Director, and Cheryl Brutvan, Curator, Museum of Fine Arts, Boston; Keith and Katherine Sachs; Bernhard Mendes Bürgi, Director, Öffentliche Kunstsammlung Basel; Alfred Pacquement, Director, Musée national d'art moderne / Centre de création industrielle, Paris; Rainer Speck, Speck-Collection, Cologne; E.J. van Straaten, Director, and Piet de Jonge, Curator, Kröller-Müller Museum, Otterlo; Hans Ottomeyer, Director, Staatliche Museen Kassel, and Marianne Heinz, Director, Neue Galerie, Kassel; Wolfgang E. Weick, Director-in-Chief Municipal Museums, Museum am Ostwall, Dortmund; and to the generous lenders who wish to remain anonymous.

Several organizations recognized the merit of this project with financial assistance, and we are delighted to acknowledge their help: Joel Wachs and Pamela Clapp at The Andy Warhol Foundation for the Visual Arts, Inc.; Andrea Lukas and Hans Müller of the Art Mentor Foundation Lucerne, with special thanks to Peter Nisbet for introducing the exhibition to the Foundation; and Elsian Cozens for advocacy of the Georges Pompidou Art and Culture Foundation. Tate Modern extends its thanks to Tate's International Council for its generosity and support.

Finally, we want to acknowledge the kind assistance of Eva Beuys and her children, Wenzel and Jessyka. We are deeply grateful for their belief in the value of this exhibition, especially during this period of political turbulence between Europe and America.

Josef Helfenstein
Director
The Menil Collection

Vicente Todolí
Director
Tate Modern

Acknowledgments

This exhibition has had an overly long gestation, but perhaps that is fitting for an artist who inspires deep feelings. It began nearly ten years ago, when I was a curator at the Solomon R. Guggenheim Museum, New York. I thank Thomas Krens, Director, and Lisa Dennison, Deputy Director and Chief Curator, of the Guggenheim for their interest and support. When I arrived at The Menil Collection in 2001, the Chief Curator and my former Guggenheim colleague, Matthew Drutt, with the encouragement of then Director, Ned Rifkin, argued that I try again to accomplish this project. I want here to acknowledge Matthew's essential and dogged contributions in a variety of areas to making this exhibition a reality. Claudia Schmuckli was herself part of the Guggenheim team working on Beuys, and happily for me resurfaced in Houston to help yet again. Her chronology is an extremely useful tool for future researchers. Josef Helfenstein, recently arrived Director of the Menil, immediately leaped into several challenging issues, and solved these with genuine diplomacy and commitment. I am very grateful to him for quickly joining the project. Further, I offer sincere thanks to the Trustees of Menil Foundation, Inc., for their continued stewardship and guidance.

At the Menil, we have greatly benefited from the following staff members who have brought their expertise to this project and made it a success: Deborah Velders, Head of Exhibitions and Programs, and the exhibitions staff— Mark Flood, Anthony Martinez, and Brooke Stroud; Gary "Bear" Parham, Head of Art Services, and his staff—Doug Laguarta and Tom Walsh; Steve McConathy, Building, Grounds, and Security Manager, and Tim Ware, Facilities Manager; Anne Adams, Registrar, along with Mary Kadish, Collections Registrar, and Judy Kwon, Registrar Assistant; Elizabeth Lunning, Chief Conservator, and her entire department—notably, Laramie Hickey-Friedman, Assistant Conservator of Sculpture and Objects; Phil Heagy, Librarian, Stephanie Capps, Library Assistant, Clare Elliott, Administrative Curatorial Assistant, and Joanna Cook, Manager of Rights and Reproductions; Will Taylor, Director of Planning and Advancement, along with his staff: Tripp Carter, Director of Development, Elsian Cozens, Special Events Coordinator, Marta Galicki, Membership Coordinator, Vance Muse, Director of Communications, and Mary Ann Pack, Director of Principal Gifts; To E.C. Moore, Chief Financial Officer, and Tom Madonna, Manager— Finance/HR, I extend my thanks for advisement. Finally, it is with profound gratitude that I acknowledge the extraordinary contribution of Susan Braeuer, Project Curatorial Assistant, who has been truly tireless and cheerful through all manner of difficulties.

Early on, I discovered a compatriot in Sir Nicholas Serota, Director, Tate, whose long experience with Beuys and wise counsel proved helpful in formulating the exhibition. To our team, he added Sean Rainbird, Senior Curator, who has provided an essay on an exceedingly important topic for Beuys studies. I would like here to further acknowledge the Tate staff: in the Curatorial department, we recognize Susanne Bieber, formerly Assistant Curator, and Juliet Bingham, Assistant Curator; for advice and support, Vicente Todolí, Director, and Sheena Wagstaff, Head of Exhibitions and Display,

Tate Modern; for delivery and installation of the exhibition, Stephen Dunn, Registrar; Stephen Mellor, Exhibition Manager; Phil Monk, Art Installation Manager, as well as the Art Handling Team; and from the Conservation department—Derek Pullen, Bryony Bery and Pip Laurenson.

Also, my gratitude goes to all those who have contributed to the wide range of activities that have supported the exhibition in London, including: Dennis Ahern, Simon Bolitho, Jane Burton, Stuart Comer, John Duffett, Ruth Findlay, Will Gompertz, Brian Gray, Adrian Hardwicke, Rebecca Lancaster, Brad Macdonald, Paul McAree, Jemima Montagu, Caroline Priest, Jane Scherbaum, Nadine Thompson and Dominic Willsdon.

And in connection with the publication, I thank Tate's photographers, Andrew Dunkley and Marcus Leith, as well as our colleagues at Tate Publishing—most notably, Celia Clear and Roger Thorp—and at Tate's Picture Library, Alison Miles and Claudia Schmid.

It has been with great pleasure to again benefit from the sensitive touch of Nathan Garland, the designer of this book, with production assistance provided by Michael Barbano. With only a brief lead-time, Susan Braeuer, Clare Elliott, and Jane Watkins skillfully edited the texts. And at Yale University Press, I am pleased to acknowledge the enthusiastic support of Patricia Fidler and Michelle Komie.

Otto Hubacek, Conservator at the Nationalgalerie im Hamburger Bahnhof, Museum für Gegenwart-Berlin, and well-known specialist of Beuys's work, graciously agreed to assist with the installations in Houston and London. Besides the persons directly responsible as lenders and named in the foreword, a number of individuals were particularly kind in facilitating last minute requests for the catalogue: Kim Bush, Solomon R. Guggenheim Museum, New York; Maurice Dorren, Museum Schloss Moyland, Bedburg-Hau; Ryan Jensen, Art Resource New York; Mario Kramer, Curator for the Collection, Museum für Moderne Kunst, Frankfurt am Main; Lucius Grisebach, Director, and Thomas Heyden, Conservator, Neues Museum Nürnberg; Urs Raussmüller, and his personal assistant, Ines Goldbach; Uwe M. Schneede, Director of the Hamburger Kunsthalle; and Marty Stein, The Museum of Fine Arts, Houston. Further, we are extremely grateful for the support provided by the following Actions photographers: Bernd Jansen, Angelika Platen, Reiner Ruthenbeck, Klaus Staeck, Manfred Tischer, Caroline Tisdall, and Peter Thomann.

The following people were particularly helpful in providing information or assistance at various stages, and I want to acknowledge their kindness here: Ronald Feldman, John Hanhardt, Ute Klophaus, Peter Nisbet, Gene Ray, Christine Stiles, and Stephan von Wiese.

My education in the art of Joseph Beuys only began in the early 1980s, but was greatly enhanced by the scholarly work of Caroline Tisdall. Then I was fortunate to begin a long association with Anselm Kiefer. I thank him for accelerating my knowledge and appreciation and, through his own work, leading me to recognize the extraordinary achievements of the post-World War II German orbit of artists.

MR

Joseph Beuys: Staging Sculpture

Mark Rosenthal

Plates 1–2 (pages 11–12).
*Kukei / akopee-No! / Brown Cross /
Fat Corners / Model Fat Corners*,
1964, Aachen

During and after his extraordinary life, Joseph Beuys has seemed apart from art history. His political activism and utopian ideas have been examined, and his life story has been studied and adored. At his death, it seemed as if a cult figure rather than an artist had departed, and every corner of society took notice. But if Beuys deserves a long-standing place in the history of art, his sculptural achievement and his artistic influence must be considered significant; otherwise, the details of his life and career will permanently consign him to the role of merely a fascinating, particularly German cultural personage. To begin to understand Beuys's approach and to characterize his aesthetic legacy, it is crucial to recognize that he approached both his life and his art as one endeavor, and constantly staged both aspects.

Staging Life / Staging Sculpture

Throughout his career, Beuys was surrounded by questions and controversy: Was he, as one critic derided, a sham or a shaman?[1] In the U.S., the answer centered on the oft-told "Story," as the art historian Peter Nisbet appropriately elevated it, of Beuys's survival after being shot down over the Crimea during World War II.[2] Beuys, who was a Nazi pilot, reported that he was rescued and revived by a band of Tartars. This feat was achieved, Beuys said, by coating his body with fat and wrapping him in felt. He attributed his aesthetic repertoire of fat and felt to the Story, which began to be questioned beginning in 1980 and was eventually disproved.[3] For some observers, the veracity of the Story demonstrated a questionable character. If he could lie about such a thing, somehow his art became suspect, too. The real point about Beuys's Story, however, was missed entirely in the ensuing recriminations and character assassination.

"Myth is at the beginning of literature, and also at its end," wrote Jorge Luis Borges.[4] Beuys's Crimean tale represents a myth of creation, the point from which his art springs. This invention, along with the artist's *Lebenslauf / Werklauf* (*Life Course / Work Course*) (see Chronology in this volume), which recounts imaginary biographical and historical events, admirably served his purposes.[5] For Beuys, like Borges, art requires mythic material from life as its font and for its substance. Thanks to this myth of creation, and thus ostensibly freed of his wartime experience (and perhaps guilt), Beuys could go forth as an artist into Germany and the world to address history. It is significant, too, that the Story concerns the healing of a physical wound. Along with being a necessity for the "psychological survival" of a suffering individual,[6] the Story offers an enchanted, sympathetic, and nonjudgmental act of kindness by the Tartars, who epitomize in Beuys's view, a constant leitmotif about an imaginary race from Eurasia. In the Story, the Tartars, in effect, forgave him for his transgressions as a pilot for the Luftwaffe. What if the Story was invented, or, more likely, an elaboration of an event? Art, too, is an invention, a myth.

Beuys's character and footstep in the European art world were writ large; indeed, one might perceive a certain narcissistic and grandiose bent. When, early in his career, during the performance *Celtic (Kinloch Rannoch) Schottische Symphonie* (*Celtic [Kinloch Rannoch] Scottish Symphony*, 1970), he hung a slip of paper on the wall asking: "Where are the souls of Van Gogh, Duchamp, Piero della Francesca, William Nicholson, Fra Angelico . . . and Leonardo da Vinci?," he was envisioning, as young artists often do, his own place within that line. In the 1970s, he would broaden that lineage to include such diverse figures as John Dillinger, Albrecht Dürer, and James Joyce.[7] In the same extravagant way, Beuys could assume a personal role within his epics, as when he wrote on the plaster block in the environment *Wirtschaftswerte* (*Economic Values*, pl. 81): "The Eurasian

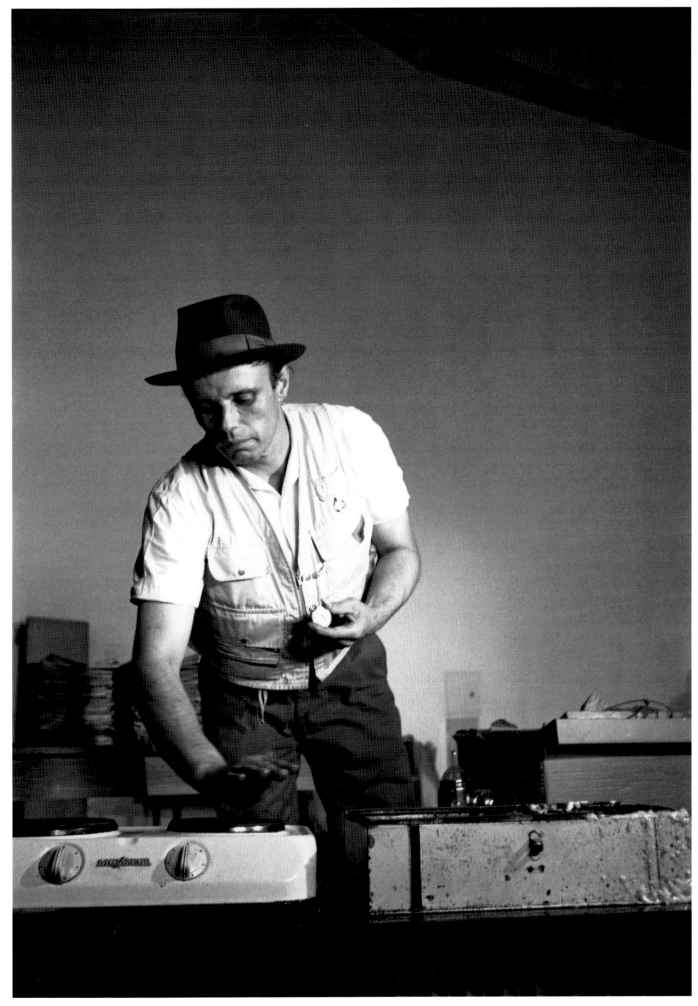

Plate 1.

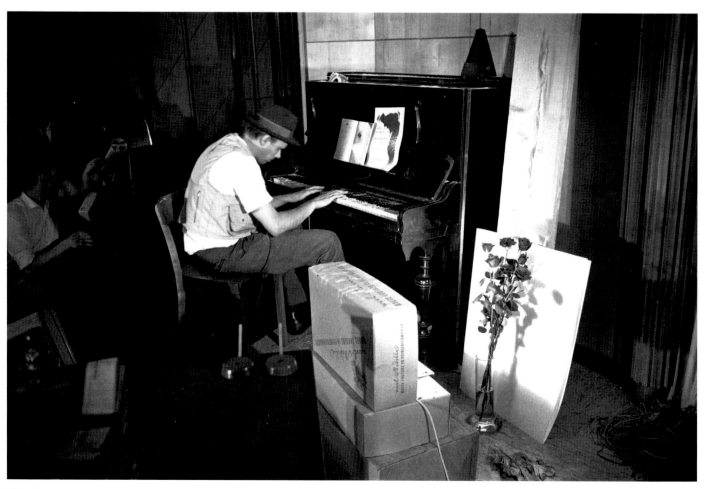

Plate 2.

sends greetings. Joseph." Imagining himself the aesthetic healer of Germany, he made a proposition that the Berlin Wall be raised by five centimeters ("better proportions!" he said); his hope was to be remembered as having "altered the course of events."[8] On a more cosmic plane, he once proclaimed himself "a transmitter, I radiate."[9] Like a shepherd, Beuys collected individuals to his various political causes; he even proclaimed himself the "chief" of a political party for animals, since they could not speak for themselves.[10] In addition to this religious likeness, as of Saint Francis with the animals, on occasion Beuys did Christ-like things, such as washing people's feet (pl. 12).[11]

As time goes by, the impact of the originality of Beuys's political ideas recedes. After an artist declares that "Every human being is an artist,"[12] where can we go? Perhaps Beuys shares the most with Buckminster Fuller, another persuasive Pied Piper, who believed that anything was possible, including simultaneously finding satisfying work, personal fulfillment, and plenty of money for anyone who wanted it. For both Beuys and Fuller, a new type of economy was called for, another *way* as it were, which would solve the shortcomings of Capitalism and Marxism, even as the soul's diet was improved. One imagines, or hopes, that Beuys himself knew the difficulty of achieving these dreams; his primary job as an artist—a dreamer by birthright—was to introduce and encourage notions of a better world.

Beuys's self-generated persona should be examined in the context of Western society in the early to mid-1960s, when he came to prominence. This era of peace marches, idealism, and collaborative societies was led by charismatic individuals—figures who, it should be noted, rarely associated themselves with specific political parties or systems. Indeed, just as John Lennon opposed violent revolution, so, too, did Beuys have little sympathy for the violent activities of the Baader-Meinhof cell of the Red Guard in Germany, a terrorist group active in the 1970s and 1980s. Instead, he preached a brand of peace and love, individual responsibility and creativity, and advanced political development, with environmental concerns thrown in; if adulation could advance his cause, he welcomed it. Beuys was establishing himself as a kind of German superstar/artist, a counterpart to Lennon in Britain or Bob Dylan in the U.S., artists deeply involved with social causes.[13] Epitomizing the superstar characterization, Beuys cultivated a distinctly recognizable identity, with his felt hat and fisherman's vest. Just as Lennon could imagine being more popular than Christ, Beuys made the same comparison in some of his *Aktionen*, or Actions, in which his flair for the dramatic abounds. For example, on the twentieth anniversary of the attempted assassination of Hitler, he performed the notorious Action *Kukei / akopee—Nein / Braunkreuz / Fettecken / Modellfettecken (Kukei / akopee—No! / Brown Cross / Fat Corners / Model Fat Corners*, 1964, pls. 1–2). In a later performance in New York called *I Like America and America Likes Me* (1974, pls. 3–10), he lived for several days with a live coyote in a gallery. It is hardly surprising that Beuys was surrounded by a cult that empathized with him at every turn. When he was dismissed from the Staatliche Kunstakademie Düsseldorf in 1972, after years of disputes, his students demonstrated and occupied the building until he was physically removed. The media onslaught at the time of his 1979 retrospective at the Solomon R. Guggenheim Museum in New York, his first retrospective anywhere and his first museum exhibition in the U.S., only increased his fame in Germany. When he died, the country went into mourning. To this day, a visit to a German bookstore reveals more books on the shelves about Beuys than any other artist. Like other artist/stars of the 1960s, Beuys used his aesthetic powers to speak to his audience's concerns, to represent their interests, and, most of all,

Plates 3–10 (pages 14–23).
I Like America and America Likes Me, 1974, New York

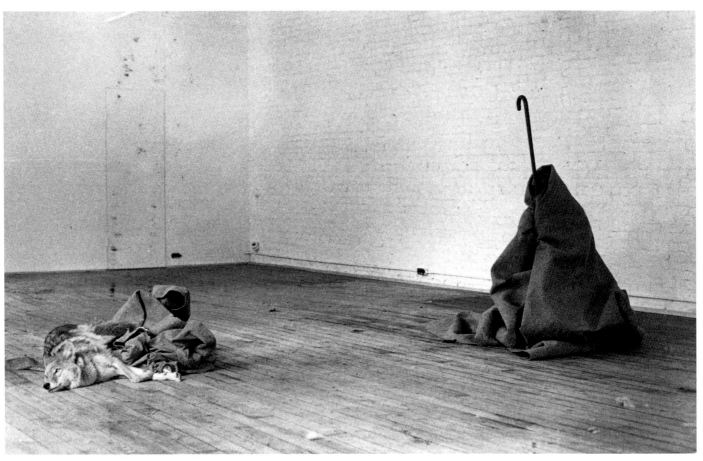

Plate 4.

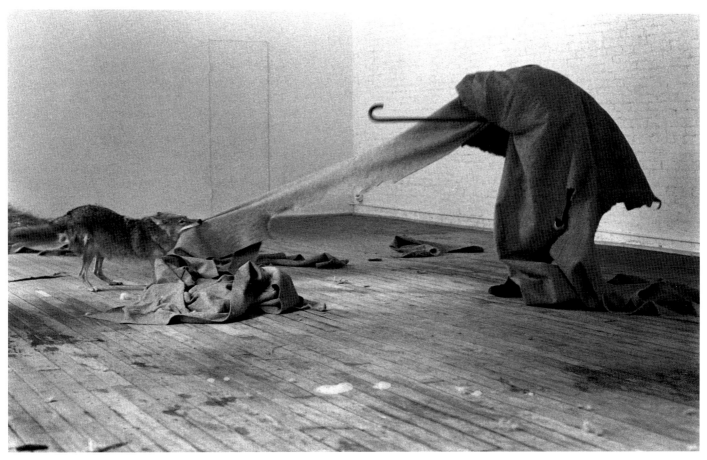

Plate 5.

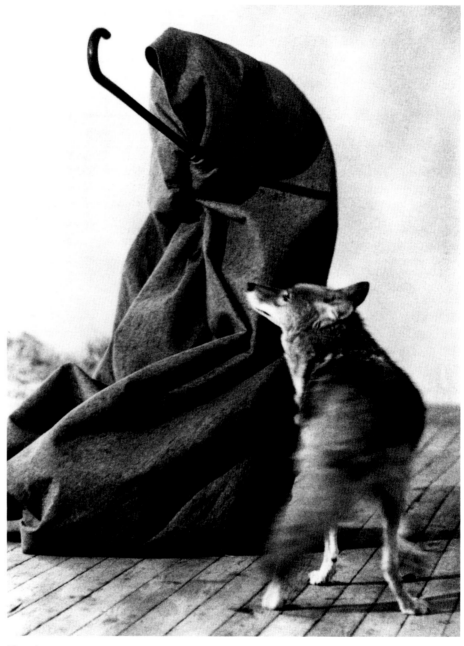

Plate 6.

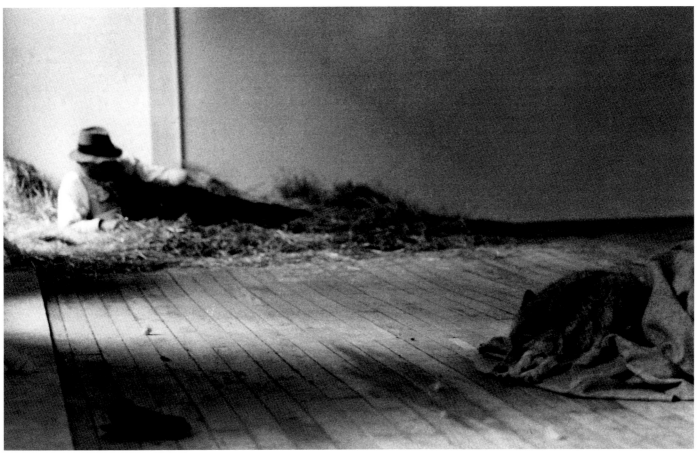

Plate 7.

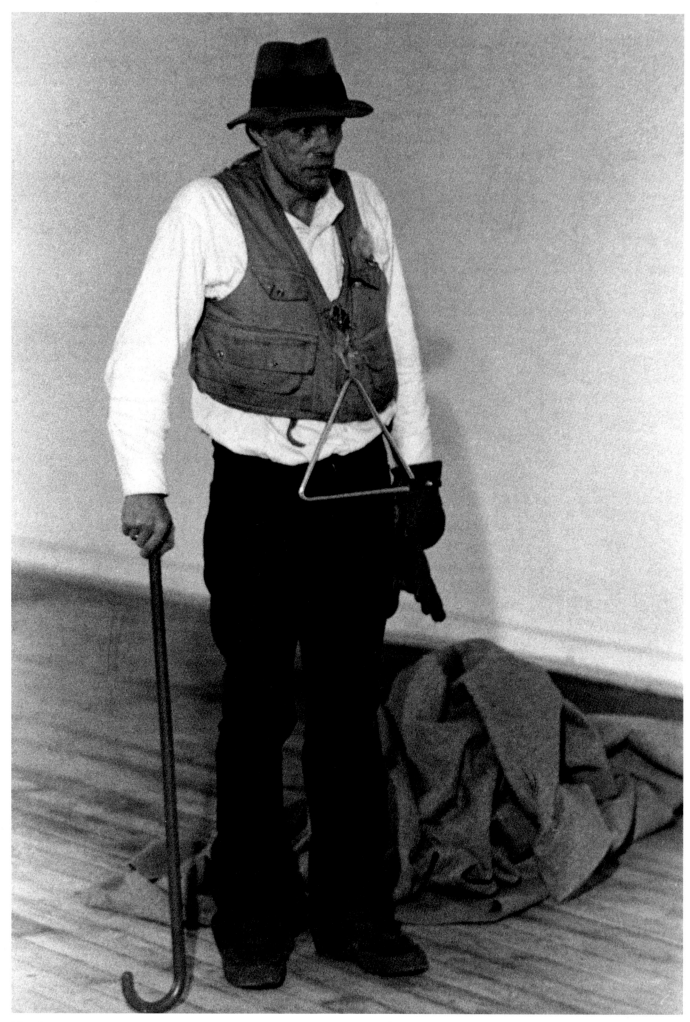

Plate 8.

Plate 9.

to move them with his works of art. Unlike Andy Warhol, with whom Beuys occasionally has been compared and who remained an observer in terms of social causes, Beuys craved involvement. If condemnation for the Crimea Story was the cost, it was a small price for an artistic career driven by ideas and the desire to affect society.

It is useful to think of Beuys's persona in the context described by Lewis Hyde in *Trickster Makes This World: Mischief, Myth, and Art*, a pan-anthropological treatise.[14] Hyde's trickster is an inherently amoral transgressor, impersonating people or animals while toying with the audience. Likewise, Beuys's creation myth deepened the ambiguity about his true self, and he assumed numerous disguises in his Actions. On the one hand, the trickster is "the Keeper of the Herds," and on the other, "the guide to Hades."[15] Indeed, the trickster is able to "erase or violate that line between the dirty and the clean."[16] This fascinating distinction could be applied to the history of Germany, with the additional connotation that "cleanliness," in Hyde's description and in Beuys's view, is itself acrid and lifeless.[17] Beuys's creation myth is simply an example of the trickster's "first lie," the cornerstone of his invented character.[18] For their part, observers wonder about the true feelings and character of the trickster, but as soon as doubt is expressed, the trickster turns face and becomes extraordinarily generous. An instance of this occurred when Beuys pronounced that "Every human being is an artist." Generous to the point of saintliness is Beuys, presumed healer of Germany, and, like the trickster, "gatekeeper who opens the door into the next world."[19] Both offer salvation. Hyde says that this "Confidence Man is a savior who only seems dark because he must work in a fallen world—and once that's been done, if he might be the Devil or . . . Christ . . . his 'true self' is hopelessly hidden."[20]

Beuys's world, like that of the trickster, is not about rules but about transgressions, not about truths but about artifice. Let it be noted that the animal who best epitomizes the trickster is none other than the coyote, which Beuys celebrated in *I Like America and America Likes Me*. Thus the conventional, even hackneyed, view of Beuys as a shaman describes only part of his character. It is Beuys the trickster whom the audience observes, a figure who concerns himself less with the spiritual orb than with this world and humankind. If we tear away the veils of personality, we find that Beuys was an artist like any other—eager to contribute to the legacy of art history. Indeed, he wanted his contribution to be recognized at an art institution, so he devoted himself, in 1961, to gaining a professorship in sculpture at the Kunstakademie Düsseldorf.[21]

Just as Beuys found ways to stage life, he imbued sculpture with a highly theatrical character. Like many artists coming to prominence in America in the 1960s, he found the physicality of sculpture most appealing, with its inherently life-filled qualities, whereas painting remained rooted in the ostensibly *retardataire* quest to convey the mere illusion of existence.[22] During the 1960s, in particular, it seemed that sculpture offered the greatest breadth of expression, and the word itself came to subsume performance art, site-specific manifestations, and even video. Beuys was a central figure in this expansive tendency, evolving a Theory of Sculpture in his writings and interviews that suggests the elasticity of his thought about the medium. He argued against the term sculpture, however, because to him it referred specifically to the activity of carving. He much preferred the term "Plastik" to describe his work.[23] It conveyed more flexible notions of what constitutes his sculpture, which uses multiple processes of modeling, molding, and forming.[24] "Plastik" effectively comprised every way that he might interact with a material or an object.

Crucial for Beuys is the premise that a "sculpture is not fixed or finished,"[25] hence he felt entirely free to reuse works in new configurations with others. An object at hand in his studio had less interest to him as a precious or sacrosanct sculpture than as a reusable resource. He wanted to oppose historically obdurate and fixed sculptures with a new type of sculpture that was as mutable as life itself. Though his use of refuse material certainly goes back to Kurt Schwitters in the 1920s and the more recent work of Robert Rauschenberg and Jean Tinguely in the 1950s, among others, Beuys courted physical and chemical change to an even greater extent. He hoped that such characteristics would serve as "stimulants for the transformation of the idea of sculpture, or of art in general." His sculptures should "provoke thoughts about what sculpture can be and how the concept of sculpting *can* be extended."[26]

In the tradition of the German art historian Heinrich Wölfflin, who created a framework by which to characterize painting styles, Beuys, in his Theory of Sculpture, charted sculptural poles and described how these could be traversed:

chaos		order
undetermined		determined
organic	movement	crystalline
warm		cold
expansion		contraction[27]

These categories are fundamental to all of Beuys's art, with movement (*Bewegung*) being most crucial. In this, Beuys's Theory of Sculpture likely owes a great deal to his knowledge of the writings of Paul Klee, an artist he singled out along with Wassily Kandinsky and Wilhelm Lehmbruck, as pillars of his German legacy.[28] Earlier, Klee had written at length about the stimulating effects of *Bewegung*. In Beuys's world view, all things can be set into motion by *Bewegung*; for instance, chaos can gain order and still phenomena can be made energetic. *Bewegung* is the artist's will at work, or simply the channeling of organic energy. In the way that Beuys always imbued physical conditions with content, he described movement in the following imaginative way: "The principle of resurrection, transforming the old structure, which dies or stagnates, into a vibrant, life-enhancing and soul—and spirit—promoting form. This is the expanded concept of art."[29] Hence, *Bewegung* is an agent of art.

The crystalline state mentioned by Beuys was a particularly fascinating phenomenon for Klee, too, who during World War I wrote that it could contain, suspended, the memories and emotions of war; crystals were what Klee conceived abstraction to be about.[30] In other words, the crystalline is not so static or hidebound as to be without life, if it has been infused with movement. We will see that Beuys held and conveyed similar ideas, and also was looking for ways to capture wartime and postwar experiences in his art.

Continuing to explain his Theory of Sculpture, Beuys emphasized that his use of fat as a medium was "an extreme position in sculpture, and a material that was very basic to life and not associated with art."[31] Here we see Beuys's frequently stated desire to push beyond the constraints of art conventions through his use of organic, unaesthetic materials, henceforth rendered appropriate for artwork. It is clear then, that the character of a work by Beuys must be defined, first of all, by its physical components, for he is so much a sculptor of materials (pl. 11). While his use of such ostensibly unseemly mediums as fat, felt, and tallow—along with his willingness to court all manner of change in his sculpture—may have shocked some viewers, each of these materials conveyed inherent

Plate 11.
MANRESA, 1966,
Düsseldorf

associations, if not meanings.[32] In this way, Beuys's sculpture manifested content rather than symbolized it, an important and notable development in art. Hence, Beuys's work succeeds best when it is drenched with an intoxicatingly redolent air. Then, each work is so visceral that its physical sensations exude an aura of associative power. Caroline Tisdall, among his most perceptive critics, would explain that the "moulding processes of art are taken as a metaphor for the moulding of society, itself an organic entity; thus we have Beuys' SOCIAL SCULPTURE."[33] This term, which was invented by Beuys, united his idealistic notions with his aesthetic practice, as if to say the latter was inadequate without the former.

 In Beuys's imaginary biography called *Life Course / Work Course*, first published in 1964, he recorded an exhibition of his art at the age of ten, in his hometown: "1931 Kleve Exhibition of connections."[34] With this entry, he proposed that a connective tissue already existed between all of his diverse activities, and this was certainly true throughout his career. Apart from works on paper, which have an obvious unifying physical quality, the preponderance of Beuys's art can be loosely understood as sculptural output. Yet, all of this work has never been given an overriding framework, although Beuys himself clearly recognized "connections." A typological parallel may be said to exist between the Actions, vitrines, and environments, which can be defined as follows: to extend the boundaries of the conventional three-dimensional object on a pedestal by "staging sculpture." Beuys's vibrant idea of sculpture is essentially that it should be set into motion, and given a lifelike force. His sculptural objects are variously handled, bitten, eroded, elevated from humble beginnings, and, especially, used as props in theatrical-type milieus. To state this in another way, Beuys described that in an Action, the material components are "initially raw, chaotic and entirely shapeless; sometimes . . . [these are] treated with heat . . . I don't mean physical heat. I mean what you call Eros . . . metaphoric . . . heat."[35] In this way, all objects—whether in an Action, vitrine, or environment, first existed in a chaotic state, before they were charged by his hand—the conveyer of heat, of movement, of Eros.

 Beuys's tendency toward theatricality, or "staging sculpture," obviously started with his Actions, beginning in 1963. It has often been suggested that performance art in general departs from the example of Jackson Pollock's painting and his physical relationship to the planar surface.[36] That Pollock's art was dubbed "Action Painting," however, makes for a provocative transition to Beuys's term *Aktion* to describe his performance works,[37] as if he wanted to align himself with Pollock in order to leapfrog him in formulating a new version of the postwar American breakthrough. In fact, Beuys said that Pollock, of all the American artists, interested him the most, and pointedly noted: "It has a lot to do with the energy problem."[38] "Energy," "movement," and "action" became interchangeable terms for Beuys—a lover of language—to describe something very meaningful to him that recurs in a variety of contexts. For instance, in a political tract entitled "Appeal for the Alternative" (1978), he wrote of a political *movement* (author's italics), and quickly followed that with an appeal *"to act."*[39] Elsewhere, he elaborated, speaking about his ritualistic act of purification (washing the feet of spectators, pl. 12): "The world must not be as it is. The true foundation of Action Art is the element of movement The form in which this embodiment of Christ takes place in our time is the element of movement as such, the person who is moving."[40] In other words, Beuys linked his Actions and Action Painting to his Theory of Sculpture and the crucial concept of movement; his activities even mimic Christ to help to change the world.

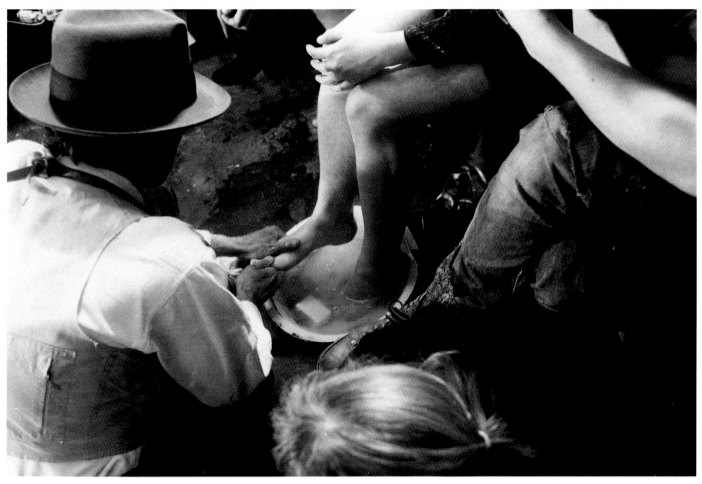

Plate 12.
Erste Fusswaschung als öffentliche Plastik
(*First Footwashing as a Public Performance*), 1971,
Düsseldorf

Unlike most other performance artists, Beuys carried out his dramas as a sequence of events during which he manipulated diverse and evocative materials. He was molding inchoate matter into form, in effect, making sculpture. All sorts of physical processes and conditions were embraced in the process. And, with each moment in an Action, a new sculptural ensemble appeared. That each dissolved did not lessen the momentary impact; photographs of the Actions show a powerful oeuvre of figurative art-tableau imagery. The Actions predicted Beuys's use of vitrines and room environments, being composed of multiple objects in a discrete space or container. Though the vitrines and environments effectively freeze a moment in an Action, there is always the same sense of Beuys's activity—handling and composing. Moreover, there exists all manner of intermingling between these manifestations.

The Actions largely converge into groupings, each concerning a particular theme or leitmotif. One of these is innocence, particularly that of animals. In *Sibirische Symphonie 1. Satz* (*Siberian Symphony, 1st Movement*, 1963, pl. 13), Beuys tore the heart from an already dead hare. The hare is an eternal symbol of renewal and rebirth;[41] it evokes a nomadic era honored by Beuys, when cultural divisions between the East and the West did not exist.[42] Although one could argue that Beuys was testing the hare's powers of renewal, his performance must also be considered a reenactment of a monstrous act committed on a defenseless innocent. In *wie man dem toten Hasen die Bilder erklärt* (*How to Explain Pictures to a Dead Hare*, 1965), Beuys walked through an exhibition mumbling to the dead hare cradled in his arms. Then, seated, with his head covered in honey and gold leaf, he held the dead animal very much like a grieving Madonna in a Pietà. Was he mourning the soul of the lost innocent or simply instructing it in the ways of art, as the title suggests? In another "movement" of *Siberian Symphony*, entitled *Teilung des Kreuzes / EURASIA, Sibirische Symphonie 1963, 32. SATZ (EURASIA) FLUXUS* (*Division of the Cross / EURASIA, Siberian Symphony 1963, 32nd Movement [EURASIA] FLUXUS*, 1963), Beuys, having painstakingly attached (crucified?) the body of a hare to poles, hauled it through the space. Again, he mourned, and perhaps yearned on behalf of his audience, for the animal's rebirth. Several years later, Beuys coexisted on stage with a horse in *Titus / Iphigenie* (1969, pls. 14–16). When shown alive as there, the innocent animal became a kind of Christian Lamb, a sign of godliness, soon to be sacrificed—or slaughtered—before being risen up again. In 1974, in *I Like America and America Likes Me*, Beuys lived in an enclosure with a coyote for a week, attempting a rapprochement with this living creature, his former victim.

Just as James Joyce's Stephen Daedalus stares at a dog and pines: "Looking for something lost in a past life,"[43] Beuys established animals as the embodiment of a lost state of innocence. They are always inherently natural, even if they have undergone corruption by man's actions or have been doused with extraneous meanings and interpretations. While animals are celebrated and seemingly eternal, as suggested by the title of a work in which a hare is about to be shot, *der Unbesiegbare* (*The Unconquerable*, 1963, Hessisches Landesmuseum, Darmstadt), most often they are mourned, as in one of the versions of *Hasengrab* (*Hare's Grave*, 1962–67, pl. 78). In Beuys's memorial, the detritus of civilization, rather than evincing an unkempt grandeur, becomes simply a pathetic offering to a revered, more significant being. In a spirit similar to that of the German painter Franz Marc, who earlier in the century had depicted deer and horses being threatened or destroyed in Apocalyptic conflagrations,[44] Beuys grieved for animals.

While an animal possesses a natural state of grace, effectively a Lamb in the Garden of Eden, Beuys recalled other connotations, too, which he suggested

Plates 14–16 (pages 30–32).
Titus / Iphigenie, 1969, Frankfurt

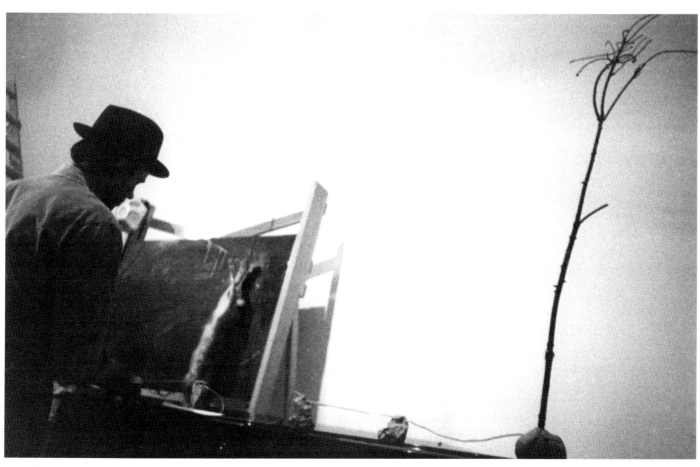

Plate 13.
Siberian Symphony,
1st Movement, 1963,
Düsseldorf

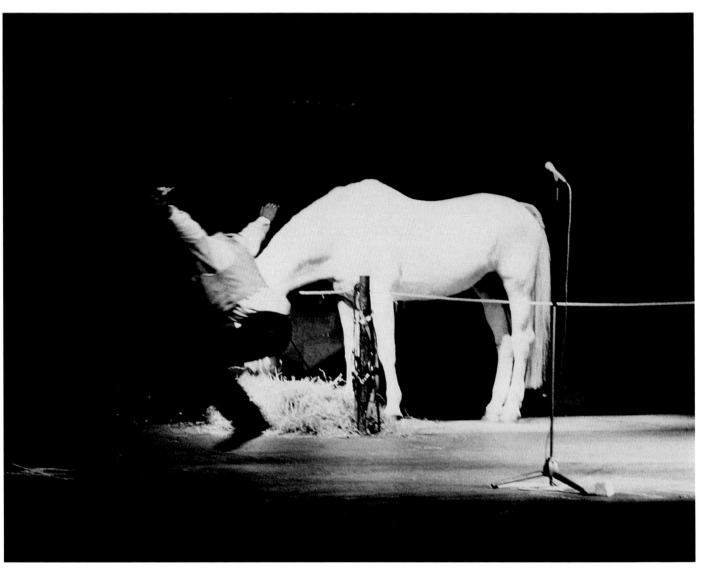

Plate 14.

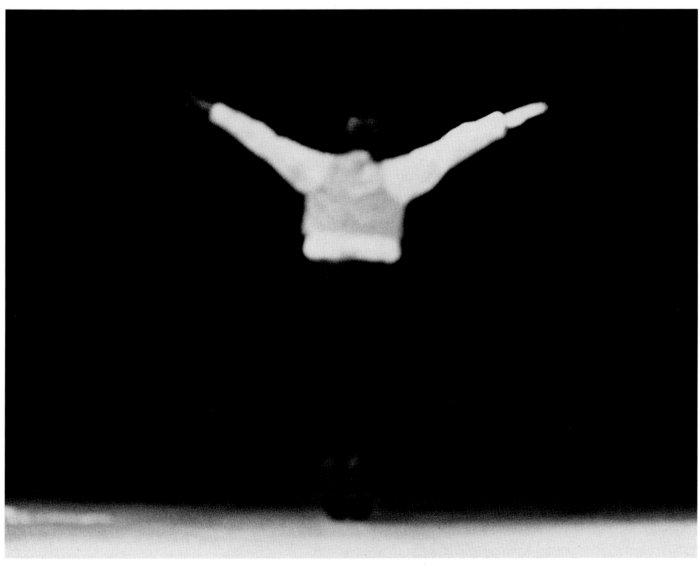

Plate 15.

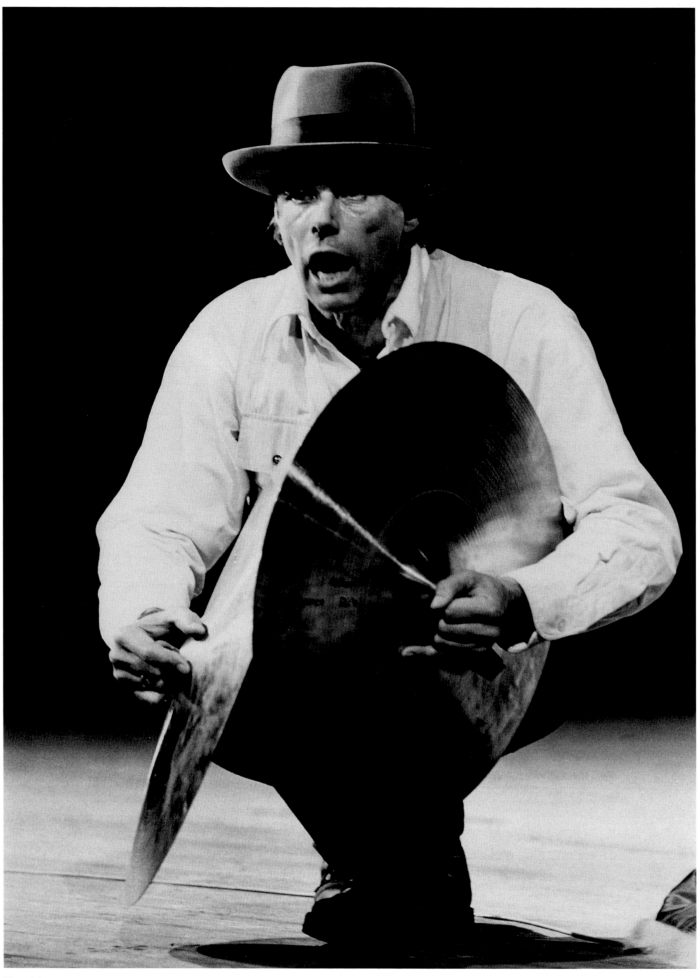

Plate 16.

are part of an animal's iconography. For instance, he discussed the coyote and its reputation for guile among Native Americans. This reputation refers not only to natural survival skills, but to a time and place when animals were more revered.[45] Besides being creatures of renewal or even incarnation, stags, sheep, and deer are herd animals, recalling for Beuys a time of shepherds with which he strongly identified.[46] The stag is also a spiritual creature, which "appears in times of distress and danger," and is "the accompanier of the soul."[47] In some of his Actions, for example, *Coyote III* (1984), Beuys made animal-like sounds in order "to switch off my own species' range of semantics Such an action . . . changes one radically. In a way it's a death Theme: how does one become a revolutionary? That's the problem."[48] Beuys had already spoken of the need for a political party for animals, saying that he would represent them.

Human innocence is a rare commodity in Beuys's art but sometimes is provided by childhood objects, such as his bathtub. More unequivocal are the frequently seen toys. In *Mammut* (*Mammoth*, 1960, pl. 17), the elephant has the jaunty air of a plaything, its position casually arranged and reminiscent of the unconcern possessed by a child. The elephant should be compared with Robert Rauschenberg's stuffed animals, which were first seen in Europe from 1957. Whereas Rauschenberg is so much the hipster, playfully collaging whatever was at hand, Beuys's stuffed animals exude a sense of portent. With *Fluxusobjekt* (*Fluxus Object*, 1962, pls. 18–19), the bewitching realm of the child is conjoined with that of the animal, both living outside a rather tired, stained cardboard box. The real character and the scale of the latter, with connotations of world weariness, exist side-by-side with the dreamy, unreal-in-scale playthings. The juxtaposition of toys with hard rectilinear objects, seen in *Mammoth* also, is a model for much to come in Beuys's career. Later, the juxtaposition will reverberate with implications of the malleable and organic, or the free and creative, versus the rectilinear and unbending, or the rigid and traditional. Earlier, however, contrast between the ages of innocence and experience is emphasized, with fresh, inspired outlooks compared to worn and deteriorating ones.

Within his intuitive iconography, Beuys related women to various creatures symbolic of innocence, in part through using a common organic or curvilinear depiction. He compared women to the hare because for both, he said, the lower torso is the primary locale of activity.[49] Like the hare, the female never dies for Beuys. Too, women embody spirituality, just like the stag. A woman is, of course, the giver of birth as well as the child rearer, and as such is as natural as a human being might ever become.[50] (The only comparable possibility for men, it would seem, is being a herder or a shepherd.) Thus Beuys goes so far as to proclaim that "the heroic position in my works is generally the female one."[51]

Nature, the archetypal embodiment of innocence and of laws that exist as preordained and without hint of vile motives, is rarely shown in Beuys's art, except very early in his career. Then, leaves are usually presented in a precious, if vulnerable, way; that condition will form a model for occasional sightings of other, similar ciphers of innocence. Drawings of natural settings, eggs perched in a precarious situation or objects hanging by a thread, all seem to suggest the potential destruction of natural states of grace.

Another major theme of the Actions is art and its healing power, about which he said: "I realized the part the artist can play in indicating the traumas of a time and initiating a healing process."[52] In this spirit, he playfully created a work in felt entitled *The Art Pill* (1963, private collection), as if medicinal-type healing could occur with an aesthetic remedy. The reality of such a remedy was indicated when, in 1964, Beuys proposed raising the Berlin Wall by five

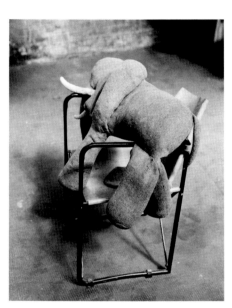

Plate 17.
Mammoth, 1960
Fabric toy, chair
39 ⅜ x 35 ½ x 23 inches
(100 x 90 x 58 cm)
Private collection, Germany

Plate 18.
Detail of *Fluxus Object*, 1962
See checklist no. 8

Plate 19.
Fluxus Object, 1962
See checklist no. 8

centimeters to give it "better proportions!"[53] Beuys's point was to show that all things are conceivable, indeed, must be considered, to forge a better world, this in keeping with his political and utopian ideas. Hence, one concern of art, namely "better proportions," could be applied to mock, if not defuse, the circumstances that led to the building of the wall. It is noteworthy that Beuys's proposal for the wall concludes his *Life Course / Work Course*, the start of which is his entry concerning the "wound" that has been "drawn together." In other words, his initial suturing procedure has been reconceived as an art procedure, with both having identical healing effects. And from the first entry to the last, the wound has been transferred from his own body to the body-politic of his country.

In Beuys's world view, art needed a larger context than was the case historically. For instance, the freewheeling, unabashed sarcasm of his proposal about the Berlin Wall is reminiscent of his interest in some lawless behaviors, about which he admired a "crazy creativity . . . without morals fired only by the energy of freedom and the rejection of all codes and laws."[54] These characteristics might be applied to Beuys himself. At the opposite end of the cultural spectrum is economic theory, and Beuys situated art there, too, saying that it has importance equal to capital. With value as a "spiritual good," it could help transform society. Otherwise, the art world existed in isolation, and was, for Beuys, an irrelevant "little pseudo-cultural ghetto."[55] In the 1970s, Beuys would often leave the narrowly defined field of art in favor of political action, and he would declare that his art objects were, in fact, meant to epitomize ideological/political concerns.

While the art world and its confines might be irrelevant, art was not so. Beuys's view of it can be characterized as "faith," faith that art could prevail to change or enhance life in an otherwise bankrupt society. "I have come to the conclusion that there is no other possibility to do something for man other than through art."[56] "Art alone makes life possible," he proclaimed,[57] a view that in the twentieth century has been held by many others, such as the early pioneers of abstraction Wassily Kandinsky, Kasimir Malevich, and Piet Mondrian. Kandinsky, whom Beuys singled out for praise, was wedded to the proposition that art could combat an overly materialistic society. Just as Kandinsky felt that he was living in a time when spiritual and artistic values were being threatened, so, too, did Beuys feel that the "economic miracle" of Germany was in reality a plague. For Beuys, art was also unsafe under Marxism.[58]

Beuys's glorification of art and its power should be seen as an impetus to his Action entitled *Das Schweigen von Marcel Duchamp wird überbewertet* (*The Silence of Marcel Duchamp Is Overrated*, 1964, pl. 20). Duchamp's professed, ironical position toward art stated early in his career, followed by his quiet life playing chess, were a provocation to Beuys. The fact that contemporaneous American artists involved with Pop, Minimalism, and Conceptualism were reviving an interest in Duchamp only added to Beuys's ire. Duchamp's silence was deadly as far as Beuys was concerned and had to be combated by art that possessed an engagement to life, even if only a shriek resulted.

To employ art to alter or resurrect life, and to fight against the forces of silence, Beuys made use of a piano in many Actions. He filled the instrument with a mass of objects for the purpose of initiating a healing process in his 1964 Action entitled *Kukei / akopee-No! / Brown Cross / Fat Corners / Model Fat Corners* (pls. 1–2).[59] "Only art is capable of dismantling the repressive effects of a senile social system that continues to totter along the deathline: to dismantle in order to build A SOCIAL ORGANISM AS A WORK OF ART," he said.[60] By this description and by his Action, the piano and art are one. The title for his sculpture *Revolutionsklavier* (*Revolutionary Piano*, 1969, pl. 21) furthered the

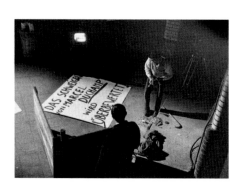

Plate 20.
The Silence of Marcel Duchamp Is Overrated, 1964, Düsseldorf

position as well as the powerful identity of the piano.

Beuys's fondness for the piano followed the practice of his colleagues in the Fluxus art movement, of which he was so much a part from 1962 through 1964.[61] Pianos could often be found in the performance works of George Brecht, Nam June Paik, and John Cage, and were also art objects. In Fluxus, high importance was given to sound, indeed noise, to interrupt the status quo of society; in contrast to older forms of art and music, Fluxus could not tolerate palliatives. But Beuys's usage of the piano in these years and later was more conceptual and symbolic. For instance, imagining an *Earth Piano*, in 1962, Beuys described four possibilities: "the idea of digging a negative piano, like a pit, out in the open; then there was the possibility of sprinkling earth over a piano; a third version was to make an entire piano out of earth . . . or to place a normal Bechstein grand piano in the ground."[62] Elsewhere in his work, pianos cease to function, or become muted, deceased, as it were. He emphasized the "trapped" silence to which the piano in *Infiltration-Homogen für Konzertflügel, der grösste Komponist der Gegenwart ist das Contergankind* (*Infiltration–Homogen for Grand Piano, the Greatest Contemporary Composer Is the Thalidomide Child*, 1966, pl. 22), was "condemned."[63] Because art can be a vulnerable enterprise, this piano is in need of warmth, and the "*protective covering* against other influences,"[64] given by the felt.

Beuys's iconography consisted, too, of certain forms possessing attendant meanings. For instance, his use of a cross is multivalent in its associations, with its Christian meaning paramount. The form is inherently *good*, referring not only to the spiritual context but embodying a unified and whole view of the world,[65] as presented by the formal coherence of the shape. Practicing his fondness for connections, Beuys, while speaking of the much-admired qualities of the beehive, a natural manifestation of an ideal social organism, described queen bees as "nothing more than moving crosses . . . pietas."[66] In other words, he imbued the spiritually seamless state of the cross with the organic dimension of the beehive. It is to this form that Beuys aspired, and to which he constantly contrasted the divided states of the world, as evoked by the halved cross.[67]

The halved cross refers, in part, to what Beuys considered a corrupted Eurasia. That is, Eurasia was a "vast uninterrupted land mass stretching from China to the Atlantic," as described by Tisdall, and "criss-crossed since time immemorial by the movements of peoples as well as migratory animals."[68] Running throughout Beuys's work is the theme of this idealized Eden (Eurasia), which became unnaturally divided between Eastern cultures, with their admirable spiritualistic tendencies and mysteriously nomadic ways, and the West, with its materialistic outlook and all-too-familiar failings. For Beuys, the "Division of the Cross" referred, among other things, to this geographical split, and demanded a resolution, with unity in diversity and the synthesis of polarities.[69] The term Eurasia occurs frequently in Beuys's titles, as do distinctions between East and West, and North and South. Of course, the nations on each side of the Berlin Wall are invoked, too;[70] when Beuys called for five centimeters to be added to the wall, he symbolically corrected a halved cross, the wall, and the political division of Germany. For Beuys, a divided condition may, at times, refer to different historical periods or to portions of an individual's personality as well as to the relationship of an individual to society.

In his 1966 Action entitled *MANRESA* (pls. 11, 23), Beuys enacted a split between sections of the world and their eventual reunification in a full cross. But, as Friedhelm Mennekes notes, it is not the reconstitution of an ancient Christian form that Beuys sought to construct but an entirely new cross.[71] In this regard, Beuys often spoke of and depicted entities he called Element 1 and Element 2;

Plate 21.
Revolutionary Piano, 1969
Vitrine containing piano, roses,
brown paint, paper
Overall dimensions: 71 x 71 x 36 inches
(180.5 x 180.5 x 91 cm)
Städtisches Museum Abteiberg
Mönchengladbach

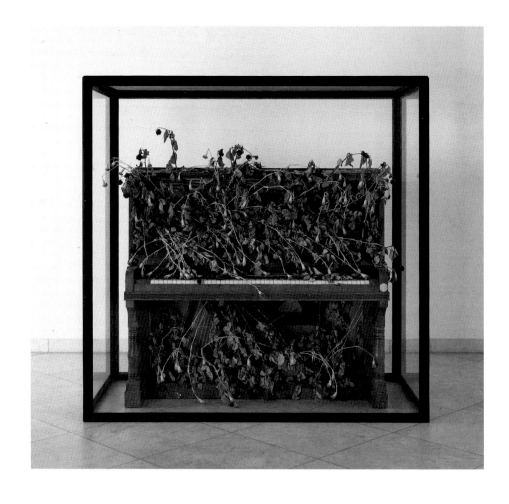

Plate 22.
Infiltration-Homogen for Grand Piano, 1966
Bechstein piano covered with felt
39 ⅜ x 59 ⅞ x 94 ½ inches
(100 x 152 x 240 cm)
Centre Georges Pompidou, Paris, Musée
national d'art moderne / Centre de création
industrielle. Inv. AM 1976-7

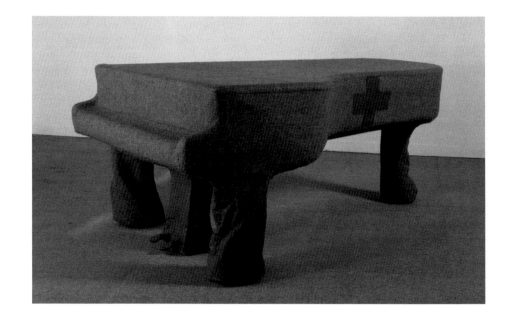

however, in his notes for *MANRESA*, he plaintively wondered, "Where is element 3?"[72] In other words, he constantly had to deal with the given divided state consisting of these two components. In *MANRESA*, he created a fully delineated cross, filling in a halved cross with a dotted line. Another way to complete or to resolve the status quo of the half cross is to literally fill it up, as he did in the 1968 Action entitled *Vakuum<—>Mass, Simultan = Eisenkiste, halbiertes Kreuz, Inhalt: 20 kg Fett, 100 Luftpumpen* (*Vacuum<—>Mass, Simultaneous = Iron Box, Halved Cross, Content: 20 kg Fat, 100 Bicycle Pumps*, pl. 24). There, he loaded up the sculpted half cross with fat and pneumatic pumps. Beuys's resolved cross was replete with potential content taken from situations in daily existence: for instance, a coalition of political parties, that is, a third way surpassing the division between Communism and Capitalism, or attaining a spiritual wholeness, whereby the alienated condition that Beuys perceived to be inherent in contemporary Western life was healed. Even Beuys's Theory of Sculpture is based on an Element 1–Element 2 situation, wherein "movement" produces the possibility of a synthesis of the poles, yielding Element 3.

The divided cross was inherently a spiritual form that was badly in need of healing. It cried out to be made symmetrical and whole. Beuys showed the dreamt-of resolution by a slip of paper having a full cross tacked at the left in *Halbiertes Filzkreuz mit Staubbild "Magda"* (*Halved Felt Cross with Dust Image "Magda,"* 1960/65, pl. 25). With, as it were, a crippled form, the half cross could be seen as Beuys's version of the wounded or amputated condition in Paul Klee's *Der Heldmit dem Flugel* (*Hero with the Wing*, 1905, pl. 26).[73] Disequilibrium and/or the lack of a parallel arm for the half cross, all require a remedial-cum-medical-cum-aesthetic attachment.

In generally maintaining the cross as an ideal, Beuys may have indicated an overarching commitment to Christian values,[74] but there was an ecumenical alternative in his work: the triangle. "The Threefold Commonwealth," in form a triangle, has a rich history within Theosophy and the writings of Rudolf Steiner, a twentieth-century philosopher who held a deep attraction for Beuys.[75] Steiner had emphasized that the progress of humanity could be charted by the progressive "movement [of]… three structures": the state, the economy, and intellectual life.[76] Celebrating that concept, Beuys called Steiner's three-sided structure "the essence of man."[77] Tisdall described Beuys's love of three-sided structures and their repeated occurrence in his lectures and blackboards as triads, trinities, or triangles.[78] Beuys's enthusiasm for Steiner followed the example of Kandinsky, who himself placed great emphasis on spiritual longing, as did Beuys, and on a "spiritual triangle" to evoke that striving.[79] Beuys joined this brother-hood when he, too, made use of the equilateral triangle. This convergence of intentions is also echoed in Steiner's insistence on "movement"; Beuys placed that word at the center of his Theory of Sculpture.

Perhaps not incidental to Beuys's interests and practices, the form of the equilateral triangle resolves the physical condition of a halved condition in that its shape effectively subsumes Elements 1, 2, and 3. Beuys examined other types of triangles, too, for instance, one with a right angle contains "the strongest of angles, the main prop of the architecture of our civilization, and the one which most clearly defines space in solid corners. All other angles are to be interpreted as in a kind of movement towards this ultimate rectangular state."[80] With this description, Beuys restated the sense of Kandinsky's aspiring triangle that moves toward some elevated state of being.[81]

Instances of the triangle are frequent and important in Beuys's work. From 1963, he would often begin an Action by placing equilateral sculptures

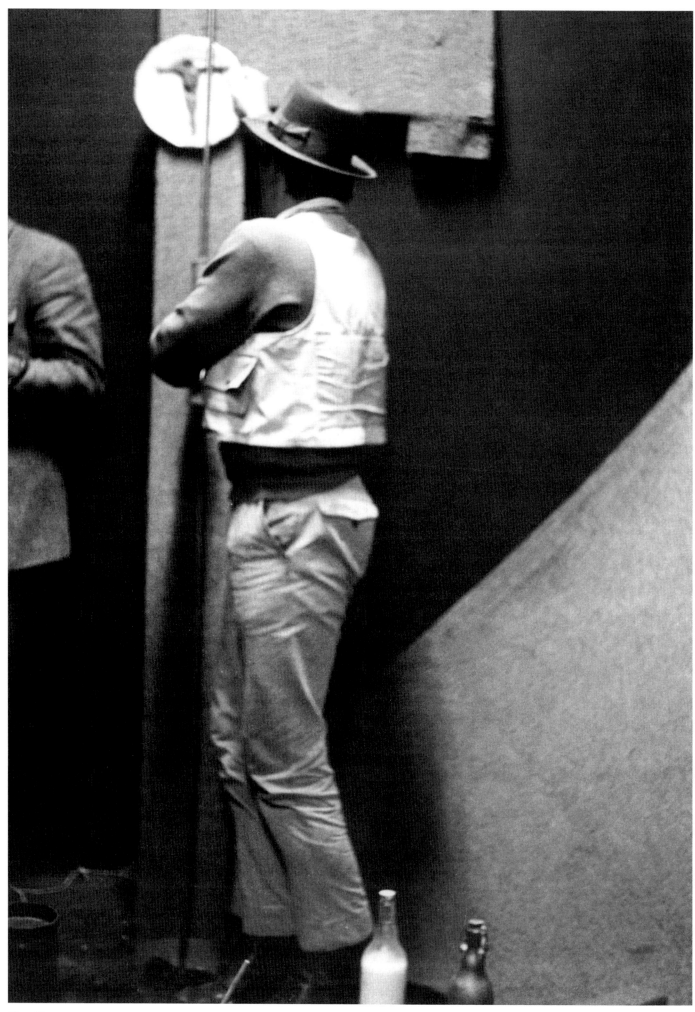

Plate 23.
MANRESA, 1966,
Düsseldorf

Plate 24.
Vacuum <—>Mass, Simultaneous = Iron Box,
Halved Cross, Content: 20 kg Fat, 100 Bicycle
Pumps, 1968, Cologne

Plate 25.
Halved Felt Cross with Dust Image "Magda,"
1960/65
Felt, paper, brown paint,
picture frame with an image in handwriting
and dust, wire and toe nails under glass,
in a metal frame
42 ½ x 26 ¾ x 2 ¼ inches
(108 x 68 x 5.5 cm)
Museum Ludwig, Cologne

Plate 26.
Paul Klee
Hero with the Wing, 1905
Etching
10 x 6 ½ inches (25.5 x 16.1 cm)
The Art Institute of Chicago. Buckingham
Fund, A. Kunstadter Family Foundation Fund,
and Frances S. Schaffner Principal Fund.
1970.241

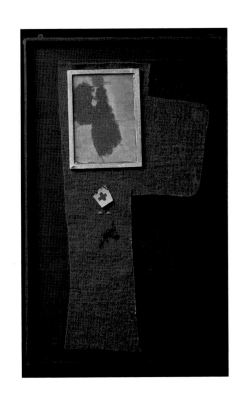

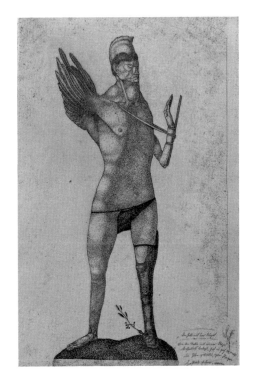

Plate 27.
Lucerne Fat Room, 1969,
Lucerne

made of fat or felt in the corners of a room, as if establishing cardinal points, as in *Luzerner Fettraum* (*Lucerne Fat Room*, 1969, pl. 27).[82] On occasion, he placed these high in corners,[83] joining himself to the practice of Malevich, who installed his monochrome paintings in this way and who himself was emulating the installation of Russian icons. In discussing the principle of his triangular *Fat Corners*, Beuys spoke of three underlying aspects: "thinking, feeling, wanting," as if these were his proposed modifications or enhancements to Steiner's triad of state, economy, and intellectual life.[84] He even wore a musical triangle on his waist during his Action *I Like America and America Likes Me* (1974, pl. 8), which acted as a kind of saintly attribute to indicate his personal inclinations. He said that this triangle "was intended as an impulse of consciousness directed towards the coyote—it helped to restore his harmonized movements." Beuys further explained that, as opposed to the roar of the turbine noise in the room signifying "undetermined energy… the triangle has the contained form of the front plane of the 'Fat Corner'… an equilateral triangle in which the undetermined nature of the fat is completely integrated with determined, mathematical form."[85] In other words, Beuys's artistic task was to mold the inchoate into form, literally and figuratively. Beuys even marked passages in his copy of Richard Ellmann's book on James Joyce[86] with a penciled triangle in the margins, tying this admired writer to an equally venerated form.[87] Upside-down triangles occur in Beuys's work, too, as in *Filzwinkel* (*Felt Corner*, 1963, location unknown), and the Action entitled *Titus / Iphigenie* (1969, pls. 14–15), in which Beuys's outstretched arms, placed in a position of crucifixion, assume the shape of a down-turned triangle.

Perhaps Beuys's best-known and most celebrated triangle is in his famous *Fettstuhl* (*Fat Chair*, 1964, pl. 28). Not only does the dramatic mass of fat hold our attention, but the chair itself is notable for its utterly styleless character.[88] With it, Beuys recalled two important sources for his work: Vincent van Gogh and Robert Rauschenberg. Van Gogh's *Chair* (1888, National Gallery, London) was an icon in subsequent years for the self-effacing life of a passionate artist at work in his studio. In making the humble chair central in his own work, Beuys placed himself in a geneological line with other tortured, sensitive spiritual beings living on the edge of society. One cannot but surmise that the Van Gogh chair later inspired Rauschenberg also, who employed this modest piece of furniture on numerous occasions, including *Booster* (1967, collection of the artist.) Rauschenberg, who was well known in Europe starting in the late 1950s, would have been important to Beuys for his celebration of ignoble material, a practice that reinforced the German model of Kurt Schwitters. From at least as early as 1959, in works such as *Ohne Titel* (*Lone Star*), *Untitled* (*Lone Star*, pl. 29), and *Royal Mortar* (Schloss Moyland Museum / Sammlung van der Grinten), Beuys referred to the U.S. not only in his titles but to Rauschenberg in the loose yet poetical, arrangements of abandoned materials.[89]

After 1970, Beuys sharply curtailed his Actions and began a transition in his career. He explained, in 1969: "One is forced to translate thought into action and action into object."[90] The transition consisted, in part, of taking an object that had played a role in an Action and calling it an independent sculpture, examples of which include *Eurasia Siberian Symphony 1963* (1966, pl. 30) from *Eurasia, Siberian Symphony* (pl. 13); *Vacuum<——>Mass* (1968, The Museum of Modern Art, New York) from the Action of the same title (pl. 24); *Filzanzug* (*Felt Suit*, 1970, pl. 31) from *Action the Dead Mouse / Isolation Unit;* and *Three Pots for the Poorhouse* (1974, pl. 32) from the *Three Pots Action* of the same year. By taking objects from the Actions, the Actions effectively become the creative process whereby an object is formed; the prop gains new life by subsequently becoming a work of art

Plate 28.
Fat Chair, 1964
Wooden chair with fat
35 ⅜ x 11 ¾ x 11 ¾ inches
(90 x 30 x 30 cm)
Hessisches Landesmuseum,
Darmstadt

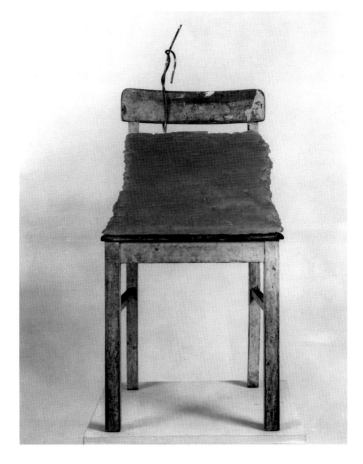

Plate 29.
Untitled (*Lone Star*), 1959
Collage of paper and cement
18 ½ x 23 ¼ x ¼ inches
(47 x 60.4 x .7 cm)
Museum Schloss Moyland,
Bedburg-Hau / Sammlung
van der Grinten
MSM 01476

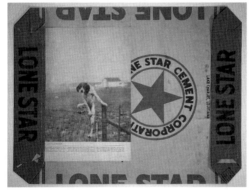

Plate 30.
Eurasia Siberian Symphony 1963, 1966
Panel with chalk drawing, felt and fat,
hare and blue painted poles
72 x 90 ¾ x 20 inches
(182.9 x 230.5 x 51 cm)
The Museum of Modern Art, New York
Purchase. 213.2000.a-b

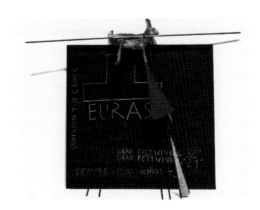

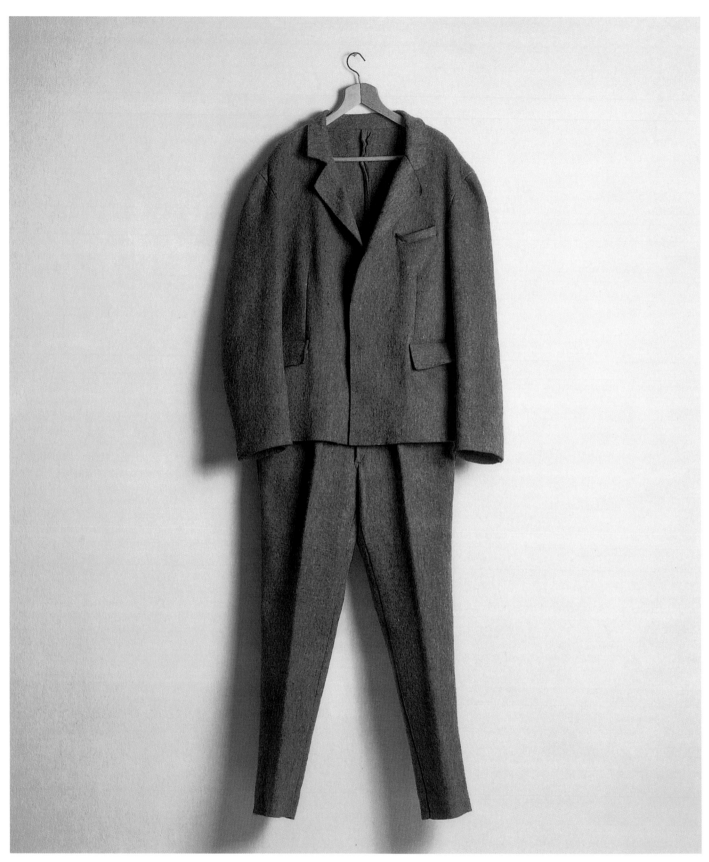

Plate 31.
Felt Suit, 1970
See checklist no. 12

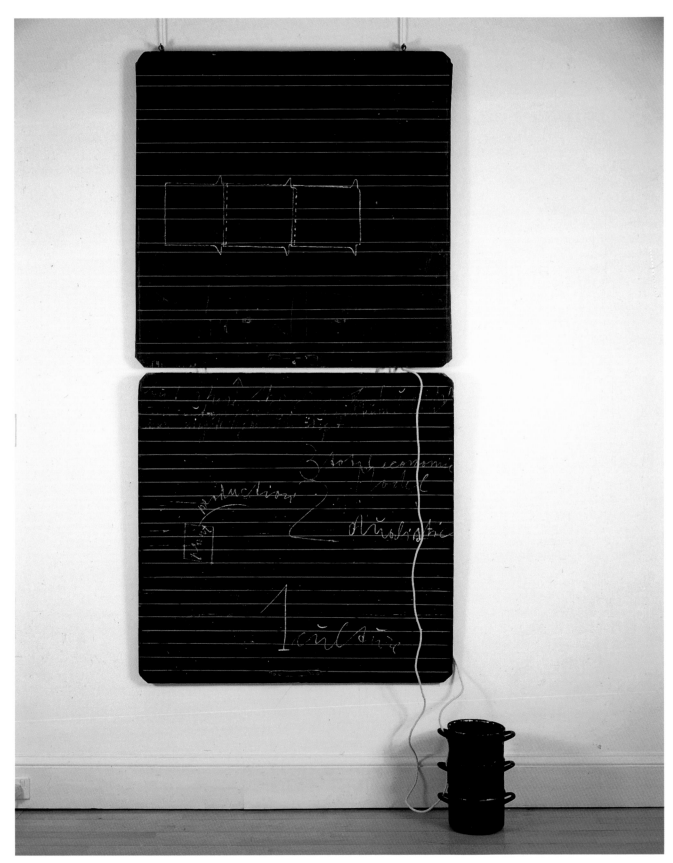

Plate 32.
Three Pots for the Poorhouse, 1974
See checklist no. 19

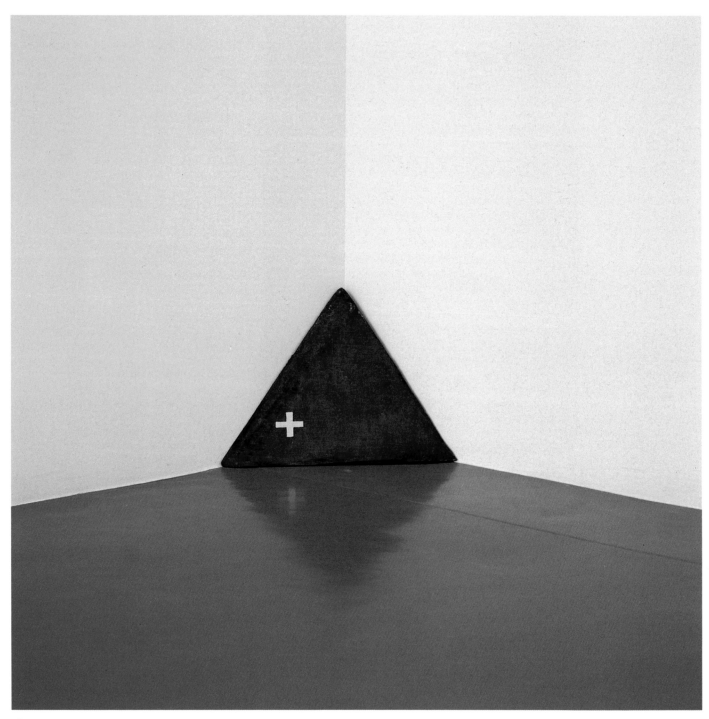

Plate 33.
Iron Corner, 1963
See checklist no. 9

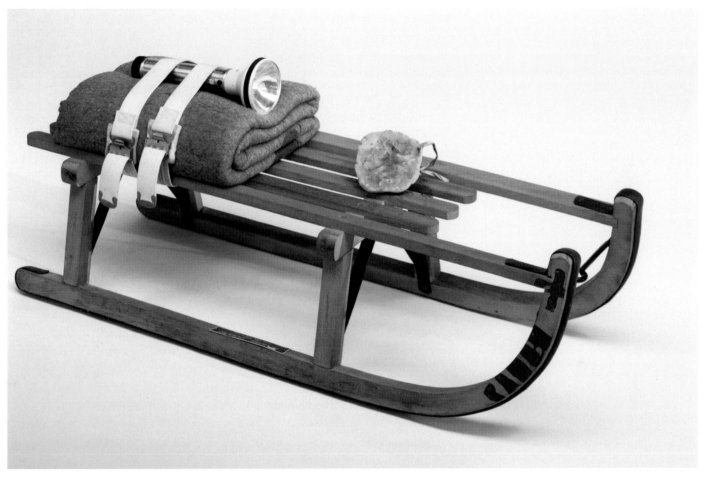

Plate 34.
Sled, 1969
See checklist no. 11

or the prop is simply a relic of the earlier event. There are also objects such as *Rostecke* (*Iron Corner*, 1963, pl. 33) and *Schlitten* (*Sled*, 1969, pl. 34), which, though they never actually played roles in Actions, powerfully recall that milieu.

From 1970, when his political activism was ascendant, Beuys's impulse toward Actions was often manifested in more didactic form, as he began to deliver lectures in which he delineated his social, political, and artistic theories by making diagrams on blackboards (pls. 35–39, 128).[91] In his highly mutable and elastic world, these were his latest versions of Actions, with the blackboards often becoming independent sculptures, as if they, too, were relics of Action-type moments. (Indeed, a blackboard appeared in the first Action, *Siberian Symphony* [1963, pl. 13]). Blackboards were, in effect, "calls to action" by which Beuys intended sculptures that would induce a state of contemplation, imaginary possibility, or a desire to change the world.[92] At the 1972 Documenta V, his artistic participation consisted of one hundred days engaged in discussion; he accompanied his activity with a beaker holding a rose, his symbol of a longed-for democratic society. The following year, the beaker too, became an artwork: *Rose für direkte Demokratie* (*Rose for Direct Democracy*, 1973, pl. 40).[93]

It is a short step from the Actions to a body of works that can be thought of as appeals, or calls, or suggestions to act. Both the striding figure of the artist and the words *La rivoluzione siamo Noi* (*We Are the Revolution*, 1972, pl. 41) are an emphatic declaration of this exhortation. Other works are more implicit. *Erdtelephon* (*Earth Telephone*, 1968–71, pl. 42) represents the possibility of a call or suggests the enactment of an imagined Action.[94] With *Dürer, ich führe persönlich Baader + Meinhof durch die Dokumenta V* (*Dürer, I Personally Conduct Baader + Meinhof Through Documenta V*, 1972, pl. 43), Beuys envisioned an Action-type activity in which he would accompany the infamous radicals through the art exhibition while wearing slippers containing fat and rose stems. Such "instruction," as was the case with his blackboard lectures and *How to Explain Pictures to a Dead Hare*, shows Beuys's compulsion to explain his work. The question of how to interpret his art, whether simply to enjoy with the eyes, to take in the panorama of an environment with the whole body, or to analyze (if not over analyze) it, is a subject that Beuys himself was aware of. Frustrated, Beuys pleaded: "People first of all have to be able to see. In art, there is nothing to understand, absolutely nothing."[95] But if that is the case, he would never have given such replete titles, nor spoken so frequently in symbolic terms about each material and aesthetic decision in his work: witness the 1979 Guggenheim catalogue of his exhibition. Chock-a-block with quotes, this volume is a thorough demonstration of an iconographic approach, and has imparted permission to subsequent generations of writers to examine each work as a puzzle in need of unraveling. The very frustration of the problem for Beuys himself was first dramatically depicted in *How to Explain Pictures*. Why should this pathetic exercise be necessary? Is it that Beuys felt doomed to explain his meanings, or that, whereas humans are deaf to his work, a dead hare can understand? Seven years later, Beuys echoed this situation with the hare in his imagined act, in *Dürer, I Personally Conduct Baader + Meinhof Through Documenta V* (1972), where he exhibited that same didactic urge, and, this time, with revolutionaries whose interest he could perhaps no better have engaged than the hare's.

Eurasian Staff (1967/68, pl. 44) is a powerful reminder of the three Actions of the same years and title (pl. 45). Wearing one iron and one felt shoe, ostensibly to transverse the continent, he installed four staffs in four corners of a room in order to accomplish his goal of uniting the now-divided lands. Within his iconography, this work exemplifies the activity of a healer,

Plate 35.
Board I (*Spirit—Law—Economics*),
1978
See checklist no. 20

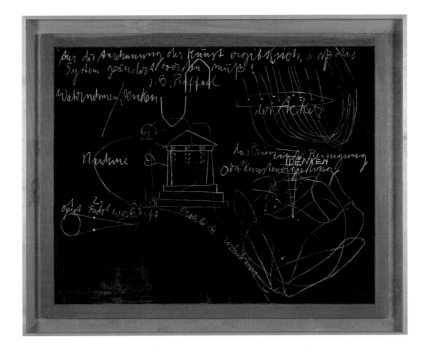

Plate 36.
Board II (*Everyone is an Artist*),
1978
See checklist no. 21

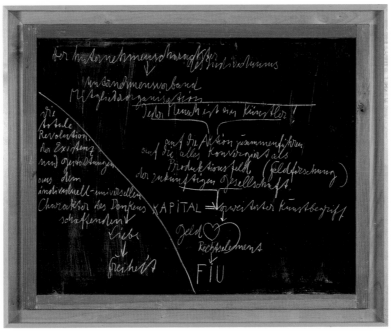

Plate 37.
Board III (*Capital = Art*),
1978
See checklist no. 22

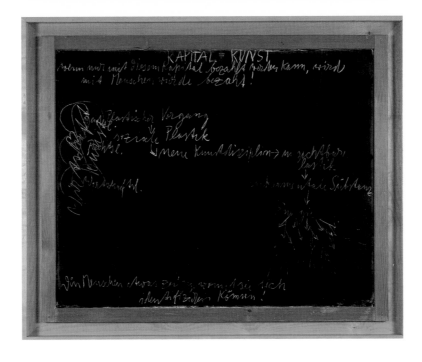

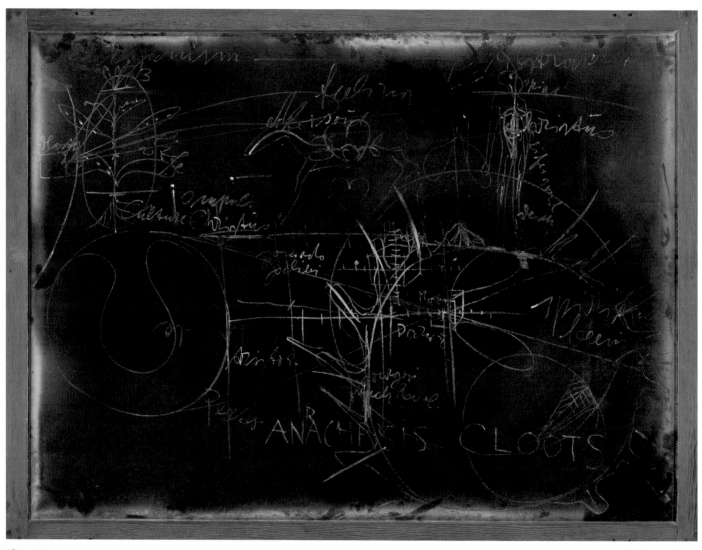

Plate 38.
Untitled, 1973
See checklist no. 18

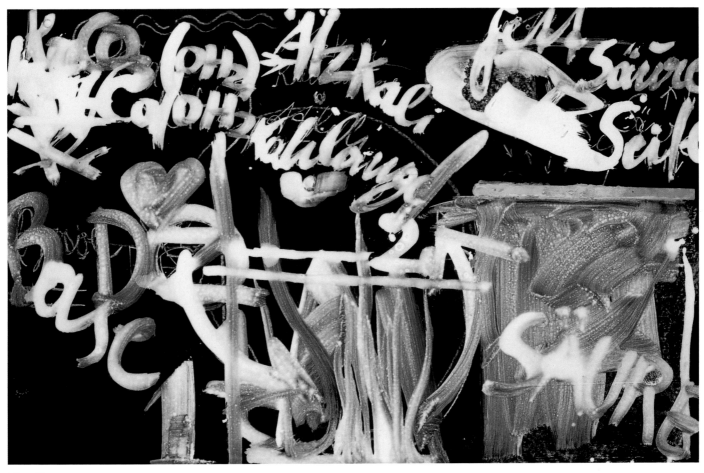

Plate 39.
Virgin, 1979
See checklist no. 23

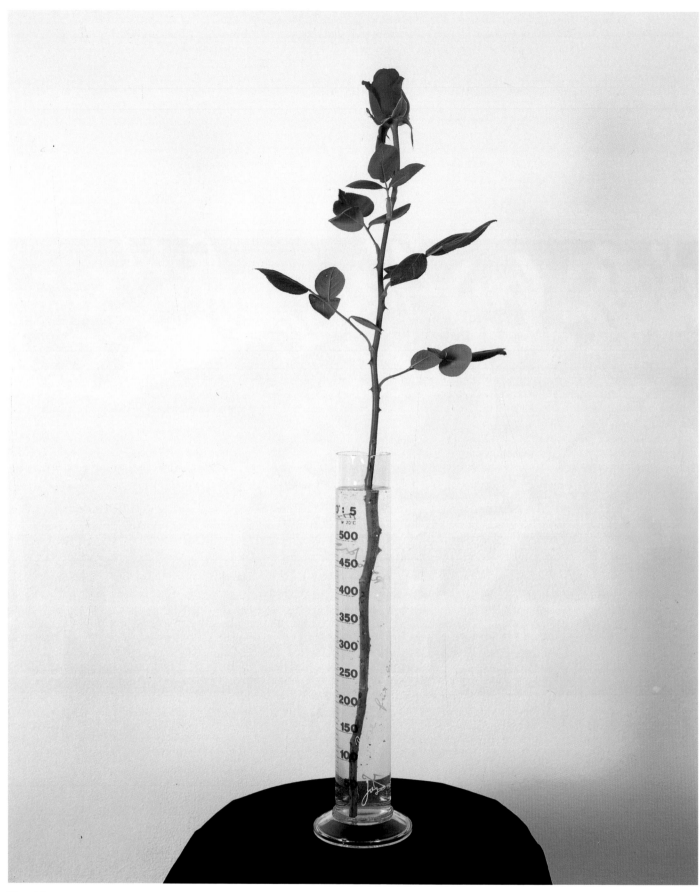

Plate 40.
Rose for Direct Democracy, 1973
See checklist no. 17

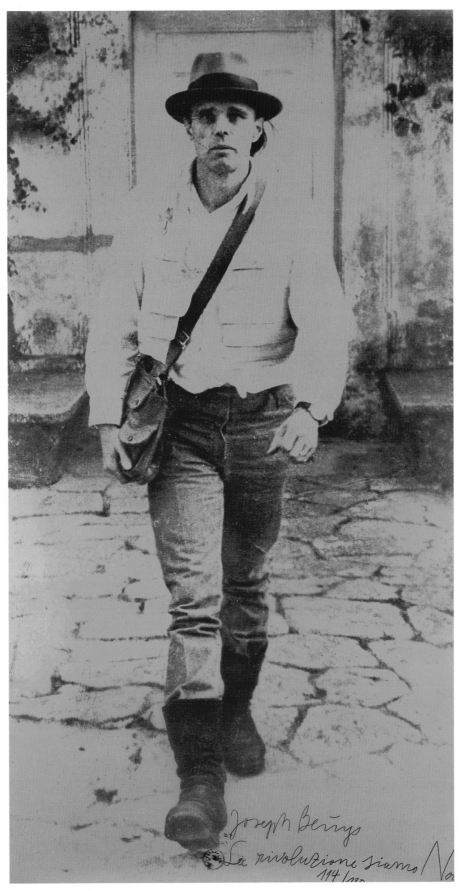

Plate 41.
We Are the Revolution, 1972
See checklist no. 15

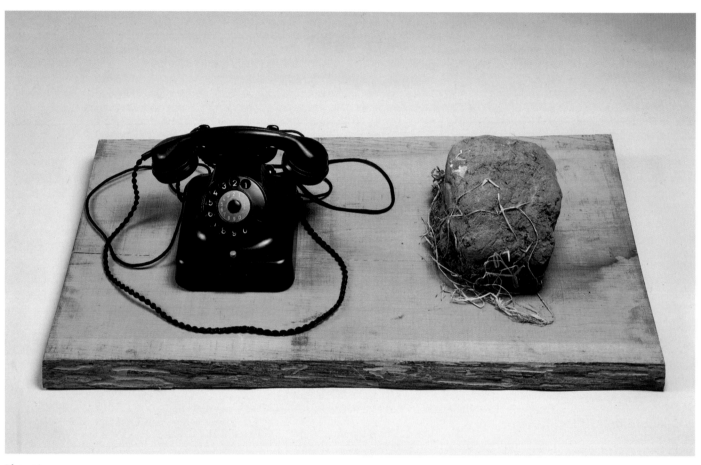

Plate 42.
Earth Telephone, 1968–71
See checklist no. 13

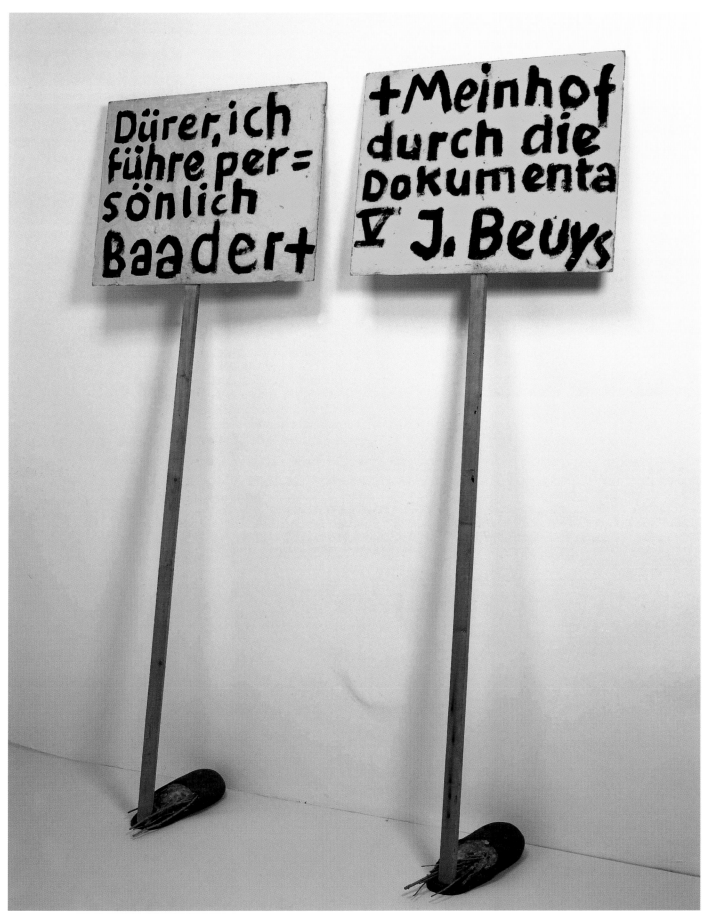

Plate 43.
Dürer, I Personally Conduct Baader + Meinhof
Through Documenta V, 1972
See checklist no. 14

Plate 45.
Eurasian Staff 82
min fluxorum organum,
1967, Antwerp

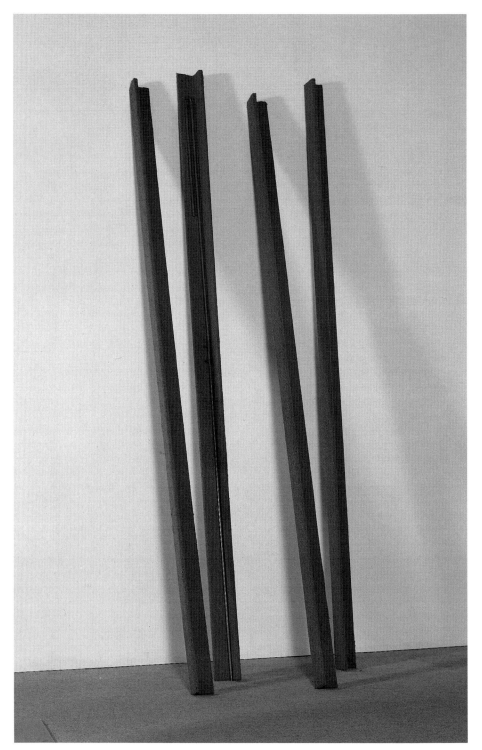

Plate 44.
Eurasian Staff, 1967/68
See checklist no. 10

reuniting the bifurcated continent back into its Eden-like state.

Just as the Actions are literally theatrical events, the ensembles—both vitrines and environments—have theatrical qualities also, in that the viewer usually finds him/herself peering into an enclosed space to view a tableau. Numerous objects are arranged with care, whatever the air of chaotic energy. But whereas the environments have a macrocosmic, large-scale ambition, the vitrines are precious and microcosmic by comparison. As opposed to the public and expository nature of the Actions and lectures, Beuys had another side to his personality, one that might be thought of as the actor talking to himself in a kind of soliloquy. Though his demeanor in the Actions often suggests that persona, his vitrine sculptures (pls. 47–51, 56–59) exemplify a literally solitary pursuit, for they are created in private moments. The vitrine soliloquy manifests itself in the placement of the detritus of his studio, including leftover materials from his Actions, into poetic ensembles within glass cases. Each vitrine offers a dense spectacle that is evocative of Beuys's personal world. In this regard, Beuys's great interest in Joyce in particular *Ulysses*, enriches our understanding of his art, especially the vitrines. *Ulysses* teems with interlocking leitmotifs and a great range of references, but explanations are never provided. Joyce invested anecdotal events with a portentous power. Whatever his symbolic intent, the characters and objects are given tremendous physical presence and visceral energy, for example, the description: "He laid the dry snot picked from his nostril on a ledge of rock, carefully. For the rest let look who will."[96] Such intense focus on the ordinary, and even distasteful, corresponds to "passages" in the vitrines that transform the ordinary into the extraordinary and poetic. The eloquence of Beuys's objects departs yet further from expectation by their dull colors, especially brown. Speaking of this palette as an "anti-image" of a beautiful world,[97] Beuys referred to the attributes of a postwar German state that was initially in ruins, and then became an ugly, urban environment, in no way the slick image of the Western materialism.[98]

Often professing a love of things wherein the soul resides, Joyce wrote: "The soul is in a manner all that is: the soul is the form of forms."[99] He extolled the "ineluctable modality of the visible....Signatures of all things I am here to read, seaspawn and seawrack, the nearing tide, that rusty boat. Snotgreen, bluesilver, rust coloured signs."[100] In Beuys's vitrines, too, there are signs, portents, leitmotifs, and ritualistic events, but not before they are "rusty" and "snotgreen." More specifically, Joyce exalted in animal organs: likewise, Beuys's use of fat and tallow. Joyce began a poem "O, O the boys of Kilkenny,"[101] and Beuys cried out "oo" in his 1967 Action *Celtic: Ö,Ö,Ö,* and created a sculpture called *öö*, referring to "the cry of the stag."[102] Embracing death, Joyce quite perversely described a character "clipping and saving [the] nails and hair of a corpse."[103] Beuys would prize nail clippings, too, as in *Ohne Titel* (*Untitled*, 1968, pl. 46). Joyce's richly woven, determinedly Irish atmosphere has an intense aura, often pungent, always dingy. In a similar vein, Beuys created a personally meaningful—in his case—German, milieu, described with humble, foul, or even disturbing details, all rendered with an intensely wrought physical reality. Beuys, like Joyce, projected an ambivalent relationship to the land of his origin, as well as to the Catholic Church. Neither artist could be said to have much faith in the promise of a heaven, or even the hope that there exists a place of retreat from their unrelentingly suffocating homelands, though Beuys was certainly a utopian about the possibility of social progress, a possibility that is scarce in Joyce. Witness, too, that both rarely disclose sensations of nature as pure or unfettered. Only human and earthly events have any real presence or teach useful lessons. All that said, Stephen

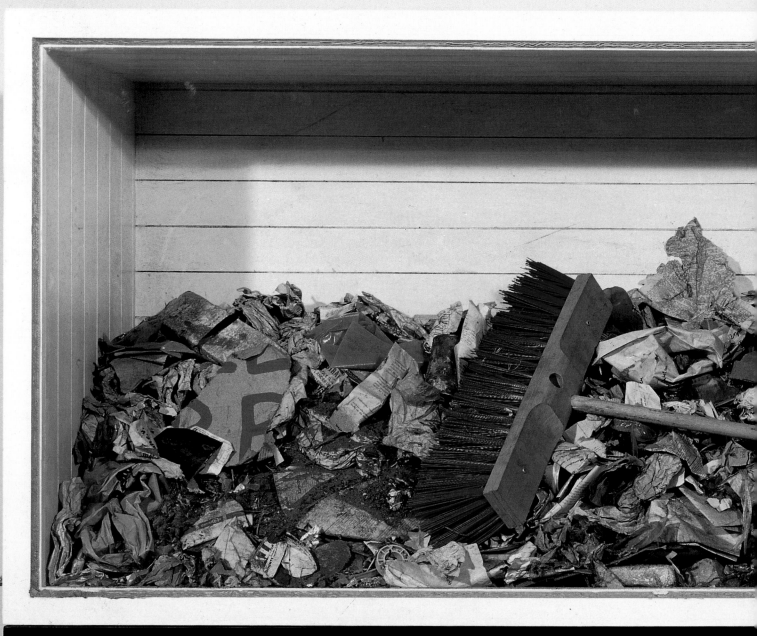

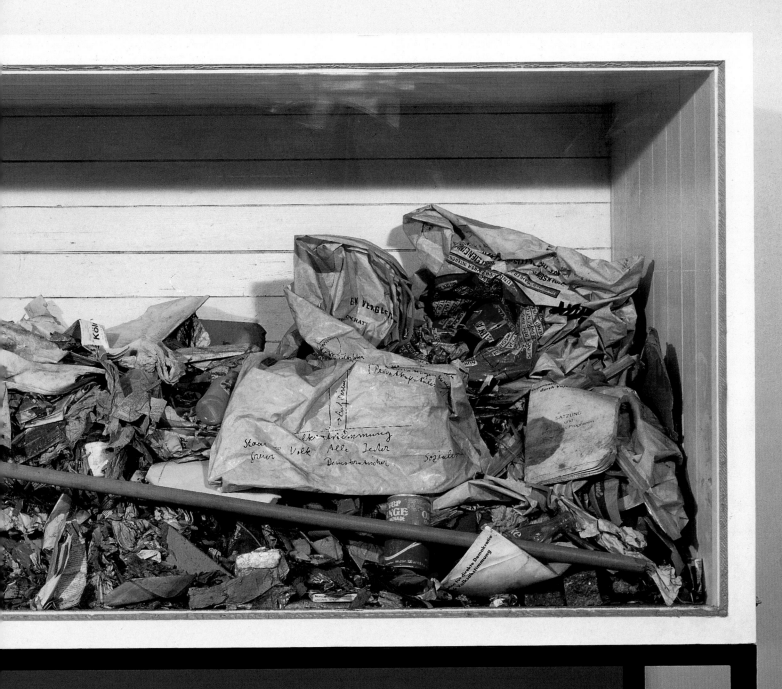

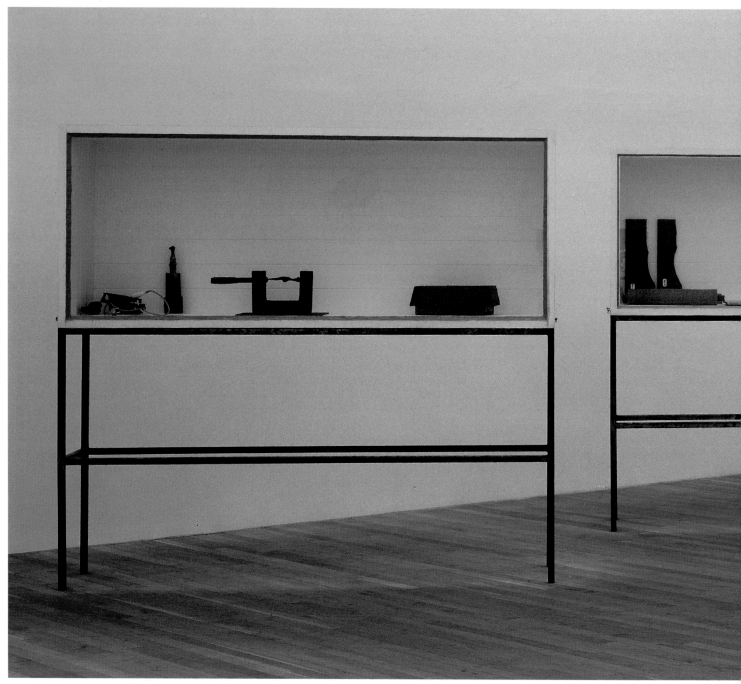

Plate 48.
Untitled, 1984
See checklist no. 39

Plate 49.
Untitled, 1983
See checklist no. 40

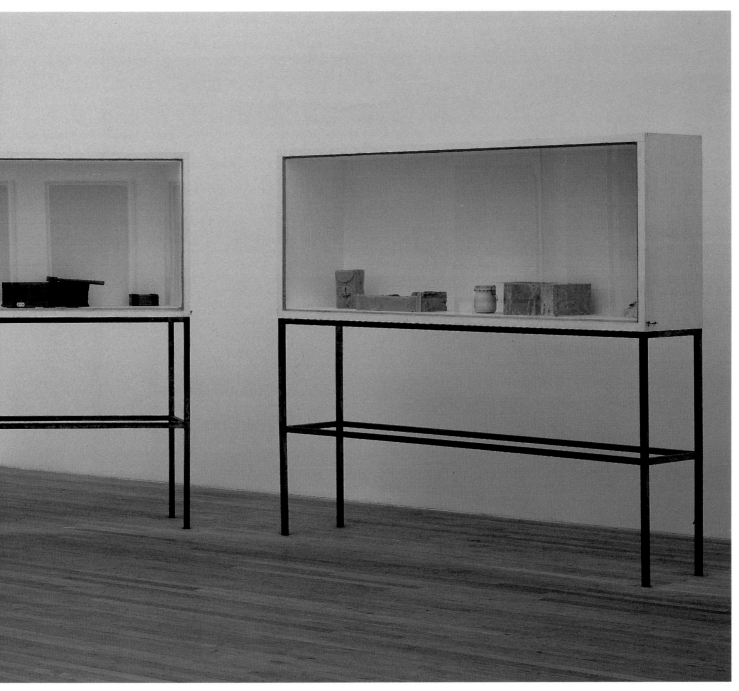

Plate 50.
Untitled, 1983
See checklist no. 41

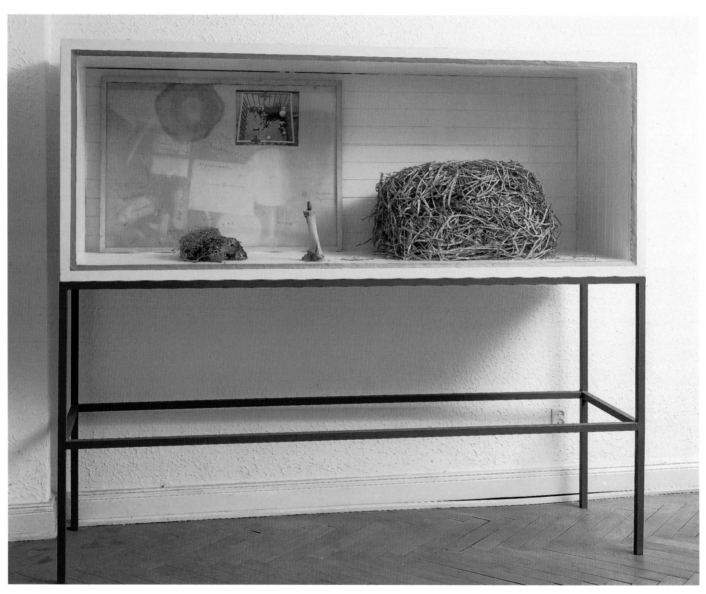

Plate 51.
Potato Plant and Dust Image, 1962/82
See checklist no. 26

Plate 52.
Rubberized Box, 1957
Pinewood, rubber, tar
39 ⅜ x 39 ⅜ x 19 ¾ inches
(100 x 100 x 50 cm)
Hessiches Landesmuseum,
Darmstadt

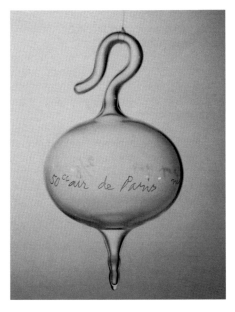

Plate 53.
Marcel Duchamp
Ready-Made, 50cc of Paris Air, 1919
Glass ampoule
5 ⅓ x 8 inches (13.5 x 20.5 cm)
Philadelphia Museum of Art
The Louise and Walter Arensberg Collection.
1950-134-78

Daedalus, in *Ulysses*, makes the claim that "History was a tale,"[104] but, at another moment, cries out that "History is a nightmare from which I am trying to awake."[105] Beuys would probably add that tales can likewise be presented as history,[106] for the oft-repeated report about Beuys being rescued during World War II by Tartars, who saved his life by warming him with fat and felt, was, in fact, an invention. By creating this tale, Beuys gave to his work a historical dimension and substance, as if actual historical events were more than he wished to comprehend or were anyway better left alone.[107] Thus Beuys, like Daedalus, found that tales are useful for his purposes.

With Joyce's words: "Coffined thoughts around me, in my mummy cases, embalmed in spice of words,"[108] Beuys's vitrines come very much to mind. Each has this quality of a mummy case, holding a collection of objects from past and current life, all cobbled together as if a manifestation of a Joycean stream-of-conscious monologue.[109] With a vitrine, one dwells in a world of diminutive things, lovingly displayed and carefully composed. The viewer is encouraged to pose questions about the origin of each object, how each relates to the other, and what might transpire by their continued proximity. Along with a kind of wonder about these objects comes an intense curiosity about the meaningful composition that has been overlaid on their arrangement. Beuys demanded that the normally rapt gaze required for conventional works of art be applied to an altogether unlikely gathering of objects.

The vitrine format has a prehistory in Beuys's work in the many open boxes to be found through the 1960s, for instance *Fluxus Object* (1962, pls. 18–19), where children's toys are given touchingly poetic life, especially as compared with the humdrum cardboard box. In contrast to full boxes, there are bare, empty containers, including *Gummierte Kiste* (*Rubberized Box*, 1957, pl. 52) and *hinter dem Knochen wird gezählt / SCHMERZRAUM 1941–1983* (*Counting Behind the Bone / PAIN ROOM 1941–1983*, 1983, Caixa Collection, Barcelona). These, devoid of life altogether, reflect the idea that "the outward appearance of every object I make is the equivalent of some aspect of inner human life."[110] Hence, *Rubberized Box*, which dates from what Beuys described as his "period of crisis," "is certainly an equivalent of the pathological state… and expresses the need to create a space in the mind from which all disturbances were removed: an empty insulated space," he reported.[111] Reconceived as *Counting Behind the Bone PAIN ROOM* (1983), the "empty insulated space" is a walk-in monochrome environment, its title indicating that this is a place to retire for permanent suffering.[112] At the opposite pole in Beuys's catalogue of leitmotifs is the box that has been filled to overflowing, such as *Vacuum<—>Mass* (1968), the piano in the Action *Kukei / akopee* (pls. 1–2), or the vitrines, the hope being that something positive comes from a composting, as it were, if not embalming of objects. No doubt this condition is, in effect, loud and full of "disturbances," interrupting the cold silence of the empty container.

Though the sense of a casual grouping is powerful, in fact, the vitrines usually take one of two forms: either crowded, as if a kind of disorganized workshop grouping or dramatically stark with the juxtaposition of just a few elements. A particularly dramatic example of the first is of *Ausfegen* (*Sweeping Up*, 1985, pl. 47), in which Beuys assembled from the 1972 action of the same name the refuse of the streets of Berlin. Here one might imagine eventual production of an Element 3 coming from this laboratory of discarded objects.[113] This is an instance of Beuys's prototypical "battery," an energy pack that combusts and produces changed conditions, or even a form of healing. One could compare this container of Berlin's aura to Duchamp's serenely empty *Ready-Made, 50cc d'air*

Plate 54.
Double Aggregate, 1958–68
Bronze, four parts
42 ¼ x 126 x 23 ½ inches
(107 x 320 x 60 cm)
Museum Ludwig, Cologne

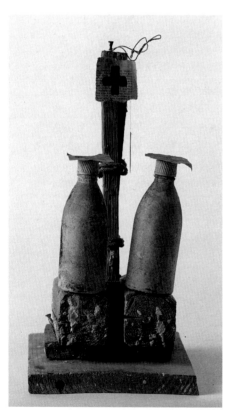

Plate 55.
Crucifixion, 1962–63
Wood, two bottles, electrical cables, wire, paper
16 ¾ x 7 ½ x 5 ⅞ inches
(42.5 x 19 x 15 cm)
Staatsgalerie Stuttgart. Inv. Nr. PLNA 159

Paris (*50cc of Paris Air,* 1919, pl. 53), as a further comment by Beuys on Duchamp's "silence." By these critiques of Duchamp it is clear that, far from being some mystic, standing apart from the field of art, Beuys's ambitions lie squarely in the field of aesthetics and "within the historical development of art. My 'anti' stance is not against art history or museums."[114]

Sometimes in the vitrines, Beuys meditated on a favorite theme—the double, creating a rich formal play between objects that may be hard or soft, open or closed, circular or rectilinear, similar but not identical, unruly or organized, and wounded, unharmed or "cured." Beuys slyly rhymed and compared many elements, all to further amplify the possibilities of this theme. Whereas the halved cross suggests a bifurcated state of affairs in need of a solution, the double suggests a more settled condition (a "duality, the coexistence of polarities"), which Beuys reluctantly accepted as given. The stark statement and elaboration of the double is rife in Beuys's work. He made so many of these that, as an artistic formula, it appears to be a kind of sonnet form for him, his metaphysical model for all the opposing situations in the world. In this arena, the sides are fated to exist in a condition of equipoise. Beuys said that from childhood he was aware of a great "contradiction" in his life, between something "very beautiful"— ideally nature in an undamaged state—and a "big debacle." That he expected "to act within this contradiction" identifies the nature of the double in his work: it is a place of unresolved conflicts.[115] However, each instance is subject to a specific connotation.[116]

The most archetypal double in Beuys's work may be the juxtaposition of male and female characteristics, the latter symbolizing, he said, "spiritual power," while the former represents an "over intellectualized concentration on the powers of the head." Always organic in form, the woman epitomizes under-glorified strengths in contemporary society, such as childbearing and rearing. By comparison, there is the "cold, hard, crystallized, burnt-old clinker that I would call the male intellect, the cause of much of our suffering." "Taken to extremes, this means man has his head buried in the ground, while woman gazes at the spheres."[117] *Doppelaggregat* (*Double Aggregate*, 1958–68, pl. 54) not only introduces several more of Beuys's key doubles but also acknowledges the strategy with its title. Here are two similar, but not identical, anthropomorphized elements. Composed of iron, copper, and steel, *Double Aggregate* has about it a hard overall materiality that is, nevertheless, multifaceted. Beuys believed that iron is inherently male, whereas copper is female.[118] Iron is tough, intransigent, and heavy; copper is light and pliant, a conductor of energy. Beuys wrote as an inscription for this work: "The iron lumps are so heavy in order to prevent me escaping lightly from this hell."[119] Not surprisingly, then, his frequently worn iron shoes in Actions maintain his gravity-bound fate, whereas the presence of copper suggests a more buoyant existence. When, a number of years later, Beuys made his series of *FOND* sculptures, for instance, *FOND VII / 2* (1967/84, pl. 77), each composed of a stack of felt covered with an identically sized copper sheet, he introduced another double. For him, the felt functioned as insulation, fermentation, and preservation of warmth and energy, and the copper conducted this energy beyond.

Another of his doubles concerns innocence juxtaposed with human culture; in other words, a double can consist of very different-looking objects, one that is organic and the other, rigid in form. Similar pairings of diverse elements include Beuys joining himself with a horse in *Titus / Iphigenie* (pls. 14–16) and with a coyote in *I Like America and America Likes Me* (pls. 3–10). Such doubles involve an obvious comparison of life forms and related interpretations of innocence versus experience. Similar but different in certain crucial ways is a

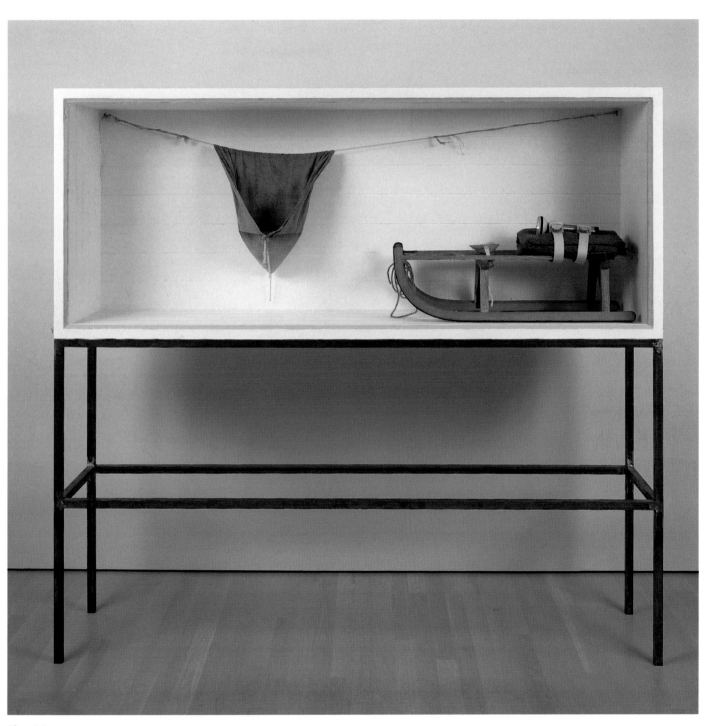

Plate 56.
Sled with Filter, 1983
See checklist no. 35

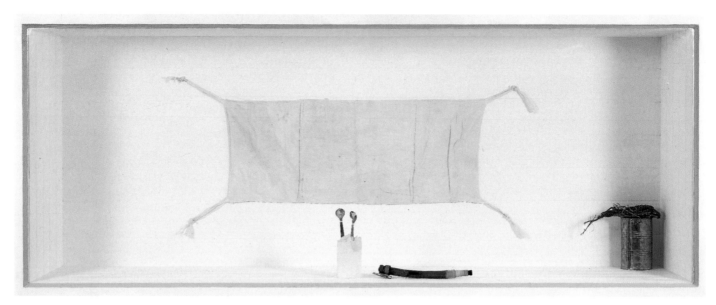

Plate 57.
Untitled, 1983
See checklist no. 38

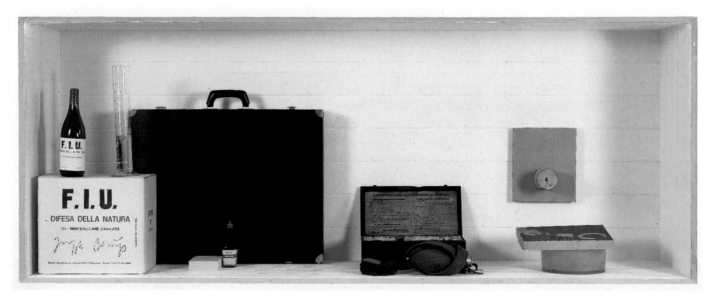

Plate 58.
Untitled, 1983
See checklist no. 37

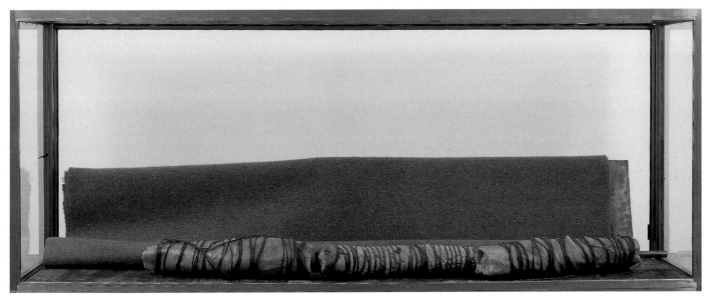

Plate 59.
Encounter with Beuys, 1984
See checklist no. 36

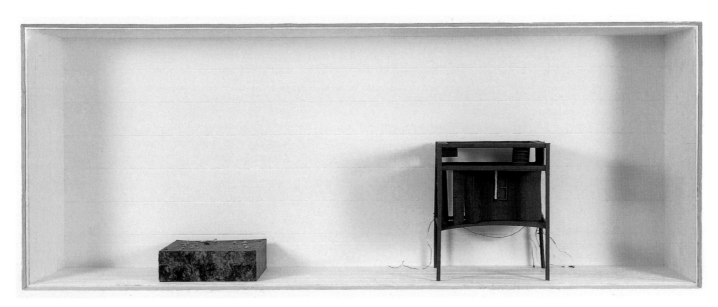

Plate 60.
Brown Cross House, 1983
See checklist no. 34

common technique applied by Beuys in many doubles. In *Alarm II* (1983, Nordrhein-Westfalen Museum, Düsseldorf), one flowerpot is empty while the second has tubes attached, as if it were on life support. Elsewhere he compared objects of similar size, but one object might be characterized with hard surfaces and geometry, while the other has some kind of humanized and/or organic quality as, for example, *Earth Telephone* (1968–71, pl. 42). Sometimes, Beuys employed a double to compare wounded and whole or unspoiled conditions. Of course, there is, as well, Beuys and his doppelgänger, the pilot who was nursed back to health in the Crimea by the Tartars.

The situation of competing political systems is a variation on the symmetrical arrangement, indeed, Beuys's stereotypical double may most often refer to the divided state of Germany, this being a ubiquitous aspect of life during most of his career. In *Kreuzigung* (*Crucifixion*, 1962–63, pl. 55), the juxtaposition of double bottles takes on an altogether different connotation, as the two seem to represent Mary and John at the Cross.[120] Finally, with *Double Objects* (pl. 61), Beuys presented a sonnet to the double for the viewer to ponder and ponder.

On occasion, Beuys created a grouping of vitrines into a kind of epic, for instance the assemblage consisting of five vitrines that are joined by two small objects hung at each end (pls. 62–69). With this sweep, Beuys created a linear narrative that encourages contemplation of sculptural "events" doubling back to recover rhymes and linkages. As is characteristic of the vitrines, it is as if an Outsider artist, in contemporary parlance, assembled debris from the streets for great poetic effect. Each detail is a touching vignette, and the collection of vignettes forms a soliloquy of isolated, then interconnected, visual thoughts. In sum, this large work is one complex ensemble, and is an apt transition to Beuys's epic-scaled environments.

If the vitrines feel like personal monologues, the room environments, which slowly began to appear in the early 1970s, overlapping with the vitrines, take the form of more expansive statements about life and the world. By comparison to the intimate viewing experience one has with the vitrines, the environments are grand and operatic. In *Zeige deine Wunde* (*Show Your Wound*, 1974/75, pl. 70), Beuys explored a deeply felt theme of his work and emotional life: the wound. Wounds are ubiquitous in Beuys's thinking, and are multivalent in meaning. For him, the term is a figure of speech referring to illnesses of all kinds, literal incursions in a body, openings into the ground, including trenches and graves, inner spaces that are empty of any incident, and, of course, emotional scars and suffering. All types of wounds are interrelated, and echo Christ's wounds, too. The context for these maladies has many sides, starting with the fact that Beuys was himself wounded five times during World War II. He quoted Nietzsche as saying "Man is an ill being,"[121] illness here being a state closer to original sin than one having a particular cause. A society can be wounded, but it is the German context that is particularly pertinent to Beuys. It starts with German Medieval and Renaissance art, which favored especially grisly wounds on Christ's body and other martyrs, as compared to Italian Renaissance depictions. Following World War I, the Germans George Grosz and Otto Dix depicted walking wounded and crippled soldiers, the latter seemingly destined to remain in their afflicted state forever. When Beuys, in 1985, famously began a speech entitled "Talking About One's Country: Germany" with the statement: "Good day ladies and gentlemen. Once again I should like to start with the wound,"[122] he stressed that this malady is well understood to be amongst his countrymen, and perhaps created a mutual condition of self-pity for his audience. Beuys saw his job as presenter of the wound, "extracting a tooth to show its state of decay," he explained.[123]

Plate 62.
Overall view of Plates 63–69
See checklist nos. 27–33

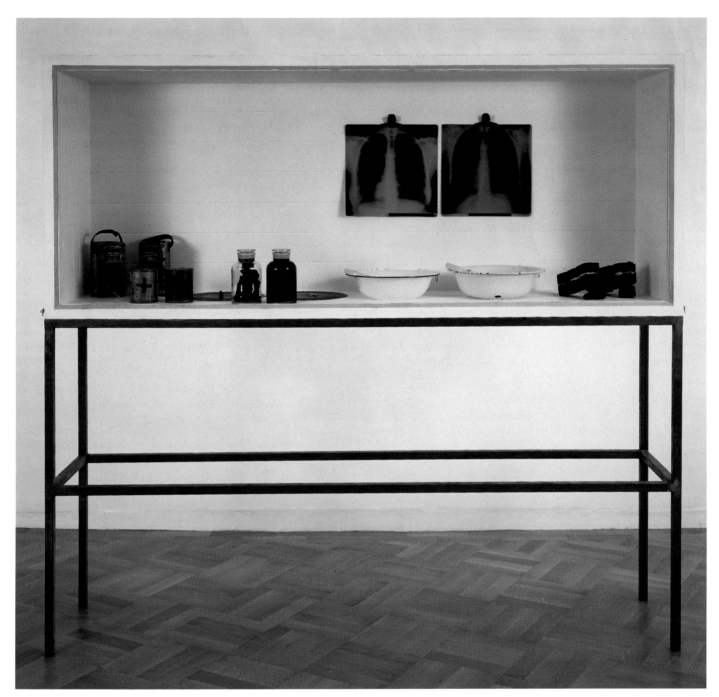

Plate 61.
Double Objects, 1974–79
See checklist no. 25

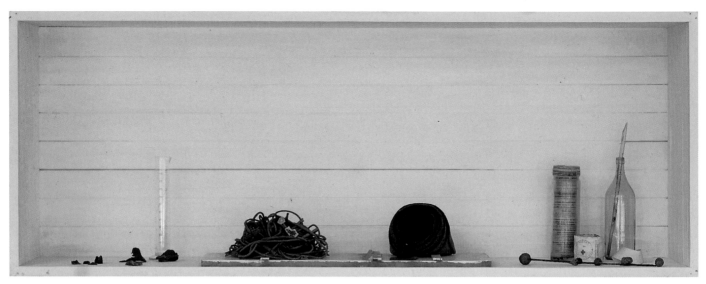

Plate 63.
Untitled I, 1962/81
See checklist no. 28

Plate 64.
Untitled II, 1956/75
See checklist no. 29

Plate 65.
Untitled III, 1948/81
See checklist no. 30

Plate 66.
Untitled IV, 1964/78
See checklist no. 31

Plate 67.
Untitled V, 1949/82
See checklist no. 32

Plate 68.
Athenian Moon Owl, 1970/82
See checklist no. 27

Plate 69.
Woman, 1971
See checklist no. 33

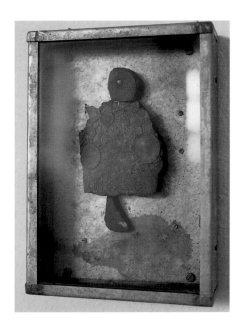

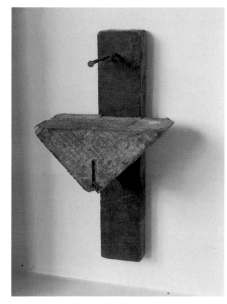

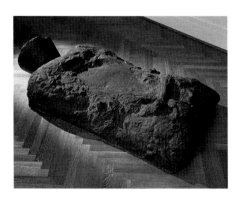

Plate 71.
Mountain King, 1958–61
Two-part bronze sculpture
14 ¼ x 33 ½ x 64 ¼ inches
(36 x 85 x 163 cm)
The Saint Louis Art Museum,
Friends Fund and funds
given by Mr. and Mrs. Donald L.
Bryant, Jr.

Badewanne (*Bathtub*, 1960, private collection) refers to the moment of birth, Beuys said, when every person experiences "the wound or trauma… as they come into contact with the hard material conditions of the world."[124] Innocence meets experience, one might say, with the former immediately infected by the latter. With a fat-soaked piece of gauze at the bottom of the tub, the birth wound is given a literal reality in keeping with the entry in *Life Course / Work Course* for the year of his birth: "1921 Kleve exhibition of a wound drawn together with plaster."[125] That his life began with a wounded condition suggests that the wound is like a birthmark, or more specifically the sin of being human, and moreover German. The bathtub was a standard-issue plumbing fixture given by the National Socialists to its citizens, a fact that reinforces this characterization of being universally damned. Beuys made a wounded condition the content of many legs of tables, stools, and pianos, all of which are identified as in need of care by having felt wrappings, recalling once again Beuys's myth of being saved by having been swaddled with felt. Variations of this device are felt-covered canes and inanimate legs placed in bottles or on sheets of copper, as well as the felt covering of *Eurasian Staff* and *The Art Pill*.

Starting with the "1928 Kleve First exhibition of an excavated trench," a series of entries in the *Life Course* creates a network of wound-like connections. In referring to a "trench," Beuys presented the possibility of opening the soil to investigate an interior space. The following entry—"1929 Exhibition at the grave of Genghis Khan"— likens a grave to the trench. Soon after comes the entry, "1933 Kleve Underground exhibition,"[126] which suggests that art activity may be a subterranean event. It is little wonder, then, that upon considering a work for an underground concourse in Munich, Beuys tied together these referents and created *Show Your Wound*, the wound being the subject of an excavation beneath the streets of the city. With the sounds of a tram overhead and lighting provided by neon tubes,[127] the dingy underground pedestrian passage exuded a hellish mood. Such a setting perfectly embodied Beuys's thinking, recalling his fascination with the city of Belfast, where the "crumbling facade of capitalism" was immediately apparent.[128] With *Show Your Wound,* Beuys emphasized that one must look underground, beneath the sanitized veneer of contemporary life, to see reality and contemplate the "wound." The Italian newspapers arranged on the left of the installation, which could have been sold in such a pedestrian passage, state the passing news of the time, specifically the rhetorical views of a leftist organization.[129] A similar tumult would have been echoed in German papers in 1974–75, including reports of terrorist activities by the Baader-Meinhof gang, Willi Brandt's resignation, and the story of a boy dying in an escape attempt from the East to the West over the Berlin Wall. But the newspapers play a small role in the larger matters indicated by the objects in *Show Your Wound*. With mortuary tables as the largest elements of this work, the crucial theme is established. Tisdall notes that the zinc boxes above the dissection tables take the position of "heads,"[130] an arrangement that recalls *Bergkönig (Tunnel), 2 Planeten (Mountain King [Tunnel], 2 Planets*, 1958–61, pl. 71) with its decapitated head and lying body. These maudlin associations are reinforced by the draining holes in the table, underneath which are jars and boxes holding fat, as if collecting bodily residue;[131] the thermometer in each would indicate a very cold temperature, indeed.[132] The paired hoes nearby have been "wounded," too, for the middle prong of each has been removed, leaving only two, and each of these is wrapped with rags. Perhaps it was not a coincidence that Beuys himself was quite ill in the summer of 1975.

Show Your Wound is an elaboration on the theme of doubles, including contrasts between the mortuary tables, the rectangles containing news events,

Plate 70.

Zeige deine Wunde (*Show Your Wound*),
1974/75
Environment consisting of two
iron tools mounted on stamped
wooden sticks; two white wooden
planks; two blackboards with
writing in chalk; two dissection
tables; two lamps; two galvanized
iron boxes covered with glass
and containing fat; two zinc boxes
containing fat; two test tubes;
two bird skulls; two clinical ther-
mometers; two preserving jars
with gauze filters; two pitch-
forks with cotton scarves atop
two blackboards; two issues of
the Italian LOTTA CONTINUA
mounted in white wooden boxes
Overall dimensions:
197 ½ x 204 ⅜ x 285 ½ inches
(501.5 x 519 x 725 cm)
Städtische Galerie im Lenbachhaus

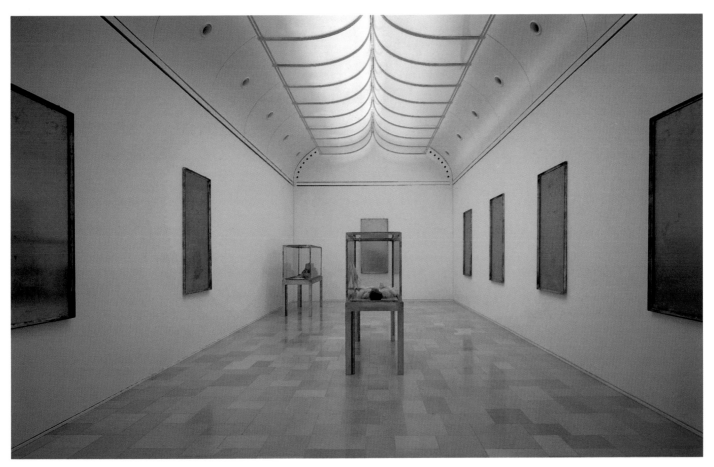

Plate 72.
Palazzo Regale, 1985
Environment with vitrines, wall objects,
and mixed media
235 ½ x 551 ¼ inches
(598 x 1400 cm)
Kunstsammlung Nordrhein-Westfalen,
Düsseldorf

the blackboards exhorting (calling on!) the German viewers to "zeige deine Wunde," and lastly the simple monochromes, referring to the purest form of abstract art. While Lucio Amelio discusses monochromes in Beuys's work as showing a concern with beauty,[133] that format also recalls the period of "inner exile" for German artists, just after the war, when abstraction was literally a kind of escape and a denial of history. Beuys often employed the planar field of color, usually brown, though at times black or gold, almost always given within a rectilinear frame. Though he did not profess a great love of abstraction, nevertheless, he found some of its strategies useful. We have already seen his replication of Malevich's placement of abstract forms in high corners of rooms with triangles in the Actions, but another monochromist was closer at hand. Yves Klein's work was well known in Germany starting in the late 1950s,[134] and his "monochrome adventure" could have been a seductive path for Beuys, who made brown and gray his signature colors, as Klein had done with blue.

Among Beuys's first monochrome-type works were *Dschingis Khans Post* (*Gengis Khan's Post*, 1960, Feelisch Collection, Remschied), a Piero Manzoni-like composition of tightly folded, flat color planes,[135] and *Object* (1960, private collection), in which a brown cloth, a kind of shroud, hangs freely. In these, Beuys worked with a familiar sense of shabby grandeur. Just as brown is for Beuys a color of refuse, and of a wasted German society, his gray felt communicates a correspondingly hollow, vacant spirit, notwithstanding the otherwise salubrious benefits of the material. With a sheet of felt covering the screen, *Filz-TV* (*Felt TV*, 1968, Hessisches Landesmuseum, Darmstadt) predicts Nam June Paik's *Zen for TV* (1975, private collection), both send-ups of exalted monochrome precedents, as well as remedies for the infernal machine that is the TV. Next to Beuys's television in Darmstadt hangs a felt "painting," as if to be compared. Just as Klein's blue has a spiritual or otherworldly sense, colored monochromes in Beuys's art may at times repeat this connotation of something beautiful and beyond contemporary events. For instance, the field of gold (namely gold leaf with honey) covering his head in *How to Explain Pictures to a Dead Hare* imparts to Beuys a guise by which he can communicate with the animal world. Later, in both *Show Your Wound* and *Palazzo Regale* (pl. 72), monochromes (black in the former and gold in the latter) contrast with more human and somewhat horrific situations within the room.

Returning to the double in *Show Your Wound*, Beuys contrasted abstraction and representation in their severest forms—the monochrome painting and the newspaper. Because information is given with the basic rectangle, Beuys can easily juxtapose meaningfulness and meaninglessness, or everyday and potentially transcendent content. Though such juxtapositions had appeared elsewhere in his art, with *Show Your Wound* Beuys placed the theme in a real space, with the monochrome/sublime holding the central upper space in the room, as if art itself is transcendent. This unrelentingly rectilinear milieu is an appropriate environment for the irretrievably wounded.

Tisdall suggests that *Show Your Wound* is a theme dating back to Beuys's Auschwitz monument and his shamanistic drawings of the 1950s,"[136] but it looks forward as well to the environment *Unschlitt* (*Tallow*, 1977, Marx Collection, Berlin), a positive materialization of an underground pedestrian tunnel in the city of Münster. As antiheroic a work as one can imagine given its forlorn source and mutton-fat medium, *Tallow*, by its heroic scale, narrates a kind of alchemical transformation of the underground passage, something that is not present in *Show Your Wound*. *Show Your Wound* also looks forward and complements the vitrines in *Palazzo Regale* in the profoundest of ways, for Beuys himself lies in state in those, filling the mortuary table as it were.

Though *Strassenbahnhaltestelle* (*Tram Stop*, 1976, pls. 73–74) has its origins in Beuys's memory of a seventeenth-century war memorial at a tram stop in his hometown of Kleve, and the head is usually considered a portrait of Anacharsis Cloots, a sympathizer of the French Revolution who was martyred, the iconography of this work is consistent with Beuys's ubiquitous concerns. Most notable is the upright orientation of the figure when initially shown at the German Pavilion of the 1976 Venice Biennale, a living, screaming, Edvard Munch-like monument to the wounded condition. It also draws upon the precedents of the numerous elongated, silently suffering Giacometti sculptures and those of Wilhelm Lehmbruck, as well as Brancusi's *Endless Column* (1925–28, The Museum of Modern Art, New York). With a deep hole beneath the figure into the Venice lagoon, Beuys gave his personage an archaeological history in a trench. This celebration of a vertically oriented human is subsequently undone, for in his later installations of *Tram Stop*, and with its subsequent cast, Beuys placed the figure, whose expression is frozen as if in death throes, flat on the ground next to the tram tracks, with four cylindrical casts of seventeenth-century shell casings nearby. The albeit-heroic suffering of the upright figure is drained by the horizontal orientation. As is so often the case in Beuys's art, the viewer looks down upon the figure, just like viewing a body in a coffin. Beuys's freedom in reordering what had been a site-specific work typified his flexible and spontaneous approach to sculpture and his environments.

Beuys's interest in movement on tram tracks rings with his desire to traverse Eurasia and from at least as early as 1961, he had conceived of a *Trans-Siberian Railway* (Hessisches Landesmuseum, Darmstadt). Though its depictions were always rather primitive, just a right-angled arrangement of wooden slats,[137] his ambitions were grand. Beuys discussed the specific movement of a tram in relation to *Das Rudel* (*The Pack*, 1969, pl. 75), saying that both signified "primitive means… taken to ensure survival. The most direct kind of movement over the earth is the sliding of the iron runners of sleds, shown at other times… by the iron soles placed on my feet in Eurasia."[138] Iron, the material of earthbound gravity and of the male psyche, is the substance of *Tram Stop*.

The all-important attribute of horizontality vis-à-vis death can be surmised from viewing Beuys's *Sled* (1969, pl. 34). With its survival implements, this work is usually thought of in the context of his imagined experience with the Tartars, but it can also be related to Giovanni Segantini (1858–1899), an Italian artist much admired by Beuys.[139] Segantini's art features an innocent world of shepherds with flocks, pastures, and peasants at one with animal life and nature. In *Ritorno al bosco* (*Return from the Woods*, 1890, Otto Fischbacher, St. Gallen), Segantini showed a lone woman pulling a sled with logs across a snowy field. Its survival function metamorphoses in Segantini's *La morte* (*Death*), the last panel of a triptych entitled *Armonia della Vita—La natura—Armonia della Morte* (1898–99, Segantini Museum, St. Moritz, Switzerland), with the empty sled apparently serving as a hearse. Beuys's sled can be said to possess a similarly multivalent or redolent interpretation, incorporating his views of death.

As opposed to the cold state of death, Beuys created situations in which warmth and therapeutic healing could occur. These contexts take various guises, including the battery, transformer, and other kinds of machines, all of which produce energy and change. These works evince the rule of chance, not rational intellect. Central to the workings of such a machine is the creation of "living form,"[140] a characterization that is at once an Element 3-level achievement, combining aesthetic and organic processes. Nothing works better in this regard than fat, a tragicomic, oversized, Pop art-like protagonist of Joycean magnificence (pl. 28). It epitomizes a warm, inchoate substance from which new structures

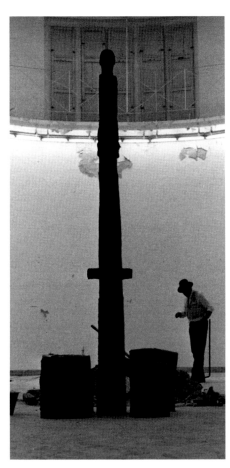

Plate 73.
Tram Stop, 1976
First installation at
the Venice Biennale,
German Pavilion
See checklist no. 44

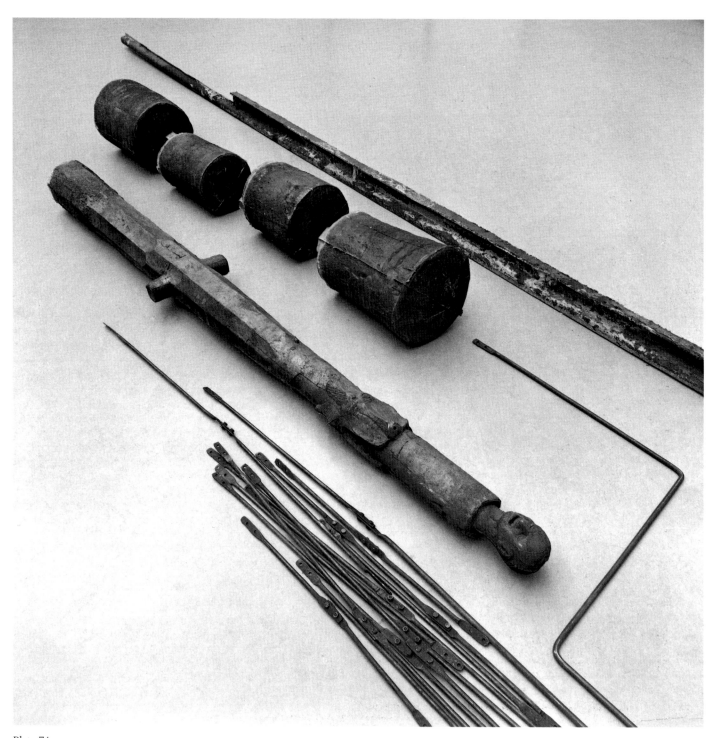

Plate 74.
Tram Stop, 1976
See checklist no. 44

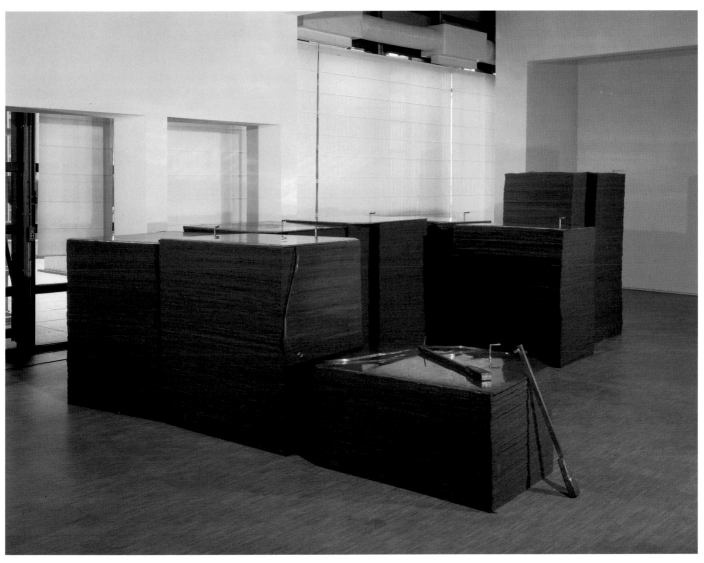

Plate 77.
FOND VII / 2, 1967/84
See checklist no. 48

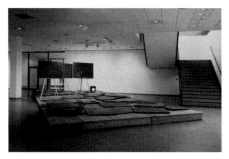

Plate 80.
Directional Forces, 1974–77
100 wood panels, 3 easels, walking stick,
light box with photograph
89 ¾ x 467 x 204 ⅜ inches
(228.5 x 1186 x 519 cm)
Nationalgalerie, Staatliche Museen zu
Berlin, Germany. Inv. B 1079

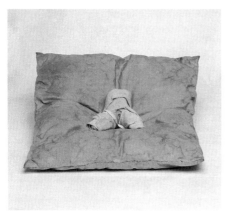

Plate 83.
Virgin, 1952
Wax, gauze on cushion
13 ⅜ x 15 x 2 ¾ inches
(34 x 38 x 7 cm)
Speck-Collection, Cologne

the world. In *Capital Room*, many pairs dominate the scene, including projectors, speakers, bottles, and tape recorders. This is a very elaborate pedagogical work (witness the many blackboards), perhaps the most important of its type in Beuys's oeuvre. With *Economic Values*, a makeover is in progress, with the shelves of decrepit-yet-honestly described products from an East German market serving the artist, like a transformer, along with a selection of paintings from the collection of whichever institution happens to be hosting the environment. (Standing before the ensemble is a plaster block with the inscription, "The Eurasian sends greetings. Joseph.") In *Directional Forces*, pedagogy gives way to anarchistic energy, even jubilation, as wild idealism and happily disconnected thoughts fill the atmosphere. Possessing much the same spirit, *Terremoto* is a single sculpture reaching so far around its space that it becomes a room environment. The printing press of Lotta Continua, the left-wing Italian group, is featured, seeking the long-dreamt of third way in its publications; Beuys joined their effort in his blackboards. *Terremoto* is a half-crazed energy/pedagogy machine. Beuys's love of these chaotic situations suggests an alienated individual, nomadically wandering about the German economic miracle, at once estranged from it but also existing at a great distance from the Eastern roots that he so admired.

With illness and the wound comes perhaps the preeminent leitmotif in Beuys's work: death. It is either shown literally or suggested by objects and anthropomorphic forms lying horizontally on the ground. Implied corpses, disintegrating materials, and unexplained devastation are ubiquitous, with the implication that the events of World War II are the constant context of Beuys's art.[147] Indeed, on one occasion he acknowledged this, saying that the sight of dead persons "lying around, everywhere" in Russia made a very profound impression and even triggered his decision to become an artist.[148] Not surprisingly, Beuys linked sleep, silence, and cold to death.[149] Beuys's Story of having been saved by the Tartars after being shot down during World War II gives the theme of death and near-death a personal context, although the theme is only rarely about himself explicitly.[150]

Beuys felt that in order to be alert in life, death had to be ever-present in his consciousness: "In other words, death keeps me awake." He embraced the idea that "death is a means of developing consciousness, of achieving a *higher life:* a higher life, that is important."[151] Hence, he could speak of the "potential liberation of death."[152] To "experiment with death"[153] must be considered the province not just of the individual but of a society, a political system, and any rigid institution; in other words, death is one more situation in which exists the possibility of transformation. However religious a cast he gave it, the maudlin aspect of death permeated Beuys's work.

The depiction of *Mountain King* (1958–61, pl. 71) includes a decapitated head as a symbol of some abandoned kingdom. Certainly, Beuys felt an enormous sense of loss for a time in the history of his homeland when its values and actions could be admired. Innocent then, as it were, Germany might have been led by such a mountain king. The pose of this figure echoes the much earlier *Jungfrau* (*Virgin*, 1952, pl. 83), a decapitated and amputated female body on a pillow. With its position beneath the viewer and its gruesome physical state, this figure may have been based on Giacometti's *Femme égorée* (*Woman with Her Throat Cut*, 1932, pl. 84), and it predicts not only Beuys's *Mountain King* but also many later works including *Tram Stop*. With *Felt Suit* (1970), there exists the possibility of a body that was atomized, the garment being the only remnant of a wounded situation. It represents a profound step beyond the signature sculptures of Giacometti, whose emaciated, alienated, and lonely figures are part of the sculptural continuum to which Beuys's work relates.[154]

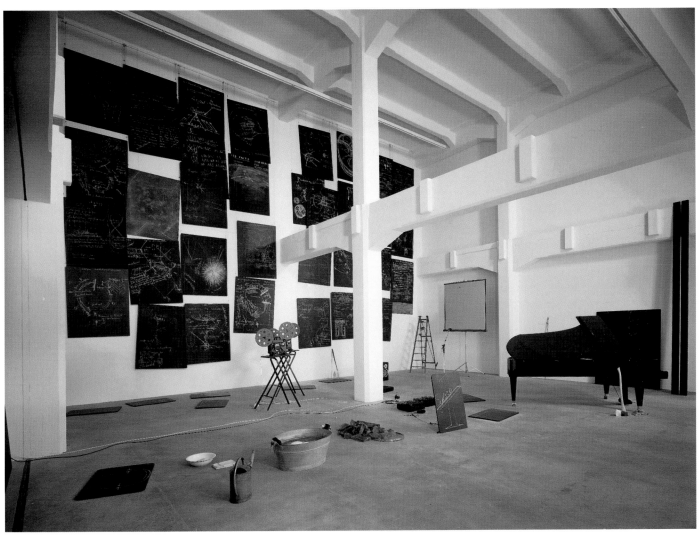

Plate 79.
The Capital Room 1970–1977, 1980/84
Blackboards, project equipment,
and miscellaneous other objects
Co-operation: Urs Raussmüller
(architectural part) Hallen für neue
Kunst Schaffhausen/Switzerland

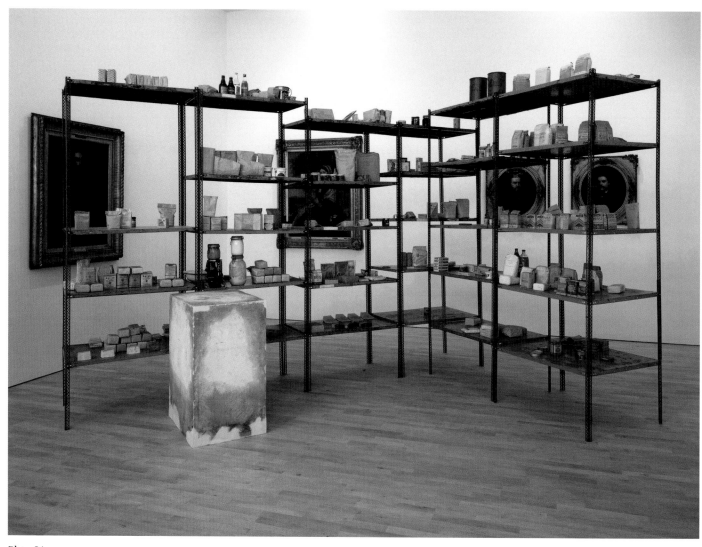

Plate 81.
Economic Values, 1980
See checklist no. 46

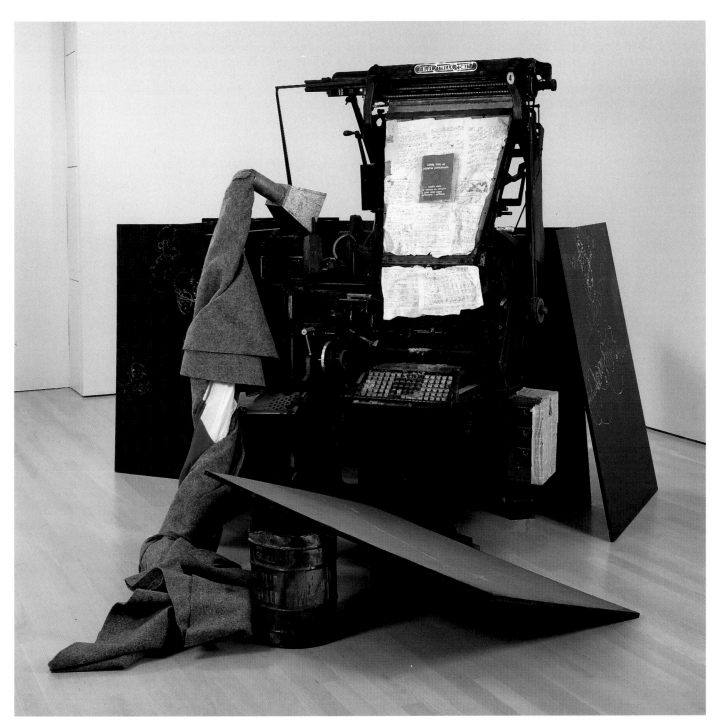

Plate 82.
Earthquake, 1981
See checklist no. 47

Plate 84.
Alberto Giacometti
Woman with Her Throat Cut, 1932
Bronze (cast 1949)
8 x 34 ½ x 25 inches
(20 x 87.6 x 64 cm)
The Museum of Modern Art,
New York. Purchase.

Plate 87.
Alberto Giacometti
City Square, 1948
Bronze
8 ½ x 25 ⅜ x 17 ¼ inches
(23 x 64 x 44 cm)
The Museum of Modern Art,
New York

While *Feuerstätte I* (*Hearth I*, 1968/74) and *Feuerstätte II* (*Hearth II*, 1978–79, pl. 85) possess a dynamic arrangement, the objects that compose these two interconnected works are foreboding. The child's wagon and the canes seem to be abandoned, and the pile of felt suits is altogether ominous. It seems a very short distance from this poignant assemblage of memento-mori to *Das Ende des zwanzigsten Jahrhunderts* (*The End of the Twentieth Century*, 1983–85, pl. 86). There is a frightening whiff of disaster in it, which recalls the apocalyptic imagery of many early twentieth-century Germans, including Kandinsky, Marc, and Ludwig Meidner.[155] Beuys's version of a Massacre of the Innocents consists of one-eyed torsos lying on the floor in the haphazard aftermath of a calamity. This casual grouping of "figures" can be compared with the *City Square* series of Giacometti (pl. 87); whereas the latter's figures are upright and carefully composed, Beuys's torsos sprawl randomly. Beuys carefully removed a cylindrical portion of each stone in the work, which he then repositioned over a cushion of felt. The final combination of the perfectly drawn circle with the roughly hewn organic shape suggests a hybrid of the parts of another double. These stones directly echo the upright stones of *7000 Eichen* (*7000 Oaks*, 1982, Kassel), the change to a horizontal position repeating the transition from the Venice version of *Tram Stop* to the later installations.

Who are these dead? Donald Kuspit insists that Beuys is projecting his own life onto them, not only for the purpose of recalling various dead but also to encourage his countrymen to learn empathy for and to mourn the victims of the Nazis.[156] This view remains a psychological interpretation only; for the most part, Beuys was studious in avoiding mention of the war dead. Nevertheless, it is true that death is a constant in his work. Regardless of whether survivor's guilt plays a role, the theme should be interpreted in the most generalized way, as richly redolent of personal and national history, as well as the fate of all life. One can chart a fascinating arc in Beuys's career: from mourning innocent dead animals in the Actions of the 1960s to another group of innocents, in this case, humans.

With *The End of the Twentieth Century*, Beuys showed an interest in creating environments that have a sense of a narrative moment in time, the first of which was *Voglio vedere le mie montagne* (*Show Me My Mountain*, 1950/71, pl. 88). *Blitzschlag mit Lichtschein auf Hirsch* (*Lightning with Stag in Its Glare*, 1958/85, pl. 124) is about a sudden event—a vignette of cosmic or apocalyptic proportions—occurring at a kind of nomadic campsite. Similar to his Actions and vitrines, Beuys's environment recycles objects or variations on objects seen before in his career, as well as ideas and leitmotifs that had their start at an earlier time.[157] The full realization of *Lightning with Stag in Its Glare* came after Beuys's installation for the 1982–83 exhibition "Zeitgeist" in Berlin, when the artist created a workshop in the central hall with objects from his studio, all residing in the shadow of a huge mountain of dirt. Subsequently, he cast several of the elements and added the *Lightning* form. The final work transforms the humble workshop into a place of mythic events and magical effects, even to the point of excrement being seen as an energy source, like compost.

Beuys's art of connections includes the titles he gave to his works, as can be seen with *Show Me My Mountain* and *Show Your Wound*, or *Terremoto, Terremoto in Palazzo* (1981, Amelia Foundation, Naples) and *Palazzo Regale* (1985). Indeed, within one of the vitrines in *Palazzo Regale* (pl. 72) is the same head as the falconet in *Tram Stop*. If the victim in *Show Your Wound* is implied, he is thus in evidence in *Palazzo Regale*. Initially perceived from a position beyond the feet, like Mantegna's great *Entombed Christ*, the "figure" is characterized with Beuys's coat from the performance *Titus / Iphigenie* and from the time of his first Italian

Plate 86 (pages 86–87).
The End of the Twentieth Century, 1983–85
See checklist no. 49

Plate 85.
Hearth I and Hearth II, 1968/74 and 1978–79
See checklist no. 45

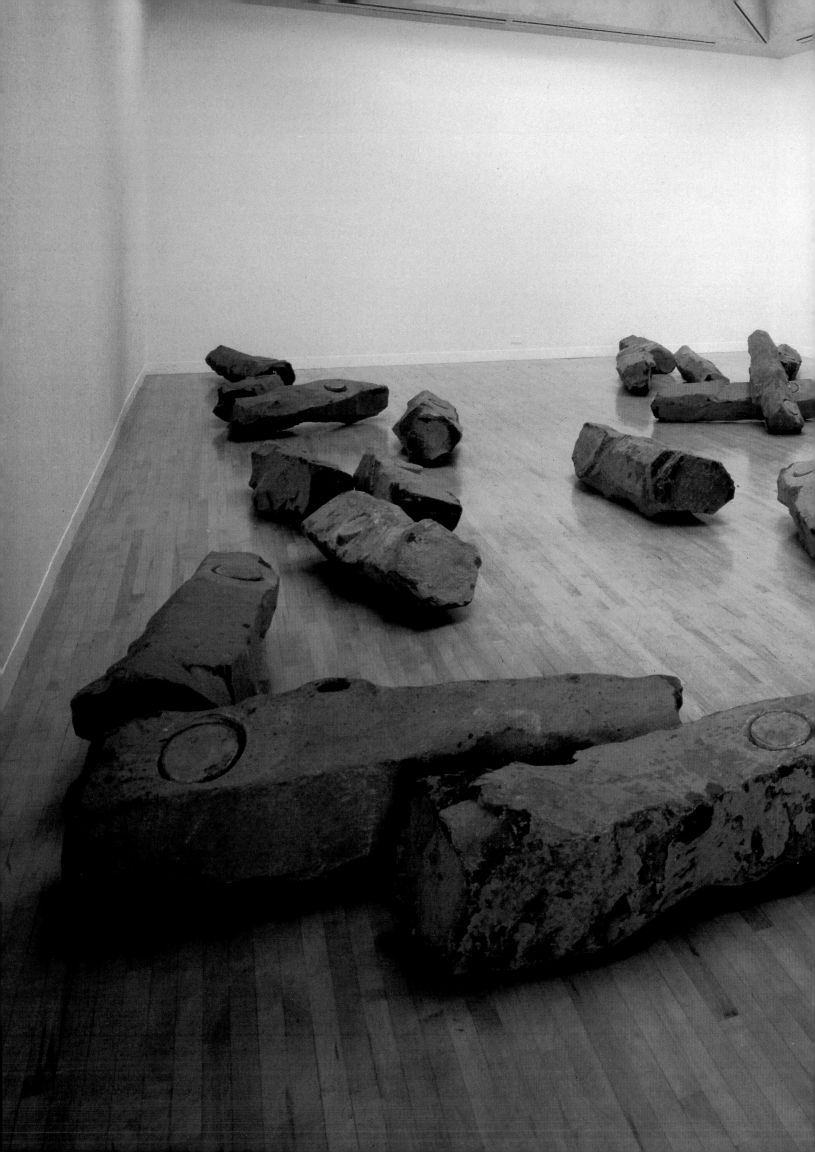

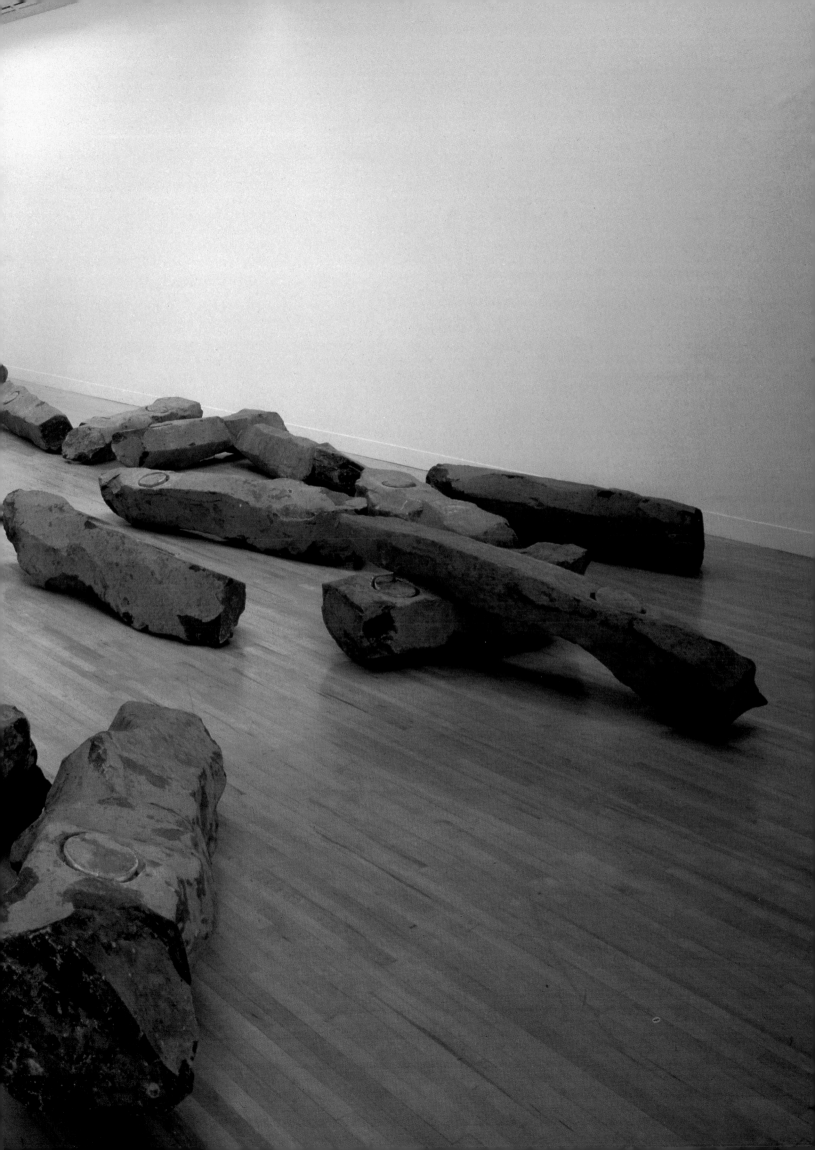

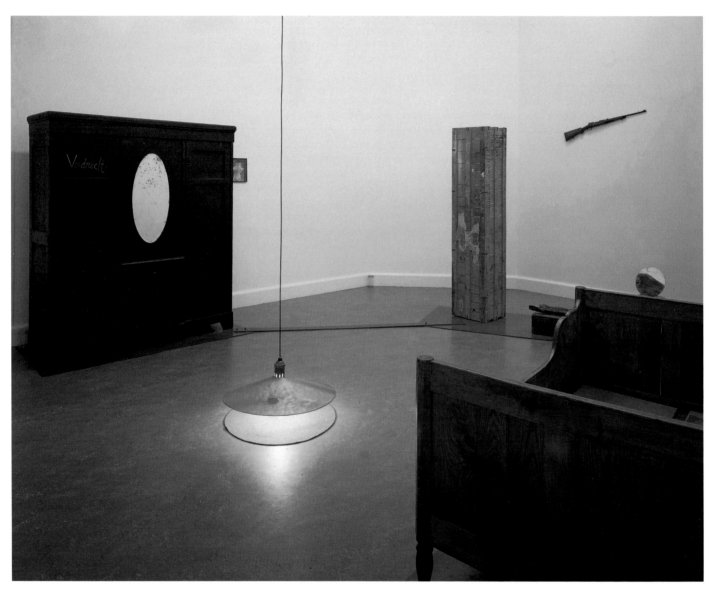

Plate 88.
Show Me My Mountain, 1950/71
See checklist no. 43

sojourn in 1971.[158] This "torso," though, has a slit, or wound, as part of it. The "hands" are given as cymbals, from the same Action. In the second vitrine of *Palazzo Regale* the body is viewed from the side and above, as if at a wake. This vitrine reenacts Beuys's early life, with a backpack and cane for survival. There, the "figure" is shown in segmented or amputated form, the canes as arms. The golden colored monochromes on the walls dominate the scene much as the black monochromes had in *Show Your Wound*. With this degree of gold, it is as if *Palazzo Regale* is a heavenly, alchemical conclusion for the depicted death, as opposed to the forbidding, very earthly, underground setting of *Show Your Wound*.

Beuys in Context

I Like America and America Likes Me is a title filled with irony, not only because Beuys had little evidence of his being appreciated in America, given a dearth of critical attention, but also because he hated the American military actions in Vietnam. Indeed a central concern for German artists trying to rebuild their practice in the postwar period was how to position themselves and how to gain attention vis-à-vis international tendencies, especially in the center of the art world, the U.S. In Europe, Beuys was a beacon in the early 1960s, representing an alternative, stylistically and charismatically, to the hegemony of American art. In contrast to the American ironic hipsters of Pop art, and the materialist Minimalists, Beuys forcefully epitomized an idealistic, even spiritual artist, notwithstanding the trickster component of his character. It was not for nothing that he so often made reference to Van Gogh—his chair, his shoes, his bed. Who better carried the heritage of the tortured artist, suffering for his work and dreaming only of art—this as opposed to the America worship of Duchamp? Beuys leapt to this position in Europe, thereby becoming the crucial figure of the postwar era. He opposed the hard-nosed, what-you-see-is-what-you-see ethos of the Minimalists and the equally hardboiled, sometimes cynical or ironic but always deadpan, position of Pop art. Rather, Beuys's sculpture prefigured and, on occasion, directly influenced the American and European reaction to Minimalism known as Postminimalism.

Beuys's work showed that it was possible to develop independence from the American hegemony, for virtually everywhere one turns in his career, he seemed to play a kind of cat-and-mouse game with the practices of American Minimalist art. It was not as if Beuys was unfamiliar with these practices; there is often an emphasis on geometrical forms, use of industrial materials, reliance on the floor as the natural position for sculpture, and presentation of objects in serial format. But he had begun to explore these issues before the advent of Minimalism in the U.S. For instance, an empty box, *Rubberized Box* (1957, pl. 52), predicts Donald Judd's sculptures (pl. 89); *FOND 0 + Eisenplatte* (*FOND 0 + Iron Plate*, 1957, Hessisches Landesmuseum, Darmstadt) appears well in advance of later floor-bound Minimalist sculpture (pl. 90). Upon the emergence of Minimal art in the early to mid-1960s, with its immediate and broad acceptance in Europe, Beuys must have felt considerable consternation. Moreover, though scant attention was paid to him in the U.S. throughout the early 1960s, critical attention there increased coincident with the onset of Minimalism.[159] He was even drawn into a comparison, in a 1969 interview, when the questioner asserted that Beuys's work has a "Minimal element," whereupon the artist objected, saying: "It overlaps.... But there is no direct connection in my work to Minimal art."[160] While the Minimalist aspect of his art evolved independently of, and earlier than American Minimalism, even foreshadowing it, Beuys's work eventually came to have an uneasy and playful relationship with American examples.[161] For Beuys, the 1960s

reigning Minimalist avant-garde tendency, which originated in New York, would have, in fact, represented an anachronistic apotheosis of the academic strain of twentieth-century geometrical abstraction, epitomizing the intellectual "burnt-out clinker" to which he was so deeply opposed.[162]

Since the end of the World War II, abstraction had been a route by which German artists could connect with the international scene, in effect normalizing their situation with regard to their colleagues in other countries. American art of the New York School had, in fact, been a breakthrough for the Germans. Gerhard Richter recounted his experience of seeing Jackson Pollock, along with Lucio Fontana, in the 1958 Documenta: "The sheer brazenness of it!... I might almost say that those paintings were the real reason why I left the GDR." He goes on to claim, along with Sigmar Polke, that there was a "moral" connotation to this "brazenness."[163] Georg Baselitz described his reaction to a 1957–58 touring exhibition of Abstract Expressionism:[164] "Nothing like it had ever been seen before."[165]

> What was really new was the presence, the size... Europeans lose in terms of competition because they carry with them a ballast that has nothing to do with freedom, nothing to do with altered forms of society. It [European art] is rooted in its solid, deep tradition... European artists barely consider the skin: they're always thinking about what lies underneath....With American artists, there isn't anything left under the skin, but the skin itself is wonderful.[166]

And so Germans were willing to look to this phase of American art with considerable respect, and to admire that "skin" (even if no "wound" was apparent). Later, Anselm Kiefer would say that beneath his epic-scaled *Jerusalem* (1986, Manilow Collection, Chicago) lay a Pollock; given the sense of the earth turned over in that work, it is as if the concept of a "wound" lying beneath the "skin,"—to combine Beuys's and Baselitz's metaphors—was ubiquitous in Germany. In this sense, too, the Germans sought to amplify, or correct, the American precedent. Beuys's large-scale environments, together with Kiefer's, Richter's, and Polke's epic-scale paintings, represent a German counterproposal to large American paintings.

While it was the reigning practice, abstraction was hated by the German public in this period.[167] It is therefore noteworthy that Beuys, followed by many others, felt compelled to take a stand against this mode of art, even if Abstract Expressionism had been a revelation. Beuys's critical view, which was repeated by Richter and Polke early in their careers, could be interpreted as a means to connect not with the art world but with the public, and by Beuys's practice of "filling" abstract structures with the material of life, he demonstrated a next step, too, namely redeeming this style.

From the early 1960s, as if fearing and loathing any association of himself with Minimalism, Beuys started making works that seemed intentionally to undermine Minimalist strategies, even as they disclosed his own deeply held views.[168] Minimal art was usually composed of tough industrial materials cut into geometrical shapes and arranged in very regular ways. By contrast, Beuys's *Fat Chair* (1963, pl. 28), featuring the geometrical form of the triangle, included messy, congealed goo; in *Schneefall* (*Snowfall*, 1965, pl. 91), the floor-bound sculpture is made of soft felt that lies naturally, if awkwardly, over three pine branches, in an arrangement that is antithetical to Minimalist composition. These works emphasize Beuys's organic, nonindustrial approach. Even in *Stelle* (*Site*, 1967/79, pl. 92), the irregularly cut sheet of felt favors idiosyncrasy in contrast to the mechanistic, industrial methods used to obtain a metal plate. With his austere *FOND* series (pl. 77), starting in 1968, Beuys began to make more direct comparisons between his approach and that of the Minimalists, placing a rectilinear plate of copper or iron atop a stack of identically sized felt sheets.[169]

Plate 52.
Rubberized Box, 1957
Pinewood, rubber, tar
39 ½ x 39 ½ x 19 ¾ inches
(100 x 100 x 50 cm)
Hessiches Landesmuseum,
Darmstadt

Plate 89.
Donald Judd
Untitled, 1982–1986
Mill aluminum
41 x 51 x 72 inches
(104 x 130 x 183 cm)
The Chinati Foundation,
Marfa, Texas

Plate 90.
Carl Andre
10 x 10 Altstadt Copper Square,
Düsseldorf, 1967
Copper, 100 units
Overall dimensions:
¼ x 197 x 197 inches
(.5 x 500 x 500 cm)
Solomon R. Guggenheim Museum,
New York
Panza Collection. 91.3673.a-.vvvv.

Just as Donald Judd had been stacking boxes from the mid-1960s, and Carl Andre had been laying industrially cut metal plates on the floor (pl. 90), Beuys played with, and even parodied, their signature techniques in his *FOND* works. For him, a stack of material must be arranged so as to have the concentrated power of an energy source; its placement on the floor has less to do with following Brancusi's example of removing sculpture from a pedestal than suggesting that's where sculpture naturally belongs, like any object in the world. With his work, Beuys critiqued an adamantly structured serial arrangement and impervious materiality. Works such as *FOND* also have the potential for an anthropomorphic reading, given Beuys's description of a related work as "beneath the stomach," and possessing a "head."[170] Such connotations would have been anathema to the strict abstractionist bent of the Minimalists. Having the sense of an impersonation, *FOND*, *Site*, and *Snowfall* show that a Minimal *look* belies a great sense of human vulnerability. In fact, Beuys's impulse in making *FOND* is entirely different than that of American art. It is predicated on an interest in warmth. Whereas Americans follow formalist strategies, Beuys offered poetry, metaphor, and iconography in his highly hermetic sculpture.

Beuys once more seemed to plot against Minimalism's impassive and, for him, bland nature in *Vacuum<—>Mass* (1968, The Museum of Modern Art, New York). Though this geometrical sculpture is placed on the floor, its external form tells only half the story, because of the twenty kilograms of fat and a hundred bicycle pumps within. By contrast with Minimalism's emphasis on the exterior appearance of a work, Beuys's preoccupation is with the interior. Compared to Frank Stella, who famously intoned that "What you see is what you see," Beuys's concern is with what is beneath "what you see." Elsewhere, he called *The Pack* (pl. 75), a "*filled* sculpture," and added such things are "rare in art, common in life."[171] He made it clear that his argument with Minimalism (as with Duchamp) had to do with its divergence from life, therefore do the sleds fall from within the Volkswagen with lifelike disorder. Beuys's argument was not with abstraction per se, which was what the Minimalists were practicing, for he had much in common with the beliefs of Kandinsky, Malevich, Mondrian, and Klee. His complaint was with any form of abstraction, or art in general, that lacked lifelike substance.

In Beuys's work, any object with a Minimalist look will reveal digressions and intuitive or imaginative leaps. *Fat Up to This Level* (1971, pl. 93), for example, seems to be a parody since the zinc plates are upright and do not, according to the title, serve as a purely abstract composition but have importance because of their relationship to the size of something outside themselves. Compared to Minimalist art, the arrangement of the plates is rather unstable, too, if not incorrigibly awry; the fact that the title is given in English adds to the explicitness of the comparison. The title *"Stelle"* (*"Site,"* pl. 92) mimics, in German, a favorite American practice of site-specific sculpture, that is, work that carefully attends to the physical conditions of its locale. The word "site" is a leitmotif among Minimalist and related artists, and is also the title for the dance work by Robert Morris and Yvonne Rainer performed during a 1964 visit to Düsseldorf, when Beuys met Morris. Beuys's work of the same title evinces none of the Americans' concerns, however. His *Site* is a rather disorderly composition, in contrast to the predictable regularity of a Minimalist sculpture; moreover, it ignores its locale. For Beuys, site "means a designated place, where something happened, or could happen in the future."[172] Human events—not physical circumstances—were his primary interest; while he, at times, may have accounted for a locale, he was more likely to demonstrate an internal or intuitive logic. Therefore, as if thumbing his nose at the Americans, he noted that his work possesses a "complicated geometry."[173]

Plate 92.
Site, 1967/79
Copper and felt with fat
112 ¼ x 63 x ¾ inches
(285 x 160 x 2 cm)
Hessisches Landesmuseum,
Darmstadt

Plate 91.
Snowfall, 1965
32 felt blankets over 3 fir branches
143 x 47 x 9 inches (363 x 120 x 23 cm)
Emanuel Hoffmann Foundation,
permanent loan to the Öffentliche
Kunstsammlung Basel. Inv. no. H 1970.2

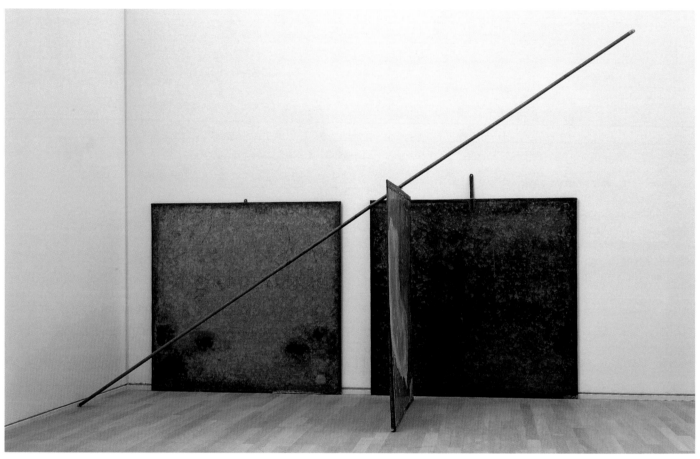

Plate 93.
Fat Up to This Level, 1971
Zinc and fat in three repeated elements, and iron rod
78 ¾ x 78 ¾ x 118 ⅛ inches
(200 x 200 x 300 cm)
Kunstsammlung Nordrhein-Westfalen, Düsseldorf

In his Action *I Like America and America Likes Me* (pls. 3–10), Beuys carried his critique directly into its home base in New York City. Props for this work include two stacks of issues of *The Wall Street Journal* that were delivered each day to the René Block Gallery, where the Action took place; according to Beuys, these evoked "an inorganic fixation" on the part of readers, in contrast to his interest in the coyote.[174] After the daily arrival of the newspapers, the coyote usually would urinate on the Judd-like stacks. In the same year, Beuys took another jab, renaming the postcard image of the World Trade Center Towers of Lower Manhattan "Cosmos and Damian." In so doing, he suggested that the power-base of the country, like a Judd stack (which it resembled), needed the healing mission of the iconic doctors.

Plate 94.
Arena—Where Would I Have Got If I Had Been Intelligent!, 1970–72 (detail)
100 framed aluminum and glass panels, 264 photographs, blocks of fat and wax, copper, iron plates, oil can
Installation at Dia Center for the Arts, NYC, October 1991–June 1992

Arena—Dove sarei arrivato se fossi stato intelligente! (*Arena—Where Would I Have Got If I Had Been Intelligent!*, 1970–72, pl. 94) and *Hearth II* (1978–79, pl. 85) are serial works in the manner of Minimalism in that a sequence of one hundred rectangular objects are arranged in a room in the former, and twenty-nine canes are composed in the latter. But unlike a Minimalist sculpture, all the objects simply lean in a lifelike, somewhat precarious, fashion. In *Arena*, each unit contains something within it, namely photographs of events in Beuys's life. (Likewise, the artist's vitrines combine the geometrical structure of the glass box with energetic contents.) Other such comparisons include Carl Andre's focus on an internally logical arrangement of copper plates on the floor, and Beuys's placement of three copper plates under the legs of a piano in *Hirschdenkmal (In Memoriam George Maciunas) (Stag Monument for George Maciunas)*, 1958/82, Hoam Museum, Seoul). Also, *Tallow* (1977, Marx Collection, Berlin) sits on the floor like a Minimalist sculpture, but its position there is metaphorical in that nothing could be more bound to the earth than death itself and its material by-products. The stones in *The End of the Twentieth Century* (1983–85, pl. 86) echo Richard Long's work, but Beuys's objects have an anthropomorphized, macabre character and are shown within a seemingly casual arrangement suggestive of the erratic aftermath of a catastrophe, whereas Long's objects appear in geometrical patterns. Logical order is not the situation in *Directional Forces* (pl. 80) either, so that Beuys implied his pedagogical aspirations are best achieved within a rambunctious, even chaotic, composition.

During the later 1960s, Beuys's colleagues joined the general assault on American art and abstraction. Their incongruous, yet creative, linkage of cynicism with idealism helps to explain their reactions to contemporaneous art. In Beuys's confrontation with and critique of Minimalism, he sought to accommodate content within abstract practices; specifically repeating such a critique, Kiefer titled one of his artist's books in English *Donald Judd Hides Brunhilde* (1976, private collection). Mocking American values and fantasy, Polke titled the image of a basketball player *Alice in Wonderland* (1971, private collection). Later, in *I Like America and America Likes Me*, Beuys investigated a deeper layer of American life— the coyote represented a "psychological trauma point of the United States," with its reference to Native Americans.[175] Besides ostensibly dealing with an American "wound," Beuys was, no doubt, speaking for his generation in trying to inculcate guilt in Americans, who so often reminded Germans of their own. Lothar Baumgarten followed on this subject in his installation *America Invention* (1993) at the Solomon R. Guggenheim Museum, New York.

Sigmar Polke's *Streifenbild (Stripe Picture)* series (1967/68), and *Moderne Kunst (Modern Art*, 1968, private collection) reduced gestural abstraction to the most hollow of styles, as was the case in Roy Lichtenstein's *Brushstroke* series; Polke's *Höhere Wesen befahlen: rechte obere Ecke Schwarz Malen!* (*Higher Powers*

Command: Paint the Upper Right Corner Black!, 1969, Froehlich Foundation, Stuttgart) made Ellsworth Kelly's abstraction the subject of a joke; *Carl Andre in Delft* (1970, Speck-Collection, Cologne) added a bit of Dutch kitsch to the American artist's signature composition; *Lösungen I–IV* (*Solutions I–IV*, 1967, private collection) turns Conceptual art into a vacuous joke. Gerhard Richter, too, referred to Kelly by mechanically turning the American's lush grids into deadpan paint-color charts of the most banal sort; like a scientist examining specimens, he studied stripes in his *Curtain* series of 1964–67 and brushstrokes in numerous pictures of the late 1960s. Though never single-mindedly faithful to abstraction as earlier abstractionists had been, Richter later evinced a sublime reinterpretation of how an abstract language could be revitalized. Nor was he flippant toward this mode of working as was Polke. For Richter, abstraction held him in sway with a romantic force. Even Baselitz took a position, saying, "I had to find a new vocabulary for abstraction; the body became a way of fragmenting the painting to generate a new abstract effect."[176]

Beuys, with his preoccupation on Eurasians, primitive peoples, and Eastern values, set aside the Western or Pop context almost altogether. But Pop art, of the early hand-painted type, was obviously liberating for Polke and Richter in the early 1960s. Then, they practiced a form of German Pop, emphasizing commonplace subjects from the daily life of their country, banal paint handling, and reliance on photographic sources (pls. 95–96). But just as Polke and Richter rejected the elevated pretension of abstraction, these two took Pop art in another direction, largely eliminating the glamour that filled the American precedent (pl. 97). Movie stars were absent, as were glitzy, attractive stylizations, except when shown with an overt sarcasm. By contrast to American Pop artists, who seemed to have become one with their society, German artists still maintained the position of an avant-garde movement, with its aggressive épater le bourgeois attitude and reverence for spiritual values. None of the Germans' subjects ever was filled with an iconic sort of presence either, as was the case with Pop art. In the spirit of Konrad Adenauer's warning to the Germans against the belief in "false illusions,"[177] Richter's and Kiefer's portraits of famous German personages were based on nondescript photographs that greatly diminished the importance of the sitters (pl. 98). The Germans never evoked advertising imagery as a new form of beauty either; for them, this source served as a reference to a decadent world of insipid imagery and materialistic values.[178] In this regard, for Richter, the depiction of a clothes dryer evoked "something tragic… because it represented life in low-cost housing."[179] If urban life and media imagery were the sources for Pop art's subject matter, and for many of its variations as practiced by Polke and Richter, Baselitz ran from this Sodom and Gomorrah atmosphere. He populated his work of the 1960s with peasant-type heroes (pl. 99) to evoke a time and place altogether distinct from modern civilization and to portray a band of lost souls, alienated from that civilization.

Beuys's departures from Minimalism mirror the position of his 1960s Actions in relation to performance art in general. For many performance artists, the activity served an anti-art, sometimes political, agenda, in which the conventions of painting and sculpture were radically overturned, and real time manifestations were introduced into the field of aesthetics. Certainly, Beuys participated in this thinking, but his Actions had an anachronistic, religious component that integrated real-time events within a mythic time-and-space performance. As Monsignore Otto Mauer observed in 1967: "Beuys' actions are rooted in the attitudes of postwar Christian existentialism; they dramatize the search for fleeting signs of transcendence amidst the terrifying succession of

Plate 97.
Andy Warhol
Blue Marilyn, 1962
Silkscreen and acrylic on canvas
20 x 15 ¾ inches (51 x 40 cm)
Princeton Art Museum.
Gift of Alfred H. Barr, Jr., Class of
1922, and Mrs. Barr

Plate 95.
Gerhard Richter
Clothes Dryer, 1962
Oil on canvas
39 x 31 inches (99.3 x 78.6 cm)
Froehlich Foundation, Stuttgart

Plate 96.
Sigmar Polke
Plastic Tubs, 1964
Oil on canvas
37 x 47 inches (95 x 120 cm)
Collection Harry
and Linda Macklowe

Plate 98.
Gerhard Richter
48 Portraits, 1971–72
Oil on canvas
27 ⅝ x 21 ¾ inches each
(70 x 55 cm)
Ludwig Museum, Cologne

Plate 99.
Georg Baselitz
The New Type, 1966
Oil on canvas
63 ¾ x 51 inches
(162 x 130 cm)
Froehlich Foundation,
Stuttgart

accidents, the flux-toward-death, that defines human life."[180] Ritualistic, symbolic, engaged with German history, and grand in the sweep of concerns, Beuys's art also displayed a love of the tableau, qualities rarely seen in other performance artists of the time. Unusual, too, in comparison to other performance works, was Beuys's use of materials and objects for their redolent possibilities. It is clear then why Beuys finally turned from Fluxus activities after 1964: Its focus, like performance art around the world, was determinedly and primarily an anti-art initiative, and this was not a satisfactory aesthetic position for Beuys, any more than the formalist issues of Minimalism.

Because Beuys was a nontraditional sculptor at a time when painting was generally discredited, he placed himself in a position virtually alone among contemporary German artists of the early 1960s, and in competition with the American avant-garde. But, prefiguring and critiquing Minimalism were only part of his achievement. Beuys's sculptural oeuvre carried with it the seeds of a countermovement, namely, what has been termed Postminimalism. While making casual use of industrially derived materials, as the Minimalists had done, Beuys added altogether unconventional, even eccentric, substances, as well as a meaningful approach to material and geometry, a loose-limbed rectilinearity and newly conceived aesthetic effects.

The earliest indication that Beuys's work would influence developments abroad and extend Minimalism into a new era was the use of felt by Robert Morris starting in the mid-1960s.[181] Beuys and Morris became acquainted in Düsseldorf in 1964, when the latter was there for an exhibition at the Galerie Schmela and for the aforementioned dance performance "Site." Morris visited Beuys's studio and, upon his return to America, began his series of felt sculptures, and made his own triangle, *Untitled* (*Corner Piece*, 1964, pl. 100). Clearly, the intentions of these two artists with regard to felt differed, as Kay Larson indicates in comparing their practices: "Beuys is Kafka, warning of the powers of the state, or the sorcerer's apprentice, warning of evil; Morris is Henry James at play."[182] While Larson's interpretation of Beuys's use of felt may go beyond even what Beuys might have imagined, he always approached his materials—whether felt, fat, bone—with dual purposes in mind. One concerned the appearance and the function that appearance might perform in a work of art; second, he considered the mythic and/or symbolic implications held by each material, all of which seemed to be well known to Beuys.

Eva Hesse, one of the pioneering figures of the Postminimalist aesthetic in America, formed her mature outlook during a 1965 stay near Düsseldorf, where she became well acquainted with Beuys's art.[183] His free use of unconventional materials, predilection for vulnerable and flimsy objects, and his desire to undo geometrical regularity and predictability must have held a powerful attraction for this young New Yorker. If one compares Beuys's *Untitled* (1961, private collection) to Hesse's *Several* (1965, private collection) or Beuys's *Rubberized Box* (1957, pl. 52) to her *Accession II* (1969, pl. 101), the resemblances are obvious. Hesse, too, wanted to make Minimalism idiosyncratic, and to "fill" its containers. Ironically, Hesse's *Tori* (1969, Philadelphia Museum of Art) would prefigure Beuys's *The End of the Twentieth Century* by sixteen years. Indeed, the basalt stones in the latter work follow the example set by Isamu Noguchi's basalt and granite, torso-like rocks with hard incised geometrical cuts.[184]

After an exhibition opening at the Kunsthalle in Bern, Switzerland, in 1968 entitled "When Attitude Becomes Form," Beuys quite correctly commented about the exhibited works, which took Minimalism in a new direction: "I have been doing those things for a very long time."[185] For instance, *Snowfall* (1965,

Plate 101.
Eva Hesse
Accession II, 1967
Galvanized steel and rubber
30 ¾ x 30 ¾ x 30 ¾ inches
(78.1 x 78.1 x 78.1 cm)
The Detroit Institute of Arts
Founders Society Purchase,
Friends of Modern Art Fund and
Miscellaneous Gifts Fund

pl. 91) must have directly influenced Bruce Nauman's *Untitled* (*Wedge Between Metal Plates*, 1968, private collection) in that the critique of Minimalism is virtually the same, but with different materials. With their chaotic arrangements and unimagined materials, Beuys's installations anticipated the sensibility of scatter-type sculptures arranged on the floor by such Postminimalists as Robert Morris (pl. 102), Barry LeVa, and Richard Serra.[186] This type of work would influence numerous artists in Germany, including, for example, Imi Knoebel and Franz Erhard Walther. Much later in America, artists such as Cady Nolan, Jason Rhoades, Sarah Sze, and Jessica Stockholder built room installations composed of casually arranged detritus from life such as fruit, product containers, bits of discarded aluminum and wood, and toys—works that had the same aura of a laboratory pregnant with energy that Beuys had made on a small scale in the *Hare Graves* (pl. 78) and on a large scale in the environment *Economic Values* (pl. 81). Whereas his works have an emphatically German cast, the Americans' use of native materials makes their context unmistakable. A more extreme comparison of an American to Beuys is Jeff Koons's *Rabbit* (1986, private collection) to Beuys's *Hase mit Sonne* (*Hare with Sun*, 1982, pl. 103). There, Beuys's highly poetic and guilt-ridden approach is contrasted with the carefree attitude of an American.

Along with the wound, Beuys initiated the theme of mourning and even nostalgia, which gave permission to subsequent generations to do the same. We see the mourning of victims often in the work of Kiefer (pls. 116–17), at times in works by Richter, such as *18. Oktober 1977* (pl. 114), and in the work of Christian Boltanski in France, and, more recently, Doris Salcedo in Columbia, among many others. The latter artist, like Beuys, hauntingly conveys historical traumas and suffering, as well as the absence of human life, through the vehicle of forlorn and forgotten furniture. Hers, too, is a profoundly wounded country. One could argue that Beuys signaled to the art world the existence of many diaspora, so that the suffering of war and its victims, as well as of survivors, could be given a voice. In particular, he made himself the displaced survivor of the land called Eurasia, his staged diaspora. To feel himself alienated from the West and at pains to return to his Eden—Eurasia—was an essential aspect of Beuys's wounded condition.

Beuys's influence on younger Americans extends in a variety of directions. His *Battery* (1963, pl. 76) and the newspaper stacks in *I Like America and America Likes Me* of eleven years later (pls. 3–10), both of which are *FOND*-like in the sense of being stacked energy sources, must have inspired Robert Gober with his stacks of newspapers, as well as the paper stacks of Felix Gonzalez-Torres.[187] By their gestures, the latter two artists were also "filling" an abstract structure with the content printed on the pages. The most fully realized assimilation of Beuys's oeuvre in the U.S. is seen in the work of Matthew Barney, whose 2003 Guggenheim Museum retrospective (pl. 104) epitomized the relationship in the very setting where Beuys had installed his own retrospective in 1979. In small ways, such as the creation of vitrine sculptures and the use of the piano, Barney specifically recalled Beuys. He did so, as well, in a larger sense: just as Barney's objects almost all emanate directly or indirectly from his films, thereby himself "staging sculpture," and just as Barney literally centered those films within his exhibition, so, too, were Beuys's Actions the starting point and source for many of his sculptures. Barney's work, saturated with the most American of content (from Gary Gilmore to Norman Mailer), is the American equivalent of Beuys's redolently German art. And, if Barney's art nevertheless appeals to non-American audiences, as it, in fact, does, it demonstrates why Beuys's art, contrary to some critical judgments,

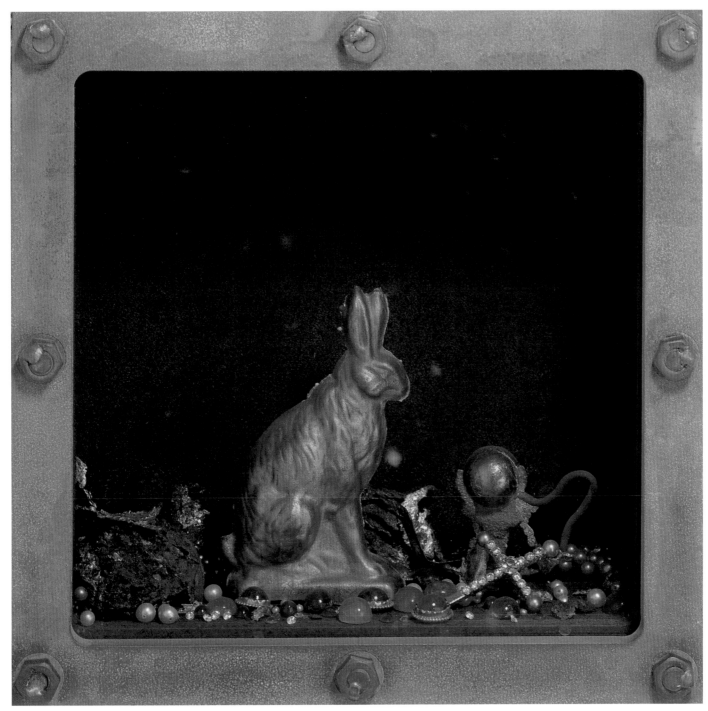

Plate 103.
Hare with Sun, 1982
Melted gold and
miscellaneous other
material
Staatsgalerie Stuttgart.
Inv. Nr. P1002

has or has the potential for a broad non-German audience.

Beuys had a formative influence on a group of Postminimalist artists based in Italy known as the Arte Povera group. They made use of crude, unconventional materials, all very poetically and meaningfully composed and evincing a kind of shabby grandeur. The fact that their materials were in a gradual state of decay only added to the artists' characterization of the historical past. Above all, Jannis Kounellis was most shaped by Beuys's example, even as he forged his individual style. For instance, in Kounellis's *Untitled* (1967, private collection), he made a filled container—a four-sided iron structure that was literally bursting at the seams with its cotton contents. A 1969 work, *Untitled* (Speck-Collection, Cologne), has a blackboard-like surface, in iron, on which he listed his own revolutionary interests (Marat and Robespierre). In 1972, for a photographic work (private collection), Kounellis painted his lips with gold, recalling Beuys's visage in *How to Explain Pictures to a Dead Hare.* Kounellis shared Beuys's desire to make homages to Van Gogh; his 1972 *Untitled* (private collection) speaks of Van Gogh's *Still Life with Shoes* (1886, Stedelijk Museum, Amsterdam), and his 1976 *Untitled (Hotel Louisiana)* (private collection) echoes both Beuys's 1971 *Show Me My Mountain* (pl. 88), and Van Gogh's *Bedroom at Arles* (1889). After Beuys exhibited *Tram Stop* in Venice in 1976, Kounellis did his own series of works involving trains starting the following year. On the other hand, Beuys must have been responding to Kounellis when he brought a horse onto the stage on May 29, 1969, for his Action *Titus / Iphigenie* in Frankfurt (pls. 14–16), for Kounellis had filled a gallery in Rome with horses in January of the same year. Kounellis's ongoing relationship with Beuys's work seems less a matter of being influenced than a series of reactions by Kounellis, as if he wanted a dialogue with the German artist's metaphors, and, especially, to invest them with a different kind of content.

As a poet of unlikely materials, Beuys was a cornerstone figure of art for nearly the last half century. Whether one refers to Eva Hesse and Ann Hamilton in the U.S.; Wolfgang Laib and Thomas Schütte in Germany; Franz West in Austria; Rachel Whiteread and Damien Hirst in England; or Miroslaw Balka in Poland, among many others, all work in the wake of Beuys. Each has sought to make unlikely materials their own, suggestive of unimagined aesthetic effects. Hence, Beuys's declarations about his art reflecting his political theories must be measured against his impact purely as a sculptor. Indeed, he never stopped being a sculptor first of all. His work constantly reflects that historical outlook, and suggests specific critiques and enhancements of art precedents. After noting his place in relation to early twentieth-century masters of elongation and/or alienation (Giacometti, Brancusi, or Wilhelm Lehmbruck), we observe a sculptor of materials intent on introducing new, especially organic, ones to his practice and thereby expanding the range of his medium.[188] Specifically, he favored materials that might convey, by their very essence, particular content. Whereas Rauschenberg and Schwitters employed junk, Beuys's "junk" should be more aptly termed organic refuse and rubble. In other words, his materials were directly inspired by, and redolent of, his specific world—his nation's totems, fixations, and subconscious— thereby forging a profoundly eloquent contribution to the history of sculpture.

In the Shadow of the Wall

Perhaps Beuys's most immediate importance was as the groundbreaking force for a revitalized German art in the aftermath of World War II and during the period of the Berlin Wall. Before, Germans had a kind of frog in their collective throats; few were willing to speak about what had happened to them. W. G. Seebald describes the unspoken presence of a *"cordon sanitaire"* that produced a deafening

Plate 104.
Installation view of
Matthew Barney: The Cremaster Cycle,
February 21–June 11, 2003
Solomon R. Guggenheim Museum,
New York

silence; perhaps people were too traumatized or could not remember, he said.[189] In such a circumstance, Beuys's staging of his life and work befits a previously silent state, enabling an approach that was emotional yet detached. He was the avatar and the signal to his countrymen that German artists had found their voice again, and could make an art based on history, recent and long past, and on their own experience. That this was clearly the case is surmised by the title and date of a painting by Jörg Immendorff: *Beuysland* (1965, pl. 105). Just after Beuys's death in 1987, Gerhard Richter wrote of him:

> This phenomenon, which took us by surprise 25 years ago, and soon appalled us, unleashing admiration, envy, consternation, fury: this absolute loner, who broke all the conventions which, for all our rebelliousness, gave us a framework in which we could "carry on" in relative security (above all in contrast with the social system that most of us had known previously, that of the GDR.)[190]

Beuys's name, said Richter, stood for "humanity, art, intelligence, courage and love," moreover, he had an attractive "dangerous quality."[191] For Anselm Kiefer, Beuys "was a total idealist....He gives us the truth to enjoy. His art is joyous."[192] To examine Beuys's role with regard to his students, contemporaries, and later generations requires volumes.[193] Suffice it to say, Beuys was in the vanguard much of the time, especially regarding his free approach to styles coming from abroad and from history, and his attitude toward Germany. Starting in the late 1950s his activities and participation in the international Fluxus group gave him authority, but after a while, Beuys was working in concert with his colleugues to form a new direction in German art.

Beuys's motifs and interests reappear in the hands of his contemporaries as well as subsequent generations. His totemic *Fat Chair* (1964, pl. 28) is likely the inspiration for Richter's series of kitchen chairs of 1965, although he claims that the chair is simply "part of my search for banal objects."[194] Sigmar Polke placed a pair of chairs, as if an insider's joke, atop the heads of the figures in *So Sitzen sie Richtig, Nach Goya* (*This Is How You Sit Correctly [after Goya],* 1982, Sammlung Frieder Burda, Baden-Baden, Germany). That Van Gogh, who was so important to Beuys, was in the air could be seen by Polke's question to an interviewer about his 1963 painting *Socks* (private collection): "Do you see any connection between it and van Gogh?"[195] It is surely Van Gogh's shoes to which he alludes. Three years later, Richter felt the need to critique Duchamp with his own nude descending a staircase (*Ema*, 1966, Ludwig Museum, Cologne). Also totemic within Beuys's early career was the hare on his lap in the Action *How to Explain Pictures to a Dead Hare;* two years later, Baselitz's figure in *Hunter* (1966, Edythe and Eli Broad Collection, Los Angeles) carries a dead hare; and Polke recalled the animal, along with another spiritual heir, in *Dürer Hase* (*Dürer Hare,* 1968, pl. 106). Polke's herons may allude to Beuys's iconography of birds, specifically his swans, but in the former's hands, the birds are comic lawn ornaments. Beuys's ubiquitous stag reappears in a 1963 painting by Richter (private collection), but in the latter's work, the stag is a kitsch symbol of the ancient forests of Germany. It's "not the stag's fault," Richter explained.[196] Such quotations, given the artists' professed regard for Beuys, may be seen as gently sardonic homages, but the citations also indicate Beuys's high place in the art of the period in Germany.

If repetitions of Beuys's hare, stag, and chair might be said to explicitly recall him, it is more difficult to state that the theme of the double in the hands of another artist is absolutely a quotation. Yet, certain instances are worth noting. In Baselitz's *Pandemonium 2*, his second manifesto published in February 1962, he wrote:

Plate 105.
Jörg Immendorff
Beuysland, 1965
Oil on canvas
48 ⅜ x 41 ¼ inches
(125.4 x 104.8 cm)
The Saint Louis Art Museum.
Friends Fund.

Plate 106.
Sigmar Polke
Dürer Hare, 1968
Latex paint on fabric
31 ½ x 23 ⅔ inches
(80 x 60 cm)
Sammlung Frieder Burda

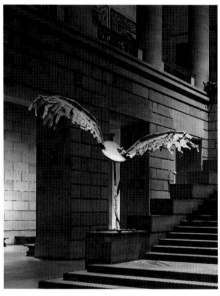

Plate 107.
Anselm Kiefer
Palette with Wings, 1985
Lead, steel, and tin
110 ¼ x 137 ¾ x 39 ⅜ inches
(280 x 349.9 x 100 cm)
Philadelphia Museum of Art: Purchased
with funds contributed by Norman
Braman and gift (by exchange) of Anna
Warren Ingersoll, 1989

*Audacious twinness (deux, deux, deux) springs from love. Doubly pregnant
cave....Dark images (splendour in front, squalor behind) mighty infatuation with
senseless death. No outstanding debts.*[197]

This restatement of Beuys's interest in the dual nature of a single situation suggests
that Baselitz was at least conscious of his strategy, if not the full range of Beuys's
possible meanings. Two years later, with Richter's depiction of a pair of Fiats
going in opposite directions, it is tempting to contemplate an elaboration of the
two Germanies theme. Polke's *Schrank* (*Wardrobe*, 1963, private collection),
Das Palmen Bild (*Palm Trees*, 1964, private collection), and *Reiherbild* (*Heron Series*,
1968), with their reiteration of pairs, all suggest that the double identity of things
is an important concept shared by him. And his *Potatoe Kartoffelköpfe (Mao + LBJ)*
(*Potato Heads [Mao + LBJ]*, 1965, Sammlung Frieder Burda, Baden-Baden,
Germany) illustrates the concept of two like entities that are, nonetheless, quite
different.[198]

Other borrowings include Dieter Rot's *Bathtub for "Ludwig Van"* (1969,
private collection), a bathtub like Beuys's but containing heads made of fat, white
sugar icing, and chocolate. After Beuys installed the columnar figure in the central
space of the German Pavilion of the Venice Biennale in 1976, it must have been a
mandate for Baselitz to place one of his large wood sculptures in the same
location in 1980. By opening the "psychological trauma point of the U.S." in *I Like
America and America Likes Me*,[199] Beuys set the stage for Lothar Baumgarten's
invocation of American Indian tribes in the aforementioned installation on the
outer ramp wall of the Guggenheim Museum in New York in 1993.

More than anyone else, Anselm Kiefer has been a protege of Beuys.
Though having only an informal relationship (Kiefer would travel to see him
periodically for critiques), nevertheless, Kiefer is obviously devoted to Beuys's
thinking, starting simply with the matter of the "wound." First, Kiefer explored at
length what it meant to be German, dealing very specifically with events from
Nazi history. Then, again following Beuys, he realized the power of unusual
materials to convey content; in regard to character, he is very much like Beuys,
for both have a voracious appetite for knowledge about, among other subjects,
the historic application and mythology of materials. The almost complete absence
of color except for brown and gray in Beuys's work is echoed by Kiefer; indeed,
he claims this practice to be the heritage of German art in general.[200] Whereas
Beuys made the piano a symbol for art, Kiefer does the same with the palette
(pl. 107). Smaller borrowings may include the dresses he shows in numerous
works, including *Lilith's Daughters* (1991, Pincus Collection, Wynewood,
Pennsylvania), in relation to Beuys's *Ohne Titel* (*Untitled [Shirt]*, 1964, private
collection), or the frequent use of roses after Beuys's recurrent roses;[201] the skis
on the surface of *Jerusalem* (1988, Manilow Collection, Chicago) with regard
to Beuys's ubiquitous sleds and iron shoes; the appearance of toys in his books and
photographs much as Beuys had done in such works as *Fluxus Object*; the deploy-
ment of beds in the room environment version of *Women of the Revolution*
(1986, private collection) after Beuys's dissecting tables in *Show Your Wound*
(1974/75, pl. 70); Kiefer's general use of lead following Beuys's *PAIN ROOM*
(1983); the broken glass in *Breaking the Vessels* (1990, pl. 108), which repeats the
primary material in *Terremoto in Palazzo* (1981), and, finally, Kiefer's vitrine
constructions, which are a virtual homage to Beuys.

Baselitz deserves credit, too, for the outbreak of art that spoke of the
national condition, starting with his *Pandemonium* manifestoes about Germany,
the first of which was published in 1961, and which also recalls the spirit of
James Joyce:

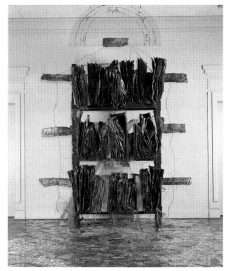

Plate 108.
Anselm Kiefer
Breaking of the Vessels, 1990
Lead, iron, glass,
copper wire, charcoal, and Aquatec
Overall 149 x 329 ½ x 204 inches
(378.5 x 836.9 x 518.2 cm)
The Saint Louis Art Museum. Funds given by
Mr. and Mrs. George Schlapp, Mrs. Francis A.
Mesker, the Henry L. and Natalie Edison
Freund Charitable Trust, The Arthur and
Helen Baer Charitable Foundation, Sam
and Marilyn Fox, Mrs. Eleanor J. Moore,
Mr. and Mrs. John Wooten Moore, Donna
and William Nussbaum, Mr. and Mrs. James E.
Schneithorst, Jain and Richard Shaikewitz,
Mark Twain Bancshares, Inc., Mr. and Mrs.
Gary Wolff, Mr. and Mrs. Lester P. Ackerman,
Jr., the Honorable and Mrs. Thomas F.
Eagleton, Alison and John Ferring, Mrs. Gail
K. Fischmann, Mr. and Mrs. Solon Gershman,
Dr. and Mrs. Gary Hansen, Mr. and Mrs.
Kenneth S. Kranzberg, Mr. and Mrs. Gyo
Obata, Jane and Warren Shapleigh, Lee and
Barbara Wagman, Anabeth Calkins and John
Weil, Museum Shop Fund, the Contemporary
Art Society, and Museum Purchase; Dr.
and Mrs. Harold J. Joseph, estate of Alice P.
Frances, Fine Arts Associates, J. Lionberger
Davis, Mr. and Mrs. Samuel B. Edison, Mr.
and Mrs. Morton D. May, estate of Louise H.
Franciscus, and anonymous donor, Miss Ella
M. Boedeker, by exchange.

The poets lay in the kitchen sink,
body in morass.
The whole nation's spittle
floated on their soup.
They grew between mucus membranes
into the roots areas of humanity.
Their wings did not carry them heavenward—
they dipped their quills in blood,

No truck with those who can't wrap art up in a smell.

We have blasphemy on our side![202]

Making himself a poet in this diatribe, Baselitz entwines his destiny with that of his nation. Like Kurt Schwitters, who compared art to a "toothache," Baselitz wants poetry to have a no-doubt distasteful smell; indeed, he himself is "sodden with memories."[203] In contrast to the "altar of Nature," he records the sad and disgusting attributes of humankind.[204] From early in his career, Baselitz exhibited a high degree of lewdness, trying to be as shocking as possible. Subsequently, painting figures in upside-down positions was for him a defiant act against the expectation for harmonic orderliness and compliance.[205] Resigned and unrepentant, he says "I'm a German artist and what I do is rooted in the German tradition."[206] While Baselitz had similar motivations as Beuys, their respective influence in the early 1960s was quite different. In the national press, Baselitz's notices were scant during this period, whereas Beuys quickly became renowned for his Actions, sculptures, pedagogical activities, and controversy. Though both artists represented for many who held the same views—that being German was the root of their artistic mission and that aggressive new versions of the beautiful needed to be created—it was Beuys who was the beacon for contemporaries and later artists.

Initially, the position struck by Beuys was for a strident stance toward other art styles, in contrast to German art after World War II that was academic if not derivative, compared to the burgeoning art scene of the U.S. Into this milieu came Beuys and Baselitz, with their new and belligerently stated forms of beauty. Beuys spoke gently when he postulated a "wider understanding of art,"[207] but his title *The Silence of Marcel Duchamp Is Overrated* represents a more forceful aspect of his approach and a break with the past. Polke and Richter pointed to Fluxus in general as leading the way in the early 1960s, with Richter saying: "It was all very cynical and destructive. It was a signal for us, and we became cynical and cocky and told ourselves that art is bull and Cézanne is stupid."[208] Polke elaborated: "There's nothing you can do anymore with terms like vulgar....What is vulgarity compared to other ailments? Agony is lurking behind every hair, every color, every picture... artists... parry with irony."[209] It was not as if Beuys himself was ironical; pain, not wit, characterized his attitude. With the title *Die grosse Nacht im Eimer* (*The Big Night Down the Drain*, 1962–63, pl. 109), Baselitz suggests that all that went before had to be cleared out; for him painting was an absolute "act of aggression."[210] With regard to either French or American influences, he reported that "In postwar Germany there was no hierarchy."[211] Polke repeated that attitude on various occasions, as when he said French painting is too "stupefied by still-lifes. If they had at least had the grace to paint their oranges with poison! The great tranquilizers, pacifiers... ."[212] If Polke is bellicose, Richter is sly: "I like everything that has no style....Because style is violence, and I am not violent."[213] He repeated this concern in an article cowritten with Polke, concluding: "We don't want war....No more war ever!"[214] Thus Richter's desire to avoid style

107

Plate 109.
Georg Baselitz
The Big Night Down the Drain, 1962–63
Oil on canvas
98 ½ x 31 ⅓ inches
(250 x 80 cm)
Ludwig Museum, Cologne

seems to emanate from the belief that it is a function of ideology, and that without the latter, a society may better defeat the sort of aggressive militaristic views that lead to conflict. To be anti-ideological, then, as Polke, Richter, and Beuys were, is to be antagonistic toward a kind of aesthetic totalitarianism. But it is not as if Duchampian neutrality is the answer, either: witness Beuys's title about the "silence" of Duchamp, or Richter saying of Duchamp "I don't like manufactured mystery."[215] In the German artistic world after 1961, and coincident with the erection of the Berlin Wall, a kind of willful promiscuity with regard to style reigned. Indiscrimination rather than posturing or ideological aestheticism fit the situation. The one constantly evoked model for these artists is real life, no matter how banal, as the sole source of beauty existing outside traditional aesthetic effects. Richter's mirror works posit reality in the most literal form possible.

At times altogether uncomfortable with the vocabulary of images from their own country and from the West in general, Polke, Richter, and occasionally Baselitz, following Beuys, all revealed a predilection for exotic themes; that was not the case in American art except where the location is described as if in a travel advertisement. In the same way that beauty and meaning emerge from unusual and surprising materials, these attributes were encountered through the artists' engagement with the exotic Other, found especially outside of Western capitals. Beuys constantly experienced this in his contemplation of the East (Eurasia), and the values, traditions, and myths to be found there.[216]

Mikhail Mikhailovich Bahktin employed the term "dialogic imagination" to describe a process of creation based on the intermingling of wildly divergent contexts. This dynamic approach is appropriate to the phantasmagoria present in German art, in which a cacophony of images emerges from a welter of varied voices: for example, Richter's *Negroes* (*Nuba*) (1964, private collection), Baselitz's *Negro* (*Neger*, 1972, private collection), Polke's *Japanische Tänzerinen* (*Japanese Dancers*, 1966, private collection) and his photographs of Pakistani and Afghan people of the 1970s, and Kiefer's Saharan scenes of the 1990s. Polke and Kiefer were especially entranced by an approach that made use of such sources, with the former having spent much of the 1970s and the latter, the late 1980s and 1990s nomadically wandering the world. Another way to manifest an appreciation of a multiplicity of sources from which knowledge could be gained was to introduce many non-native languages into one's oeuvre, as Beuys and others often did.[217] With a gluttony of sources comes a faith that monolithic thinking, such as resulted in the rise of Nazism, would be skirted, including notions about art. Polke raves about tribal peoples' practices: "They use blood, real blood, not to paint their bodies, but to glue the ornamentation to their bodies!"[218]

The unrelenting redolent ugliness of Beuys's debris epitomized the German point of view. In character, the new German voice was like a stew with the taste of fat and gristle in its mass of disparate media and experiences. Since 1960, German art almost never pretends to elegance; slightly unkempt if not dirty, and always unashamed if it lands on your lap, this art generally avoids elevated states. Compared to the New York School, which in its earliest phase has a similarly grim quality that nevertheless aspires to transcendence, German artists prefer willful, even angry, gestures that remain decidedly of this world. Indeed, beauty is always a debatable concept and is certainly an ambivalent pursuit. Germans are resigned to the idea that moments of classical harmony and clarity are as rare as sights of nature in a pure state, for the physical and cultural condition of Germany will always press in on these artists' collective world view.

In Beuys's art, beauty must be wrenched from his surroundings, not picked like a flower in a sweet, if meaningless gesture. Pamela Kort has persuasively

compared Beuys's creation of beauty based on a wounded world to a reaction against Nazi aesthetics, with its sentimental emotions, pseudo-classical order, and propagation of an image of a noble German race.[219] After World War II, with that notion of aesthetics completely debased, Beuys revised its formulation by basing beautiful effects on unconventional materials, and on poetic qualities founded in small, seemingly modest and insignificant things. Beuys's art of fragments and Baselitz's segmented wholes (as in his fracture series) evoke the contemporary experience of a bifurcated society as opposed to the ostensibly seamless world of Nazi sculpture. Beuys's materials were not simply chosen for their humble demeanor or source, however. The artist was interested in their physical character, that is, their malleability, appearance, and historic and/or mythical background. If Beuys's materials are fragile or transitory, especially as compared to the National Socialists' extravagant use of marble, that too suited an unstable world. He said: "My sculpture is not fixed and finished. Processes continue in most of them: chemical reactions, fermentations, color changes, decay, drying up. Everything is in a *state of change*."[220] The italics here could be extrapolated to suggest that the "state," Germany, is in flux also, not just its materials. In Germany after World War II, Beuys wanted to use debris to formulate new possibilities. While his sense of a dilapidated beauty is shocking at first, it serves as a homily, as well. Underlying was the alchemical concept that materials could be transmuted, the static could become dynamic, the humble could become holy and, therefore, beautiful in the most significant way—recall his Theory of Sculpture. This thinking prefigures Polke's and Kiefer's use of organic materials.

From the start Baselitz had himself been seeking new forms of beauty, but based on his notion of the "ugly and expressive" German tradition, which attempts "to spill out garbage, to show the soul, to be dirty."[221] He sought brutal, shocking confrontations with the viewer, such as a masturbatory act in *Hommage à Wrubel-Michail Wrubel–1911–Alte Heimat-Scheide der Existent* (*Homage to Vrubel-Mikhail Vrubel–1911–The Old Country-Border of Existence*, 1963, Neue Galerie, Kassel) or the depiction of penises in various works of the early 1960s. When he titled one of his figures *Der neue Typ* (*The New Type*, 1966, pl. 99), he sarcastically echoed the utopian Bauhaus and its proposal for The New Man; by contrast, Baselitz's cast of figures during the 1960s included perverse characters like the one in *Geschlecht mit Klössen* (*Sex with Dumplings*, 1963, private collection), a hermaphrodite in *Mann im Mund-Franz Pforr* (*Man in the Moon–Franz Pforr*, 1965, private collection), and a desperate artist caught in a web, *Der Dichter* (*The Poet*, 1965, private collection). Not unlike Beuys's persona in many Actions, Baselitz's *Hero* in the painting series of that name (1965–66) possesses a kind of grand, if disheveled, optimism.

Polke's and Richter's responses to making a new form of beauty in the early 1960s occurred mainly in the area of subject matter: banality reigned in opposition to traditional forms of grandeur (pls. 95–96). Polke depicted cheap objects sought by the lower and middle classes, to indicate what the West German consumer society had wrought, and what the East Germans no doubt yearned for. "My repertoire can't be banal enough... no modern art of sacred iconography," he declared.[222] By making use of department-store-bought fabrics as a support for some of his paintings, Polke made his own inroad into new materials for art, and achieved poetic effects based on the cheap products of his country.

Richter related his sense of beauty to Beuys when he said that his gray monochrome paintings possess:

> *A sensual sensitive presence. But also a certain beauty. That is also what Beuys*
> *has. When everybody accused him—in former times perhaps more often than*

today—of creating disgusting fat and felt scribbles, nowadays you realize... when
you surround yourself with the work: it's beauty!... the beauty of truth.[223]

Hence Richter's concern with "the wounding of beauty"[224] shows the degree to
which beauty was a very precious commodity in need of resuscitation, as if in so
doing, life would also be healed.

 Beuys's constant reiteration of the need to examine the "wound" when
few people even wanted to mention what the subject inferred, let alone have
a dialogue on its nature, gave him an unusual position. Like the playwright Rolf
Hochhuth, who said that "authors must articulate the bad conscience of their
nation because politicians have such a good one,"[225] Beuys willingly grappled with
Germany's past and its present while his audience still suffered amnesia. Thus
Beuys stressed his nationality rather than some broadly conceived European
identity, and in so doing only deepened his confrontational tone. Was he by impli-
cation a Nazi sympathizer just by virtue of remaining rooted to his own past; was
that act of commitment reason to speak of an unseemly if not altogether horrific
patriotism? During the 1960s, even studies of Hitler were considered suspect,
with examination of the past being condemned as a subtle form of glorification.[226]
Instead of projecting the outlook of an international modernist, a formalist, in
effect, Beuys's position meant that his art would always remain part of a national
dialogue, however dynamic and rich that dialogue might be. That the Nazi period
was similarly uncosmopolitan—cosmopolitan thinking having been synonymous
with Jews—made Beuys's aesthetic position susceptible to raised eyebrows.
And when his work attracted a cultlike following, Beuys's image became doubly
disturbing. Nevertheless, by suggesting a personal as well as a collective examina-
tion, Beuys made his viewers confront their identity.

 The Nazi era that so underlies Beuys's work puts to shame whatever
glory could be surmised about earlier periods in German history, since those eras
laid the groundwork for the eventual disintegration of the country. For this reason,
sentimentality towards Germany's past was a tricky and slippery pursuit[227]—
witness Jörg Immendorff's *Cafe Deutschland* series, which drips with uncomfortable
nostalgia. The distant past has a parallel only in Beuys's early, unadorned depictions
of nature in its purest state. But with Beuys suggesting that some of the worthy,
old values were still ostensibly held in the East, even if artists including Baselitz,
Polke, and Richter had just escaped that region, further confusion reigned.
What did it mean to be German? Was it desirable to claim allegiance to the values
of the East or the West,[228] or was one condemned to dwell always in a conflicted
emotional state? At any rate, one was condemned to being German forever,
notwithstanding Kiefer's emigration to France and his declaration of having
become a French artist, as he recounted to the author.[229] Craig describes an era of
"pervasive cultural pessimism,"[230] in which fear about Western Capitalism's rapid
advance led to unrealistic sentimentality for Eastern ways. For those with this
affliction, he explains, the "guardians of the values that could make Germany great
and powerful again were to be found in the fields and the villages."[231] Beuys
exhibited the same attitude constantly, not only by referring to rural myths but
also through his political discussions; Baselitz repeatedly depicted peasant heroes;
Kiefer epitomized this dream, too, with his views of the March Sand and the
nostalgic journey of Theodor Fontane; on occasion, it could attract Polke, as well,
as in his peasant subjects. With this subject matter, the ideals of soulful, old
Germany still existed, albeit in the East.

 The year 1961 can be established as a key moment for Beuys for several
reasons: he was appointed that year to the Kunstakademie Düsseldorf, and that
was the date when Germany became a divided land yet again. The profoundly felt

desire for reunification exaggerated the prevailing political and social divisions in the country. With the Berlin Wall in place in 1961, Germans felt more compelled than ever to consider not only their recent, unsavory past, but also in doing so, to cast blame. The onset of this new German bifurcation led to the much-debated issue of who was or was not the inheritor of the recent German past, that is, who was, indeed, guilty for the suffering caused by the Nazis.[232] Of course, on each side of the Berlin Wall, these discussions were grounded on different and opposing interpretations of history. Hence, the Berlin Wall, for Beuys, was a stark restatement of and metaphor for the "wound" affecting his country.

Reference to the two Germanies likely is embedded in Beuys's usage of the double. It is also implied in Baselitz's *Man in the Moon-Franz Pforr* (1966–67, private collection) and his fracture series, with its figures divided, as if in their loyalties and psyches toward East and West. Decisively split, and out-of-sorts, Baselitz's figures are in a seemingly permanent state of melancholy and ennui. For Kiefer, too: "Ambivalence is the central theme of my work. There is no place so ambivalent as Germany."[233] The situation of the two Germanies implies a lack of security and a conviction normally found in monolithic structures; in effect, faith in a single truth is lost. Revisionism of all kinds becomes possible. This Zeitgeist perhaps makes Germany the perfect crucible for the postmodern condition, which values and doubts everything equally. Disillusionment coexists with nostalgia, whereupon pessimism is unleashed, as when Richter bitterly says of his times: "Consolations are sold: all shades of superstition, puffed-up ideologies, the stupidest lies."[234]

Just the possibility of a clearly and unequivocally stated German subject is an instant reminder of what it means to be German, how one deals with the burden (read "wound") of history, and how one distinguishes, embraces and/or rejects aspects of the country's past and its present. Beuys, Baselitz, Kiefer, Polke, and Richter all refer to these issues in various ways, and when they do not, it seems but a temporary departure. Theirs is a mentality steeped in a cold-war zone of conflict—recall Walter Benjamin's "angel of history facing backward into the past but blown forward into the future by the wind of progress, watching the debris accumulate as he was driven away from it."[235] An art based on being German is an art necessarily replete with memories, veils of reality, and uncertainty about all current events. A phantasmagoria perfectly embodies the state of being German during the period of the Berlin Wall: Multiple realities fit the real situation of there being two authentic Germanies.

Such an art inevitably reflects the profound love-hate relationship of the artist toward his/her country. Though written more than a century earlier, in 1844, Heinrich Heine's piece "Germany—A Winter's Tale," with a formerly Jewish protagonist disclosing an unsightly love of an at-times despicable country, could be a model:

> *I think it's love of country they call*
> *this foolish, foolish longing*
> *I'd rather not speak of it; I think*
> *it's really a sickness.*
> *I'd much prefer to hide my wound.*[236]

Heine's discomfort with patriotism—for him, his "wound"—is shown side-by-side in "Germany—A Winter's Tale" with an admiration for his country's values and dreams, and with a looming sense of a terrible future. That Heine was, notwithstanding his conversion, persecuted by anti-Semites did not cause him to recoil from the "deep passion for Germany [that] remains in my heart. It is incurable."[237] Heine's self-pity and melancholy, along with his ambivalence, could

serve as just one model for an endemic condition after World War II. It was no accident that among the placards held up by students at the time of Beuys's dismissal and expulsion from the Kunstakademie Düsseldorf was one that read: "Beuys—another Heine."[238]

A country that no longer exists in its original state makes for a compelling historical situation in which artists might work. As Baselitz says, "Germans, in general, and I in particular, need to have a reason for everything we do."[239] Richter indicated that a bond existed between these artists, when he said in 1962:

> Every word, every line, every thought is prompted by the age we live in, with all its circumstances, its ties, its efforts, its past and present. It is impossible to act or think independently and arbitrarily. This is comforting, in a way. To the individual, the collective experience of the age represents a bond—and, also, in a sense, security; there will always be possibilities even in disaster.[240]

And Polke says, "A German can only paint Germany, everything else is treason!"[241]

Having this sense of an inescapable lineage and an interconnectedness, German artists make frequent reference to their forebears; for instance, Baselitz recalls the paintings of feet by Adolf Menzel in his own series on that subject in 1963, as well as the nineteenth-century Nazarene painter Franz Pforr, in *Man in the Moon–Franz Pforr*. Beuys, Polke, and Kiefer recall Dürer: Beuys, with *Dürer, I Personally Conduct Baader + Meinhof Through Documenta V*; Polke, with *Dürer Hare* (1968); Kiefer, with Dürer's engraving title and the tetrahedron motif in *Melancholia* (1989, private collection); and Kiefer also echoes Caspar David Friedrich in the last page of his Occupation series of photographs about Nazis from 1969 (private collection).

Baselitz described the title *The Big Night Down the Drain* (pl. 109) as referring to a German saying "It's all in the bucket," meaning "It's all in a mess, down the chute."[242] Wounded and standing amidst ruins, Baselitz's rural heroes of the 1960s point to the state of postwar Germany. On the other hand, the figures in Richter's *Party*, with its title in English (1962, Burda Collection, Baden-Baden, Germany), are dramatically part of the contemporary Western world, but are utterly and despicably superficial. Their abnormally cheerful depiction[243] is literally undercut by the Lucio Fontana-like red slashes that create wounds, as it were, which Richter has stitched back together.[244] While ostensibly part of the contemporary world, Richter's deer and cows of 1963–64 may function as Beuys's hare had—a pathetic recollection of nature in a Germany better characterized by the Autobahn, with roaring sports cars such as Richter had also depicted in 1964. Beuys's nostalgic animal iconography, in particular *Hare with Sun* (1982, pl. 103), may be seen not just as a reliquary for the animal but for a country that valued it so much. Equally nostalgic, and seemingly based on a kitsch postcard, Richter's rendering of *Schloss Neuschwanstein* (*Neuschwanstein Castle*, 1963, Sammlung Frieder Burda, Baden-Baden, Germany) has the deadpan air of a Jasper Johns recording of the American flag. When Polke painted a series of herons as if they were lawn ornaments, in 1969, it was perhaps a bitter joke about contemporary life along with a comment on Beuys's swans and hares. Richter's family scenes of 1964–65 (pl. 110), like Polke's banal portraits of the same period, suggest a contemporary land of hollow values. Polke's specific references to his homeland are more infrequent or elliptical in this period, as for example, *Berliner* (*Doughnuts*, 1965, private collection), a sardonic characterization of the happy pastry chef who hardly suffers with the wall, or John F. Kennedy's language confusion between a citizen of Berlin and a jelly doughnut.

It has been suggested that there was a slight "ebbing of conventional

Plate 110.
Gerhard Richter
Family, 1964–65
Oil on canvas
59 ⅛ x 70 ⅞ inches
(150 x 180 cm)
Private collection

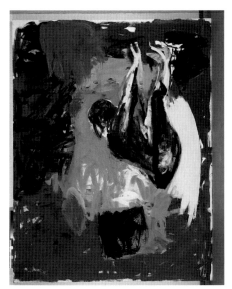

Plate 111.
Georg Baselitz
The Gleaner, 1978
Oil and tempera on canvas
129 ⅞ x 98 ⅜ inches
(329.9 x 250 cm)
Solomon R. Guggenheim Museum,
New York, Purchased with
funds contributed by Robert and
Meryl Meltzer. 87.3508.

national identification" during the 1970s,[245] but that situation was undone in the 1980s. Then, with the many commemorations of World War II-era events, including Hitler's coming to power, the anniversary of the plot to assassinate him, the 1945 surrender, together with the Bitburg Cemetery controversy, the past again was clearly in focus.[246] But during the late 1960s and early 1970s, the artists did not lose their focus; moreover, there seems to have been a convergence of interests: for instance, Beuys's rabbits, stags, and swans; Polke's herons; Richter's eagles; and Baselitz's eagles and cows together formed an animal iconography of Germany. Likewise, Baselitz's upside-down figures (pl. 111), which gain momentum at this time, could be linked to Beuys's *Felt Suit* (1970, pl. 31), both images being statements about Germany's identity character. Although an ambivalent toughness toward what went before could be said to characterize some of Richter's and Kiefer's images of historical figures, there is, as well, a sentiment of longing for when things were right in Germany. Baselitz wistfully describes how Germany's problems concern "a tradition that cannot be continued."[247]

Baselitz reported that Beuys did not think much of him, that Beuys "was of a different generation, the people who had fought the war. I am of the generation that fled the war and continues to run away."[248] It is perhaps for this reason that Beuys never exhibited the same cynicism or irony as the others do in coming to terms with German history, nor their willingness to parody the past and Germans' sensitivity to it. He is more likely to express the sentiment of melancholy; his entire oeuvre is permeated by this tone, after all, it was his generation that witnessed suffering, sacrificed the values that had held the country together, and was the perpetrator of the Holocaust. However, in Beuys's works, outward mourning is primarily reserved for animals: these having, along with an inherent degree of innocence, significant symbolic import in German mythology. Hence, animals may be said to evoke the German nation itself. On the other hand, mourning for the victims of the Nazis, which is certainly rare in Germany and in Beuys's work, did appear in his proposed Monument for Auschwitz. Lying forms abound in his art, too, but these ghosts of lost souls are unidentified.

The generation after Beuys knew only the privations of the postwar period and the explanations of their parents, the reactions from the rest of the world toward them as Germans, and the images that were photographed during the war. In that regard, Polke's *Fluchtlingslager* (*Refugee Camp*, 1994, pl. 112) and *Watchtower* series (1984–88) seem to be based on the stereotypical image of a prison or concentration camp, although the paintings also recall rickety staircases overlooking the Berlin Wall. With these works, he recollects a dark, frightening period, if not a mood of mourning. Richter, too, has an interest in the photographs of death camps and their victims, juxtaposing these with pornographic snapshots in his pictorial *Atlas* (1962–67, private collection). Richter says that the combination of images indicates the idea that both are a form of voyeurism.[249] Similarly, Polke feels that the photograph used as a source for *Refugee Camp* is simply a "reproduction… I used… the assumed objectivity of a photograph to reproduce tragedy." He continues by saying that, although "You feel it as guilt," the picture is about a "hearsay" situation. He concludes enigmatically: "In how many pictures can you tell how hard the brush was used, the pressure on it?—'Beating your head against a wall.'"[250]

Similarly elliptical are Richter's *Candle* paintings (pl. 113), which may be thought of as memorials. In general, Richter's work has many references to death, including his October paintings (pl. 114), as well as an oblique reference in the townscape *Paris* (1968, pl. 115).[251] About this, he said: "When I look back on the townscapes now, they do seem to me to recall certain

Plate 113.
Gerhard Richter
Two Candles, 1982
Oil on canvas
55 ⅛ x 55 ⅛ inches
(140 x 140 cm)
Private collection

Plate 114.
Gerhard Richter
Dead (Tote) from the series entitled
18. October 1977, 1988.
Oil on canvas
13 ¾ x 15 ½ inches (35 x 39 cm)
The Museum of Modern Art, New York,
The Sidney and Harriet Janis Collection,
gift of Philip Johnson, and acquired through
the Lillie P. Bliss Bequest (all by exchange);
Enid A. Haupt Fund; Nina and Gordon
Bunshaft Bequest Fund; and gift of Emily
Rauh Pulitzer. 169.1995.k

images of the destruction of Dresden during the war."[252]

Kiefer's mourning is expressed for many groups, starting with the *Margarethe (Margarete)* and *Sulamith (Shulamite)* personages from Paul Celan's poem "Death Fuge" (pls. 116, 117). The former represents German womanhood, while the latter refers to Jewish womanhood. Like Polke in the *Watchtower* series, Kiefer makes use of a hallmark image of Nazi times, a railway track, starting with *Eisen–Steig (Iron Way,* 1986, pl. 118); Beuys's tram tracks in *Tram Stop* were a precedent here. Kiefer extends his mourning sentiment to include artists, theoretically "degenerate" ones who were persecuted by the Nazis, and to *Die Frauen der Revolution (Women of the French Revolution,*1986). Pretending to follow the Byzantine prohibition against figural images of gods or Christ, known as the time of the Iconoclastic Controversy,[253] Kiefer often recalls the deceased through objects, words, or strands of hair, rather than with explicit depictions.

When, in 1961, Baselitz spoke of being "sodden with memories," it was "the many killings," in particular, that weighed on him.[254] But, a year later, he extricated himself from mourning specific individuals: "Mourn the loss—no mourning for the lost."[255] His liberation, as it were, typifies the self-pity that is sometimes present in Germans' approach to the theme of mourning. For them, this theme is chiefly devoted to themselves and the lost state of Germany, both of which were spelled out initially and quite extensively by Beuys with his focus on the "wound." Kiefer repeats this sentiment in his many fatalistic "prayers" entitled *Wege der Weltweisheit-die Hermanns-Schlacht (The Paths of the Wisdom of the World: Herman's Battle,* pl. 119), starting in 1976, an ambivalent image if ever there was one, but an image that suggests at least, in part, the burned ruin of a German golden age.

Equating the suffering of both the Jews and the Germans is one of the uncomfortable aspects of the postwar era—witness a law that was passed in Germany making it a "criminal offense to deny or speak lightly of the Holocaust *or* of the expulsion of Germans from the East in 1944–45, a law, in other words, that equates the suffering of the Germans with that of the Jews, and thereby seeks to wipe the historical ledger clean."[256] In *Stranded Objects: Mourning, Memory, and Film in Postwar Germany,* Eric Santner distinguishes between Germans' sense of melancholy and their feeling of mourning, the former being far more pervasive. Santner describes this as occurring when the object (read Germany) that is lost "was loved not as separate and distinct from oneself, but rather as a mirror of one's own sense of self and power." He continues on to say that the Germans' mood is, therefore, narcissistic, and never develops into the more healthy state of mourning.[257] In order to rationalize their guilt and to avoid mourning their victims, he says, Germans often claimed to be victims, hence their sympathy is reserved for themselves.[258]

Land is another object mourned, specifically nature that has been inalienably spoiled by the events of history. Hope for the future is severely hampered when the land is so saturated with past events, therefore, one might regard Beuys's involvement in environmental activities, including helping to start the Green Party and the planting of the *7000 Oaks* at Documenta, in 1982. Given his German locale, Beuys's ecological activities concerned, as well, what he called "Field Character," which was to be found on or beneath the surface of the land, that is, the energies from the historical past. The "wounded" condition of the land became a major leitmotif of Kiefer's work, where no landscape is ever presented simply as a beautiful site in nature. Rather, each exudes its historical content, and each place name rings out with those memories. Baselitz reiterated this theme when he said that he was "born into a destroyed landscape."[259]

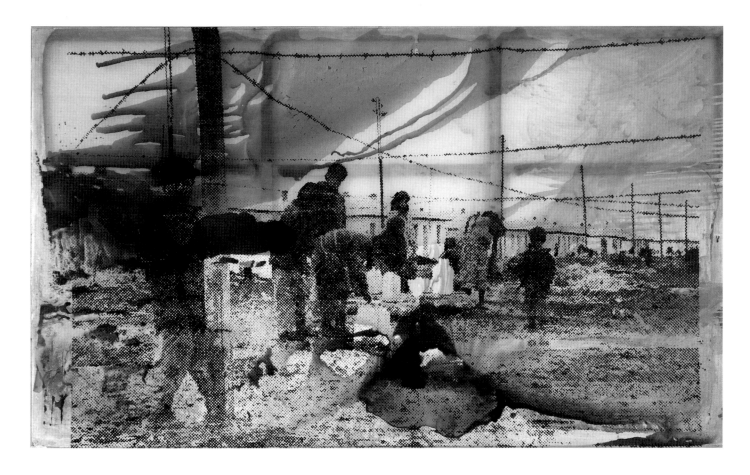

Plate 112.
Sigmar Polke
Refugee Camp, 1994
Synthetic resin and lacquer on polyester fabric
118 x 196 7/8 inches (300 x 500 cm)
Keith and Katherine Sachs

Plate 115.
Gerhard Richter
Stadtbild Paris, 1968
Oil on canvas
78 ¾ x 78 ¾ inches
(200 x 200 cm)
Froehlich Foundation,
Stuttgart

Plate 116.
Anselm Kiefer
Margarete, 1981
Oil, emulsion and straw
on canvas
110 x 149 ⅝ (280 x 380 cm)
Private collection, San Francisco

Plate 117.
Anselm Kiefer
Sulamith, 1983
Oil, acrylic emulsion, shellac,
and straw on canvas, with
woodcut
114 ¼ x 145 ¾ inches
(290 x 370 cm)
Private collection, San Francisco

Plate 118.
Anselm Kiefer
Iron Path, 1986
Oil, acrylic, and emulsion on canvas, with olive
branches, iron, and lead
86 ⅝ x 149 ⅝ inches (220 x 380 cm)
Collection of Mr. and Mrs. David Pincus,
Wynnewood, Pennsylvania

Plate 119.
Anselm Kiefer
*The Paths of the Wisdom of the World:
Herman's Battle*, 1980
Woodcut with additions in acrylic
and shellac on ivory wove paper
135 ¾ x 208 inches
(344.8 x 528.3 cm)

Art Institute of Chicago. Wirt D.
Walker Fund and Restricted Gift
from Mr. and Mrs. Noel Rothman,
Mr. and Mrs. Douglas Cohen, Mr.
and Mrs. Thomas Dittmer, Mr. and
Mrs. Lewis Manilow, Mr. and Mrs.
Joseph Shapiro, and Mr. and Mrs.
Ralph Goldenberg

Plate 120.
Gerhard Richter
Meadowland, 1985
Oil on canvas 35 ⅝ x 37 ½ inches
(90 x 95 cm)
The Museum of Modern Art, New York.
Blanchette Rockefeller,
Betsy Babcock, and Mrs. Elizabeth Bliss
Parkinson Funds

Surely, Richter has the most fascinating response to that "destroyed land-scape." From his first landscapes of the mid-1960s to the early 1970s, his paintings seem to represent an idealization of the land, unaffected by events from history (pl. 120). Compared to Kiefer's forests, echoing with German voices, Richter's are composed simply of plant life, water, and/or clouds. Some of his idylls are in the tradition of, for example, a Lucas Cranach Garden of Eden, in which all is right with the world; others have the quality of a Caspar David Friedrich storm-tossed scene. At other times, these pictures have an artificial too-good-to-be-true quality. Is Richter's landscape painting an act of parody or is he accommodating an audience too naive to know better about the history of his land? Recall that the Nazis loved sweet nineteenth-century landscapes, too. Asked in 1964 why he painted such landscapes, he said: "I felt like painting something beautiful,"[260] a sentiment suggesting that he still believed in nature in its pure state. But, in 1981, he put the issue in a different light: "The landscapes... show my yearning... these pictures are motivated by the dream of classical order and a pristine world— by nostalgia, in other words—the anachronism in them takes on a subversive and contemporary quality."[261] Later, he added that nature is "stupid," its beauties projected by the viewer. By glorifying nature, Richter says he is being "untruthful," that the seductive appeal originates from the kitschy quality of nature itself.[262] Richter is playing a game with his audience, leading them on by using their escapist desire for beauty, which he considers only a projection. Not only ironical, however, Richter is like a grieving child holding a doll, speaking to his own as well as his audience's desperate desire to still have the land. But it is gone and available only in images that can be mourned. His painting is simply another religious "consolation," to use his word.[263]

In *Stranded Objects*, Eric Santner wrote of the matrix of idyllic themes that made "Heimat" such a great success on German television in 1984.[264] This program, by Edgar Reitz, was made in response to an American program entitled "Holocaust," of 1979, and was intended to show Germans that their country, unlike America, was a land with deep and admirable roots. The idyll represents the temporary denial of the ravages of time and history, and expresses mourning for a better world that was lost.[265] In the context of "Heimat" and its central metaphor, Richter's landscapes may be understood as a sentimental trope, not a simple statement about nature. Much like his family portraits of the 1960s and his series on mother and child of the 1990s, the landscape idylls are imaginary and hopeful constructs of a time that was free of the disjunctions of life.

In *Dialogic Imagination*, Mikhail Bahktin describes a traditional epic about "the national historical past: it is a world of 'beginnings' and 'peak times' in the national history, a world of fathers and of founders of 'families'....The epic is a poem about the [inaccessible] past" from "the reverent point of view of a descen-dant."[266] To some extent, this description accords with the epic outlook of Beuys, who with Baselitz, Kiefer, Polke, and Richter, in the postwar period, constructed a national epic tale, telling of their country's past and present, its dreams and reality. Their description of the German past is seen from a grudgingly obedient and reverently angry point of view. Whether in Actions or room environments, Beuys set an example in terms of his theatrical aspiration. And, with his historically mandated subjects and narratives, he led the way in terms of the German context. "Peak times" is the case in Beuys's *Lightning with Stag in Its Glare* (1982/83, pl. 124) and in Kiefer's *Emanation* (1984–86, Walker Art Center, Minneapolis), where momentous changes occur on a large stage set. Last Judgment-type scenes abound, as in *The End of the Twentieth Century* (1983–85), *Kiefer's Die Ordnung des Engel* (*Order of the Angels*,1983–84, The Art Institute of Chicago), and Polke's

$-Bild (*$ Painting*, 1971, private collection). Richter's *48 Portraits* (1972, pl. 98) and Kiefer's *Paths of Wisdom* series (pl. 119) portray the founding "fathers" who established this troubled land.

Another kind of epic, according to Bahktin, is the "Menippean satire," in which epic and humble characteristics come into crude contact. "In this world, utterly familiarized, the subject moves with extreme and fantastic freedom; from heaven to earth, from earth to the nether world, from the present into the past, from the past into the future." In this milieu, "heroes of the absolute past, real-life figures from various eras of the historic past... and living contemporaries jostle one another... [in a] confrontation of times."[267] That air of parodic satire is also part of the Germans' approach to the epic, no doubt because of their ambivalence about being reverent toward a past that produced the Nazi era. When Beuys assumes poses from the life of Christ, fills a half-cross with bicycle pumps, and makes a cross with a sausage, he evoked that sense of the "Menippean satire." When Jason is presented as a washbasin by Beuys, or Kyffhäuser is depicted in a desolate basement by Kiefer, the artists are confronting the past with the present in a mock-heroic exercise. If Kiefer plays at being a Nazi or at Gilgamesh, he is both serious about the subject and desirous of mimicking for the purpose of parodying it. Baselitz's "heroes" are obviously bedraggled types as compared to most German, let alone Nazi, versions of a hero; the title speaks both to aspiration and irony. According to Bahktin, when a hero is chosen from "a foreign and barbaric past... one's own monolithic and closed world has been replaced by the great world of one's own." This is an "alien heroism,"[268] just the kind with which Baselitz wished to shock his German viewers, and which Polke proposed when he grouped Turkish drug-takers in a composition recalling a Last Supper. "In Menippean satire the unfettered and fantastic plots and situations all serve one goal—to put to the test and to expose ideas and ideologies."[269] It is in this regard that attempts to call Beuys, Kiefer, or Baselitz neo-Nazi are completely misguided, if not distorted: Their biases and points of view are not stated simply by the choice of a subject. Regardless of how epic in scale or depiction a theme is, nevertheless, more often than not, the artists are either interrogating, ridiculing, exaggerating, or parodying it. They are, in effect, conversing with the subject. Though Bahktin suggests that the classical epic is part of an unchanging world, as compared to the transitory present,[270] these artists seek to overturn that classical epic by their stress on alchemical possibilities and by their revisionist views.

Bahktin further describes the epic as "concrete and saturated with a time that is... substantial: space is filled with real, living meaning, and forms a crucial relationship with the hero and his fate." In such spaces, the "hero experiences events that are *exclusively extraordinary*."[271] Such is the case in Beuys's Actions, with their highly theatrical qualities, and, also, in his room environments, for example, *Terremoto in Palazzo* (1981) or *Lightning with Stag in Its Glare* (1958/85, pl. 124). In the latter, Beuys evoked what Bahktin called the road-type narrative, where important historical events or encounters occur.[272] That world-on-the-road would seem to be the situation also in many of Kiefer's 1974 works, including the March Sand series and Polke's Turkish photographs. Kiefer and Polke, especially, play with issues of time a great deal, mixing present, past, and future at will. Theirs is, in Bahktin's terms, a "miraculous world"[273]—highly subjective, emotional, and lyrical. "There are attempts to lay open the world as a cross-section of pure simultaneity and coexistence [a rejection of the inability to see the whole of time that is implicit in any *historical* interpretation]."[274] Hence, Polke's *Laterna Magica* series (*Magic Lantern* series, 1988–92) allows the real world to coexist, if not intrude, on the fairy tales that are depicted, and Kiefer's photographs

place, squalid environments at the service of historical events.

Polke reported: "I find many amateur photos better than the best Cézannes. It's not at all a matter of painting good pictures, because painting is a moral act."[275] Polke's antic humor and cynicism are predicated on a larger, "moral" position. For him, art is a mission, just as it had been for Beuys: recall, for example, Beuys's statements, "Art alone makes life possible"[276] and "I have come to the conclusion that there is no other possibility to do something for man other than through art."[277] Beuys's messianic glorification of the potential for art, and his expansive belief that every human being is an artist, extend the German romantic roots that ultimately underlie this group of artists. Besides Polke, the others, too, unequivocally echo Beuys, proclaiming their faith in art: witness Kiefer's many painted or sculpted palettes. However sorry in appearance these are, nevertheless, they are shown with wings, having power over the scarred and blackened earth. More explicit than Beuys's pianos, Kiefer's palette speaks to the act of painting. Responding to a question about the impossibility of writing lyric poetry after Auschwitz, Kiefer said: "I believe art has to take responsibility."[278] For him, art has a mission, a commandment to respond to history. Baselitz repeats this sentiment in his own way when he says, "Art can only have meaning for society if it shows a conflict."[279]

Richter's fervor equals Beuys's and the others. In 1962, he wrote: "My concern is never art, but always what art can be used for."[280] If art's mission was ever to be completed, then "We shall no longer need pictures: we shall just be happy....we shall know what eternity is."[281] Recalling Beuys's views about John Dillinger, as well as the trickster analogy, Richter responded in an interview with Polke to the question: "Have you no scruples?" with the response, "I am an artist."[282] This degree of existential freedom results in the willingness to court risks: "Art has to do with life. There must be no scene which is taboo to art, whatever risks this may entail."[283] As self-consumed as Beuys, Richter writes: "Now that there are no priests or philosophers left, artists are the most important people in the world."[284] Repeatedly, Richter, like Beuys, asserts a religious context for art, as when he says, "Art has always been basically about agony, desperation and helplessness. (I am thinking of Crucifixion narratives from the Middle Ages to Grünewald; but also of Renaissance portraits, Mondrian and Rembrandt, Donatello and Pollock.)" These themes "cannot be represented except aesthetically, because their source is the wounding of beauty (Perfection)."[285] This remarkable passage places art on a very high altar, indeed, where beauty, agony, and hope coexist. In a jubilant and romantic statement, Richter exclaims: "Art is the highest form of hope," and furthermore that "Art is… not only existential pleasure but Utopia."[286]

Alchemy was allied to the model of art for the Germans. Beuys's emphasis on transitory materials, which have the potential for metamorphosis or dynamic changeability, became a central concern for many others. In his "alchemical" series, starting in 1982, Polke explored a great range of unlikely materials, including resins, solvents, and lacquers.[287] These materials react to light, warmth, and humidity and are, therefore, in a continuous state of flux. In this state, his work, like Beuys's, could be more than metaphorical: it had a physical presence that reinforced his belief in a world undergoing constant change. As for his use of toxic substances, he said, "Poison has consequences. Art has none… I was looking for brilliance of color, and it happened to be toxic.… There are a lot of things that you can't get anymore because they've found ways to make them harmless, like art, too."[288] This determined sense of purpose echoes Beuys's willingness to take art in new directions. In the German

milieu, art had to exhibit a consequential purpose, or even be dangerous.

In the early 1980s, at the same time that Polke came to his "alchemical" works, Kiefer also carried on the model of Beuys with regard to materials. Having earlier narrated and interpreted events from German history in conventional paintings, Kiefer now gave these subjects a physical presence and reality through his use of straw, flowers, sand, and other unconventional art materials. Each was chosen, as Beuys had done, for its physical properties as well as for its historical implications. Hence, sand was important not only because of its color but because it could extinguish fire, such as the fires that burned in Germany during the war, as well as recall the March Sand landscape of the Brandenburg region of Germany. Kiefer also willingly courted the dangers of using lead for his purposes; like Polke or Beuys, he was undeterred by the toxicity of his material.

Beuys's use of gold, from at least as early as his Action *How To Explain Pictures to a Dead Hare*, signaled a major theme of hope that could occur through the traditions and myths of alchemy. Of course, there was a precedent in the striving after the Rhine gold in Wagner's *Ring of the Niebelungen*, so that the gold metaphor was already deeply ingrained, if multivalent, in Germany. In this Action, Beuys had put gold leaf on his face, suggesting that some kind of transformative power was held by him; also, the gold threads over copper and felt in *Fond VII / 2* imparted to the function of the battery heavenly properties. With the golden colored monochromes dominating *Palazzo Regale* from high above, Beuys gave this substance the obvious celestial connotation. As those monochromes dramatically and explicitly correspond to the black rectangles in *Show Your Wound*, Beuys introduced the magnum opus of alchemy, namely the transformation of earthy black to magical, heavenly gold. This transformation evokes the healing process and the metamorphosis of Germany that Beuys so desperately wanted to effect. But in the siren call of gold lucre, as described by Wagner, is a dangerous and foolish pursuit; the alternative possibility is that striving after gold becomes one more impulse toward empty romantic yearning and hollow ideals.

One wonders that, even amongst the tough-minded postmodern Germans, they seem unable to avoid the spell of gold. Polke and Kiefer were particularly entranced by its possibilities, notably during the early 1980s, when both were also much involved in Holocaust imagery. Could heaven be the dreamt-of conclusion to these hellish scenes? Certainly, the possibility of actively seizing control, as an alchemist might, would have been desirable.[289] Polke had used gold, along with silver, to color his 1970s photographic images of Pakistan and Afghanistan, as if to suggest a heavenly race of people. His gold-encrusted abstractions of the early 1980s, for example, *Goldklumpen* (*Lump of Gold*, 1982, Stedelijk Van Abbemuseum, Eindhoven), continue to undergo change throughout their existence due to the materials that have been used. These "have a life of their own.... They are simply found pictures."[290] Given this description, Polke's materials correspond to Beuys's detritus, but they are chosen for properties that have specific, alchemical associations. Polke's fascination with gold as the material of transformation culminated in his 1986 installation in the German Pavilion of the Venice Biennale entitled *Athanor;* this is the name of the furnace in which change is wrought by alchemists. Not unlike the Rothko Chapel in Houston, in which the viewer is enveloped by a single color harmony, his work, according to Polke, stirs "a longing for the unknown mystery."[291]

The possibility that the yearning for gold is a poignant, but naive, pursuit seems very much the case with Kiefer. On the one hand, he was deeply involved in the alchemy myth, witness the touch of gold over the ground-up terrain in

Jerusalem and above the black earth in *Nigredo* (1984, Philadelphia Museum of Art). (*Nigredo* is the alchemist's term for the blackest of earth, from which such a transformation is possible.) The sleight-of-hand performed in but a moment by the alchemist/artist/magician is applied here to the task of making over the German soil. In another context, a rivulet of gold traces a connection from below the earth through a pyramid to the heavens in *Die goldene Bulle* (*The Golden Bull*, 1995, private collection). But when gold appears above the railroad tracks in *Iron Path* (1986, pl. 118), it seems to be a chimera, altogether an illusory, even a pathetic apparition. In a similar vein, Kiefer refers to Icarus, the mythic figure who made wings of wax in order to fly to heaven, only to have his wings melt in the rays of the sun. Such abject yearning for a heavenly goal reappears with Kiefer's *Winged Palette* series starting 1985 (pl. 107); these lead palettes are too weighty and dilapidated, and would certainly plummet to the earth, as Icarus did. With this series, art's potential is as questionable as alchemy is for Kiefer.

Although Richter does not employ gold in the same alchemical fashion, his fascination with clouds, in particular from 1969 to 1975, could be said to correspond to a heavenward inclination. From the German tradition of Friedrich and other artists, clouds had served such a purpose, and Richter's have a similarly portentous quality. Aside from whether there is an acknowledged iconography of clouds—witness Polke's *Hoffen heisst Wolken ziehen Wollen* (*Hope Means: Wanting to Pull Clouds*, 1992, National Gallery of Art, Washington, D.C.)—there is a related sense that clouds are the repository of fate, and certainly the goal of a yearning individual.

Many other interchanges occurred between these artists, as if they themselves were consciously, or unconsciously, sharing a matrix of concerns. One artist might take an action only to be followed by a counterproposal by another. For instance, in contrast to Beuys's hotly committed outlook about the East, both Baselitz and Richter rejected political stands, in large part due to their experiences in East Germany, where they found Marxist ideology to be corrupt and utopian proposals to be of no value.[292] On the other hand, Polke, also a former East German, was willing to engage in politically involved work.[293] Though he believed in social evolution, Beuys alluded to the theme of revolution by his title *Dürer, I personally conduct Baader + Meinhof through Documenta V* and lived it through his anarchistic actions at the Kunstakademie Düsseldorf, as well as his aggressive environmental protests.[294] Later, in the mid-1980s, simultaneous with the Red Army faction killings, revolution became a central theme. Kiefer made a series entitled *Women of the French Revolution* (1985-87), followed by Polke's French Revolution series of 1988.[295] The same year as Polke, Richter looked directly at the recent German attempt at revolution, with his series (*18. October 1977*, pl. 114), which explored the Baader-Meinhof debacle. Kiefer and Polke distance the subject of revolution to past events, as if a moral lesson from history, whereas Richter, who evinced little interest in politics, grappled with the most painful of political themes in contemporary Germany. But if Richter's paintings represent a political statement at all, it is about the sad end that comes for deludedly idealistic people, especially if they are violent and live in repressive societies.

In the 1960s, Polke and Richter's often-united approach set an example, a kind of call-and-response series of exchanges between various artists. For example, Baselitz's series of eagles, starting in 1971–72, is echoed by Richter in 1972,[296] and perhaps by Kiefer, too, with his *Winged Palette* series. Following on Richter's cityscape paintings (1968), which might have inspired Polke's *Dublin* of the same year (Nationalgalerie, Berlin), Kiefer made his sweeping views of São Paulo (1987–90, private collection). Similarly, Richter's *48 Portraits* precedes

Kiefer's long series devoted to portraits of Germans, *Paths of Wisdom*. The military jets that Richter painted on several occasions in 1963–64, which may themselves have been inspired by Roy Lichtenstein, reappear as sculptures by Kiefer starting about 1988. Polke's witty bookshelves, *Goethes Werke* (*Goethe's Opus*, 1963, Brandthorst Collection, Cologne) and Polkes *gesammeltewerke* (*Polke's Collected Opus*, 1969, private collection) form a backdrop for Kiefer's Herculean libraries, including *Breaking of the Vessels* (pl. 108). These comparisons are made not so much to delineate influences, though that may certainly be the case on occasion, as to suggest a shared outlook among this group of artists.

One of the most extensively examined themes among these German artists is the relationship between men and women. Beuys had been concerned with a symbolic, if stereotypical, comparison: women as creators, men as "burnt-out" linear thinkers. Both Polke and Richter depict syrupy renderings of couples, for instance, the former's *Liebespaar* (*Lovers*, 1965, private collection) and the latter's *Liebespaar im Wald* (*Lovers in the Forest*, 1966, private collection). Complementing Richter's images are such "pretty" girls as *Helga Matura* (1966, private collection), but this coy work is undercut the following year by his pornographic images, also suggestive of men's gaze. Kiefer's emphasis on the theme of Siegfried and Brünhilde, starting in 1978, delineates a relationship that eventually results in conflict and lost ideals about men, women, and love. Less concerned with such matters, Baselitz usually presented his wife, Elka, in such a way as Cézanne had done with Madame Cézanne.

The sharing of certain interests could be said to have extended beyond the painters and sculptors to many filmmakers in the German milieu during the time of the Berlin Wall. The general interest in an epic outlook is shared by Werner Herzog; Beuys's specific interest in an East-West split was repeated by Hans Jürgen Syberberg in the 1972 film "Ludwig," in which American consumerism threatens the utopian dreams of the characters. Recalling Polke and Richter of the 1960s, Ranier Fassbinder's films depict a suffocatingly banal West German atmosphere that holds people in a permanent stranglehold. Fassbinder, like other Germans, was obsessed by the subject of evil and wanted to explore many of its most base occurrences—recall his "Fox and His Friends," in which "friends" treat one another in the most perverse of ways. Of course, German painting and sculpture of the Medieval and Renaissance periods frequently exhibited blood and pain with an almost willful glee, and, in answer to a question about the "nasty" quality in his work, Baselitz responded: "I believe that that 'nastiness' is probably more a handicap that I have and that many German painters share."[297] Fassbinder's infamous play "Der Müll, die Stadt und der Tod" (1985), in which a Jewish landlord is presented as a villain, was an especially provocative moment. There, the filmmaker's "nasty" desire was, it would appear, to make a blasphemous epic, taking the position of the Nazis, as Kiefer had done in his Occupation series (1969, private collection), so as to experience what that identity was like. In this way, he relived a time he did not know first-hand, but for which he, as a German, was fated to be guilty.[298] Seemingly amoral in his action, Fassbinder went well beyond the *épater le bourgeois* to dare his audience to put aside the Capitalist dream for a moment in order to re-experience its past. The powerful sense of history possessed by these artists yielded an intense nihilism and fatalism —"fewer illusions," according to Richter[299]—along with a self-proclaimed and self-conscious tragic streak. Filled with their incredibly well-honed irony regarding virtually all subjects, Germans' profound black humor perceived even common events to be strange. Beneath it all, however, was usually that old German romanticism, and a fondly held dream of "The Art Pill," to reiterate Beuys's term.

Plate 31.
Felt Suit, 1970
See checklist no. 12

When the Berlin Wall was erected in 1961, a defining moment had arrived in Germany, one to which artists responded. What emerged was in effect a "school," not unlike the New York School, in the sense that while the artists could certainly be distinguished in significant stylistic ways, nevertheless, they were shaped by the same forces and possessed a similar outlook toward art and society. With a Cold War theater in place, from 1961 to 1989, the urgency was palpable, and it resulted in a crucible for artistic creativity. The artists stopped emulating their Western counterparts, their fate as Germans being ubiquitous and in need of examination. Because their current lives were so predicated on it, they formed a dialogue with the past, unlike what Americans were experiencing. Having a frontier at their doorsteps, they formulated an avant-garde that was at once antagonistic to Western Capitalist values, even as it was desirous of humanizing the West.

As a group, these artists established a new step away from the post—World War II domination of art by the U.S. However painful for artists, there was no choice; they had to deal with their German identity and feelings in order to make an authentic art form. Once emboldened to do so, they became increasingly free and confident about such an art. Just as the U.S. had been a crucible in the days immediately following the war, Germany became the same in this period, evincing an outlook that, among other things, predicted the postmodernist point of view. Iconic styles were deconstructed, indeed, styles were to be treated with a good deal of irony, as was the subject matter of art. Certainly, American Pop art was an inspiration, but Germans did not share the same country. These German artists were freewheeling in terms of mediums and art issues, while evincing that postmodern uncertainty, humor, and irony that so typifies the new mode of thinking.

Beuys was the spearhead through all this, having already, in the 1950s, begun to establish a postwar German point of view and agenda. To the extent that Beuys may be said to preside over this period, having defined the issues for German art, his influence could be said to resemble that of Duchamp; moreover, his sham/shaman twin identity also recalls that of Duchamp. And like the Frenchman—perhaps more so—Beuys's eloquent work is every bit as important as his persona. The most successful Actions, vitrines, and environments have a visceral presence that overrides whatever political or metaphoric content is intended. Beuys effectively propagated a new form of beauty that installed the malleable in place of the permanent, and an expansive context in place of the modernist, art-for-art's-sake point of view. All his activities were sculpture, and, together, represent a forward outlook for that medium. Art was a field of vast ambition. Using all manner of activities, art, for Beuys, could be the force for change, a means of triggering dialogue about society, maybe even a way to produce redemption for the individual and for German society. It was an inquiring, anti-authoritarian corporeal force to be reckoned with, its beauty having a dignity and presence in world affairs.

While Beuys may have been in advance of his German colleagues in the early 1960s, they fairly quickly reached him in terms of their own eloquence and maturity. Still, it was Beuys, with his retrospective exhibition at the Solomon R. Guggenheim Museum in New York in 1979, who once more created a defining moment. Until then, German art was still rather unknown in the U.S., as was clear by the absence of Baselitz, Beuys, Kiefer, Polke, and Richter in the 1977 exhibition "Europe of the 1970s," organized by the Art Institute of Chicago and seen in several American cities. (Instead, the exhibition concentrated on European conceptualist artists who were related fraternally to the American scene.) But

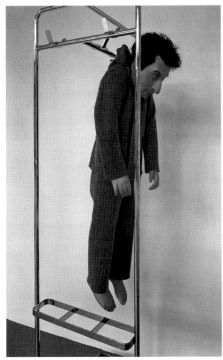

Plate 121.
Maurizio Cattelan
We Are the Revolution, 2000
Polyester resin figure, felt suit and metal
coat rack
Figure: 48 ¾ x 14 x 17 inches
(123.8 x 35.6 x 43.2 cm)
Wardrobe rack:
74 ¾ x 18 ½ x 20 ½ inches
(189.9 x 47 x 52.1 cm)
Solomon R. Guggenheim Museum, New York
Purchased with funds contributed by
the International Director's Committee and
Executive Committee Members: Ann Ames,
Edythe Broad, Henry Buhl, Elaine Terner
Cooper, Dimitris Daskalopoulos, Henry
David, Gail May Engelberg, Linda Fischbach,
Ronnie Heyman, Dakis Joannou, Cindy
Johnson, Barbara Lane, Linda Macklowe, Peter
Norton, Willem Peppler, Denise Rich,
Simonetta Seragnoli, David Teiger, Ginny
Williams and Elliot K. Wolk. 2000.116

after the celebrated 1979 Beuys retrospective, other German artists were quickly taken up with exhibitions and critical articles in the U.S. In other words, it was Beuys, again, who effectively signaled a change, and who successfully put German art on the world stage. The 1980 showings of Baselitz and Kiefer in Venice further cemented the new direction. With this era of acceptance came a degree of confidence, too, which may explain why all of these artists' work from this period on became increasingly accomplished, indeed masterful.

More specifically, Beuys should be seen as a crucial and pivotal figure of modern sculpture: witness the extraordinary breadth of his achievement. To wax extravagant, he advanced the tradition of Giacometti and modern alienation; he challenged Duchamp, the unmatched artist-poseur-provocateur; his groundbreaking use of found objects predicted and invigorated Minimalism; and the astonishing reservoir of photographed images from his performance works are among the most memorable of any known as "Body Art." With vitrines and environments both, Beuys developed the enterprises of personally evocative narrative and epic art. No more German than Warhol was American, Beuys's contributions and influence should be recognized as ubiquitous and far-reaching.

Without Beuys as a lightning rod, what does the future hold for German art? It is hardly coincidental that that question is tied to the state of Germany now, where there is no East to dream about or to serve as a counterpoint to sustain an avant-garde vision. Beuys's mature career neatly encapsulates the Cold War period and helps to define this era for art historians. His belief in the relevance of art vis-à-vis society was already reaching a pinnacle before his death and the end of the Cold War. By the mid-1980s, it could be argued, Beuys's influence was waning, at least in terms of his idealism, and the next generation of German artists was far less entranced by his theoretical goals, with the result that in certain ways Beuys's career became eclipsed.[300]

On the other hand, Beuys's sculptural achievement has continued to play a powerful role in the aesthetic-stylistic sphere, as is obvious in the work of an artist as contemporary as Matthew Barney. Consider, too, *We Are the Revolution* (2000, pl. 121), by Maurizio Cattelan, for there the totemic force of Beuys as a general influence and as a sculptor is encapsulated. The title repeats Beuys's title, thereby establishing a kind of homage. And, Cattelan portrays a felt-suited figure of himself, confined within a Giacometti-inspired cagelike structure. Cattelan's gesture is very canny, suggesting that for him to achieve something as an artist, he will have to leapfrog the body of Beuys (pl. 31), a very tall order.

Notes

1. For instance, Kay Larson, "Joseph Beuys: Shaman, Sham, or One of the Most Brilliant Artists of Our Time?" *ArtNews* (New York), vol. 79 (April 1980), pp. 126–27.

2. See Peter Nisbet, "CRASH COURSE: Remarks on a Beuys Story," in Gene Ray, ed., *Joseph Beuys: Mapping the Legacy* (New York and Sarasota, Florida: D.A.P. and The John and Mable Ringling Museum, 2001), pp. 5–17. See also Frank Giseke and Albert Markart, *Flieger Filz und Vaterland: Eine erweiterte Beuys Biografie* (Berlin: Elefanten Press, 1996), p. 76.

3. Benjamin H. D. Buchloh, "Beuys: The Twilight of the Idol. Preliminary Notes for a Critique," *Artforum* (New York), vol. 18, no. 5 (January 1980), pp. 35–43.

4. Jorge Luis Borges, "Parable of Cervantes and Don Quixote," *Selected Poems,* ed. Alexander Coleman, trans. Kenneth Krabbenhoft (New York: Viking-Penguin, 1999), p. 79.

5. Beuys wrote the *Lebenslauf / Werklauf* for program notes to the "Festival der Neuen Kunst", in Aachen, on July 20, 1964. See Ann Temkin and Bernice Rose, *Thinking Is Form: The Drawings of Joseph Beuys* (Philadelphia and New York: Philadelphia Museum of Art and The Museum of Modern Art, 1993), p. 24, n. 2.

6. Discussed by Donald Kuspit, "Joseph Beuys: Between Showman and Shaman," in David Thistlewood, ed., *Joseph Beuys: Diverging Critiques,* vol. 2, *Tate Gallery Liverpool Critical Forum Series* (Liverpool: Liverpool University Press and Tate Gallery Liverpool, 1995), pp. 28–30.

7. See Caroline Tisdall, *Joseph Beuys* (New York: Solomon R. Guggenheim Museum, 1979), pp. 32, 274, 139.

8. Beuys, "Interview with Willoughby Sharp" (1969), reprinted in Carin Kuoni, ed., *Energy Plan for the Western Man: Joseph Beuys in America* (New York: Four Walls Eight Windows, 1990), p. 92.

9. Beuys in Tisdall, 1979, p. 138.

10. See Beuys, "Interview with Willoughby Sharp" (1969), in Kuoni, ed., 1990, p. 82.

11. In the Action *Celtic* +~~~ (1971).

12. Cited in Dia Art Foundation, New York, *Joseph Beuys* (New York: Dia Art Foundation, 1987), p. 26.

13. Beuys would at one point even take up singing, this in support of Green Party causes.

14. Lewis Hyde, *Trickster Makes This World: Mischief, Myth, and Art* (New York: North Point Press, 1998).

15. *Ibid.,* p. 73.

16. *Ibid.,* p. 177.

17. *Ibid.,* p.179–80.

18. *Ibid.,* p. 66.

19. *Ibid.,* p. 159.

20. *Ibid.,* p. 53.

21. See Pamela Kort, "Beuys: The Profile of a Successor," in *Mapping the Legacy,* 2001, pp. 22–31.

22. *Ibid.,* p. 28.

23. Caroline Tisdall translates "Plastik" as "moulding" in Tisdall, 1979, p. 72; in New York, 1987, p. 26, the term "Plastik" is translated as "to form."

24. Tisdall, 1979, p. 7.

25. *Ibid.*

26. *Ibid.,* p. 44.

27. *Ibid.*

28. Cited in Joseph Beuys, "Talking about One's Own Country: Germany," in *In Memorium: Joseph Beuys, Obituaries, Essays, Speeches,* trans. Timothy Nevill (Bonn: Inter Nationes, 1986), p. 38. The literature on the relationship of Beuys to Klee and Kandinsky includes Mark Rosenthal, *Blitzschlag mit Lichtschein auf Hirsch* (Frankfurt: Museum für Moderne Kunst, 1991); Matthias Burge, *Zwischen Intuition und Ratio: Pole des Bildnerischen Denkens bei Kandinsky, Klee und Beuys* (Stuttgart: Franz Steiner Verlag, 1996); and Tilman Osterwold, *Concept, Paul Klee trifft Beuys* (Osterfildern-Ruit: Hatje Cantz Verlag, 2000).

29. "Joseph Beuys in Conversation with Friedhelm Mennekes," in Memorium, 1986, p. 34.

30. Paul Klee, *The Diaries of Paul Klee, 1898—1918,* trans. Pierce B. Schneider, R. L. Zachary, and Max Knight (Berkeley and Los Angeles: University of California Press, 1968), p. 313.

31. Tisdall, 1979, p. 72.

32. See Gene Ray, "Joseph Beuys and the After-Auschwitz Sublime," in *Mapping the Legacy,* 2001, pp. 62–64, for a discussion of Beuys's use of fat as referring to burnt bodies in crematoriums, and felt as the hair of Holocaust victims.

33. Tisdall, 1979, p. 72.

34. *Ibid.,* p. 9.

35. Quoted in "'Death keeps me awake,' interview with Achille Bonito Oliva" (1986), in Kuoni, ed., 1990, pp. 159–60.

36. Discussed by Paul Schimmel, *OUT OF ACTIONS: Between Performance and the Object, 1949–1979* (Los Angeles: Museum of Contemporary Art, 1998), pp. 18–21.

37. Kim Levin notes that from the Nazi era *Aktion* referred to a round-up and liquidation of "undesirables." Levin, "Joseph Beuys: 'The New Order,' *Arts Magazine,* vol. 8, no. 54 (April 1980), p. 157, n. 11. Ann Temkin in *Thinking Is Form*, 1993, p. 48, points out that the term *Aktion* "has the connotation of a political or military maneuver." Donald Kuspit notes how Beuys's theatrical approach has its roots in his interest in shamanistic performance, stating that both are equally pretentious and are unintended for an aesthetic audience. See Kuspit, in Thistlewood, ed., 1995, pp. 27–49.

38. Cited in Kim Levin, "Some Neglected Bequests: The Inheritance of Beuys," in *Mapping the Legacy,* 2001, p.179.

39. Joseph Beuys, "Auf zur Alternative," translated in Lucrezia de Domizio Durini, *The Felt Hat: Joseph Beuys, A Life Told,* ed. Anthony Shugaar, trans. Howard Rodger MacLean (Milan: Edizioni Charta, 1979), p. 167.

40. Beuys, "Conversation with Friedhelm Mennekes," in *Memorium,* 1986, p. 33.

41. "The hare has a direct relation to birth. For me the hare is the symbol of incarnation. The hare does in reality what man can only do mentally: he digs himself in, he digs a construction. He incarnates himself in the earth." Beuys in Götz Adriani, Winfried Konnertz, and Karin Thomas, *Joseph Beuys: Life and Works,* trans. Patricia Lech (Woodbury, New York: Bassoris, 1979), pp. 38, 132.

42. Tisdall, 1979, p. 12.

43. James Joyce, *Ulysses* (Cambridge: Oxford University Press, 1983), p. 47.

44. Mentioned by Pamela Kort, "Joseph Beuys' Aesthetic 1958–1972," in Thistlewood, ed., 1995, p. 75. In *Hase mit Sonne* (*Hare with Sun,* 1982), the dead hare, prepared with the care of a mortician, has a reliquary status, an icon for a "new altar," as Franz Marc might have stated it.

45. Beuys in Tisdall, 1979, p. 228: "For the Indians, the coyote was one of the most mighty of a whole range of deities. He was an image of transformation, and like the hare and the stag in Eurasian myths, he could change his state from the physical to the spiritual and vice versa at will."

46. *Ibid.,* p. 21: "The figures of the horse, the swan and the hare constantly come and go: figures which pass freely from one level of existence to another, which represent the incarnation of the soul or the earthly form of spiritual beings with access to other regions." Joyce also saw himself as a deer, and a hunted one at that. See Ellmann, 1983, p. 145. Compare *Monogram* (1955–59, Moderna Museet, Stockholm), by Rauschenberg, with its angora goat. For Beuys's identification with shepherds, see Adriani, Konnertz, Thomas, 1979, p. 38.

47. Beuys in Tisdall, 1979, p. 34.

48. *Ibid.,* p. 95.

49. *Ibid.,* 1979, p. 101: "The hare relates more to the lower part of the body, so in particular he has a strong affinity to women, to birth, and to menstruation."

50. *Ibid.,* p. 50.

51. How then to understand the disabused state of *Torso* (1949–50, private collection) Notwithstanding the role of the heroine, certain of Beuys's female figures may be ruined, deceased, or even murdered, much as his beloved animals are often depicted. See *ibid.*

52. Dia Art Foundation, New York, *Joseph Beuys* (New York: Dia Art Foundation, 1987), p. 18.

53. From *Life Course / Work Course,* reprinted in Tisdall, 1979, p. 9.

54. Passage translated from an interview with Germano Celant in Celant, *Beuys tracce in italia* (Naples: Amelio Editore, 1978), p. 235.

55. Beuys in Jörg Schellmann and Bernd Klüser, eds., *Joseph Beuys: Multiples,* trans. Caroline Tisdall (Munich: Verlag Schellman & Klüser, 1977), p. 16.

56. Cited in New York, 1987, p. 16.

57. Beuys, "Interview with Willoughby Sharp" (1969), in Kuoni, ed., 1990, p. 87.

58. "In the simplest terms, I am trying to reaffirm the concept of art and creativity in the face of Marxist doctrine." Beuys, "Interview with Willoughby Sharp" (1969), in *ibid.,* pp. 90–91.

59. See Beuys's description of the Action in Tisdall, 1979, p. 90.

60. *Ibid.,* p. 268.

61. For more on Beuys's participation in Fluxus, see Joan Rothfuss, "Echoes in America," in *Mapping the Legacy,* 2001, pp. 40–46.

62. Beuys in Adriani, Konnertz, Thomas, 1979, p. 78.

63. "The sound of the piano is trapped inside the felt skin. In the normal sense a piano is an instrument used to produce sound. When not in use it is silent, but still has a sound potential. Here, no sound is possible and the piano is condemned to silence." Beuys in Tisdall, 1979, p. 168.

64. *Ibid.*, p. 120.

65. For more on the cross, see Wouter Kotte and Ursula Mildner, *Das Kreuz als Universalzeichen bei Joseph Beuys* (Stuttgart: Verlag Urachhaus, 1986); Friedhelm Mennekes,"Joseph Beuys: MANRESA," trans. Fiona Elliot, in Thistlewood, ed., 1995, pp. 149–64; Ann Temkin notes that the symbol of the cross is also associated with Germany's militaristic past. Temkin in *Thinking Is Form*, 1993, p. 38.

66. Beuys in Adriani, Konnertz, Thomas, 1979, p. 44.

67. A cross is "a symbol for earth . . . the materialistic constellation. The vertical and the horizontal line of the constellation of the cube, and this is exactly the crystallized condition of death." "Joseph Beuys and the Dali Lama: Interview with Louwrien Wijers" (1983), in Kuoni, ed., 1990, p. 252. One might compare Beuys's interest in the cross to another abstractionist, Mondrian.

68. Tisdall, 1979, p. 108.

69. Beuys in *ibid.*

70. *Ibid.*, p. 114.

71. Friedhelm Mennekes, "Joseph Beuys: MANRESA," trans. Fiona Elliot, in Thistlewood, ed., 1995, pp. 149–50.

72. Beuys in Adriani, Konnertz, Thomas, 1979, pp. 153–54. Also discussed by Mennekes, *ibid.*

73. Beuys shared a great deal with Klee, for instance, his invented biography *Life Course / Work Course*, as did Klee with his diaries, which were written in retrospect. Both were pilots during wartime. Klee titled a work KN der Schmied (*KN the Blacksmith*), and Beuys put together the vitrine *FALSE I FALSE II* (1949–84), with an object entitled *K + N* (1949–79). Klee created a system of mythical references as would Beuys. Beuys's *Window* (1963), a box within a box, recalls Klee's *Kettledrummer* (1940). The emphasis on triangles recalls Klee, too, for example, *Untitled* (*Felt Wedge*, 1963), a down-turned triangle echoing Klee's arrows. Klee also made use of the pose of a figure with arms outstretched, for instance in a 1928 drawing entitled *Höehe*, much as Beuys would enact in his Action entitled *und in uns . . . unter uns . . . landunter* (and in us . . . beneath us . . . land under, 1965).

74. See Mennekes in Thistlewood, ed., 1995, pp. 149–64.

75. Discussed in Heiner Stechelhaus, *Joseph Beuys*, trans. David Britt (New York: Abbeville Press, 1991), p. 108; Adriani, Konnertz, Thomas, 1979, pp. 23–25.

76. Beuys in Adriani, Konnertz, Thomas, 1979, pp. 220–21. On the other hand, Beuys noted about the 1966 Action *MANRESA*, "The division of the cross enables a further expansion of the un-Christian message." Adriani, Konnertz, Thomas, 1979, p. 155.

77. Beuys in *ibid.*, p. 270.

78 Caroline Tisdall, "Beuys in America or the Energy Plan for the Western Man," in Kuoni, ed., 1990, p. 10.

79. Mark Rosenthal, "Le dialogue de Joseph Beuys avec la géométrie à l'écart du minimalisme americaine," *Revue de l'Art*, vol. 113 (1996), p. 76. There are many other parallels to Kandinsky, including the fact that Kandinsky discussed the piano as a metaphor for the painter's practice in *Concerning the Spiritual in Art* (New York: George Wittenborn, 1947), pp. 45, 49–50.

80. Beuys in Tisdall, 1979, p. 120.

81. See Kandinsky, 1947, pp. 27–40.

82. There is an instance of a triangular form sitting in a work called *Tafel* (1954) illustrated in Adriani, Konnertz, Thomas, 1979, p. 49.

83. See Beuys's 1969 Lucerne installation in Alain Borer, *The Essential Joseph Beuys* (Cambridge, Massachusetts: MIT Press, 1997), pl. 103. One wonders whether Beuys was thinking about modifying Yves Klein's installation called *The Void*, in effect saying that his own "Void" would include these triangles. For more commentary on the triangle, see Johannes Am Ende et al., *Joseph Beuys und die Fettecke* (Heidelberg: Edition Staeck, 1987).

84. Beuys, "Interview with Willoughby Sharp" (1969), in Kuoni, ed., 1990, p. 91.

85. *Ibid.*, p. 142.

86. Richard Ellman, *James Joyce* (Cambridge: Oxford University Press, 1983).

87. Pamela Kort, "Joseph Beuys' Arena: The Way In," in *Joseph Beuys: Arena—where would I have got if I had been intelligent!* (New York: Dia Art Foundation and D.A.P., 1994), p. 24.

88. For Beuys, the chair represents human anatomy, where sexual and digestive functions occur; drawing from the double-entendre of the German word *Stuhl* which means both furniture as well as human excrement.

89. See *Empire II* (Philip Johnson Collection, New York) and *193466* (Kate Ganz Collection, New York), both of 1961. In the first, Rauschenberg used an old ventilation duct and a roller skate; in the latter, a bucket full of dried cement and number plates. Then, with *THE CHIEF* (1964), the comparison in the use of slatted materials is even more direct, for instance to the American's *Summerstorm* (1959, Ovitz Collection, Los Angeles) or *Trophy IV (For John Cage)* (1961, collection of the artist). Rauschenberg's famous animal imagery is more coincidental with Beuys's interests. But by calling a bathtub *Jason* (1961, Hoffman Collection, Dallas), Beuys recalled such unlikely characterizations by Raushchenberg as the rooster titled *Odalisk* (Museum Ludwig, Cologne) and the fish cages in *Three Traps for Medea* (1959, collection of the artist).

90. Beuys, "Interview with Willoughby Sharp" (1969), in Kuoni, ed., 1990, p. 92.

91. Beuys's blackboards share an uncanny resemblance to Rudolf Steiner's blackboard drawings, made between 1919 and 1924. Using an economical range of imagery, joined with variously poetic or didactic language, Steiner introduced a body of work that must have influenced the latter-day follower of Theosophy. Steiner's blackboards, as would Beuys's later, came about during lectures and were saved by a colleague. Alain Borer notes that the blackboards should be compared to the art of Ad Reinhardt and Kasimir Malevich (Borer, 1997, p. 14). One could also draw parallels to Rauschenberg's and Cy Twombly's work, in which the written word plays so dominant a role.

92. When discussing his conflict with the Kunstakademie Düsseldorf, Beuys never wanted to compromise. Instead, he would say "Time for action." Thus all his activity was in his mind an "Action." See Stachelhaus, 1991, p. 89.

93. In the Action *Kukei / akopee—Nein! / Brown Cross / Fat / Corners / Model Fat Corners* (1964), although Beuys was constantly changing positions, he always kept a vase of roses in his immediate proximity; in *Revolutionary Piano* (1969), he covered an entire piano with dried roses.

94. Beuys never employed a telephone in an Action according to Reiner Speck. See Ann Temkin, "Sender-Receiver: A Conversation with Dr. Reiner Speck," in *Joseph Beuys: Just Hit the Mark* (London: Gagosian Gallery, 2003), pp. 13–14; and its capacity to communicate truths may be questioned (Pamela Kort, "Catalogue Notes Continued," in *ibid.*, p. 103).

95. Beuys, "Die Fragezeichen sind der Titel" (1974), in Adriani, Konnertz, Thomas, 1979, p. 4, translated from German.

96. Joyce, *Ulysses*, p. 51.

97. Schellmann and Klüser, 1977, p. 8.

98. Antithetical, too, is Beuys's world to the National Socialists' favorite sculptural style, which was smooth, polished marble. See Pamela Kort, "Joseph Beuys' Arena: The Way In," in *Arena*, 1994, p. 21. The issue is also discussed in Sigfried Gohr, "Über das Hässliche, das Entartete und den Schmutz," in *Bilderstreit: Widerspruch, Einheit und Fragment in der Kunst seit 1960*. (Cologne: Museum Ludwig in den Rheinhallen der Kölner Messe, 1989), pp. 48–49.

99. Joyce, *Ulysses*, p. 27.

100. *Ibid.*, p. 38.

101. *Ibid.*, p. 45.

102. Beuys in Tisdall, 1979, p. 94.

103. Joyce, *Ulysses*, p. 86.

104. *Ibid.*, p. 126.

105. *Ibid.*, p. 35.

106. By turning fact into fiction and fiction into fact, Beuys and Joyce reordered their lives and universes to fit the purposes of their production of art. Discussed by Pamela Kort, "Joseph Beuys' Aesthetic 1958–1972," in Thistlewood, ed., 1995, p. 74.

107. Beuys recounted that, in his childhood, "I sought to . . . invent experiences I had had." Adriani, Konnertz, Thomas, 1979, p. 12.

108. Joyce, *Ulysses*, p. 191.

109. Though it seems inconceivable that Beuys was unaware of or uninfluenced by Joseph Cornell—see, for example, Beuys's *Untitled* (1951–63, Etzold Collection)–the master of the boxed tableau was not seen in Europe until the mid-1960s.

110. Tisdall, 1979, p. 70.

111. *Ibid.*

112. *PAIN ROOM*, with its walls seemingly resistant to filtration of any kind, should be compared to the felt-saturated *PLIGHT*, in which the walls appear altogether permeable. There the piano, symbol of art, sits as if in a hospital room, protected, and with a thermometer charting its condition. The empty box—like a coffin awaiting its occupant—gives to Beuys's works an uncomfortably ghoulish tone, beyond the weighty condition of emptiness as metaphor of the wounded condition.

113. See *Untitled Vitrine* in Gerhard Theewen, *Joseph Beuys Die Vitrinen* (Cologne: Walter Konig, 1997), p. 40.

114. Beuys, in Adriani, Konnertz, Thomas, 1979, p. 164.

115. Beuys, "Interview with Kate Horsefield" (1980), in Kuoni, ed., 1990, p. 62; see also Beuys' s statement in New York, 1987, p. 10.

116. For example, because Beuys so often placed two Crucifixes within one work, the condition of the double may signify his feelings regarding religion. When that pairing is multiplied by two stopwatches in *3 Hurling Crosses with 2 Toy-Stopwatches* (1951–85), another layer of Beuysian complexity is added.

117. Beuys in Tisdall, 1979, p. 50.

118. *Ibid.*, p. 26.

119. *Ibid.*, p. 28.

120. Rauschenberg made a similar triad in *Coca Cola Plan* (1958, The Museum of Contemporary Art, Los Angeles).

121. Schellmann and Klüser, 1977, p. 13.

122. Hans Meyer, Joseph Beuys, Margarete Mitscherlich-Nileson, and Albert Schönherr, *Reden über das eigene Land. Deutschland 3* (Munich: C. Bertelsmann, 1985), p. 37. English translation by Timothy Nevill in *Memoriam*, 1986, p. 35. One might also note that Klee, describing himself during World War I in his discussion of the crystalline, said: "The heart that beat for this world seems mortally wounded in me Am I turning into the crystalline type?" Klee, *Diaries*, 1968, p. 313.

123. Beuys in Tisdall, 1979, p. 248.

124. *Ibid.*, p. 10.

125. *Ibid.*, p. 9.

126. *Ibid.*

127. Later, in 1980, Beuys installed *Show Your Wound* in the Städtische Galerie im Lenbachhaus in Munich. In his usual fashion, he freely adapted the work from its initial large dimensions to the much smaller room of the museum.

128. Tisdall, 1979, p. 248.

129. The newspapers are two examples of one issue of *Lotta Continua*, an Italian Marxist newspaper; but as Armin Zweite points out, Beuys had no interest or identification with its cause. See Armin Zweite, Joseph Beuys: *Zeige Deine Wunde* (Munich: Schellmann & Klüser, 1980), n.p.

130. Tisdall, 1979, p. 214.

131. Gene Ray's conclusions about Beuys's use of fat should be recalled; see "Auschwitz Sublime," in *Mapping the Legacy*, 2001, pp. 62–63.

132. Contrast Beuys's maudlin thermometer to Duchamp's ironic one in *Why Not Sneeze Rrose Sélavy?* (1921).

133. Pamela Kort, "The Neopolitan Tetralogy: An Interview with Lucio Amelio," in *Arena*, 1994, p. 45.

134. In 1962, Beuys did *Demonstration on the Occasion of the Death Hour of Yves Klein*. Kim Levin describes how Klein came to Krefeld and Düsseldorf in the early 1960s, where he and Beuys collaborated in public dialogues and exhibitions. Levin, "Introduction," in Kuoni, ed., 1990, p. 3. The influence of Klein is graspable in such works as *Australo-Kretischer Altar* (1956, Van der Grinten Collection, Schloss Moyland), one of numerous works with gold and silver from the late 1950s. Beuys might also have known Rauschenberg's early 1950s gold work, which predated and possibly influenced Klein.

135. This work, as well as others of this period, as for example, *Untitled* (1963). See *Thinking Is Form*, 1993, pl. 99. The title *Gengis Khan's Post* can be understood as a somber allusion to the more recent German past. Hitler liked to compare and justify his plans for a "final solution" by evoking the reign of Gengis Khan. See Eckhart Gillen, ed., *Deutschlandbilder: Kunst in einem geteilten Land* (Berlin and Cologne: Martin-Gropius-Bau, and DuMont, 1997), p. 52.

136. Tisdall, 1979, p. 214.

137. Compare *Trans-Siberian Railway* (1961–64) and *Hasengrab* (1964–79).

138. Beuys in Tisdall, 1979, p. 190.

139. Lucio Amelio talks about Beuys's affinity with Segantini in Pamela Kort, "The Neopolitan Tetralogy: An interview with Lucio Amelio," in *Arena*, 1994, p. 35. See also "Nicht blosse Bilder," interview with Dieter Koepplin, in Kunstmuseum, Basel, *Edvard Munch: His Work in Swiss Collections* (Basel: Kunstmuseum, 1985), pp. 139–40.

140. Beuys, in *Memorium*, 1986, p. 37.

141. Adriani, Konnertz, Thomas, 1979, p. 41.

142. Beuys in Stachelhaus, 1991, p. 101.

143. Beuys felt an affinity with Cage. See Beuys, "Interview with Willoughby Sharp" (1969), in Kuoni, ed., 1990, p. 87.

144. Beuys in Dia Art Foundation, 1987, p. 18.

145. Adriani, Konnertz, Thomas, 1979, p. 107.

146. Tisdall, 1979, p. 10.

147. See Kim Levin, "Joseph Beuys: The New Order," *Arts Magazine*, vol. 8, no. 54 (April 1980), pp. 154–57; and Gene Ray, "The Use and Abuse of the Sublime: Joseph Beuys and Art after Auschwitz," Ph.D. diss. (University of Miami, 1997).

148. Kuoni, ed., 1990, p. 79.

149. Tisdall, 1979, pp. 120,168.

150. The subject of death is recurrent in his drawings of the mid- to late 1950s, during the time of Beuys's depression, for example, *Dead Man* (1955) and *Untitled* (1954).

151. Beuys, "Death keeps me awake," interview with Achille Bonito Oliva (1986), in Kuoni, ed., 1990, p. 180.

152. Tisdall, 1979, p. 34, quoted from Caroline Tisdall, *Joseph Beuys Coyote* (Munich: Schirmer & Mosel, 1976).

153. Beuys, "Death keeps me awake," interview with Achille Bonito Oliva (1986), in Kuoni, ed., 1990, p. 176.

154. *Back support for a fine-limbed person (hare–type) of the 20th century A.D.* (1972) might be considered an orthopedic corrective to *Felt Suit*, for Beuys said that it was "a plaster bed for curing deformation." Beuys in Schellmann and Klüser, 1977, p. 20.

155. Armin Zweite discusses whether *The End of the 20th Century* is truly apocalyptic in intention. Notwithstanding its title, the work may represent the end of life as we now perceive it, and direct the viewer to a subsequent evolution. See Zweite's entry on *The End of the Twentieth Century* in Bastian, 1988, p. 308.

156. See Donald Kuspit, "Joseph Beuys: Between Showman and Shaman," in Thistlewod, ed., 1995, pp. 37–41.

157. Rosenthal, 1996, pp. 74–84.

158. Pamela Kort notes that Beuys "appends himself into the tradition of the hagiographic self-portrait," with Dürer at the beginning of this tradition. The fur coat might be read as an allusion to Dürer's *Self-Portrait in Fur Coat*, which was painted in 1500, and with which he established himself as an artist-genius. See Kort, "Joseph Beuys' Arena: The Way In," in *Arena*, 1994, p. 27. On the subject of Beuys and his body, one ought to recall his 1956–57 statement about the impact of his wartime experiences: "I had far too long dragged a body around with me." Adriani, Konnertz, Thomas, 1979, p. 56.

159. For a summary of Beuys in relation to American Minimalism, see Rosenthal, 1996, pp. 74–85.

160. Beuys, "Interview with Willoughby Sharp "(1969), in Kuoni, ed., 1990, p. 85.

161. Kim Levin notes that Beuys's work is unfairly compared to American Pop, Minimalism, and performance art when first seen in the U.S., rather than being seen as an independent development. Levin, "Introduction," in *ibid*.

162. Beuys in Tisdall, 1979, p. 72.

163. Richter, 1995, p. 132.

164. "The New American Painting," organized by The Museum of Modern Art, New York, was shown in connection with the traveling Jackson Pollock retrospective in Berlin at the Hochschule für Bildende Kunste from September 1 to October 1, 1958.

165. Henry Geldzahler, "Georg Baselitz," *Artwords 2: Discourse on the Early '80s*, ed. Jeanne Siegel (Ann Arbor, Michigan, and London: UMI Research Press, 1988), p. 101.

166. Cited in Siegfried Gohr, "Georg Baselitz: Paintings Don't Come with Guarantees," trans. Shaun Whiteside, *Flash Art*, vol. 26, no. 171 (Summer 1993), p. 70.

167. Kynaston McShine, ed., *Berlinart, 1961–87* (New York: The Museum of Modern Art, 1987), p. 39.

168. See Rosenthal, 1996, p. 85.

169. This juxtaposition of the malleable with a hard demeanor had been part of his dualistic approach from much earlier, for example, in the first *FOND* (1957, private collection), he put pears into a jar.

170. Tisdall, 1979, p. 154.

171. Beuys in *ibid*., p. 190.

172. *Ibid*., p. 160.

173. *Ibid*.

174. *Ibid*., p. 235.

175. *Ibid*., p. 228.

176. Donald Kuspit, "Goth to Dance: Donald Kuspit Talks with Georg Baselitz," *Artforum* (New York), vol. 23, no. 10 (Summer 1995), p. 79.

177. Quoted in Gordon A. Craig, *The Germans* (New York: Putnam, 1982), p. 45.

178. In certain ways, the Germans' unglamorous approach could be likened to another renegade from Pop art, Richard Artschwager. He, too, demythologized an inherently national subject matter; also, his use of gray, like Richter's, tended to deaden the themes. But Artschwager seems to have been unknown in Europe until his inclusion in a group show at the Galerie Ricke in Cologne in 1968 and his participation at the Documenta IV in Kassel the same year.

179. Gerhard Richter, *The Daily Practice of Painting: Writings and Interviews* 1962–93, ed. Hans-Ulrich Obrist, trans. David Britt (London: Anthony d'Offay Gallery, 1995), p. 211.

180. Monsignore Otto Mauer, paraphrased in Christopher Phillips, "Arena: The Chaos of the Unnamed," in *Arena*, 1994, p. 58.

181. Barry LeVa also used black felt in *Continuous Related Activities: Discontinued by the Act of Dropping, Series III* (1967, collection of the artist).

182. Larson, 1980, p. 127.

183. See Rosenthal, 1996, p. 85, n. 48.

184. See, for example, Noguchi's *Awakening* and *Mountain Landscape* (both 1981) or *Untitled* (1983).

185. Beuys, "Interview with Willoughby Sharp" (1969), in Kuoni, ed., 1990, p. 88.

186. Barry LeVa may have been in advance of Beuys on this count; for a discussion of Beuys vis-à-vis Serra, see Rosenthal, 1996, p 85, n. 47.

187. Compare, as well, Damien Hirst's vitrine-like medicine chests.

188. See Buzz Spector, "A Profusion of Substances," *Artforum* (New York), vol. 28 (October 1989), pp. 123–25.

189. W. G. Seebald, *On the Natural History of Destruction*, trans. Anthea Bell (New York: Random House, 2003), p. 96.

190. Richter, 1995, p. 124.

191. *Ibid.*,

192. Kiefer, interview by Donald Kuspit (1987), reprinted in Kuspit, "Anselm Kiefer," in *Artwords*, 1988, p. 87.

193. Compare Cornelia Lauf, "Joseph Beuys: The Pedagogue as Persona," Ph.D. diss. (Columbia University, 1992); Städtische Galerie im Lenbachhaus, Munich, *Beuys zu Ehren* (Munich: 1986); Andreas Franzke, "New German Sculpture: The Legacy of Joseph Beuys," *Art and Design*, vols. 9/10 (October 1989), pp. 28–34.

194. See Richter, in *Gerhard Richter* (London: Tate Gallery, 1991), p. 126.

195. Polke in Bice Curiger, "Poison is Effective; Painting is Not: Bice Curiger in Conversation with Sigmar Polke," trans. Catherine Schelbert, *Parkett*, vol. 26 (December 1990), p. 25.

196. Richter, 1995, p. 211.

197. Reprinted in Whitechapel Art Gallery, London, *Georg Baselitz: Paintings, 1960–83* (London: Whitechapel Art Gallery, 1983), p. 38.

198. As with Beuys, the theme of the double was ongoing for Polke, witness his *Two Rocks "Celebrate" a Double Wedding* (1984).

199. Beuys in Tisdall, 1979, p. 228.

200. Kiefer, interview with the author (1986).

201. From the Action *Kukei / Akopee-No! / Brown Cross / Fat Corners / Model Fat Corners* (1964), to *Revolutionary Piano* (1969), to the diagram *We Don't Do It Without the Roses* (1972), to *Rose for a Direct Democracy* (1973).

202. Baselitz, in London, 1983, p. 30.

203. *Ibid.*; Stedelijk Museum, Amsterdam, *Georg Baselitz, Schilderijen / Paintings 1960–83* (Amsterdam: Stedelijk Museum, 1984), p. 30.

204. *Ibid.*

205. Baselitz, in Stedelijk Museum, Amsterdam, *'60 '80 attitudes / concepts / images* (Amsterdam: Van Gennep, 1982), p. 88.

206. Gohr, 1993, p. 69.

207. Cited in Anna Dahlem, "Interview: Joseph Beuys," *The New Age Review*, p. 10.

208. Richter, quoted in Solomon R. Guggenheim Museum, New York, *Reconfigured Painting: The German Image 1960–88* (New York: Solomon R. Guggenheim Museum, 1988), p. 279. Polke mentions the importance of Fluxus, with which Beuys was involved, and Dada in Bice Curiger, "Poison is Effective; Painting is Not: Bice Curiger in Conversation with Sigmar Polke," trans. Catherine Schelbert, *Parkett*, vol. 26 (December 1990), p. 19.

209. *Ibid.*, p. 24.

210. See Baselitz, "An Interview with Georg Baselitz by Jean-Louis Froment and Jean-Marc Poinsot," in Anthony d'Offay Gallery, London, *Georg Baselitz: Sculpture & Early Woodcuts* (London: Anthony d'Offay Gallery, 1988), n.p.

211. *Ibid.*

212. Polke in Curiger, 1990, p. 23.

213. Richter, 1995, p. 35.

214. *Ibid.*, p. 43.

215. *Ibid.*, p. 272.

216. His pursuit in this regard, too, distinguished him from virtually all artists in the U.S., except Rauschenberg.

217. Bahktin spoke of polyglot or polyglossia as a technique that "fully frees consciousness from the tyranny of . . .[one's] own language and its own myth of language." "Only knowledge of a language that possesses another mode of conceiving the world can lead to the appropriate knowledge of one's own language." Mikhail Mikhailovich Bahktin, *The Dialogic Imagination* (Austin: University of Texas Press, 1981), pp. 61–62.

218. Paul Groot, "Sigmar Polke," *Flash Art*, vol. 140 (May/June 1988), p. 67.

219. Pamela Kort, "Joseph Beuys' Aesthetic 1958–1972," in Thistlewood, ed., 1995, pp. 69–70.

220. Beuys, in *Memorium*, 1986, p. 22.

221. Gohr, 1993, p. 69.

222. Paul Groot, "Sigmar Polke," *Flash Art*, no. 140 (May/June 1988), p. 66.

223. Christiane Vielhaber, "Interview with Gerhard Richter," *Das Kunstwerk*, vol. 39 (April 1986), p. 43.

224. Richter, 1995, p. 102.

225. Hochhuth in Gordon A. Craig, *The Germans* (New York: New American Library, 1982), p. 229.

226. Craig, 1982, pp. 64–66.

227. *Ibid.*, p. 63.

228. Charles S. Maier, *The Unmasterable Past: History, Holocaust, and German National Identity* (Cambridge, Massachusetts, and London: Harvard University Press, 1988), p. 116.

229. Conversation with the author, 1995.

230. Craig, 1982, pp. 123–24.

231. *Ibid.*, p. 205.

232. See Maier, 1988, p. 6.

233. Donald Kuspit, "Anselm Kiefer," in *Artwords*, 1988, p. 86.

234. Richter, 1995, p. 172.

235. Quoted in Maier, 1988, p. 159.

236. Heinrich Heine, *Germany—A Winter's Tale*, trans. Herman Salinger (New York: L.B. Fischer, 1844), p. 109.

237. Heine, 1884, p. 139.

238. See Stachelhaus, 1991, p.102.

239. Baselitz, "An Interview with Georg Baselitz by Jean-Louis Froment and Jean-Marc Poinsot," in London, 1988, n.p.

240. Richter, 1995, p. 11.

241. Polke in Curiger, 1990, p. 23.

242. *Ibid.*

243. Richter, 1995, p. 186.

244. Richter, in Staatliche Kunsthalle, Baden-Baden, Germany, *Richter / Polke / Rainer. Sammlung Frieder Burda* (Baden-Baden, Germany: Staatliche Kunsthalle, 1996), pp. 44–45.

245. Maier, 1988, p. 49.

246. *Ibid.*, p. 56.

247. Geldzahler, 1988, p. 94.

248. Kuspit, 1995, p. 126.

249. Baden-Baden, 1996, pp. 44–46. He regarded photos as *pictures*, not depictions (p. 44).

250. Polke, in Curiger, 1990, p. 26.

251. See Richter in Tate Gallery, London, *Gerhard Richter* (London: Tate Gallery, 1991) p. 126, in which he approved of an interpretation of his work as showing an interest in death.

252. See Richter, in London, 1991, p. 126.

253. Mark Rosenthal, *Anselm Kiefer* (Chicago and Philadelphia: Prestel Verlag, 1987), pp. 76–79.

254. Cited in Solomon R. Guggenheim Museum, New York, *Refigured Painting* (New York: Solomon R. Guggenheim Museum, 1989), p. 254.

255. Baselitz, in London, 1983, p. 23.

256. "Reiner Werner Fassbinder's Garbage, the City and Death: Renewed Antagonism in the Complex Relationship Between Jews and Germans in the Federal Republic of Germany," (A round-table discussion with Andrei S. Markovits, Seyla Benhabib, and Moishe Postone.), *New German Critique*, no. 38 (Spring/Summer, 1986), p. 24.

257. Eric L. Santner, *Stranded Objects: Mourning, Memory, and Film in Postwar Germany*. Kuspit, 1995, p. 76.

258. Santner, 1990, p. 6.

259. Kuspit, 1995, p. 76.

260. Richter, 1995, p. 64.

261. *Ibid.*, p. 98.

262. *Ibid.*, pp. 124, 212.

263. *Ibid.*, p. 172.

264. Santner, 1990, p. 65.

265. *Ibid.*, p. 67, 73–74, 79–89.

266. Bahktin, 1981, p. 13.

267. *Ibid.*, p. 26.

268. *Ibid.*, p. 29.

269. *Ibid.*, p. 26.

270. *Ibid.*, pp. 19–20.

271. *Ibid.*, pp. 20–21.

272. *Ibid.*, pp. 243–44.

273. *Ibid.*, p. 155.

274. *Ibid.*, p. 158.

275. Staatliche Museum, Schwerin, *Sigmar Polke Transit* (Schwerin: Staatliche Museum, 1996), p. 21.

276. Beuys, "Interview with Willoughby Sharp" (1969), in Kuoni, ed., 1990, p. 87.

277. Adriani, Konnertz, Thomas, 1979, p. 226.

278. Kuspit, "Anselm Kiefer," in *Artwords*, 1988, p. 86.

279. Kuspit, 1995, p. 79.

280. Richter, 1995, p. 13.

281. *Ibid.*, p. 52.

282. *Ibid.*, p. 27.

283. Gregorio Magnani, "Gerhard Richter," *Flash Art*, no. 146 (May/June 1989), p. 97.

284. Richter, 1995, p. 58.

285. *Ibid.*, p. 102.

286. *Ibid.*, pp. 100, 128.

287. Polke also used silver, silver-bromide, silver-oxide, iodine, silver-nitrate, tellurium, arsenic, nickel, and so forth.

288. Polke in Curiger, 1990, p. 20.

289. Polke related alchemy to Jewish cabalistic religion. See Groot, 1988, p. 70.

290. *Ibid.*, p. 68.

291. *Ibid.*, p. 67.

292. Baselitz, "An Interview with Georg Baselitz by Jean-Lous Froment and Jean-Marc Poinsot," in London, 1988, n.p.; Richter, 1995, pp. 103, 108, 125, 132.

293. For example, *Das Problem Europa, Sargdeckel* (*The Problem Europe, Coffin Cover*, 1981, private collection) and *Amerikanische-Mexicanischi Grenze* (*American Mexican Border*, 1984, Burda Collection, Baden-Baden, Germany).

294. Stachelhaus, 1991, pp. 109–10.

295. See Staatliche Museum, Schwerin, *Sigmar Polke Transit* (Schwerin: Staatliche Museum, 1996), p. 21.

296. Richter painted images of eagles upon Broodthaers's invitation to exchange work. See Richter, 1995, p. 239.

297. Geldzahler, 1988, p. 103.

298. See Santner, 1990, p. 174, n. 23; *New German Critique*, 1986, p. 24.

299. Richter, 1995, p. 253.

300. See Armin Zweite, "Distance and Nearness," in Armin Zweite, *Beuys zu Ehren*, trans. John Ormrod (Munich: Städtische Galerie im Lenbachhaus, 1986), pp. 573–74.

At The End of the Twentieth Century: Installing After the Act

Sean Rainbird

It is now an unavoidable aspect of making Joseph Beuys exhibitions that the question of creating an ensemble of works, even the siting of individual works, introduces a challenge not encountered by exhibitions of many other artists, living or dead.[1] During his lifetime, Beuys treated his exhibitions as flexible propositions, and treated each opportunity to exhibit his work as a dynamic inter-action between artist, object, and space. His exhibitions appeared to possess a fluidity, not simply in the additive nature of their constitutive parts, but also because of the contexts he created anew each time individual works or objects were brought together. Even in extreme examples such as the comprehensive *Beuys Block*, when an entire exhibition was acquired by a collector, Karl Ströher, and reassembled in 1969 by the artist in the collector's local museum in Darmstadt, those same works which had toured several European cities acquired a fresh visual context and set of meaningful relations based upon their new configuration in the Hessisches Landesmuseum.

Many Beuys installations, expansive or modest in scale, can be understood as a form of mise-en-scène. The first occasion on which he assembled a group of objects to form a specific environment was in response to an invitation from Jan Leering, director of the Van Abbemuseum, Eindhoven, in 1971.[2] Leering had designated one modest-scale room in the suite of galleries as a place for environments, and Beuys was one of the earliest artists he commissioned. On later occasions, such as with the massive *7000 Eichen* (*7000 Oaks*) project for Documenta VII in Kassel or *Hirschdenkmäler* (*Stag Monuments*, 1982) at Martin-Gropius-Bau, Berlin, Beuys's installations constitute something akin to a "total work of art." *Stag Monuments* was disassembled after its Berlin showing, with parts becoming elements in, or models for, *Blitzschlag mit Lichtschein auf Hirsch* (*Lightning with Stag in Its Glare*, 1958/85) a work cast in a small edition that Beuys did not live to install in its entirety. *7000 Oaks* was also completed after his death, but the long-term planning of the project and Beuys's constant attention to it at significant intervals during the final years of his life meant that its shape and future trajectory is how he intended it to be.

There are, of course, other works by Beuys that were removed from their original setting and re-sited. Some, such as *Show Your Wound*, were first seen in public spaces, in this case a desolate pedestrian underpass, before the artist readapted them for a specific institutional location. Others, such as *Tram Stop*, which like *Lightning with Stag in Its Glare* also exists in more than one cast, found permanent homes after a first showing in a temporary exhibition (pl. 122). With the Kröller-Müller's *Tram Stop* (pl. 74), borrowed for this exhibition, any differences between the original and subsequent configurations were determined by the artist. Interestingly, Beuys made no attempt to replicate the vertical emphasis he gave the sculpture when he first installed it in the German Pavilion at the 1976 Venice Biennale. When acquired by the Dutch museum Beuys gave instructions to install the constituent parts on the floor, with no relation between them. Beuys declared that he had "cast aside" the work. In one sense abandoned, this left it, nonetheless, with a future potential for regeneration or reconfiguration. This example alone, however, demonstrates the impossibility of second-guessing how an artist so closely associated with the installation and combination of his works might act under new conditions and in different circumstances. With that in mind, curators encountering Beuys's works now need to adopt a more independent stance, one that respects his intentions, so far as they can be

136

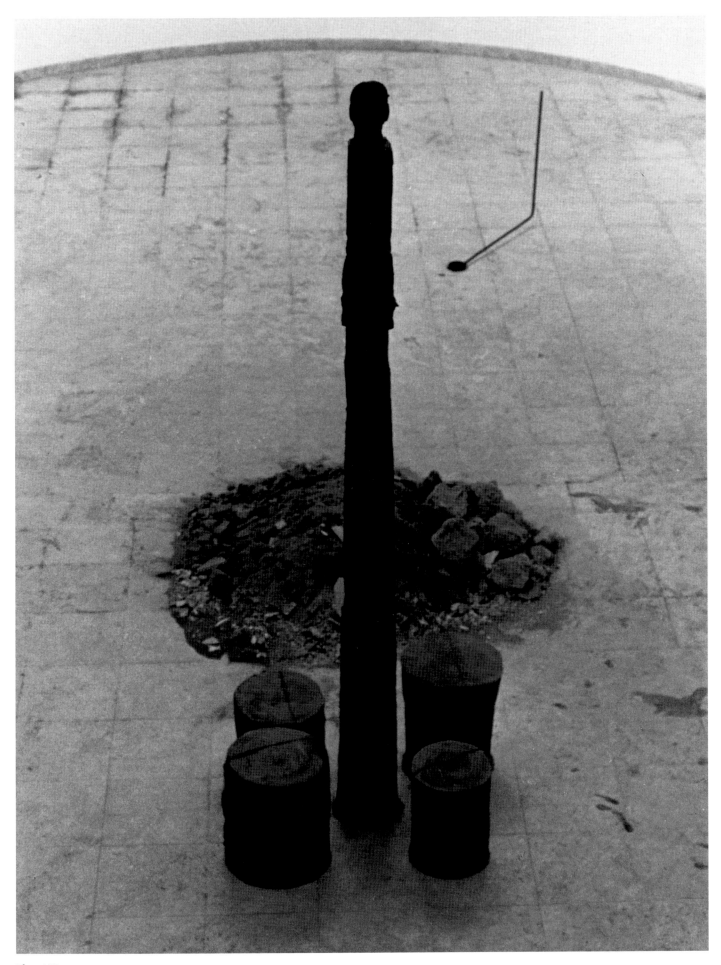

Plate 122.
Tram Stop, 1976
First installation at the Venice Biennale,
German Pavilion
See checklist no. 44

fathomed from documentation and past examples, but one that recognises the need for creative solutions for unanticipated new challenges.

Without the guiding, shaping hand of the artist, curators, of necessity, are now required to adapt Beuys's works to the requirements of spaces, many of which the artist neither exhibited in, nor, in some cases, actually existed when he was still alive. Although several Beuys installations have been left as he installed them, notably *Das Kapital Raum 1970–1977* (*The Capital Room 1970–1977*, 1980/84) in Schaffhausen, Switzerland, *Dernier espace avec introspecteur* in Stuttgart, and the suite of galleries in Darmstadt, other works have found new homes. The absence of precise display parameters set by the artist, about spatial dimensions but also such details as wall colors, wall coverings, lighting, and flooring—all important aspects in innately dramatic environments—require the curator to take a more active role than is customary in successfully reinstalling Beuys's larger installations and environments. *Das Ende des zwanzigsten Jahrhunderts* (*The End of the Twentieth Century*, 1983–85) is a sculptural installation that exists in several versions. It is presented here as a case study for the issues surrounding the display of Beuys after his death in 1986. It is a work he installed several times, with the exception of one version which was never installed directly by the artist himself.

In 1991, five years after the artist's death, the Tate acquired one of three large-scale versions of *The End of the Twentieth Century* by Joseph Beuys (pl. 86). The other two versions, one with forty-four stones, the other with twenty-one stones, are in the collections of the Staatsgemäldesammlungen, Munich, and of Erich Marx (on loan to the Nationalgalerie im Hamburger Bahnhof Museum, für Gegenwart-Berlin), respectively. A fourth version, with only five stones, has recently been acquired by the Kunstsammlung Nordrhein-Westfalen in Düsseldorf, along with other Beuys works from the Ulbricht Collection.[3] *The End of the Twentieth Century*, one of the major sculptures from the last decade of the artist's life, has its origins in Beuys's *7000 Oaks* project for Documenta VII in Kassel, 1982. They share the same raw material and an expansive temporal dimension. Around the time of Documenta VII, Harald Szeemann invited Beuys to participate in an exhibition "Der Hang zum Gesamtkunstwerk" ("Tending Towards The Total Work of Art"). A new sculpture was needed when the show traveled from Zurich to Düsseldorf in early 1983, as *Das Kapital Raum*, the work Beuys had shown in Switzerland, was unable to travel to subsequent venues. To solve this omission, Beuys created *The End of the Twentieth Century*. He made not one, but two versions of the sculpture. One, with twenty-one stones and with technical equipment for moving and installing the stones, was shown in Szeemann's exhibition. A larger version with more than twice the number of basalt blocks, originally intended for Szeemann's show but dropped because of anxiety about floor loadings, was assembled instead in the basement space of the nearby Galerie Schmela. The version now at the Tate was completed two years later, in 1985.[4]

From the outset, the Tate's *The End of the Twentieth Century* experienced less of the artist's direct intervention than the other versions, not least in never having his guiding hand to arrange the stones. However, Beuys was as involved in its making as all the other versions. He gave instructions about what kind of stones should be selected and finalized their overall number.[5] The artist indicated to the stonemasons where to extract the cones of basalt, establishing with them the procedures for drilling and smoothing down the holes. Finally, he repositioned the cones, after they too were smoothed down, back into holes now lined with felt and clay. Beuys was well known for his involvement throughout his life in creating environments for his works. He made many installations that were specific to a time and a place. To consider the history and reality of these

installations beyond the artist's own lifetime, we will need to examine the role of the curator, gallerist, and institution in any later or alternative displays of Beuys's sculpture. In the case of the Tate's *The End of the Twentieth Century* this question gains in importance, as Beuys, while installing other versions of the work himself, sometimes more than once, never installed the Tate's version. From this flows a further question. How influential might or should be those installations made by the artist himself when considering how and where to display the Tate's version?

The fact that this question can be posed signals the unique place of *The End of the Twentieth Century* among Beuys's late installations. By comparison, *Lightning with Stag in Its Glare* (1958/85), which also exists in several versions, in this case different but identical casts in an edition of four, was never installed in its entirety by Beuys. Subsequent installations of the complete ensemble of elements have been based on several sources. Beuys installed the *Blitzschlag* (*Lightning*) element alongside other works by him (unrelated to the finished *Lightning with Stag in Its Glare* sculpture) in the octagonal gallery of the Royal Academy, London (pl. 123), in late 1985 as his contribution to the exhibition "German Art in the Twentieth Century" (October 11–December 22, 1985). There are photographs of other elements of *Lightning with Stag in Its Glare* at the foundry, which appear to have been placed by the artist in relation to one another. A final, perhaps the most critical, hint about a possible interrelationship of some of its individual parts is found in Beuys's *Stag Monuments* part of his *Werkstatt* (*Workshop*) installation at the Martin-Gropius-Bau, Berlin, for the "Zeitgeist" exhibition (October 16, 1982–January 16, 1983). Several sculptures later cast for inclusion in *Lightning with Stag in Its Glare* were integrated into *Stag Monuments*. The *Stag* element, then constructed of a wooden ironing board and split logs of lumber is surrounded by *Lehmling* (*Primordial Animals*). Nearby is the cube of earth surmounted by a compass, upon a sculptor's stand, which became *Boothia Felix* in *Lightning with Stag in Its Glare*. At some distance, on the periphery of that section of *Stag Monuments* is the sculpture Beuys later cast as the *Ziege* (*Goat*) in *Lightning with Stag in Its Glare*.

When the work was acquired by the Museum für Moderne Kunst, Frankfurt am Main in the late 1980s, the first of the edition to be sold, the plan was to create a permanent installation in a uniquely proportioned room at the museum (pl. 124). The installation was led by museum staff but was also attended by Eva Beuys, the artist's widow.[6] They scattered those *Primordial Animals* Beuys had selected for inclusion in *Lightning with Stag in Its Glare* around the *Goat* using photographs of the Berlin installation as a template, even though several *Primordial Animals* in the Berlin installation were not included in *Lightning with Stag in Its Glare*. Although this changed the density and spatial relationships of the *Primordial Animals*, this solution was arguably closer to Beuys's possible intentions than following a more general tendency in *Workshop* and simply scattering the available *Primordial Animals* around the *Stag* in a random fashion. A further connection to the Berlin environment was the positioning of the three larger elements in front of the lightning, an echo of their positions in relation to the mound of earth in *Stag Monuments* from which Beuys cast the lightning. Not all of the *Primordial Animals* and *Workshop* sculptures in Berlin were subsequently cast for inclusion in *Lightning with Stag in Its Glare*. This underlines the tenuousness of using even closely related installations as precise models for each other when their physical forms have evolved in different ways. All installations of *Lightning with Stag in Its Glare* are posthumous and are, therefore, essentially speculative in their organization of individual elements.[7] By comparison with the exhibition history of *Lightning with Stag in Its Glare*, the fact that Beuys installed different versions of

The End of the Twentieth Century on several occasions means that any curatorial invention, necessary as it is in realizing the sculpture in settings other than those Beuys worked in, is at least underpinned by knowledge of how the artist approached the installation at different times and in several locations.

Beuys appears to have stipulated few parameters for the display of the sculpture. His own installations of *The End of the Twentieth Century* do, however, offer guidance for future installers. Moreover, Beuys installed the sculpture in different contexts; on its own and in the vicinity of other works by himself and by other artists. The task is complicated by fluidity in the layout of the work and the informal interrelationship of its individual parts. The artist's own installations of *The End of the Twentieth Century* hint about his intentions for the sculpture. Moreover, they indicate several approach routes for others to ponder on possible meanings. In this we are aided by the existence of several sketches. The range of different installations of this work created by Beuys suggests that there is some flexibility in considering how, even without the artist's personal intervention or in the absence of explicit instructions, someone else can install the sculpture. This issue becomes more pertinent as most versions of the work have been displayed in buildings opened after 1986, or in places Beuys was not invited to consider as possible settings for the work when he was alive. *The End of the Twentieth Century* thus presents a fascinating conundrum. The artist installed versions of it enough times to give a sense of possible interpretations for the work. On the other hand, there remains the fundamental issue for curators planning Beuys displays of what guidelines they follow and who should set them. Should, for instance, the acquired title of a work of art bring automatic authority over how it is displayed? One final consideration will be the continuing history of the sculpture's display and changes that have occurred since the Tate acquired *The End of the Twentieth Century*. The immediately perceptible and most intrusive of these changes has been the addition of barriers after its first display at the Tate Gallery at Millbank in 1992 and its subsequent showing at Tate Liverpool in 1993–94. Visually intrusive barriers now prevent visitors from moving freely between stones. From a protective point of view, however, they also minimize physical contact between visitors and the work, and reduce possible damages. Alongside this display history at, now, three Tate sites runs a curatorial process of gathering documentation about the work from those most closely involved with its fabrication.[8]

The two versions originally shown in Düsseldorf were acquired by their current owners during the artist's lifetime. There, then on subsequent occasions in Munich (for the forty-four-stone version), and Darmstadt (for the twenty-one-stone version), the artist installed and reinstalled the sculptures. By comparison, the Tate's version, completed only in 1985, was never installed by the artist, who died in January 1986. After Beuys's death, it was lent to several group shows and retrospectives in Europe and America before its acquisition by the Tate. During those travels, it was installed by the Munich gallerist Bernd Klüser, who was handling its sale for much of this period and who had worked with the artist on several occasions. The Tate's policy since January 1990 of rotating displays of its permanent collection has ensured that this sculpture, for all its monumentality and physical weight, has been on and off public view several times since its acquisition. Also, perhaps somewhat surprisingly, it has rarely been shown on its own, but usually in the context of other works by Beuys. Undoubtedly the tendency to view Beuys's artistic activities as cumulative, notably in his creation of "blocks" of work, but present on a smaller scale also in the agglomeration of related objects in vitrines, has influenced museum displays, which often seek the connective tissue binding Beuysian ideas by grouping works rather than showing

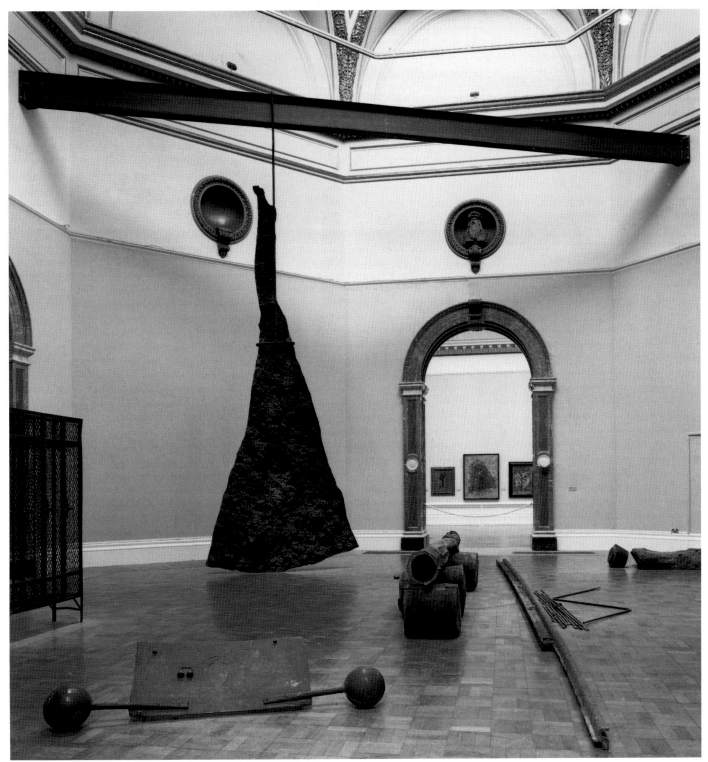

Plate 123.
Lightning with Stag in Its Glare (detail),
along with other works by Beuys,
"German Art in the Twentieth Century,
Painting and Sculpture 1905–1985,"
Royal Academy of Arts, London

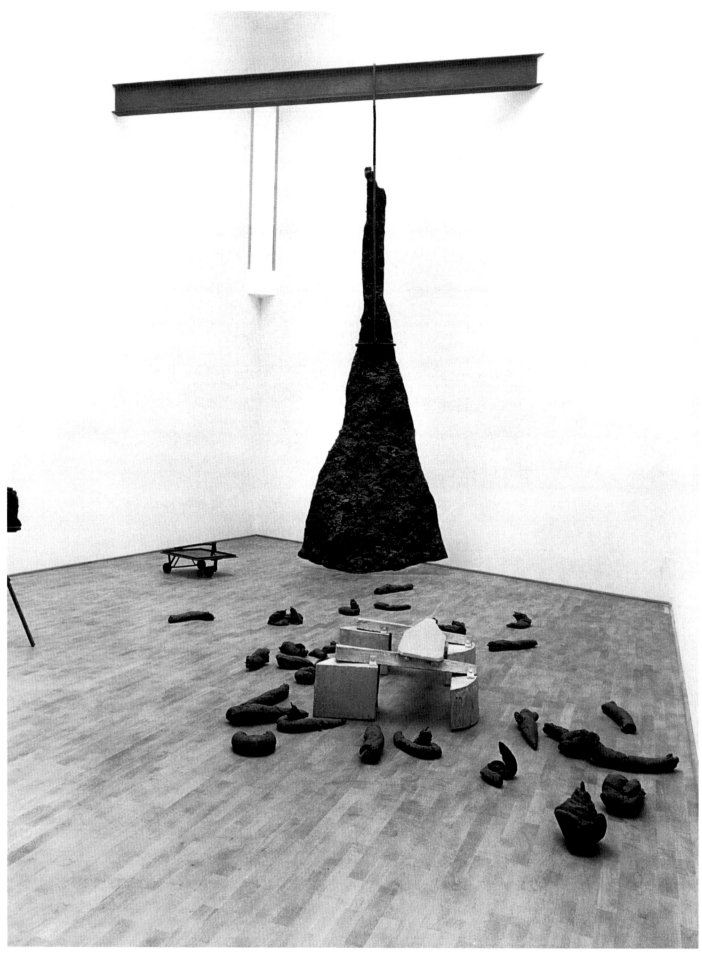

Plate 124.
Lightning with Stag in Its Glare, 1958/85
Environment consisting of 39 parts:
bronze, aluminum, iron, compass, and suspended
construction of iron
Measurements variable
Museum für Moderne Kunst, Frankfurt am Main

single sculptures.[9] The generous space at the Tate devoted to Beuys in recent years also compensates, possibly, for a belated recognition of the artist's importance. Until the acquisition of two vitrines in 1983, there were no larger scale works by Beuys in the collection. Undoubtedly a contributory factor to this notable omission, incidentally one shared by many major institutions in Germany and America, was the internal debates since the 1970s about the material deterioration of many of his sculptures, which had earlier inhibited the Tate from acquiring certain types of his work.

The End of the Twentieth Century was shown first as a new acquisition in early 1992. In an adjoining gallery were 1980s vitrines (three in the Tate collection, others lent by Anthony d'Offay) and some borrowed works on paper. After six months, the stones were sent to Liverpool, where the Beuys display was expanded to include prints and a selection from Bits and Pieces, the "block" Beuys had assembled for Caroline Tisdall. The End of the Twentieth Century was next seen at Millbank in 1998 as part of an annual series of summer displays in which works from the Froehlich Collection were combined with works from the Tate's own collection. Following this, it was shown in the double-height gallery in Tate Modern for the inauguration of the building in May 2000. There The End of the Twentieth Century was combined with vitrines from the collection and loans from the Daros Foundation and Froehlich Collection. If this changing history of display compares unfavorably with the permanent accessibility of the sculpture in Munich, one should not forget that this reflects the Tate's long-term policy of rotating displays and sharing works between different Tate sites. Equivalent jewels in the Tate's collection such as the group of Seagram murals by Mark Rothko (1958–59), Matisse's Snail (1953), or the collection of Turner paintings, have also been intermittently shifted between galleries, even though the Matisse, Rothkos, and Turners have remained more continuously on display than Beuys's The End of the Twentieth Century. The Tate's version remains the most mobile of the three large versions of The End of the Twentieth Century. In spite of a material fragility that belies its massiveness and apparent solidity, The End of the Twentieth Century has been lent, since its acquisition, to the Edinburgh and London venues of the exhibition "The Romantic Spirit in German Art, 1970–1990" (July 1994–January 1995).[10] It is included in the current exhibition, shared between London and Houston. The history of Beuys's sculpture at the Tate has, in fact, some of the characteristics of many chefs-d'oeuvre in today's major museums that travel between the stores, collection displays, and as exhibition loans with a frequency that did not exist only twenty years ago.

The Tate has provided extensive curatorial and technical advice for those journeys, but has, essentially, allowed borrowing institutions to install the sculpture according to their own aesthetic conceptions. Documentation, plans, and photographs of previous installations are sent to all borrowers. When showing the sculpture at the Hayward Gallery, London, in "The Romantic Spirit in German Art, 1970–1990," for example, the curator Susan May constructed a raised viewing platform at one end of the Beuys sculpture. This referred, distantly, to the original display of the forty-four stone version in the basement of the Galerie Schmela, where it was also first sighted from above. Viewed from the perspective of Munich's painstakingly careful recent transposition of its version of the sculpture from the Haus der Kunst to its new home in the Pinakothek der Moderne, using the instruments of global positioning technology to precisely

replicate the gaps between the stones, the Tate's attitude might appear rather relaxed. Just as arguable, however, the Munich approach could appear to have over-compensated for losing the ambience of the original location for the sculpture by insisting on extraordinary precision to retain just one of several critical relationships; the one between the stones. It is very possible that Beuys, were he still alive, might, after all, have modified his arrangement of the stones to suit the new spatial and lighting conditions offered by a new building. By their actions the Munich museum staff have emulated the efforts of their Frankfurt colleagues installing *Lightning with Stag in Its Glare* at the Museum für Kunst, fifteen years earlier. Yet, however faithfully certain aspects of the artist's earlier activities or stipulations are followed, placing a work in a new space introduces an unavoidable dimension of invention, however responsibly this is handled.

Beuys's own installations of different versions of the sculpture give us not simply a visual record but also some images of how he might have wished *The End of the Twentieth Century* to be understood. The presence of the stones along with a wooden pallet, a pallet truck, timber blocks, wooden wedges, and crowbars in Szeemann's exhibition "Der Hang zum Gesamtkunstwerk" at the Kunsthalle Düsseldorf suggests ideas of process and formation; a contingent "work in progress" rather than a finished design.[11] This concept is a familiar one in Beuys's work and could also be seen in the *Workshop* element of *Stag Monuments* in the Martin-Gropius-Bau, the work Beuys made for the 1982 "Zeitgeist" exhibition. Alternatively, photographs of the forty-four-stone version in the Galerie Schmela suggest a herd of animals and the more general idea of drift or flow. One might think of logs floating down a river or, more specifically, recall the sledges in Beuys's seminal sculpture *Das Rudel* (*The Pack*, 1969, pl. 75), to which *The End of the Twentieth Century* appears formally related. Images of Beuys installing this same version in the Haus der Kunst during February 1984, after its acquisition by Munich, evoke other associations. Because of the vertical accent given by a single standing stone, an innovation when compared with Beuys's previous installations, the ensemble might be interpreted as referring to the pile of boulders and ice of Caspar David Friedrich's *The Sea of Ice* (1823–24, Hamburger Kunsthalle, Hamburg) or more generally, to sacred ground at a ritual site.

These images, subjective though they are, are suggested by the artist's own installations of the work. They give a range of associations that installers can work with after the artist's death. Neither conclusive nor consistent, Beuys's different installations nonetheless propose different readings, as much dependent on the arrangement of the stones as on their setting. The single doorway in the Haus der Kunst, for example, was instrumental in concentrating the visual power of the work. Visitors encountered the sculpture frontally upon entering the room, a dramatic vista heightened by the presence of a lone, gray standing stone starkly profiled against the white gallery walls. By contrast, Beuys inserted *The End of the Twentieth Century* into the Hessisches Landesmuseum, Darmstadt, in 1984, into the opening room of a sequence of galleries already devoted to the *Beuys Block*, which he had originally installed there in 1969, after its acquisition by Karl Ströher.[12] As a prelude to these subsequent rooms, the necessity of creating a passageway through the gallery required the arrangement of stones to be permeable. The conclusion drawn is that there can be no single definitive installation of this work unless it is a still extant one made by the artist in a specific place.[13] With the removal of Munich's version to its new home, *The End of the Twentieth Century* is now at one further remove from the artist's own lifetime experience and handling of the work.

Aside from the photographic documents that exist, Beuys left several detailed plans and sketches related to the origins and fabrication of the sculpture. Beuys's original intention for what became *The End of the Twentieth Century* appears to have been a sculpture using basalt blocks with cones drilled out from one end. A two-sided sketch of about 1982 (private collection) shows, on one side, various methods of extracting cylindrical and cone-shaped plugs from basalt blocks. The other side continues this theme, but includes a circular pattern indicating the multiple drill marks on the surface of a basalt block which are needed to drill out the cone plug. It carries the inscription "12 Symphytum." The inclusion of "Symphytum," perhaps a possible title at this stage, commemorates the homeopathic herbal preparation Beuys was, at that time, applying to his cheek to alleviate the pain of a toothache.[14] By using a mineral lotion (clay) in the sculpture to line the "wound" in a mineral corpus (the basalt block), Beuys created an analogy to the homeopathic principle of treating "like with like." U We Claus, one of the stonemasons who fabricated the first stones Beuys used, suggested a possible explanation for the number "12" that appears on the sketch. When in the autumn of 1982, Claus and the stonemason Walter Giskes took the first stone to Beuys for his approval, the artist mentioned his intention of placing twelve of the stones in a circle, with the end of the stone from which the cones were extracted oriented toward the middle of the circle.[15] While hinting at possible meanings for the work, especially its connection with time, this sketch and Claus's recollection is of limited use when considering the installation of *The End of the Twentieth Century* in its final form.

There are, however, other drawings that can be usefully consulted. One small sketch from about 1984 (private collection), probably made in preparation for an exhibition of works from the Ulbricht Collection at the Seibu Museum of Art in Tokyo (June–July 1984), shows the five-stone version distributed among other works by Beuys, some of which can be easily identified. Responding perhaps to the elongated proportions of the available space, Beuys proposed laying three of the stones in a loose zig-zag line to emphasize its length, while also clustering three stones at one end in the rough form of an arrowhead to give it a sense of breadth. While the juxtaposition of *The End of the Twentieth Century* and other works suggests that Beuys was content to put the sculpture in a mixed display, as a guide to laying out twenty-one, thirty-one, or forty-four stones of the larger versions, however, the sketch is also of limited value. A second work on paper, from 1983 (pl. 125), was originally three pages of a sketchbook. They are now framed as a three-part drawing.[16] The uppermost sheet shows two drills extracting a cone from a block of basalt. The other two sheets appear to be working drawings, which show the stones arranged on the floor of a space that corresponds to the Galerie Schmela. In each sketch, the stones are numbered (as they were when they came from the stonemasons' workshop in the Frielenberg quarry). It cannot be confirmed if these sketches were made before, during, or after installation. However, the stones' arrangement suggests that Beuys had considered contrasting approaches to his installation. One depicts an orderly arrangement of stones mostly laid parallel to one another, with gaps between them but with a few touching. This was more in tune with the final installation. The other consists of a disorderly assemblage of stones fanning out as they reach the wider part of the Galerie Schmela. Their jostling and overlapping is most apparent at the point where they tip over the waist-high drop in level between the upper and lower parts of Schmela's basement gallery. Another drawing (1984, private collection) relates to the twenty-one stone version. It shows the floor plan

of the first room of the *Beuys Block* in Darmstadt, to which Beuys was planning to add *The End of the Twentieth Century.* Ranged along both the long walls of the gallery, Beuys sketched the positions of nineteen of the twenty-one stones.[17] Although the Tate version has thirty-one stones, the distribution of stones in this sketch, along with knowledge of Beuys's other installations in Düsseldorf, Darmstadt, and Munich, provided the basic information with which Bernd Klüser and the author planned the first display of the stones at Millbank in the spring of 1992.

When acquired, neither the vendor nor the artist's estate proposed or stipulated any procedures for displaying the sculpture (the Tate routinely informs the artist or their estate after making new acquisitions). It is customary at the Tate, however, for the artist, their representative, or someone else closely associated with the fabrication or installation of a work to be invited for their contribution the first time a new acquisition goes on display. The installation process is usually recorded for future reference, with detailed notes, photographs, and sometimes videos. Further information is sought at this stage about variables such as doorways or lighting, including how a large-scale work such as *The End of the Twentieth Century* might be reconfigured for other galleries at the museum. Although Anthony d'Offay was the vendor, he recommended that the Tate invite Bernd Klüser to assist with the first display of *The End of the Twentieth Century* because of Klüser's close association with the artist and his past role in installing the Tate's version of the sculpture. His involvement had included contrasting venues in Pittsburgh (as part of the Carnegie International, 1988), in Berlin ("Joseph Beuys: Skulpturen und Objekte," February 20–May 1, 1988), and, most recently, at the Anthony d'Offay Gallery (1991). After providing him with a floor plan of the gallery, Klüser arrived at the Tate with a set of four sketches, each with a different schematic arrangement of thirty-one stones. While most stones were laid directly on the floor, Klüser envisaged two instances where stones were to be propped on others. This was an echo of the original Galerie Schmela installation, where several stones were tilted between the upper and lower levels of the gallery, or of the Munich arrangement, where five such pairings exist, and perhaps also of the Düsseldorf/Darmstadt installations where stones were raised off the ground on wooden blocks.[18] Klüser and the author agreed to follow one of the sketches, the one that had superficial similarities to the Beuys drawing for rearranging the first room of the *Beuys Block* in Darmstadt. After selecting this rough guide to the distribution of the stones across the floor, two further key decisions remained. One concerned the selection of individual stones. With variations in length and girth and substantial differences in the manner in which Beuys had reinserted the cones, it was clear that the selection of stones and their highly individual characteristics would influence the rhythm and flow of the installation. The second decision concerned the method of placing the stones. Klüser and the author decided early on to avoid minute adjustments once the position of any stone on the floor had been established. Too fussy, we feared, and the ensemble would lose the robust, workmanlike quality that was attained by the rhythm soon created of selecting, moving and then placing the stones, as they gradually accumulated to form the installation. Developing an essential and close rapport with the technicians, essential collaborators in this task, as indeed they always were for the artist, the installation took a day and a half to complete.[19]

By their nature, large institutions such as the Tate Gallery rely for future displays as much on accurate records as on individual expertise and guidance. As lifetime careers in single institutions become, for the contemporary curator at

Plate 125.
Three Part Drawing for "The End of the Twentieth Century," 1983 Pencil on paper
Each 8 ¼ x 11 ⅜ inches (21 x 29 cm), unique
Tate. Presented by Anne and Anthony d'Offay
in honour of Sir Nicholas Serota
to mark the opening of Tate Modern 1999.
T07490

least, more unusual in modern museums, the value of precedents and well-maintained display documentation gains importance. Over the past dozen years, the Tate's version of *The End of the Twentieth Century* has been installed by several in-house and external curators. Some installations have been more successful than others. However, it is almost impossible to establish objective criteria for assessing what is, in fact, merely a set of best judgments. What weighs most heavily, perhaps, is a developed sensibility toward the work of the artist and an essential respect for his achievements. This encompasses not only knowledge about his art but also sensitivity toward his materials and the physical presence of his works. Beuys's works often possess a tension between structure and flow, and *The End of the Twentieth Century* exemplifies this characteristic. Finding a serviceable balance between them can release the power of imaginative association and evoke the natural energies of the physical materials Beuys used for the sculpture through his selection and handling of them. While emulating the artist, we can never supplant him. However, it is an unarguable reality that very few installations by Beuys remain as he left them. The fabric of those still extant gradually changes as the materials they contain, or their own physical substance, deteriorate. With appropriate sensitivity and creative intelligence, other hands can meaningfully reconstitute Beuys's works. In the case of the Tate's sculpture, the necessity to achieve this objective has been present from the start.

Notes

1. This essay is a revised version of one written for the Doerner Institute, Munich (forthcoming), investigating the museological treatment of the different versions of *The End of the Twentieth Century*.

2. Information courtesy of Christiane Berndes, Curator, Van Abbemuseum, Eindhoven.

3. See Armin Zweite and Anette Kruszynski, *Kunstsammlung Nordrhein-Westfalen Düsseldorf. Joseph Beuys: Werke aus der Sammlung Ulbricht* (Düsseldorf: Kulturstiftung der Länder, 2004).

4. According to the Munich gallerist Bernd Klüser (correspondence with the author, September 12, 2003), Beuys wished to use the last few stones from the quarry to create a third, large variant of the sculpture.

5. Bernd Klüser (correspondence with the author, September 12, 2003) reported that thirty-two stones were selected and prepared, with the thirty-second stone "in reserve" in the event of a damage to another stone. This extra stone was given to Klüser by Beuys.

6. Information from a conversation with Mario Kramer, Curator, Museum of Modern Art, Frankfurt, November 10, 2001.

7. This point was instructively developed in a conference in Frankfurt on November 10, 2001 during which curators from European and American institutions discussed how they approached installations of *Lightning with Stag in Its Glare*. Radically different approaches emerged. Conventions, such as one which sees the I beam supporting the lightning element extending across a corner of the space, with the other elements ranged essentially in front of it, were abandoned by Mass MoCA at North Adams in favor of an installation with the lightning element in the center of the room surrounded by all the other parts of the installation. By contrast the Museum of Modern Art modeled its installation on the spatial relationships between those elements in *Lightning* that were already in the "Zeitgeist" installation, even though many other objects present in Berlin were not included later in *Lightning with Stag in Its Glare*. The critical curatorial question remains whether to view related instances as a guide and how far to exercise curatorial autonomy. In this instance, Beuys left few indications as to the correct layout of *Lightning with Stag in Its Glare*.

8. On cataloguing files at the Tate are detailed letters with copies of photographs and relevant documentation from Eva Beuys (dated December 26 1991) and from U We Claus (letters dated February 7 and 15, 1992). The exhibition history of this and related works is discussed in correspondence with the gallerist Eberhard Hoves (dated January 10, 1992) and in the record of a conversation with Andreas Brüning of the Galerie Schmela on February 6, 1992.

9. Beuys's works have been a constant presence at Tate Modern since the opening and dominate a spectacular double-height gallery. After one set of display changes (December 2001 to December 2002), four galleries out of a total of sixty were dedicated to Beuys.

10. The twenty-one-stone version, already on loan in Berlin, was used for that venue of this touring exhibition.

11. Eva Beuys, in a letter to the author (dated December 26, 1991), commented that various items of this technical equipment were added or taken away as the work toured after Düsseldorf. Such were the changes when Heiner Bastian deposited the twenty-one-stone version on loan in the Wilhelm-Lehmbruck-Museum, Duisburg, after removing it from the Landesmuseum, Darmstadt, after Beuys's death, that Eva Beuys became reluctant to grant permission for reproduction of the installation.

12. The sculpture, a loan from Erich Marx, was removed by Heiner Bastien in 1986, shortly after the artist's death.

13. Even while using photographic records of Beuys's own installation of the five-stone version, the Kunstsammlung Nordrhein-Westfalen have marginally adjusted their installation to better suit the dimensions of the space it occupies. Information courtesy of Anette Kruszynski.

14. See the postcard of Beuys visiting East Berlin in 1982 (Edition Staeck, no. 15028), which clearly shows the white cream on his cheek.

15. U We Claus, letter to the author (December 15, 1992). Claus also recalled that the artist never again mentioned this idea for installing the stones.

16. They were donated by Anne and Anthony d'Offay in 1999 to mark the opening of Tate Modern already combined in a single frame and mounted in a vertical formation.

17. The few photographs of the 1984–86 installation in Darmstadt document an installation that was, in fact, spread across the middle of the gallery as well as the two long walls, blocking easy access through the room in emulation, perhaps, of the placing of a monumental felt and copper *FOND* that hindered access into the second room.

18. This was done, ostensibly, because the floor in the Kunsthalle, Düsseldorf, did not have sufficient point load-bearing strength to place the stones directly on the floor.

19. Eva Beuys recalls that Beuys completed the installation of *The End of the Twentieth Century* at the Kunsthalle in one day, then continued the next day at the Galerie Schmela (letter to the author dated December 26, 1991).

1921

May 12: Joseph Beuys is born in Krefeld, the only child of Josef Jakob Beuys and Johanna Maria Margarita Beuys, born Hülsermann.

September: The family moves to Kleve, an industrial town in the Lower Rhine close to the Dutch border. Beuys's father runs a local dairy cooperative, and his mother works as a receptionist.

1930

During the economic depression the dairy cooperatives fold. The family moves to Rindern, near Kleve, where his father opens a flour and fodder business, in partnership with his brother. Beuys starts to collect all sorts of plants and animals that he and his playmates show in public in the form of small "exhibitions."

> Then came the interest in plants and botany, which has stayed with me all my life. It started as a kind of cataloguing of everything that grew in that area, all noted in exercise books. Our games became more elaborate. We would go off hunting for anything we could find, then build tents from rags and bits of material so we could show our collections. There was everything from beetles, mice, rats, frogs, fish, and flies to old farm yard machines or anything technical we could get our hands on. Then we had our underground spaces too: dens and caves in a labyrinth we tunneled under the earth.[2]

Beuys builds his first makeshift laboratory at home in order to conduct experiments, a practice he would keep up throughout his life. Parallel to his amateur excursions into natural science, he follows his artistic inclinations and a talent for drawing and music, the latter enhanced by piano and cello lessons.

1931

Beuys is enrolled in the Hindenburg Secondary School at Kleve (now the Freiherr-von-Stein-Gymnasium).

1933

May: A member of the National Socialist German Workers' Party (NSDAP) is appointed mayor of Kleve, and National Socialism soon regulates and controls every aspect of life in the city.

1936

Beuys participates in the Sternmarsch to Nuremberg, organized by the Hitler Youth (HJ), the youth organization of the National Socialist German Workers' Party, adherence to which was obligatory.[3]

1937

Beuys probably meets the sculptor Achilles Moortgat (1881–1957),[4] a Kleve artist working in the tradition of the Brussels Academy, who introduces him to the work of the artists Constantin Meunier and Georges Minne, and whom Beuys would visit frequently during his school years.

1938

One year before his graduation, Beuys runs off to work as a roustabout with a traveling circus, putting up posters and looking after the animals. His parents locate him in the Upper Rhine Valley, where the circus is performing, and take him back home. Although his father wants to take him out of school and send him to apprentice in the local margarine factory, Beuys goes back to school and starts playing in the school orchestra.[5]

Plate 126 (facing page).
Joseph Beuys making *Directional Forces* at the Institute of Contemporary Arts, London

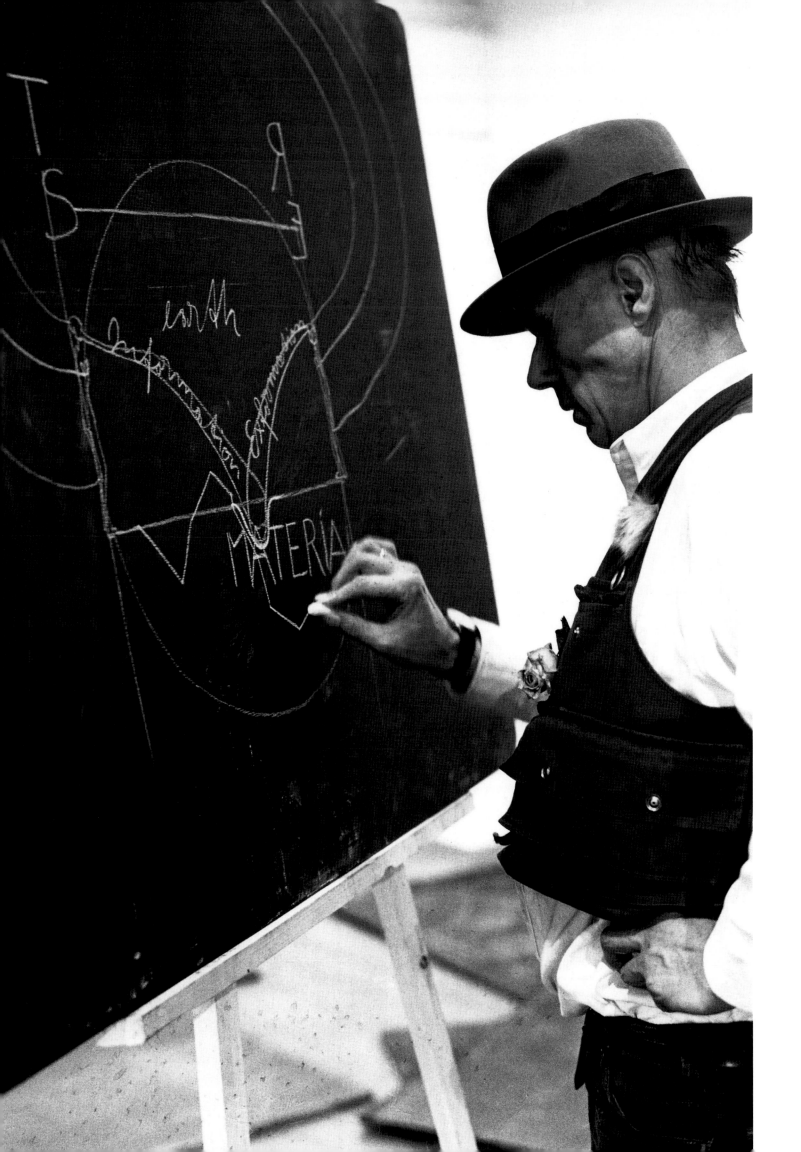

1940

Beuys takes his final examinations. He considers taking on medical studies but then decides, in the atmosphere of general mobilization, to join the Wehrmacht. On his last day at secondary school, he and a friend volunteer for the Luftwaffe before a general draft note is sent out.

> *When the war in Poland started, the classes became empty, and it was very clear, that I did not want to stay home. I did not want to be treated differently.*
> *If the others go, I go too. There was simply a strong cohesion, like in a community. Cooperative behavior was natural. For me it was natural that I would not be an exception.*[6]

1941

May: After his graduation, Beuys begins his military training as an aircraft radio operator in Posen, where he befriends his aviation instructor Heinz Sielmann, the future producer of television documentaries such as "Expeditions to the Animal Kingdom," as well as the head of the armory, Hermann Ulrich Asemissen, who would teach philosophical and ethical anthropology at the University of Kassel after the war. In their leave time, they attend biology, botany, geography, and philosophy lectures at the Reichuniversität Posen. During this time, and due to his experiences with the professors at Posen University, Beuys turns away from a scientific profession and seriously considers a career in the arts.

Beuys would later refer to his discovery of the work of the German sculptor Wilhelm Lehmbruck, who was declared "degenerate" by the Nazis, as a revelatory experience, which compelled his decision. His first experience of Lehmbruck's work supposedly dates to Posen in 1933, when Beuys saw reproductions of a sculpture by the artist and came across a book on him.[7] In 1986, following the award of the Lehmbruck Prize, Beuys explicitly referred to these early encounters with Lehmbruck's art, which according to him, "touched a threshhold situation within the concept of sculpture [which] provided a culmination that was apparently no longer capable of further development.[8]

> *I owe him [Lehmbruck] the decision to engage with sculpture ["Plastik"]. When I coincidentally came across a brochure with Lehmbruck figures in my youth I immediately realized that something like it would become my profession. These simple images of Lehmbruck's sculptures told me that one could to do anything with sculpture, one could do something all encompassing. This is your thing… His sculptures become elements of hearing, or inner hearing or thinking: thus symbols for something, an indication that the future of sculpture will happen in time.*[9]

December: Beuys is transferred to Erfurt to continue his training as a radio operator.

1942

May: Beuys makes a short trip to Weimar to visit the Nietzsche archives.[10]

June: He is sent to fight on the Russian Front and is stationed in the Crimea, from whence the Wehrmacht conquers Sevastopol. In December, Beuys continues his training as a radio operator and a private at the Air Force News School in Königsgrätz (today Hradec Kralové in the Czech Republic), where he is a member of various combat bomber units that fight on the Russian Front.

1943

May 18: Beuys writes to his parents from Foggia, Italy, that he has made the decision to become an artist.

May 28: He applies for acceptance in the Preussische Akademie der Künste (Prussian Academy for Fine Arts), Berlin. [11]

1944

March 3: Beuys receives the Abzeichen für Fliegerschützen ("Medal for Fighter Pilots").

March 16: On the Crimean Front once again, Beuys's JU87 plane crashes. The pilot, Hans Laurinck, dies. Beuys, seriously injured, is found by a German search commando and brought to a military hospital from March 17 to April 7, where he recovers. [12] Beuys will later refer to this wartime experiences in an imaginative way, creating a mythic tale of death and survival woven around the long-lost nomadic life of the Tartars, then collaborating with the German army, which would highly inform the iconography and material symbolism of his work.

> Had it not been for the Tartars I would not be alive today....I was... uncon-
> scious... and only came round completely after twelve days or so, and by then I
> was back in a German field hospital. So the memories I have of that time are
> images that penetrated my consciousness... I remember voices saying "Voda"
> (Water), then the felt of their tents, and the dense pungent smell of cheese, fat and
> milk. They covered my body in fat to help it regenerate warmth, and wrapped
> it in felt as an insulator to keep the warmth in. [13]

April 12: Beuys is awarded the Iron Cross 2nd class.

May 2: Beuys receives the Iron Cross 1st class.

May: Beuys is stationed in Pardubitz and finishes training as a combat pilot.

1945

Beuys fights in the so-called Erdmann Phantom Division at the Western Front, where he is injured severely.

May 1: Beuys receives the Silver Ribbon for the Wounded.

May 7/8[14]: Beuys is awarded the Gold Ribbon for the Wounded.

May 9: British forces capture his division, and they are held in prison in Cuxhaven.

August 5: Beuys is released and returns home to Rindern, to live with his parents in their new home at Tiergartenstrasse 187, where they moved in 1944.

1946

Back home, Beuys meets the sculptor Walter Brüx and the painter Hanns Lamers, who encourage him in his decision to become an artist. In 1947, he becomes a member of the "Niederrheinischer Künstlerbund Kleve" (Lower Rhine Artists Collective Kleve), a regional artists' league founded by Brüx and Lamers after one that had originated in 1936, the "Künstlergilde Profil" (Artists' Guild Profile).[15] This association organizes group exhibitions; Beuys participates in three of their exhibitions between 1948 and 1950, in the former studio building of Barend Cornelius Koekkoek.[16]

Beuys encounters the brothers Hans and Franz Josef van der Grinten in the house of Heinrich Schönzeler,[17] his former English teacher at secondary school, while studying with Schönzeler's son Ernst for the entry exam of the Staatliche Kunstakademie Düsseldorf. Hans (born 1929) and Franz Josef (born 1933), the sons of a farmer from nearby Kranenburg, will become his close friends, the first important collectors of his art, and the founders of the Joseph Beuys Archive Nordrhein-Westfalen.

1947

Beuys contributes to Heinz Sielmanns's zoological documentary series about the Ems region entitled "The Song of Wild Birds." He meets Konrad Lorenz, the founder of ethnology, and he befriends the Krefeld writer Adam Rainer Lynen. He rents a room in the house of Fritz Niehaus and his family. Niehaus, a renowned piano player, renews Beuys's interest in music.

April 1: Beuys enrolls in the Kunstakademie Düsseldorf, where he befriends Erwin Heerich. They are both in the class of the Joseph Enseling (1886–1957), a former student of Auguste Rodin, and, according to Beuys, an "orthodox academic."[18]

October/November: Beuys changes classes. His new teacher is Ewald Mataré (1887–1965). Beuys selects him for his emphasis on craftsmanship and sensibility.

1948

Beuys assists Mataré with a series of mosaic reliefs for the bronze doors of the south portal of the Cologne Cathedral. Beuys spends a lot of time with Lynen in his house, Kull. It is a time of intense intellectual exchange and stimulation that evolves around science, art, philosophy, and its synthesis in alchemy and anthroposophy, whose founder Rudolf Steiner, will become an influential figure throughout Beuys's artistic career.

1949

Beuys begins to develop in private his own sculptural language in which the stylized but conventional formalism taught by Mataré at the Kunstakademie Düsseldorf gives way to a very personal symbolism.

1950

Beuys develops a deep interest in the writings of James Joyce. Alice Schuster, a Joyce specialist, runs a nearby meeting place for artists from the Netherlands and Germany. He also becomes fascinated by the artistic, scientific, and technical achievements of Leonardo da Vinci.

April 1–2: Beuys takes part in an exhibition of work by students of Mataré entitled "Junge Künstler Rheinischer Schulen" ("Young Artists from Schools of the Rhine Region") in the home of a local industrialist, Fritz Steinert, who together with his wife plays an important role in the regional cultural life. It is at one of these exhibitions that Beuys receives a fee for his contribution of a wooden spoon, a seemingly archaic bowl, and a wooden crucifix.

December: Beuys creates two slate epitaphs after sketches by Mataré.

1951

Beuys finishes his education at the Kunstakademie Düsseldorf as a master pupil of Mat(é)'s. He and Erwin Heerich share a studio, where Beuys works until 1954. It is there that he reestablishes an amateur laboratory to satisfy his scientific curiosity.

The brothers van der Grinten, advised by the Dresden artist Herman Teuber, buy two early woodcuts, the first works in what would become an extensive Beuys collection.[19] The same year, they buy twenty more drawings that Beuys himself chooses for them. He executes his first private commission, a gravestone for Fritz Niehaus, today at the cemetery in Büderich near Düsseldorf.

August: Beuys takes a trip to Biel and visits the Goetheanum in Dornach.

1952

Beuys participates in the exhibition "Eisen und Stahl" ("Iron and Steel"), organized by the association of iron works, Düsseldorf, with a Pietà, and wins a prize. About the same time, he makes a fountain for the industrial exhibition "Rhein-Maas," Amsterdam, which is installed in the courtyard of the Kaiser Wilhelm Museum and belongs to the city of Krefeld.

September: Paul Wember organizes an exhibition entitled "Kunst des Niederrheins" ("Art of the Lower Rhine Region"), for which a jury chooses two vitrines with "crucifix and slate boards" by Beuys.

1953

February 22–March 15: Exhibition of 85 works in the home of the brothers van der Grinten. A selection of sculptures, woodcuts, and drawings in this exhibition, later known as the "Scheunenschau" ("Barn Show"), is shown at the Von der Heydt Museum, Wuppertal, in the exhibition "Wolfgang Träger—Josef Beuys," from March 22 to April 5.

August 29–September 6: Beuys participates in the competitive exhibition, "Grosse deutsche Rundfunk- Phono- und Fernsehausstellung" ("Great German Broadcasting Exhibition"), Ehrenhof, Düsseldorf.

1954

Beuys leaves his studio at the Kunstakademie Düsseldorf and rents another studio in Düsseldorf, which he keeps until the fall of 1958. Commissioned by the collector Marie Louise von Mahlzahn, Beuys produces several pieces of furniture. At the same time, he executes countless drawings and watercolors.

1955

Beuys realizes a grave sculpture in the form of a cross for the Düsseldorf collector Joseph Koch, which had been commissioned in 1953. It was never erected but a variant of the horizontal beam becomes part of *FOND 0 + Eisenplatte (FOND 0 + Ironplate*, 1957), today in the *Block Beuys* in the Hessisches Landesmuseum, Darmstadt.

1956

Artistic self-doubt, money problems, and the experiences of World War II are the source of a personal crisis, in which Beuys isolates himself successively from friends and family. He enters a period of serious depression, and seeks medical treatment in psychiatric clinics in Essen and Düsseldorf.

1957

April–August: Beuys lives and works in Kranenburg on the farm of the van der Grinten family. While recovering in the company of the brothers van der Grinten and the artist couple Hans and Ilse Lamers, he begins to draw again and revives his interest in scientific, artistic, and philosophical questions.

1958

Beuys participates in an international competition for a memorial for the former concentration camp Auschwitz-Birkenau, his first large sculptural undertaking after his period of physical and psychological crisis. His design consists of a series of three elevated geometric forms or "landmarks:" gatelike asymmetrical quadrangles raised up on two pillars in diminishing scale, tracing the way from the camp's main entry gate to the site of the gas chambers and crematoria. There, a polished-silver bowl form was to be positioned to catch and reflect the sunlight. His entry was registered on March 15 and confirmed on April 15. It was never realized.

Beuys installs his studio in a former municipal sanitarium in Kleve, where his father is in the hospital. Together, with his cousin Norbert Hülsermann, a blacksmith, he creates a war memorial for the community of Büderich, his largest public commission to date that he has completed. It is inaugurated on May 16, 1959.

Beuys probably begins the cycle of Ulysses drawings.[20] When completed in 1961, he will claim to have added, on behalf of James Joyce, six chapters in the form of six exercise books filled with 355 drawings to Joyce's Ulysses.[21]

Beuys embarks on what he calls "4 Bücher aus dem Projekt Westmensch," four books of drawings with nearly three hundred pages each, which would be completed in 1965.

Beuys meets Alfred Schmela, who proposes an exhibition of his work. It will be realized in 1965. Through Schmela, Beuys encounters Yves Klein, who is working on the decoration of the theater in Gelsenkirchen.

In the spring, Beuys meets the art teacher Eva Wurmbach, twelve years his junior, who is the daughter of a renowned zoologist, at a party at the Kunstakademie Düsseldorf.

May 15: Death of Josef Jakob Beuys, his father.

1959

September 19: Beuys marries Eva Wurmbach. The couple honeymoons in Paris.

Beuys intensifies his analytical critique of disparate scientific theories and methods on the basis of which he will develop his own notions of science, art, and their interrelation.

1960

August: Beuys and his wife travel, via train and ship, to Bornholm, Stockholm, Malmö, and Sylt.

Fall: Beuys and Eva leave Kleve and move to Düsseldorf Oberkassel, Drakeplatz 4.[22]

1961

October 8–November 5: "Joseph Beuys," an exhibition of drawings, watercolors, oil paintings, and sculptures from the van der Grinten Collection is shown at the Städtisches Museum Haus Koekkoek in Kleve. It is Beuys's first exhibition

accompanied by a catalogue, in which Beuys publishes his curriculum vitae "Biographische Notizen" ("Biographical Notes").

November 1: After having submitted his candidacy for the position of professor of monumental sculpture at the Kunstakademie Düsseldorf, Beuys is elected unanimously by the members of the academy board and takes up his position as the successor of Sepp Mages. Beuys had already been suggested for this position in 1958, but his application was turned down because of the intervention of Ewald Mataré, who did not approve of his former student taking over the professorial chair.

December 22: Birth of their first child, a son, Boien Wenzel Beuys.

1962

Beuys befriends Nam June Paik, a member of the international Fluxus movement and, like him, a professor at the Kunstakademie Düsseldorf, and George Maciunas, founder and chief ideologist of Fluxus, who is in Germany to organize the Fluxus Festivals in Wiesbaden, Copenhagen, and Paris the same year. Fluxus is a loosely knit, international and multidisciplinary group of artists experimenting in film, performance, music, and the visual arts, who embraced all manner of activity as art. Fluxus's message that anything could be art resonates strongly with Beuys, who is enlisted as a participant in the Wiesbaden Festival. However, Beuys never realizes his Earth Piano, which he conceived for that occasion.

1963

February 2–3: Beuys initiates and participates in the first Fluxus festival to take place in Düsseldorf: the "Festum Fluxorum–Fluxus. Musik und Antimusik. Das instrumentale Theater", held at the Kunstakademie Düsseldorf.[23] For this occasion, Beuys, for the very first time, enters into the realm of performance. He presents *Sibirische Symphonie 1. Satz* (*Siberian Symphony, 1st Movement*) on February 2, and then *Komposition für 2 Musikanten* (*Composition for 2 Musicians*) on February 3. *Siberian Symphony* is the first of many performances Beuys would undertake under the title of *Aktion* (*Action*), and it introduces the blackboard as a sculptural object, which remains part of his Actions and environments long before he would shift his emphasis to lectures and political action in the 1970s.

> The Siberian Symphony was in itself a composition for piano. It began with a free movement that I composed myself and then I blended in a piece from Erik Satie; the piano would then be prepared with small clay hills, but first the hare would be hung on the slanting blackboard. In each of these small clay hills a bough would be placed, then, like an electric overhead wire, a cable would be laid from the piano to the hare, and the heart would be taken out of the hare. That was all; the hare was actually dead. That was the composition, and it had for the most part sound; then something else would be written on the blackboard.... This action had absolutely nothing to do with Dadaist concepts.... When for instance I use the hare, which appears here for the first time in the flesh, the intention has nothing to do with neo-Dada attempts to shock the bourgeois but with the expression of transformation through material, of birth and death.[24]

For Beuys, this Action "contained the essence of all my future activities and was, I felt, a wider understanding of what Fluxus could be."[25] Beuys performed two more Actions in the context of Fluxus events,[26] but his association with the movement eventually ends in 1964 over philosophical and aesthetic differences. Nonetheless, Beuys would continue to apply the term to his activities despite his overt rejection by the movement and its leader Maciunas.[27]

March 11: During the opening of Nam June Paik's exhibition "Exposition of Music—Electronic Television" at the Galerie Parnass, Wuppertal, Beuys realizes the spontaneous *Piano-Aktion* (*Piano-Action*) using one of the four pianos displayed in the gallery.

> *My first concert (apart from Beethoven at school and Satie at the opening of my exhibition in Kleve in 1960) was at the Galerie Parnass in Wuppertal in 1963. Dressed like a regular pianist in dark grey flanel, black tie, and no hat, I played the piano all over—not just the keys—with many pairs of old shoes until it disintegrated. My intention was neither destructive nor nihilistic:"Heal like with like"—similia similibus curantur—in the homeopathic sense. The main intention was to indicate a new beginning, an enlarged understanding of every traditional form of art, or simply a revolutionary act.*[28]

July 19: On the occasion of Allan Kaprow giving a lecture at Rudolf Zwirner Gallery in Cologne, Beuys, for the very first time, uses fat in a spontaneous Action. Beuys explains the discovery of fat, and subsequently felt, as sculptural materials as a natural and logical result of his involvement with Fluxus:

> *As far as the materials are concerned, I actually did nothing else but further developed the basic ideas of Fluxus and attempted to translate them into materials / render them materially.*[29]

September 14: Participation in Wolf Vostell's 9 *Nein De/Coll/Agen* (*Happening*), Galerie Parnass, Wuppertal, with *Fluxus Schlafstück Kartenstück'* (*Fluxus Sleep Piece Card Piece*).

October 11: Beuys participates in the legendary exhibition "Leben mit Pop. Demonstration für den kapitalistischen Realismus" ("Life with Pop. Demonstration for Capitalist Realism") organized by Konrad Lueg, Sigmar Polke, and Gerhard Richter in the Möbelhaus Bergen, a furniture store in Düsseldorf.

October 26[30]– November 24: "Joseph Beuys Fluxus," an exhibition of 282 works from the van der Grinten Collection opens at their farmhouse in Kranenburg, and within days acquires notorious fame for its display of Fluxus-related works.

1964

June 27–October 5: His participation at Documenta III in Kassel marks Beuys's first exposure to a larger audience. At the instigation of Eduard Trier and Kaspar König, he shows drawings from 1951–59 and the sculptures *Bienenköniginnen I—III* (*Queen Bees I—III*, 1952), and *SaFG-SaUG* (1953).

July 20: Coinciding with the twentieth anniversary of the failed assassination attempt on Adolf Hitler, a festival of new art entitled "ACTION / AGIT- OP / DECOLLAGE / HAPPENING / EVENTS / ANTI-ART / L'AUTRISME / ART TOTAL / REFLUXUS" is organized at the Technische Hochschule Aachen (Technical College Aachen) by artist Tomas Schmit, who is the representitative for the student Union called Austa.[31] By linking the event to the anniversary, the organizers sought not to commemorate the attack but to emphasize art as a political tool. In the accompanying catalogue, Beuys first publishes *Lebenslauf/ Werklauf* (*Life Course / Work Course*), a fictional biography in which artistic and personal life are indistinguishable. In the form of an exhibition history, *Life Course* would become the referential basis for his public persona. Beuys participates with the Action entitled *Kukei / akopee—Nein! / Braunkreuz / Fettecken /*

Joseph Beuys:
Life Course/Work Course:

1921	Kleve Exhibition of a wound drawn together with plaster
1922	Exhibition of dairy cows Molkerei near Kleve
1923	Exhibition of a moustache cup (contents: coffee with egg)
1924	Kleve Open exhibition of heathen children
1925	Kleve Documentation: "Beuys as Exhibitor"
1926	Kleve Exhibition of a stagleader
1927	Kleve Exhibition of radiation
1928	Kleve First exhibition of an excavated trench
	Kleve Exhibition to elucidate the difference between loamy sand and sandy loam
1929	Exhibition at the grave of Genghis Khan
1930	Donsbrüggen Exhibition of heathers with healing herbs
1931	Kleve Connecting exhibition
	Kleve Exhibition of connections
1933	Kleve Underground exhibition (digging beneath the ground parallel to the surface)
1940	Posen Exhibition of an arsenal (together with Heinz Sielmann, Hermann Ulrich Asemissen, and Eduard Spranger)
	Exhibition of an airfield, Erfurt-Bindersleben
	Exhibition of an airfield, Erfurt-Nord
1942	Sebastopol Exhibition of my friend
	Sebastopol Exhibition during the interception of a JU-87
1943	Oranienburg Interim exhibition (together with Fritz Rolf Rothenburg +Heinz Sielmann)
1945	Kleve Exhibition of cold
1946	Kleve warm exhibition
	Kleve Artists' Union "Profile of the Successor"
	Happening Central Station, Heilbronn
1947	Kleve Artists' Union "Profile of the Successor"
	Kleve Exhibition for the hard of hearing
1948	Kleve Artists' Union "Profile of the Successor"
	Düsseldorf Exhibition in the Pillen Bettenhaus
	Krefeld Exhibition "Kullhaus" (together with A.R. Lynen)
1949	Heerdt Total exhibition three times in a row
	Kleve Artists' Union "Profile of the Successor"
1950	Beuys reads "Finnegans Wake" in "Haus Wylermeer"
	Kranenburg Haus van der Grinten "Giocondologie"
	Kleve Artists' Union "Profile of the Successor"
1951	Kranenburg "Van der Grinten Collection" Beuys: Sculpture and Drawing
1952	Düsseldorf 19th prize in "Steel and Pig's Trotter" (consolation prize, a light-ballet by Piene)
	Wuppertal Museum of Art Beuys: Crucifixes Amsterdam
	Exhibition in honor of the Amsterdam-Rhine Canal
	Nijmegen Museum of Art Beuys: Sculpture
1953	Kranenburg "Van der Grinten Collection" Beuys: Painting
1955	End of the Artists' Union "Profile of the Successor"
1956–57	Beuys works in the fields
1957–60	Recovery from working in the fields
1961	Beuys is appointed Professor of Sculpture at the Düsseldorf Academy of Art
	Beuys adds two chapters to "Ulysses" at James Joyce's request
1962	Beuys: The Earth Piano
1963	FLUXUS: Düsseldorf Academy of Art
	On a warm July evening on the occasion of a lecture by Allan Kaprow in the Zwirner Gallery, Cologne Kolumba churchyard Beuys exhibits his warm fat
	Joseph Beuys Fluxus stable exhibition in Haus van der Grinten, Kranenburg, Lower Rhine

1964	Documenta 3 Sculpture Drawing
1964	Beuys recommends that the Berlin Wall be heightened by 5 cm (better proportions!); 1964 Beuys "VEHICLE ART"; Beuys the Art Pill; Aachen; Copenhagen Festival; Beuys Felt works and Fat Corners. WHY?; Friendship with Bob Morris and Yvonne Rainer; Beuys Mouse Tooth Happening Düsseldorf-New York; Beuys Berlin "The Chief"; Beuys: The Silence of Marcel Duchamp is overrated. 1964 Beuys Brown Rooms; Beuys Stag Hunt (behind); 1965 and in us . . . under us . . . landunder, Parnass Gallery, Wuppertal; Western Man Project; Schmela Gallery, Düsseldorf: . . . any old noose. . . ; Schmela Gallery, Düsseldorf "How to Explain Pictures to a Dead Hare"; 1966 and here already is the end of Beuys: Per Kirkeby "2,15"; Beuys Eurasia 32nd Set 1963–René Block, Berlin–". . . with brown cross"; Copenhagen: Traekvogn Eurasia; Affirmation: the greatest contemporary composer is the thalidomide child; Division the Cross; Homogen for grand piano (Felt); Homogen for Cello (Felt); Manresa with Björn Nörgard, Schmela Gallery, Düsseldorf; Beuys The Moving Insulator; Beuys The difference between Image Head and Mover Head; Drawings, St. Stephan Gallery, Vienna; 1967 Darmstadt Joseph Beuys and Henning Christiansen "Hauptstrom"; Darmstadt Fat Room, Franz Dahlem Gallery, Aha-Strasse; Vienna Beuys and Christiansen: "Eurasienstab" 82 minute fluxorum organum; Düsseldorf June 21st, Beuys founds the DSP German Student Party; 1967 Mönchengladbach (Johannes Cladders) Parallel Process I; Karl Ströher; THE EARTH TELEPHONE; Antwerp Wide White Space Gallery: Image Head – Mover Head (Eurasienstab); Parallel Process 2; THE GREAT GENERATOR 1968 Eindhoven Stedelijk van Abbé Museum Jan Leering. Parallel Process 3; Kassel Documenta 4 Parallel Process 4; Munich Neue Pinakothek; Hamburg ALMENDE (Art Union); Nuremberg ROOM 563 x 491 x 563 (Fat); Earjom Stuttgart, Karlsruhe, Braunschweig, Würm-Glazial (Parallel Process 5); Frankfurt: Felt TV II The Leg of Rochus Kowallek not carried out in fat (JOM)! Düsseldorf Felt TV III Parallel Process; Intermedia Gallery, Cologne: VACUUM-MASS (Fat) Parallel Process. . .Gulo borealis. . .for Bazon Brock; Johannes Stüttgen FLUXUS ZONE WEST Parallel Process-Düsseldorf, Academy of Art Eiskellerstrasse I: LEBERVERBOT; Intermedia Gallery, Cologne: Drawings 1947-1956; Christmas 1968: Crossing over of the IMAGE HEAD track with the track of the MOVER HEAD in All (Space) Parallel Process-1969 Düsseldorf Schmela Gallery FOND III; 12.2.69 Appearance of MOVER HEAD over the Düsseldorf Academy of Art; Beuys takes the blame for the snowfall from 15th–20th February; Berlin – René Block Gallery: Joseph Beuys and Henning Christiansen Concert: I attempt to set (make) you free – Grand piano jom (zone jom). Berlin: National Gallery; Berlin: Academy of Art: Sauerkraut Score– Eat the Score! Mönchengladbach: Transformation Concert with Henning Christiansen; Düsseldorf Kunsthalle Exhibition (Karl Ströher); Lucerne Fat Room (Clock); Basel Kunstmuseum Drawings; Düsseldorf PROSPECT: ELASTIC FOOT PLASTIC FOOT.

Modellfettecken (Kukei / akopee—No! / Brown Cross / Fat Corners / Model Fat Corners).

> *After making a quiet sculpture with ultra-violet beams I filled a grand piano with geometric shapes, sweets, dried oak leaves, marjoram, a postcard of Aachen Cathedral, and soap powder. Very loosely, so that it was still playable, but the tone was altered by the filling.... The piano was not ruined by me but by its former owners. It had been part of the interior décor.... The intention: healing chaos, amorphous healing, in a particular direction through which the frozen and rigid forms of the past, and of social convention, are dissolved and warmed, and future form becomes possible.* [32]

Just as Beuys moves on from melting a block of fat to a cardboard box filled with fat he then lifts a copper rod wrapped in felt above his head. The Action is interrupted by a group of students who storm the stage, and one student physically attacks him by punching him in the face. Violence in the auditorium results in police intervention, following which the event officially comes to an end. Unofficially, it continues in front of the university building with discussions and arguments between students and the artists. Following the events at the Technische Hochschule Aachen, the July 20th, 1944 Working Committee, an organization to commemorate the abortive plot against Adolf Hitler, files a disorderly conduct complaint against all the artists involved, as a result of which the interior ministry investigates the possibility of Beuys's dismissal from his professorial chair.

At the same time, Beuys has to officially explain himself to the Nordrhein-Westfalen Department of the Interior because of the entry in his *Life Course / Work Course* recommending elevating the Berlin Wall by five centimeters. The prosecuting attorney's office of the city of Aachen announces inquiries because of disorderly conduct in public, but drops the accusations on October 22. In his justification addressed to the ministry, Beuys explains:

> *This is an image and should be seen as an image.... It is surely permissible to contemplate the Berlin Wall from an angle that takes only its proportions into account. This defuses the Wall at once. Through inner laughter. Destroys the Wall. One is no longer hung up on the physical Wall. Attention is redirected to the mental wall and how to overcome it, and surely that is the real issue.* [33]

August 30: After Beuys and Vostell were excluded from the official Fluxus concert because the other participating artists deemed their performances too personal, expressive, and symbolic to be considered Fluxus in character, the two of them organized their own event. On the occasion of Maj-udstillingen (7 koncerter—nye koncertfænomener, Happening Action Music), from August 29 to September 11, Beuys performs *DER CHEF (THE CHIEF)* Fluxus Gesang, followed by Wolf Vostell's *BUS STOP*, at the Charlottenborg in Copenhagen, in the presence of a small group of friends and family .

October 24: Beuys meets Robert Morris on the occasion of an evening of talk and dance with Yvonne Rainer and Morris at the Kunstakademie Düsseldorf organized by the Galerie Schmela. Morris visits Beuys in his studio. Beuys invites Morris to stage a transatlantic performance of *THE CHIEF*, with Beuys in Berlin and Morris in New York.

November 10: Birth of daughter Jessyka Beuys.

December 1: Beuys performs *THE CHIEF* at the Galerie René Block, Berlin. This is the first time that an Action is performed not in the context of a festival but in the controlled layout of a gallery within which the spaces of viewers and that of performer is clearly delineated. Beuys also, for the first time, inscribes his body into sculpture. From 4:00 p.m. to 12:00 a.m., he lies on the gallery floor, wrapped in a blanket of felt, his body forming part of an ensemble of two dead hares, two coppers rods, one of them wrapped in felt, and fat marks on the walls, carefully arranged to form triangles and rectangles in space. Beuys remained immobile for most of the Action, making his presence known through the emission of a variety of sounds. His murmurs, breathing, whistling, and animal cries were transmitted from a speaker leaning against the gallery wall, occasionally competing with a soundtrack by Erik Andersen and Henning Christiansen. The parallel Action discussed with Robert Morris did not take place in New York.

> *For me* THE CHIEF *was above all an important sound piece. The most recurrent sound was deep in the throat and hoarse like the cry of the stag: öö. This is a primary sound, reaching far back.... The sounds I make are taken consciously from animals. I see it as a way of coming into contact with other forms of existence, beyond the human one. It's a way of going beyond our restricted under-standing to expand the scale of producers of energy among co-operators in other species, all of whom have different abilities—like the coyote for instance. This means that my presence there in the felt was like that of a carrier wave, attempting to switch off my own species' range of semantics. It was a parallel to the old initiation of the coffin, a form of mock death. It takes a lot of discipline to avoid panicking in such a condition, floating empty and devoid of emotion and without specific feelings of claustrophobia and pain, for nine hours in the same position. Such an action, and indeed, every action, changes me radically. In a way it's a death, a real action and not an interpretation.* [34]

December 11: Staging of *Das Schweigen von Marcel Duchamp wirt überbewertet* (*The Silence of Marcel Duchamp Is Overrated*), at the Landesstudio Nordrhein-Westfalen des Zweiten Deutschen Fernsehens (Second German Television Studio) in Düsseldorf. The event is broadcast live from the television studio, together with Actions by Bazon Brock, Wolf Vostell, and Tomas Schmit. It is not recorded.

1965
June 5: Beuys performs *und in uns... unter uns... landunter* (And In Us... Beneath Us. . . Land Under) on the occasion of "24 Hours" at the Galerie Parnass, Wuppertal (from 12:00 a.m. to 12:00 a.m.), organized by Beuys, Charlotte Moormann, Nam June Paik, Ekhard Rahn, Tomas Schmit, and Wolf Vostell. The action ends at midnight, marking the anniversary of D-Day on June 6, 1944.

November 26: Action *wie man dem toten Hasen die Bilder erklärt (How to Explain Pictures to a Dead Hare)*, on the occasion of the opening of Beuys's first solo exhibi-tion in a private gallery: "Joseph Beuys... irgend ein Strang..." ("Joseph Beuys... Any Old Noose..."), on view at Galerie Schmela in Düsseldorf until December 31. For three hours, Beuys, his head covered with gold leaf and honey, clasps a dead hare to his chest, either moving along a wall with pictures or sitting on an elevated stool all the while inaudibly murmuring into the dead hare's ear.

> *This was a complex tableau about the problem of language and about the prob-lems of thought, of human consciousness and of the consciousness of animals, and of course the ability of animals. This is placed in an extreme position because this*

> *is not just an animal but a dead animal.*[35]

> *Even a dead animal preserves more powers of intuition than some human beings with their stubborn rationality.*[36]

> *This seems to be the action that most captured people's imaginations. On one level this must be because everyone consciously or unconsciously recognizes the problem of explaining things, particularly where art and creative work are concerned, or anything that involves a certain mystery or questioning. The idea of explaining to an animal conveys a sense of the secrecy of the world and of the existence that appeals to the imagination.*[37]

November 27–December 31[38]: Exhibition "Joseph Beuys… irgend ein Strang…" ("Joseph Beuys… Any Old Noose…"), with compliments from FLUXUS mit Sondergenehmigung von 'Project Westmensch,'" Galerie Schmela in Düsseldorf.

1966

Together with their spouses, Beuys and his friend Per Kirkeby embark on an imaginary journey to southern Spain, which Kirkeby puts into writing.[39]

June 17[40]–24: ". . . mit Braunkreuz." Exhibition with drawings by Joseph Beuys from the "edition 2," Galerie René Block, Berlin.

July 28: *Infiltration-Homogen für Konzertflügel, der grösste Komponist der Gegenwart ist das Contergankind (Infiltration-Homogen for Grand Piano, the Greatest Contemporary Composer is the Thalidomide Child)* is enacted as two "intermezzi" during a concert by Charlotte Moorman and Nam June Paik at Kunstakademie Düsseldorf.

> *The auditorium was completely empty, a large hall, and at a certain point the piano was pushed inside—that sowed-in beast, and underneath the piano, that thing with the two red crosses, the small toy duck and an ambulance, also with a red cross, ran along, following the movement of the pushing. And it was simply placed in the middle. . . .*

> *The greatest composer is the one who suffers. Who cannot do anything at all. . . . Many people are smart and intelligent, some are also beautiful and can run very fast, some are capable of great public deeds, but what about those people who cannot express anything, who encounter a fate that that renders them incapable of such production. That was the idea, and the Thalidomide affair was the occasion.*[41]

September 9: 4th Annual New York Avant Garde Festival, Central Park, New York City.

Charlotte Moorman plays *Infiltration Homogen für Cello (Infiltration Homogen for Cello)*, which Beuys composed for Moorman at her request after the Düsseldorf concert.

October 14–15: During the "Experimentalforestillingen Tilstande " of the artists' group 'Traekvogn 13' " at the Galerie 101, Copenhagen, Beuys performs *Filz-TV (Felt-TV)* on October 14 and *Teilung des Kreuzes / EURASIA, Sibirische Symphonie 1963, 34. SATZ (EURASIA) Fluxus (Division of the Cross / EURASIA, Siberian Symphony 1963, 34. Movement [EURASIA] Fluxus)* on the night of October 15.[42] *EURASIA* is the first of two Actions to be performed on October 14, the anniversary of the date Hitler was wounded in 1918, the other being *Vacuum< — >Mass* in 1968. Beuys comments on two key components of the Eurasia action:

The division of the cross represents the split between East and West, Rome and Byzantium; Eurasia is the vast uninterrupted land mass that stretches from China to the Atlantic, criss-crossed since time immemorial by the movement of peoples and migratory animals. It means unity and diversity and the resolution of polarities.[43]

In the action, the hare is the element of movement, which changes the immobile notion of art. The hare, an inhabitant of Eurasia, transgresses all borders and even surmounts the Berlin Wall. The idea of the great entity is connected with it, an entity that emerges from middle Europe. The hare is an old Germanic symbol: its Easter egg signifies renewal, spring, and resurrection. It stands as an alchemical sign for transformation.[44]

October 31: Second demonstration of *Eurasia Siberian Symphony 1963*, at Galerie René Block, Berlin, in the context of a series of soirées.

November 4–23[45]: Exhibition "Handzeichnungen," Galerie nächst St. Stephan in Vienna.

December 15: Beuys stages the Action *MANRESA*, together with Henning Christiansen and Bjorn Norgaard, for the closing of the Galerie Schmela, Düsseldorf. Manresa is a small village in the province of Barcelona, which Kirkeby and Beuys "visited" earlier on their imaginary journey. The locale Manresa represents spiritual renewal and purification, where the great counterreformer Ignatius of Loyola experienced enlightenment and conversion, as described in his "Spiritual Exercises."

1967

March 20: *Hauptstrom FLUXUS (Mainstream FLUXUS)*. Ten-hour Action performed with Henning Christiansen on the occasion of the opening of the exhibition "Fettraum" ("Fat Room") March 21–28, 1967, at the Galerie Franz Dahlem, Darmstadt. In his conversations with Caroline Tisdall for the catalogue of his retrospective at the Solomon R. Guggenheim Museum in 1979, Beuys said that:

There was a lot of concentrated aggression in Mainstream, *closely integrated with the fat as material, biting it, jumping around like a hare in the slippery space, repairing the walls. The fat corners made on my body were also done with the jerkings of an epileptic fit, like the initiation ceremony.*[46]

March 21–28: Exhibition "Fettraum" ("Fat Room") Galerie Franz Dahlem, Darmstadt.

May 12: Foundation of the "Free Democratic State of EURASIA."

June 21–24: Following the shooting of a student, Benno Ohnesorg, in Berlin, during a demonstration against the visit of the Shah of Persia, Beuys assumes the role of spokesperson for the students' movement and proceeds to found a "German Student Party" ("Deutsche Studenten Partei"). The DSP is called into existence on June 22, just after midnight, the same day that Germany's invasion of Russia began in 1941. After its first meeting on the morning of June 22, Beuys holds an assembly on June 23, on the front lawn of the Kunstakademie Düsseldorf, since the academy does not tolerate political assemblies within its walls. On June 24, the DSP is entered into the society register.

The party, that declares itself in favor of the Basic Law in its pure form and that strives for Human Rights, works for the necessary extension of consciousness by

using spiritual and rational methods, hence progressively for progress, and thus human, and emphasizes therefore the radicality of its demands for a fundamental renewal of all common forms of men's life and thought.[47]

According to Beuys: "The German Student Party is the world's largest party, but most of its members are animals."[48]

In mid-December, Beuys renames the Party, "Fluxus Zone West," in an attempt to emphasize the necessity for structural changes at schools and universities in all of (Western) Europe.

July 2: On the occasion of the "XIII. Internationale Kunstgespräche," at the Galerie nächst St. Stephan in Vienna, organized by Monsignore Otto Mauer, from July 2 to July 4, Beuys performs *EURASIENSTAB 82 min fluxorum organum*, with music by Henning Christiansen.

> *Eurasian Staff is the symbol of a future unity. It runs from East to West, then doubles back towards the East.... As a conductor of energies [it links] the Eastern capacity for transcendental thought with Western materialism, the idea being that if the two abilities were united the split between intuition and reason would be overcome.*[49]

September 13–October 29: First museum exhibition, "Beuys," at the Städtisches Museum Abteiberg Mönchengladbach. For this exhibition, Beuys installs his smaller objects in free-standing vitrines for the first time. Although these vitrines were borrowed from the museum's display furniture depot, the vitrine would become a major form of presentation for his work from 1970 onward. Two-thirds of the exhibited works are sold to the private collector Karl Ströher, under the condition that this major body of work would be kept together and made accessible to an interested public. The main body of the Ströher Collection is installed at the Hessisches Landesmuseum, Darmstadt, opening on April 24, 1970, under the title "Bildernische Ausdruckformen 1960–70" ("Plastic Forms of Expression 1960–70"). It will become the basis of *Block Beuys*, an ensemble of work that is progressively expanded and modified by Beuys until Ströher's death. Before its installation in Darmstadt, the Ströher Collection is shown in several exhibitions throughout Germany and Switzerland, provoking controversy and debate. In 1981, *Block Beuys* is bought by Anthony d'Offay and the collector Dr. Erich Marx, who would sell it to the Landesmuseum Darmstadt in 1989.

November 2: The director of the Kunstakademie Düsseldorf, Eduard Trier, recommends Beuys for the status of a life-long state employee in a letter to the minister of culture of Nordrhein-Westfalen.

November 17: Ratification of the foundation protocol and the statutes of the German Student Party by Beuys, Johannes Stüttgen, and Bazon Brock as the first, second, and third chairmen of the organization.

November 30: For the matriculation ceremony at the Kunstakademie Düsseldorf, Beuys, with an ax in his hand, opens the proceedings with the so-called "ÖÖ-program:" ten minutes of barking, whistling, hissing, and bellowing in the microphone.

1968

February 10–March 5: "Joseph Beuys Zeichnungen, Fettplastiken" at the Wide White Space Gallery in Antwerp. The exhibition is opened on the evening of

February 9 with the Action *EURASIENTAB 82 min fluxorum organum*, 1967, performed by Beuys and Christiansen.[50] A twenty-minute black and white movie is realized on this occasion to document the Action.

March 22–April 27: "Live in your Head. When Attitudes become Form: Works-Concepts-Processes-Situations-Information," Kunsthalle Bern. Traveled to London, Institute for Contemporary Arts, September 28–October 27.

March 23–May 5: The exhibition "schilderijen, objecten, tekeningen" ("Paintings, Objects, Drawings") is on view at the Stedelijk Van Abbemuseum, Eindhoven.

June 15–August 9: An exhibition of the collection of Karl Ströher is organized by the Galerie-Verein München at the Neue Pinakothek at the Haus der Kunst Munich. The exhibition provokes great controversy, especially in Berlin and Switzerland, where any manifestation of Beuys causes public uproar. Beginning with the Galerie-Verein München at the Neue Pinakothek at the Haus der Kunst, Munich (June 15–August 9, 1968), the collection travels to the Kunstverein Hamburg (August 24–October 6, 1986), the Neue Nationalgalerie, Berlin (March 1–April 14, 1969), the Kunsthalle Düsseldorf (April 25–May 15, 1969), and the Kunstmusem Basel (November 16–January 11, 1970). The Ströher Collection is originally scheduled to be on view at the Kunsthalle Bern, but after the public upoar in Basel, followed by his contribution to the group exhibition "Düsseldorfer Szene," Kunstmuseum Lucern, where Beuys installs the *Lucerne Fat Room* from June 15–July 13, the exhibition committee of Bern cancels the exhibition; ultimately, the show is taken on by the Kunstmuseum Basel.

June 27–October 6: Beuys participates in Documenta IV in Kassel with works ranging from 1952–68, all from the Ströher Collection.

July 20–September 5: "Raum 563 x 491 x 563, Fettecken und auseinandergerissene Luftpumpen," Künstlerhaus, Nürnberg.

October 14: Beuys presents *Vakuum<——>Mass, simultan = Eisenkiste, halbiertes Kreuz, Inhalt: 20 kg Fett 100 Luftpumpen* (*Vacuum<——>Mass, Simultaneous = Iron Box, Halved Cross, Content: 20 kg Fat 100 Bicycle Pumps*) at the gallery Art Intermedia in Cologne as an opening event for the exhibition "Zweite Realität" ("Second Reality") with works by 15 artists on view from October 15 to November 28, together with a twenty-minute-long fragment from the film *Eurasian Staff*. Beuys commented on the Action in 1979:

> Vacuum<——>Mass *relates to the principles of expansion and contraction. This I see as the most important primary character of sculpture in general.... On the occasion when the iron chest from Vacuum Mass was made, this principle was extended to a social process through the presence of a crowd of people in the cellar and the discussions we had before and afterwards, and the projection, during the Action, of a film* [Eurasian Staff] *relating to a wider understanding of sculpture.*[51]

November 24: Nine professors of the Kunstakademie Düsseldorf[52] sign a mistrust manifest against their colleague Joseph Beuys, in which they reproach him of

> presumptous political dilettantism, passion for ideological tutelage, demagogical practice—and in its wake—intolerance, defamation, and uncollegial spirit aimed at the dissolution of the present order.[53]

Again a commission of the ministry for education and culture (Kulturministerium) is charged with the examination of the possibility to dismiss Beuys from the Kunstakademie Düsseldorf.

December 5: *Stahltisch/Handaktion (Eckenaktion)* (*Steel Table/Hand Action [Corner Action]*) on the occasion of the performance "Drama 'Stahltisch'" by Anatol Herzfeld with Joachim Duckwitz, Ulrich Meister, and Johannes Stüttgen at Cream Cheese, a Düsseldorfer pub run by the artists Günther Uecker, and Ferdinand Kriwet, and the film director Lutz Mommartz that is a center for Action art.

December 14–February 15, 1969: Beuys opens the exhibition "Joseph Beuys Zeichnungen—Objekte" ("Joseph Beuys Drawings – Objects") at Art Intermedia Cologne with a public dialogue.

1969

January 29–February 21: "Joseph Beuys *FOND III*," Galerie Schmela, Düsseldorf.

As with the other *FOND* pieces, the key idea for Beuys is:

> the idea of the battery. These felt piles are aggregates, and the copper sheet is the conductor. And so, to me, the capacity of the felt to store energy and warmth creates a kind of power plan, a static action.[54]

February 12: Exhibition of *Revolutionsklavier* (*Revolutionary Piano*) at the Kunstakademie Düsseldorf.

February 27: *Ich versuche dich freizulassen (machen)* (*I am Trying To Let [Make] You Free*) Concert with Christiansen at the Berlin Akademie der Künste, opening event of "Blockade '69," a series of nine environments/exhibitions at the Galerie René Block, Berlin. The concert is interrupted by a group of vandalizing students, who destroy the inventory in protest against the political message of the Action, which in these leftist circles is perceived to be reactionary and affirmative, and not revolutionary enough—unlike the conservative criticism Beuys encountered in Aachen or subsequently in Switzerland.

February 28–March 26: "Joseph Beuys Konzerflügeljom (Bereichjom)," on view at Galerie René Block, Berlin.

March 27: *... oder sollen wir es verändern?* (*...Or Should We Change It?*) The second concert with Christiansen held at the Städtisches Museum, Mönchengladbach, is performed successfully and in its entirety.

May 7–15: Beuys presents *Aktionen vor der durch das Kulturministerium geschlossenen Kunstakademie* (*Actions in Front of the Art Academy Closed by the Ministry for Culture and Education*). The Kunstakademie Düsseldorf is closed as a reaction to the "Internationale Arbeitswoche der Lidl Akademie" ("International Work Week of the Lidl Academy") initiated by Jörg Immendorff and held May 5–10. Immendorff founded the Lidl Academy as an alternative "free academy" that rejects the traditional system from within that very structure. Beuys and two other professors, Warnach and Wimmenauer, put their classrooms at the Academy's disposal. The Kunstakademie Düsseldorf is reopened on May 22.

May 16: *Veränderungskonzert* (*Concert of Transformation*) with Christiansen at the "Intermedia '69," Heidelberg, May 16–June 22.

May 29: *Titus / Iphigenie*, by Beuys, Johann Wolfgang von Goethe, Claus Peymann, William Shakespeare, and Wolfgang Wiens, took place at Theater am Turm, Frankfurt am Main, on the occasion of experimenta 2, organized by the *German Academy of the Performing Arts*, May 29–June 7. The second performance, planned for the next day, is interrupted.

June 15–July 13: Group exhibition "Düsseldorfer Szene," Kunstmuseum Luzerne, where Beuys installs the *Lucerne Fat Room*, 1968. The exhibition causes a public outcry, which results in the cancellation of the exhibition of the Ströher Collection at the Kunsthalle Bern.

June: Beuys takes a stance against a newly introduced limit for the number of students to be admitted to the Kunstakademie Düsseldorf. His protests against the numerus clausus, a system of restricted access to university programs based on high-school grades, leads to an open conflict between him, the directors of the academy, and the ministry of culture and results in the closure of the academy for several weeks.

July 5–August 31: "Joseph Beuys Zeichnungen, kleine Objekte" ("Joseph Beuys Drawings, Small Objects"), Kunstmuseum Basel, Kupferstichkabinett. On exhibit are works from the van der Grinten Collection and the Ströher Collection.

1970

March 2: Beuys founds the "Organisation der Nicht-Wähler, Freie Volksabstimmung" ("Organization of Non-Voters—Free Referendum"), which effectively replaces his Fluxus Zone West (formerly known as the German Student Party), in a concerted effort to extend his political activity from the university into the society as a whole.[55]

April 24: Installation and opening of the Ströher Collection at the Hessisches Landesmuseum Darmstadt (now known as *Block Beuys*) under the title "Bildnerische Ausdrucksformen 1960–1970" ("Plastic Forms of Expression 1960–1970").

May 1[56]: Beuys engages in a semi-private discussion with Willi Brandt on the occasion of the opening of the André Masson exhibition at the Museum am Ostwall, Dortmund, in which he suggests a monthly discussion forum for artists on public television in order to allow the "real" opposition to be heard and seen by a large public.

June 1: First broadcasting of the film *Ludwig Van Hommage von Beethoven*, 1969, by Mauricio Kagel on the Westdeutscher Rundfunk, for which Beuys, among other artists, produced an environment. Beuys's contribution, *Beethoven's Kitchen*, was shot on October 4, 1969, in his studio.

June 6–July 4: "Zeichnungen von Joseph Beuys aus der Sammlung van der Grinten" ("Drawings by Joseph Beuys from the van der Grinten Collection"), Vleeshal van het Stadthuiste, Middelburg (organized by the Zeeuws Museum, Middelburg). The exhibition travels to the Museum Groningen July 30–August 30. Different selections of drawings from the van der Grinten Collection are circulated in Europe in 1970 and 1971 as traveling exhibitions with stops in Innsbruck, Vienna, Braunschweig, Kiel, Stockholm, and Wuppertal.

August 23–September 12: "Strategy: Get Arts, Contemporary Art from Düsseldorf," organized by the Städtischen Kunsthalle Düsseldorf in collaboration

with Richard Demarco Gallery, Edinburgh, in the Edinburgh College of Art, on the occasion of the Edinburgh Festival. During the exhibition Beuys and Christiansen enact *Celtic (Kinloch Rannoch) Schottische Symphonie (Celtic [Kinloch Rannoch] Scottish Symphony)*. It includes a short film Beuys had made earlier the same year entilted *Rannoch Moor (Rannoch Bog)*, that is shown, August 23, 24, 25, and 30.[57]

September 24: Beuys, Klaus Staeck, H. P. Alvermann, Wolf Vostell, and Helmut Rywelski issue an open letter protesting the government-supported establishment of the Cologne Art Fair in the Kunsthalle and the Kunstverein and boycott the opening of this then-exclusive sales exhibition on October 12 with an Action in front of the Kunsthalle.

October 30: *Freitagsobjekt '1a gebratene Fischgräte' (Friday's Object '1st-Class Fried Fish Bone')* at Daniel Spoerri, Eat Art Galerie, Düsseldorf.

November 24: *Isolation Unit* by Terry Fox and *Action the Dead Mouse* by Beuys in the basement of the Kunstakademie, Düsseldorf.

1971

January: Beuys makes plans for a Freie Internationale Hochschule für Kreativität (Free International Academy for Creativity). Within this new academy, Beuys hopes to integrate artistic and sociological studies, since he believes that an inter-disciplinary education allows for the determination of the self and the world.

> From that point alone emerges the power of self-realization, the free realization of man's self...I see this notion of art as revolutionary in its total expansion, in its totality. From there on I am willing to specialize and to differentiate and say: Only at a certain point in man's biography does each human being have to become a specialist in a society of divided labor.... But before such a decision for special-ization occurs, each human being has to develop within this notion, which is the total notion of art, meaning, how is it possible to craft a human being from the human powers of thinking, feeling, and wanting, who can determine something.[58]

February 5: *Action ~~~* in the 'Raum 20' of the Kunstakademie Düsseldorf on the occasion of the presence of journalist Hans Emmerling, who, together with a team from the Saarländischer Rundfunk, produces a documentary entitled *Joseph Beuys und seine Klasse. Beobachtungen. Gespräche (Joseph Beuys and Class: Observations. Discussions)*. The Action consists of two elements, a footwashing and a baptism, which will be intergrated in another version of the Action *Celtic +~~~* that Beuys would perform a year later in Basel.

February 10: Beuys, in collaboration with Erwin Heerich and Klaus Staeck, publishes another appeal against the exclusivity of the art fairs of Cologne and Berlin. Following the protests surrounding the Cologne Art Fair, this manifesto-like petition is internationally recognized and signed by numerous artists, art dealers, critics, and museum directors. The idea of a free art fair and a free artmakers' fair is integrated into the concept of the Free Academy, which would offer, in addition to its educational program, a permanent exhibition space where artists from all over the world could exhibit and sell their work.

April 5: *Celtic +~~~* with Henning Christiansen in a bunker within the storage area near the stadium St. Jakob, Basel, Scherkesselweg. The idea of change and transformation is characterized by Beuys as the key element of every Action:

Plate 127.
1st-Class Fried Fish Bone, 1970,
Düsseldorf

The whole character of the action and the idea of the action is also the idea of a trans-formation, to break away from a traditional notion of art, to mark the border between a traditioned, traditional art, that includes modernism, and an anthropological art, an art directed at man in general, which has a much higher notion of itself... Thus the action as the transforming element in and of itself is also presented as a process of transformation.[59]

June 1: Foundation of the "Organisation für direkte Demokratie durch Volksabstimmung (freie Völkerinitiative e.V.)" ("Organization for Direct Democracy through Referendum [Free People's Initiative, Inc]"), Düsseldorf. Beuys's concept of direct democracy draws upon Rudolf Steiner's interpretation of the three principles of the French Revolution: freedom of the spirit, equality before the law, and fraternity in economics.[60] The organization is not conceived as a party but as a forum for discussion and experimentation toward the realization of a real democracy.

June 5: Dialogue between Beuys and one of his students, El Loko: *Wollen wir nicht endlich einmal über die Bundeswehr demokratisch entscheiden?* (*Should We Not Finally Make a Democratic Decision on the West German Armed Forces?*), one act in the play "Who is Still Interested in Political Parties?" during the experimenta 4, Frankfurt am Main. The dialogue takes on the format of a public discussion as a form of "Plastic Procedure."

June 18: During the event "Aktuelle Kunst Höhe Strasse," ("Contemporary Art High Street"), Cologne, Beuys distributes carrying bags, which were created in collaboration with Art Intermedia as an edition of 10,000. This bag contains a felt disc and carries on one side a schematic drawing of the tasks and goals of the "Organization for Direct Democracy through Referendum" and on the other side a diagram of his political program.

July–August: Beuys, in protest against admission restrictions, invites 142 students who had been refused admission to the Kunstakademie Düsseldorf to join his class, but, as he put it himself,

> *that did not mean, that any student could cozily establish himself with me, as is so often falsely maintained; the students were scrupulously examined by me as to whether study at the Academy of Art could have a certain value for their life.*
>
> *For me the current system of determining admission with the help of a portfolio of the student's drawings is no longer valid; my experience with this principle of choosing has been very negative. My most interesting students have been in fact not those who sought to present a glittering portfolio but rather among those who had been rejected.*
>
> *If I did not have this certainty about the progression of the principles of school, education, university, culture, creativity, freedom—I could not justify my position. But because I have this conviction I want to accept students without restrictions. And as I am responsible for them, I will strive for a method of teaching and appropriate instruction in the current unsatisfactory situation.*[61]

August 16[62]: While traveling with friends and photographers Ute Klophaus and Gianfranco Gorgoni along the Zuider Zee, a large body of water in northeastern Holland, Beuys realizes the spontaneous *Aktion im Moor* (*Bog Action*), which is recorded by both Klophaus and Gorgoni.[63] For Beuys,

> *Bogs are the liveliest elements in the European landscape, not just from the point of*

view of flora, fauna, birds, and animals, but as storing places of life, mystery, and chemical change, preservers of ancient history. They are essential to the whole eco-system for water regulation, humidity, ground water, and climate in general. Drying them out for polders and the Zuider Zee is something I have always disagreed with.[64]

August 17–September 5: Exhibition of the highly autobiographical *Voglio vedere le mie montagne* (*Show Me My Mountain*), at the Stedeljik van Abbémuseum, Eindhoven. *Show Me My Mountain* is the first of many large-scale permanent environments developed and presented independently from an Action. The title is a direct quote of the last words of the Italian painter Giovanni Segantini, who, on September 28, 1899, while dying, demanded to be brought closer to the window of his chamber so that he could see the mountains. The exhibition brochure reads: "The title of this work does not directly reflect what one sees. The question is raised what there is to see."[65]

September 6–7: Beuys, Erwin Heerich, and Klaus Staeck meet in Heidelberg to develop a concept for the organization of a "Free International Art Fair." This meeting is followed by a second "International Meeting Freier Kunstmarkt" ("International Meeting Free Art Fair") at the Städtische Kunsthalle Düsseldorf on October 6.

September 17–October 2: *BARRAQUE D'DULL ODDE 1961—1967* is exhibited at the Galerie Schmela, Düsseldorf, accompanied by two television sets showing for the first time the five-and-a-half-hour video of the Basler *Celtic +~~~* Action.

October 5–30: "Joseph Beuys—Zeichnungen und Objekte" ("Joseph Beuys—Drawings and Objects"), Galerie Art Intermedia, Cologne.

Octobre 15: Beuys occupies the office of the Kunstakademie Düsseldorf with sixteen students, who previously were refused admission. After three days of deliberation, the ministry of science accepts the inscription of those students into Beuys's class. He receives written notification on October 21.

November 1: Beuys founds the "Komitee für eine Freie Hochschule" ("Committee for a Free University").

November 13: Exhibition "Ciclo sull Opra di Joseph Beuys 1946–71" ("The Political Problems of the European Society"), Modern Art Agency, Lucio Amelio, Naples. This is Beuys's first exhibition in Italy, and the poster features a photograph of Beuys in Capri by Giancarlo Pancaldi that he took during Beuys's visit from October 9 to 15 in preparation for the exhibition. Effectively a retrospective of his drawings with 150 works from the Collection Lutz Schirmer, the exhibition is opened by Beuys's "Politische Aktion: *Freier, Demokratischer Sozialismus: Organisation für direkte Demokratie durch Volksabstimmung*" ("Political Action: *Free, Democratic Socialism: Organization for direct Democracy through Referendum*"), an informational event about the activities of the Düsseldorf office and Beuys's conception of direct democracy following the principles of Rudolf Steiner.

November 16–December 15: "Zeichnungen, Aquarelle, Gouachen" ("Drawings, Watercolors, and Gouaches"), Galerie Thomas, Munich.

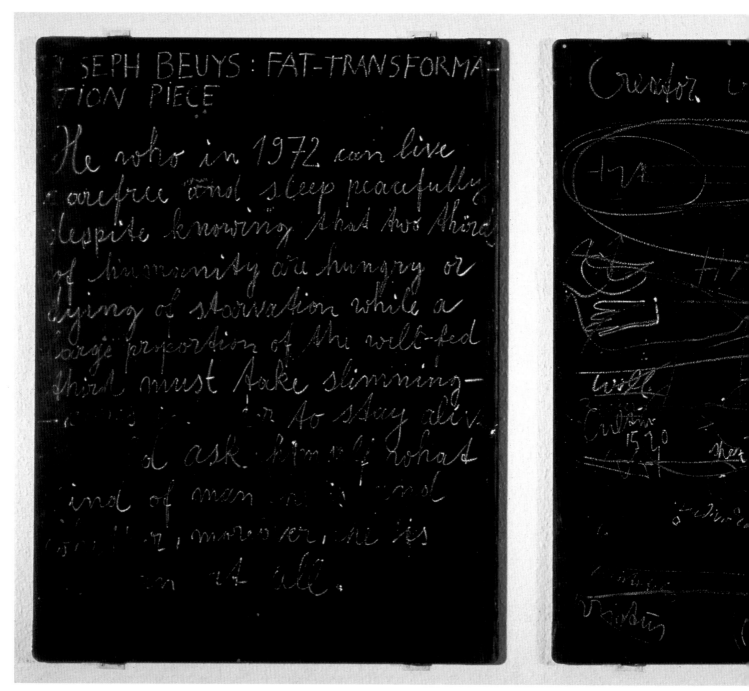

Plate 128.
Untitled (*Three Blackboards*), 1972
See checklist nos. 6,16

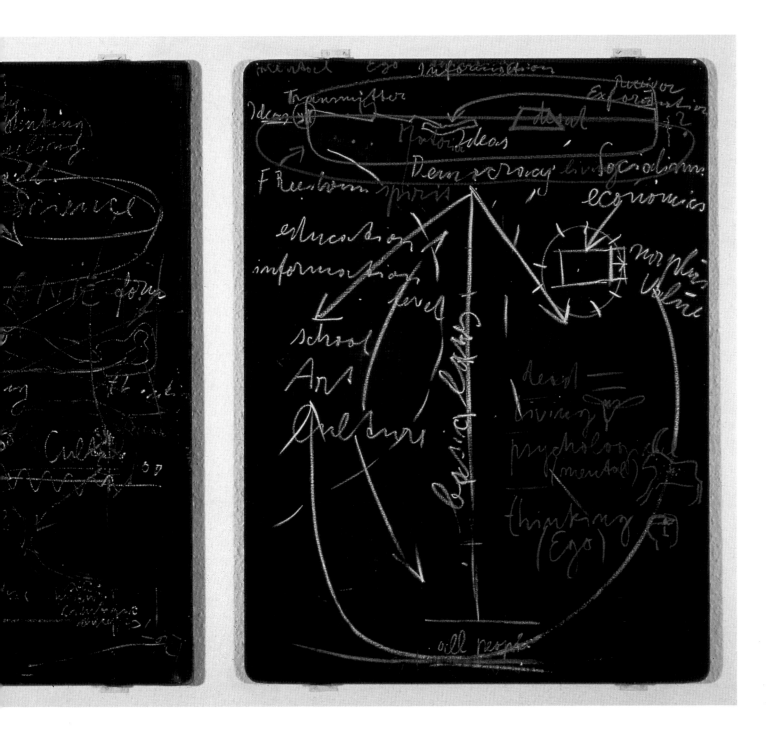

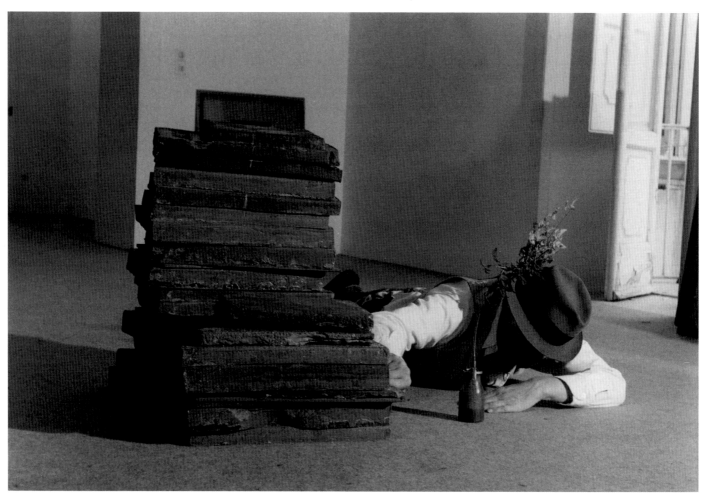

Plate 129.
Vitex agnus castus, 1972,
Naples

December 14: *Überwindet endlich die Parteiendiktatur (The Party Dictatorship Finally Conquers)*. Sweeping paths and marking trees to be felled in the Grafenberg forest in Düsseldorf, Beuys and a group of about 50 students demonstrate against the expansion of the Rochus-Tennis-Club, which threatens to destroy a significant part of this public recreation area. The Action provokes a wave of protest among the population against the destruction of the forest.

December 15: Lecture "Joseph Beuys Kunst = Mensch," Kaiser-Wilhelm Museum, Krefeld. The first in a series of lectures on the topic of Free Democratic Socialism.

1972

January 19: Lecture "Kunst = Mensch. Freier Demokratischer Sozialismus," Museum Folkwang Essen.

February 10–March 3: "Collected Editions," John Gibson Gallery, New York.

February 26–27: *Information–Action*. Beuys performs two Actions akin to seminars on social and political structures held on two consecutive days at Tate Gallery and Whitechapel Gallery, London. At Tate, the six-and-a-half-hour lecture/Action is part of Beuys's contribution to "Seven Exhibitions," a series of shows running from February 24 through March 23 (pl. 128). Beuys was the only artist based outside Britain invited to participate. The others were Keith Arnatt, Hamish Fulton, Bob Law, Michael Craig-Martin, Bruce McLean, and David Tremlett. A flyer introducing the exhibitions emphasized that each artist was quite autonomous and that the choice of artists was not an attempt to define a group or movement. Beuys's contribution, videos and recordings of previous Actions, ran from February 24 to March 6.

March 31: Beuys and Jonas Hafner organize a "Friedensfeier" (Peace Celebration) on Good Friday in collaboration with students in front of the Münster in Mönchengladbach, through which he attempts to redefine the notion of peace:

> *Much disorder has been set in motion by the concept of peace in the course of history. Certainly, "peace," was originally an immensely active concept, which, however, in the course of time has acquired a softened character. When one carries war battle over to the level of consciousness and with it avoids external war, then one has reached a positive condition of peace. The war of ideas itself would be the actual desirable peace.*[66]

May 1: Following the first May Day parade on the Karl-Marx-Platz in Berlin, Beuys sweeps the entire place with the assistance of two students, who collect the trash and put it into the plastic bags of the "Organisation of Non-Voters, in Favor of Free Referendum." The ritual of cleaning is Beuys's answer to the ritualistic form of demonstration in the ideologic (Marxist) fixation of protesters. Immediately after the Action, the trash is presented in the gallery René Block, Berlin, which organized *Ausfegen* (*Sweeping Up*), and which hosts public discussion on freedom, democracy, and socialism. The trash was installed in a vitrine of the same name in 1985.

May 19: Foundation of the "Committee for a Free University" and open discussion at the Kunstakademie Düsseldorf about the "Free College for Creativity." The podium discussion between Beuys, Willi Bongard Johannes Cladders, Erwin Heerich, Hans van der Grinten, and Alfred Schmela is an incentive to enhance

the foundation of the "Freie Internationale Hochschule für Kreativität und interdisziplinäre Zusammenarbeit" ("Free International University for Creativity and Interdisciplinary Research–FIU").

June 11–October 1: Venice Biennale.

June 15[67]: Beuys opens the exhibition *"Arena—Dove Sarei Arrivato Se Fossi Stato Intelligente!"* (*"Arena—Where Would I Have Got If I Had Been Intelligent!"*) with the Action *Vitex agnus castus*, at Lucio Amelio, Modern Art Gallery. Beuys uses a sculpture consisting of two piles of wax-fat-plates, copper, and iron with an oilcan next to it as a point of departure for this Action. Placed in the center of the room, the sculpture / Action is surrounded by 264 aluminum frames containing overworked photographs documenting his works and Actions from the sixties.

June 30–October 8: Beuys installs an information office, the "Büro für direkte Demokratie durch Volksabstimmung" ("Office for Direct Democracy Through Referendum"), during the 100 days of Documenta V as a forum of permanent discussion. The name of the office shines in blue neon over a large desk, a parallel bar, seven blackboards, and a red rose, which is renewed every day, and which Beuys uses to explain the relation between evolution and revolution:

> For me the rose is a very simple and clear example and image for this evolutionary process to the revolutionary goal, as the rose is a revolution with regard to its genesis. The flower's coming into existence does not happen abruptly, but in the organic process of growth. The petals are present in seminal form within the green leaves from where they are developed; the calyx and the petals are transformed green leaves. The flower is a revolution with regard to the leaves and the stem, although it has grown in organic transformation, the rose becomes only possible through this organic evolution.[68]

October 6–November 26: Beuys is, for the first time, included in a group exhibition in the U.S., "Amsterdam—Paris—Düsseldorf," Solomon R. Guggenheim Museum, New York.

October 8: *Abschiedsaktion* (*Farewell-Action*), a boxing match between Joseph Beuys and Abraham David Christian Moebuss, an organizer of Documenta who appears as the "challenger," is organized on day 101 of Documenta V. Beuys proposes this *Box Fight For Direct Democracy* as a spectacular conclusion. After three rounds, the arbiter Anatol Herzfeld declares Beuys the winner "by points for direct democracy through direct hits."[69] The proceeds of this event are donated to the Organization Office for Direct Democracy.

October 10–11: The open conflict carried out in letters and sit-in protests between Beuys and the ministry of education and the arts, dating back to August 28 over the renewal of admission restrictions for the Kunstakademie Düsseldorf, leads to Beuys's dismissal from the Kunstakademie Düsseldorf. A wave of protest breaks loose; students, artists, critics, and art dealers from all over the world declare their solidarity with Beuys, who, not accepting his dismissal, files a suit against the land of Nordrhein-Westfalen on October 30. This decision marks the beginning of an extended judicial procedure during which Beuys tries to obtain his reestablishment. With demonstrations and protests ongoing, ten other professors of the academy declare loose class cooperations, within which Beuys can continue to see his students.

October 30: For the opening of the exhibition *"Arena—Where Would I Have Got If I Had Been Intelligent!,"* Galeria Attico, Rome, Beuys reads from a book about the life of Anarchasis Cloots, a baron from the Lower Rhine Region, who, because of his tragic and uncompromising investment in the ideals of the French Revolution, was a figure of identification for Beuys.

1973

January 13–February 16: "Joseph Beuys- drawings 1947–72," Ronald Feldman Fine Arts, New York. The exhibition travels to Dayton Gallery, Minneapolis, where it is on view from March 2 to 31.

February 10–March 3: Exhibition "Collected Editions." John Gibson Gallery, New York.[70]

March 28–May 26: "Joseph Beuys - Gesammelte Editionen" ("Joseph Beuys – Collected Editions"), Galerie Loehr, Frankfurt am Main.

April 27: Foundation of an association to support the realization of the "Free International University for Creativity and Interdisciplinary Research." Beuys reiterates the concept of creating a free non-restricitve, non-competitive, open academy offering an interdisciplinary curriculum integrating cultural, sociological, and economical education as a stimulant of an all-encompassing creativity.

August 9–13: Beuys participates at a conference of the international cultural center Achberg near Lindau, with the goal to create the "Ständiger Jahreskongress Dritter Weg" ("Permanent Yearly Congress Third Road") in which critics of eastern and western societies would try to develop alternative models.

August 20: *Midday to Midnight, 12 Hours Lecture*. Action at Richard Demarco Gallery, Edingburgh, in the context of the Edingburgh Arts Summer School at which Beuys uses the blackboard both as an integral element of the teacher on stage and of the artist in public.[71]

September 23: Beuys, Ernst Bloch, Heinrich Böll, Mauricio Kagel, Alexander Kluge, and Klaus Staeck appeal to the chancellor Willy Brandt to grant asylum to persecuted Chileans after the empowerment of the military junta.

Oktober 20: Beuys crosses the Rhine in "The Blue Miracle," a dug-out built by Anatol Herzfeld, and is symbolically brought home to the Kunstakademie Düsseldorf by his students in an Action to demonstrate their wish for his return to the faculty.

1974

January 5–24: Exhibition "Collected Editions II," John Gibson Gallery, New York.

January 9–19: Having refused to come to the U.S. during the Vietnam War,[72] Beuys finally accepted an invitation by Ronald Feldman. For his first trip he chooses not to do an exhibiton, but rather to engage in public dialogues with students and women's groups: Beuys's first Action in the U.S., on the heels of his lecture tour. Despite publicity and packed auditoriums in every city, Beuys's visit generated curiously little media attention, with very few reviews and few of those positive. With the American art world well aware of his cult status in Europe, and especially in Germany, he is received with curiosity, but his public lectures on ideas of social sculpture are received with great skepticism and sometimes even

overt hostility.[73] Beuys's itinerary reads as follows: a three-hour conference entitled "The Energy Plan for the Western Man," on January 11 at the New School for Social Research, New York; lectures on January 14 and 15 at the Art Institute of Chicago, on January 17 at the Minneapolis College of Art; and on January 18 at the Dayton Gallery, also in Minneapolis.[74] On January 14, Beuys improvises a spontaneous Action in front of the movie theater "Biograph" in Chicago in remembrance of the killing of the gangster John Dillinger, who was shot by the police in front of this theater on July 22, 1934. The thirteen-second Action is caught on video and later published by Edition Staeck as *DILLINGER, He was the gangster's gangster*. For Beuys,

> *the artists and the criminal are fellow travelers; both have a wild creativity, and both are amoral, driven only by the force of liberty.*[75]

February 20: Together with Heinrich Böll, Georg Meistermann, Willi Bongard, and Klaus Staeck, Joseph Beuys founds the "Freie Internationale Hochschule für Kreativität und Interdisziplinäre Forschung" ("Free International University for Creativity and Interdisciplinary Research"). The foundation manifest explains the mission of this new institution:

> *Creativity is not limited to those who execute one of the traditional arts, and even with those it is not limited to the execution of their art. There is potential for creativity within everybody, a potential which is covered up by aggressions of competition and success. It is the task of this school to discover, research, and develop this potential. . .*
>
> *It should not be the purpose of this school to create new political or cultural directions, to develop styles and models for industrial and commercial application; the main goal is the encouragement, discovery, and fostering of democratic potential and its expression. In a world increasingly dominated by advertisement, political propaganda, cultural industry, and media, a forum should be provided not for names, but that which remains nameless.*[76]

April 7–May 12: "The Secret Block for a Secret Person in Ireland," organized by the Museum of Modern Art, Oxford, is a comprehensive presentation of the 327 drawings still in Beuys's possession at the time. It travels to the National Gallery of Modern Art, Edinburgh (June 6–13); the Institute of Contemporary Art, London (July 9–September 25); the Municipal Gallery of Modern Art, Dublin (September 25–October 27); and the Arts Council Gallery, Belfast (November 6–30). At the time of Beuys's death this body of work had grown to comprise 456 works, today in the collection of Erich Marx. Beuys's comments underline the unique importance of this body of work for the understanding of the artist's thinking process:

> *These are the drawings that I have put aside over the years, a few each year here and there. There are thousands of drawings in private collections, but the nature of this secret block is different... as a whole it represents my selection of thinking forms in evolution over a period of time.*[77]

April 13–22: Family vacation in Yugoslavia.

May 19–June 30: "Zeichnungen 1946–71" ("Drawings 1946–71"); Museum Haus Lange, Krefeld.

Plate 130.
Dillinger Action, 1974,
Chicago

May 23–25: For the opening of the Manhattan gallery of René Block, the art dealer who had worked with Beuys for ten years, Beuys stages his longest Action ever, *I Like America and America Likes Me*, in an ironic allusion to the complex relationship between the artist and his host country. As part of the Action, Beuys, still at the airport, is wrapped in felt, and then driven in an ambulance to the gallery, where he would spend three days in the company of a coyote, his movements entirely focused on the creature, and occasionally talking to spectators. At the end of the three days, he would be again wrapped in felt and driven back to the airport the way he came, thus never touching American soil except within the gallery space.

June 5: *Three Pots Action*, organized by Richard Demarco, Poorhouse, Forest Hill, Edinburgh, as the opening event of the exhibition "Beuys at Forest Hill," Richard Demarco Gallery, Edinburgh, from June 6–June 29.

June 20–30: In preparation of the exhibition "Tracce in Italia – Traces in Italy," scheduled to open at the Modern Art Agency, Naples on October 1, Beuys and his family visit Lucio Amelio in Naples. Together they make a journey to the traces of Beuys's past, which leads them to Foggia and Manfredonia, where Beuys revisits Monte Gargano and Vallo Malbasso. After Naples, the exhibition travels to Genoa (June 10–July 20, 1978) and to Luzerne (April 22–June 17, 1979).

August 18–25: Beuys participates at an "Oil conference" in Edinburgh, organized by the Richard Demarco Gallery, where he speaks about the effects of the discovery of oil off the Scottish coast.

August 30: Death of his mother Johanna Beuys.

October 30–November 24 Beuys creates *Directions of Energies to a New Society— Richtkräfte*, an ensemble of 100 blackboards with chalk diagrams, three easels, one walking stick, and a photographic projection, during public dialogues parallel to the exhibition "Art into Society-Society into Art," at the Institute of Contemporary Art, London.

Fall: Beuys creates over 200 drawings inspired by the publication of the rediscovered sketchbooks "Madrid Codes" by Leonardo da Vinci. One-hundred and six of these technological drawings are printed as an edition in 1975.

Winter 1974–75: Beuys teaches as a guest professor at the Hochschule für Bildende Künste, Hamburg.

December 1974–January 1975: Beuys and his family spend two weeks over Christmas and New Years with the photographer Charles Wilp at Diani Beach, Kenya.

1975
February 5: Opening of the exhibition "Joseph Beuys—Lithographien und Holzschnitte," at the gallery Schellmann & Klüser, Munich.

February 20: The Supreme Court in Kassel repeals the decision of the county court declaring Beuys's dismissal from the Kunstakademie Düsseldorf final.

April 5–May 10: Beuys lectures on "Reciprocal Dialogue" on April 5 at the René Block Gallery and on April 6 and 7 at Ronald Feldman Fine Arts on the occasion of the opening of two exhibitions in New York: *Hearth* at Ronald Feldman Fine

Arts and *beuys-sculpture—Richtkräfte 1974* at the René Block Gallery. He would not return to the U.S. until 1979.

April 12–May 19: "Dokumentation zu Joseph Beuys" ("Documentation to Joseph Beuys") Bonnefantenmuseum/Limburgs Museum voor Kunst en Oudheden, Maastricht.

April 17–May 11: Beuys travels to Belgium and visits the battlefield of Waterloo during preparations for the group exhibition "Je/Nous– exposition d'art d'aujourd'hui" ("I/Us –Exhibition of Art of Today"), Musée d'Ixelles, Brussels (May 24–July 13), organized by Harald Szeemann, and Isi Fiszman as a benefit for the liberal magazine *Pour*, formerly *Le Point*, a leftist weekly newspaper, which functioned as a mediator between student activists and the artistic avant garde.

May 23–June 29: "Zeichnungen, Bilder, Plastiken, Objekte, Aktionsphotographien" ("Drawings, Paintings, Sculptures, Objects, Action Photographs"), Kunstverein Freiburg, Städtische Galerie im Schwarzen Kloster.

May: Beuys suffers from a heart attack. His rehabilitation takes three months.

1976

January 14: Following the initiative of Beuys and Staeck, thirty internationally reknowned artists found the "Internationales Künstlergremium," an international artist's council after the example of the Pen-Club, to guarantee the liberty of the arts and to develop international standards for the understanding and support of the arts.

January 30: The Düsseldorf county court justifies Beuys's dismissal from the Kunstakademie Düsseldorf from March 28, 1973, within the period stipulated for September 30 of the same year.

February 12–March 6: On the incentive of Schellmann & Klüser, Beuys installs *Show Your Wound* in the Kunstforum, a space in a pedestrian underpass between Maximiliansstrasse and Altstadtring in Munich.

March 22–April 10: "Bits and Pieces," Generative Art Gallery, London.

May 8: Beuys travels to Novia Scotia to receive an honorary doctorate from the Nova Scotia College of Art and Design, Halifax.

July 18–October 10: Beuys represents the Federal Republic of Germany at the 37th Venice Biennale with the exhibition of *Strassenbahnhaltestelle (Tram Stop)*, now in the possession of the Rijksmuseum Kröller-Müller in Otterlo.

September 6–30: Exhibition of *Fond IV/4* at the Galerie Schmela, Düsseldorf.

October 3: Beuys runs for the Bundestag elections as a candidate for the Aktionsgemeinschaft unabhängiger Deutscher (AUD, Active Society of Independent Germans), which had appointed him in May. The AUD claims free culture, free universities, and representation of 50 percent women in the parliament.

November 5– January 2, 1977: Exhibition "Mit/neben/gegen/Joseph Beuys und die Künstler der ehemaligen und jetzigen Beuys-Klasse" ("With/Next To/ Against/Joseph Beuys and the Artists of the Former and Present Beuys Class"), Frankfurter Kunstverein, Frankfurt am Main. Beuys and several other artists withdraw their works from the exhibition.

Following two pages:

Plate 133 (page 184).
Tram Stop, 1976
First installation at the Venice Biennale,
German Pavilion
See also checklist no. 44

Plate 134 (page 185).
Beuys with the staff of the Venice Biennale,
1976, during the installation of *Tram Stop*

Plate 132.
Tram Stop, 1976 (detail)
See checklist no. 44

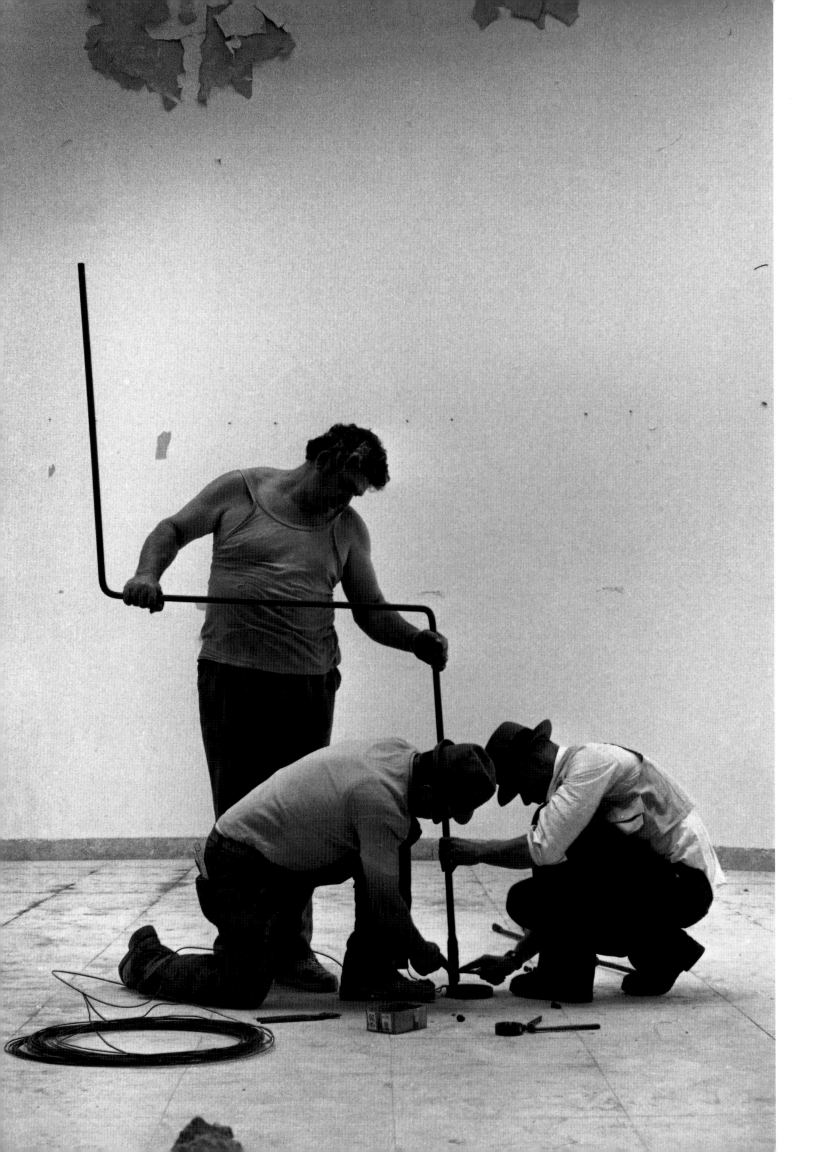

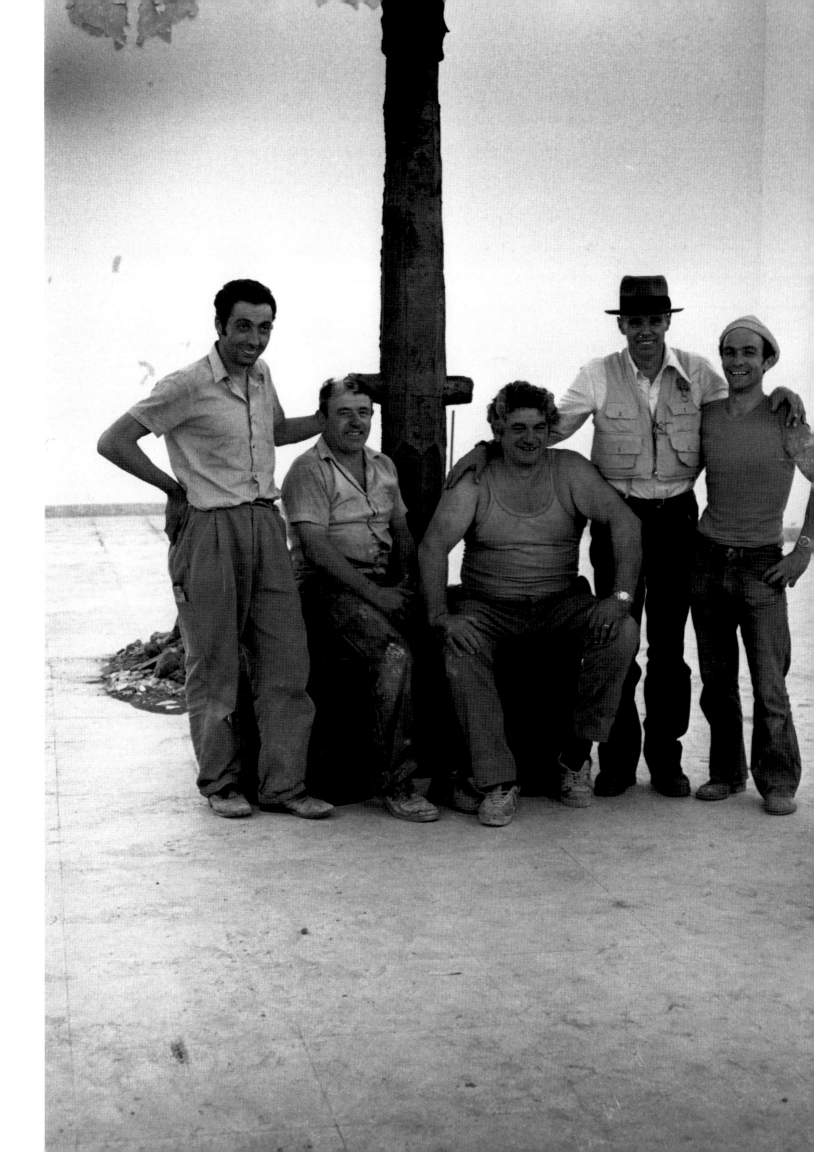

1977

March 4: Beuys receives the Lichtwark-Preis of the Hamburger Kunsthalle followed by two days of lectures and discussions in the Hamburg Kunstverein.

March 15: Action *Kartoffelpflanzung* (*Potato Planting*), in front of the Galerie René Block, Berlin.

April 16-June 26: "Joseph Beuys: the secret block for a secret person in Ireland," Kunstmuseum Basel.

June 24–October 2: Beuys maintains an information office concerning the *100 Tage Freie Internationale Hochschule für Kreativität und Interdisziplinäre Forschung* (*100 days Free International University for Creativity and Interdisciplinary Research*) and installs *Honigpumpe am Arbeitsplatz* (*Honey Pump at the Workplace*, 1974/77) at Documenta VI, Fridericianum Kassel. Additionally an exhibition of his "Handzeichnungen" ("Hand Drawings") is shown at the Orangerie, Kassel.

July 3–November 13: "Skulptur '77" in Münster. As a contribution to this exhibition, Beuys creates the work *Unschlitt* (*Tallow*), a ten-meter long wedge, broken into five blocks, made out of a mixture of wax and tallow. It reproduces the dead space between a pedestrian overpass and the adjoining building of the hall of the University in Münster, which Beuys chose as an example for the inhumanity of modern architecture. It takes three days to form the material and another ten days for it to cool off and harden. It is installed in the court of the Westfälische Landesmuseum Münster.

Oktober 14–November 20: Exhibition of the Collection Ulbricht entitled "Joseph Beuys—Multiplizierte Kunst," Städtisches Kunstmuseum Bonn, with participation of the Bonner Kunstverein. The exhibition travels to Kunstverein Braunschweig (January 20–February 26, 1978), Museum Folkwang, Essen (August 31–October 17, 1978), Kulturhuset, Stockholm (August 31–October 17), and the Neue Galerie am Landesmuseum Joanneum, Graz (November 9–December 3, 1978).

1978

January 14: Beuys receives the Thorn-Prikker medal of honor of the city of Krefeld.

February 15: The members of the carnival association "Alti Richtig" celebrate the carnival under the motto "Hearth," a direct reference to the controversial acquisition of the equally named work by Beuys by the Kunstmuseum Basel for a sum of 300,000 Swiss francs. The participants wear animal masks and felt suits, designed after Beuys's multiple felt suits, and carry copper poles. Beuys joins the parade in a fur-lined coat and distributes tracts against the acquisition.[78] At the end of the parade, they enter the court of the Kunstmuseum, where they throw off their costumes with which Beuys creates *Feuerstätte II* (*Hearth II*), which he subsequently offers to the museum.

March 17[79]: Opening of the exhibition "Beuys—Tracce in Italia," Museo Diego Aragona Pignatelli Cortes, Naples. The exhibition travels to the Palazzo Ducale, Genoa (June 10–July 20) and to the Kunstmuseum Lucerne (April 22–June 17).

April 7: After six years of legal battles, Beuys finally wins his case against the Kunstakademie Düsseldorf, when the Bundesgerichtshof in Kassel declares his 1972 dismissal an illegal act.

April 23–May 21: "Joseph Beuys—Zeichnungen und Objekte," Kunstverein Bremerhaven. The exhibition travels to Universitätmuseum für Kunst und Kulturgeschichte, Marburg (October 29–December 3) and the Kunstverein Göttingen im Städtischen Museum (March 4–April 8, 1979).

May 6: Beuys is nominated as a full member of the Akademie der Künste (Academy of the Arts) Berlin, Department Bildende Kunst.

July 7: *In memoriam George Maciunas, Klavierduett Beuys & Nam June Paik*. During a fluxus soirée organized by the gallery René Block in the great hall of the Kunstakademie Düsseldorf, Beuys and Paik perform a piano duet honoring the founder and protagonist of Fluxus, who died in May the same year.

November 23: The current minister for education and the arts, Prof. Dr. Reimut Jochimsen, offers a settlement to Beuys, according to which he, although no longer teaching at the Kunstakademie Düsseldorf, can keep his studio until age sixty-five, and which allows him to keep his title as a professor. Jochimsen initiates this arrangement after Beuys has been offered a position at the Hochschule für Angewandte Kunst (University for Applied Arts) in Vienna. Beuys uses his old studio at the academy, the famous "Raum 3," which had remained untouched for six years, for the further development of the FIU, Free International University for Creativity and Interdisciplinary Research, founded in 1977 at Documenta VI.

1979
February 16: Beuys declines the position at the Hochschule für Angewandte Kunst, Vienna.

February 27–March 10: "Joseph Beuys—Kunst ist wenn man trotzdem lacht—Installationen, Raumkonzepte, 1. Basisraum Nasse Wäsche, 2. Unsichtbare Plastik 1971" ("Joseph Beuys—Art is, if one laughs nonetheless—Installations, Room concepts 1. Base room wet laundry, 2. Invisible sculpture," 1971), Edition Galerie Nächst St. Stephan, Vienna. The gallery also holds a discussion with Beuys on April 4 of the same year.

March 17: Beuys becomes a member of the "sonstige politische Vereinigung" (other political union), a party that would become the Green Party (Grüne). He is elected a candidate for the European Parliament. The Greens win 3.2% of the votes on June 10, falling short of the 5% needed to gain representation.

May 18: First meeting with Andy Warhol, at the opening of an exhibition of his latest work in the gallery Denise René/Hans Mayer, Düsseldorf. Following the encounter, Beuys creates the multiple *Das Warhol-Beuys Ereignis* (*The Warhol-Beuys Happening*), and Warhol embarks on the creation of a series of portraits of Beuys.

June 22: "Internationale Biennale für Graphik und visuelle Kunst" ("International Biennial for Prints and Visual Arts") in Vienna, for which Beuys installs *Basisraum Nasse Wäsche* (*Base Room Wet Laundry*) in the rooms of the Vienna Secession.

August 21–September 15: "Joseph Beuys—Ja, jetzt brechen wir hier den Scheiss ab—*Coyote II*" ("Joseph Beuys —Yes, Now We are Tearing the Shit Down *Coyote II*") Action, on the occasion of the closing of the Galerie René Block, Berlin. This Action is the basis of one performed later that year at Ronald Feldman Gallery in New York.

September 8–November 4: "Joseph Beuys Zeichnungen and Objects," Mönchehaus Museum für Moderne Kunst, Goslar, in connection with which Beuys is awarded the Kaiserring Prize of the city of Goslar for the year 1979.

October 3–December 9: Beuys represents Germany on the "International Biennial in São Paulo," for which he creates *Brazilian Fond* (*FOND V*).

November 1–January 15, 1980: "Joseph Beuys Zeichnungen Tekeningen Drawings," Museum Boymans—van Beuningen, Rotterdam. The exhibition travels to Nationalgalerie Berlin (February 21–April 20), Kunsthalle Bielefeld (May 29–July 20), and Wissenschaftszentrum Bonn (August 21–September 28).

November 2 –January 2, 1980: "Joseph Beuys," the first and only major retrospective of Beuys's work during his lifetime, organized in collaboration with Caroline Tisdall, opens at the Solomon R. Guggenheim Museum, New York. For Beuys, "This here is just my past, my biography."[80] The Guggenheim exhibition is the first comprehensive presentation of Beuys's work and ideas to an American public who was only allowed a glimpse of his art during in his lecture series and the Action at René Block Gallery in 1974. The exhibition is a lightning rod for American criticism; Beuys's ideas and work are widely perceived as problematic in their ties to the cultural heritage of the Third Reich, and the personality cult surrounding Beuys causes great discomfort in an art world dominated by conceptual strategies. American reception of Beuys's work remains static for over a decade, and it is only in the early 1990s that a critical revision of his art takes place.

November 3–December 31: "Joseph Beuys – From Berlin: Neues vom Kojoten" ("Joseph Beuys — From Berlin: News from the Coyote"), Ronald Feldman Gallery, New York.

November 7: "Heute arbeitet Beuys in der Galerie Schmela" ("Today Beuys Works in the Galerie Schmela"), Action at Galerie Schmela, Düsseldorf.

1980
January 11–12: Beuys, along with nineteen other members of the FIU, participates in the founding meeting of the Green Party in Karlsruhe.

March 22–23: Participation at the Bundesparteitag (federal assembly) of the Green Party in Saarbrücken.

April 1: Meeting between Beuys and Warhol in the gallery Lucio Amelio, Naples, on the occasion of the exhibition "Joseph Beuys by Andy Warhol," showing the nine portraits Warhol made of Beuys.

April 2–3: Beuys draws six diagram blackboards in Perugia for the exhibition "Beuys –Burri," which are bought by the city as a basis for a local museum of modern art.

May 4–June 22: "Joseph Beuys—Sammlung Ulbricht—Multiplizierte Kunst 1965–80" ("Joseph Beuys—Ulbricht Collection—Multiplied Art 1965–80"), Wilhelm Hack-Museum, Ludwigshafen. The exhibition travels to the Kunstmuseum, Düsseldorf (August 10–September 14), to the Henie-Onstad Kunstsenter, Hovikodden (September 25–November 30).

June 1–September 28: In "L'arte degli anni settanta" ("Art of the Seventh Year") at the 39th Venice Biennale, Beuys exhibits the environment *Das Kapital Raum,*

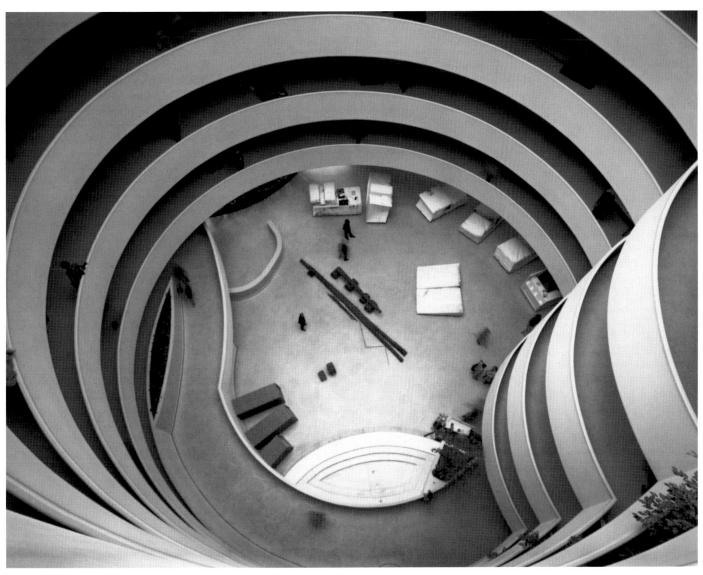

Plate 135.
Tram Stop, 1976,
at the "Joseph Beuys" retrospective, 1979–80
at the Solomon R. Guggenheim Museum,
New York
See checklist no. 44

1970–1977 (*The Capital Room, 1970–1977*, 1984/85), an ensemble of relics from Actions and discussions, which is bought by the Hallen für neue Kunst, Schaffhausen, in 1984. At the same time, Warhol exhibits his portraits of Beuys.

June 21–August 31: "Kunst in Europa na '69" ("Art in Europe after '69"), at the Museum for Hedendaagse Kunst, Ghent. It is for that exhibition that Beuys creates *Wirtschaftswerte* (*Economic Values*) on June 16 and 17.

August 13–September 10: "Stripes from the house of the shaman, 1964–1972 Words which can hear," an exhibition of 148 drawing, is shown at Anthony d'Offay Gallery, London.

August 17–September 6: "Joseph Beuys—Alternative policies and the work of the FIU" (Free International University), Richard Demarco Gallery, Edinburgh.

September 22–October 5: In his function as official candidate for the Green Party for the federal elections, Beuys erects a booth in front of the main theater in Düsseldorf. The Green Party gets 1.5% of votes in the elections, against expectations of 3%. Claiming that Beuys's language is too remote from everyday reality, the party refrains from naming him a candidate for federal election in 1983, thus putting an end to his political career within the party system.

November 1: Beuys founds the "Forschungsinstitut Erweiterter Kunstbegriff" ("Research Institute for an Enlarged Notion of Art") at the Kunstakademie Düsseldorf.[81]

November 24: Beuys is elected a member of honor of the Königliche Akademie der Freien Künste (Royal Academy of Free Arts), Stockholm.

November 29–February 1, 1981: "Zeichen und Mythen—Orte der Entfaltung" ("Signs and Myths—Premises of development/Unfolding"), Bonner Kunstverein, where Beuys, for the first time, installs *vor dem Aufbruch aus Lager I* (*Before Departure from Camp I*).

December 22–January 4: Vacation in the Seychelles. The journal of this vacation is published in *Incontro con Beuys* (Bologna 1984).

1981
January 17–March 8: "Art allemagne Aujourd'hui," Musée d'Art Moderne de la Ville de Paris, for which Beuys creates the work *Grond*.

February 15–March 31: "*Das Kapital Raum 1970–1977*," Hallen für internationale neue Kunst, Zurich.

April 4–9: Beuys follows the call of Ceccho Zotti, a supporter of the struggling leftist newspaper *Lotta Continua*, and travels to Rome where he creates *Terremoto*. Presented in the Palazzo Braschi, the sculpture is put up for auction in order to raise money for the dying newspaper.

April 10–17: During his stay in and around Naples, Beuys creates, following an invitation of Lucio Amelio, the environment *Terremoto in Palazzo* in remembrance of an earthquake on November 20, 1980 in southern Italy. The environment is presented to the public on April 17 in the Galerie Lucio Amelio and is bought by the Fondazione Amelio Institut per l'Arte Contemporeana. While in Naples, Beuys writes an article entitled, "Alcuni richieste e domande sul, Palazzo nella

testa humana" ("Questions and Interrogations on the Palace Within the Human Head") for the daily newspaper Il Mattino, which the newspaper refuses to publish. It is later printed in the catalogue *Terrae Motus* by the Fondazione Amelio in 1984.

May 29: Opening of the environment *Joseph Beuys—Raum: 90.000,—DM* (*Joseph Beuys—Room: 90,000 DM*), Galerie Jöllenbeck, Cologne. The title refers to Beuys's effort to determine a fixed price for his works, independent from their market value.

August 15–23: Beuys donates about 800 works on paper to the Museum Sztuki in Lodz. Beuys, accompanied by his family, drives with a camper through Poland to bring the works to the museum and to install them. Beuys conceives this Action as a gesture of reconciliation against the division of Europe as Eastern and Western blocs. It is also an appeal for social change, which he sees embodied in the development of the movement Solidarnosc, today Poland's leading political party.

September 2–October 18: "Joseph Beuys Arbeiten in Münchner Sammlungen" ("Joseph Beuys Works in Munich Collections"), at the Städtische Galerie im Lenbachhaus, Munich.

September 5–October 11: Two hundred works from the van der Grinten Collection on the theme of women are presented in the exhibition "Joseph Beuys: Vrouwen" ("Joseph Beuys: Women"), Museum Commanderie van Sint Jan, Nijmegen. The exhibition travels to the Stadtsparkasse Düsseldorf (November 9–December 3), Kunstverein Ulm (March 7–April 12, 1982), and the Kunstverein Heilbronn (May 16–June 13, 1982).

October 31–December 31: "Joseph Beuys, Sammlung Ulbricht—Mulitplizierte Kunst 1965–1980" ("Joseph Beuys, Ulbricht Collection—Multiplied Art 1965–80"), Ständige Vertretung der Bundesrepublik Deutschland, Ostberlin. The first exhibition of Beuys's work in East Germany travels to the Kunstmuseum Bonn (February 10–March 28, 1982).

November 10: In Kassel, Beuys presents his project *7000 Eichen* (*7000 Oaks*) for Documenta VII, for which he tries to raise three million DM. Beuys's plan calls for the planting of 7,000 trees, each paired with a columnar basalt stone about four feet high, throughout the city of Kassel and its environs. Seven-thousand basalt stones are piled up on the lawn in front of the Fridericianum, with the idea that the pile would shrink with every tree planted. The project is carried forward under the auspices of the Free International University (FIU) and takes five years to complete, the last tree being planted at the opening of Documenta VIII in 1987. The Kassel project is the first stage in an ongoing scheme of tree-planting to be extended throughout the world, as part of a global mission to effect environmental and social change. Locally, the Action is meant as a gesture towards urban renewal. In 1996, the Dia Art Foundation, New York, a major funder of the original project, would extend this project by planting eighteen new trees, each paired with a basalt stone, in the Chelsea section of New York, adding red oak, elm, honey locust, gingko, and linden trees. Over the years, Beuys would give many lectures and hold many conferences in connection with *7000 Oaks*.

December 23–January 4, 1982: Beuys and his family spend their vacation in Naples, Taormina, Gibellina, and Reggio di Calabria.

1982

January 30–March 20: "Joseph Beuys letzter Raum? Last space? dernier espace?," Galerie Liliane & Michel Durrand-Dessert, Paris. The environment is then shown at Anthony d'Offay Gallery, London, as *dernier espace avec introspecteur 1964/82*, from March 27–May 12.

March 1: Joint Venture Agreement between the Free International University for Creativity and Interdisciplinary Research and the Dia Art Foundation, New York, regarding financial support of *7000 Oaks*.

April 29: Discussion with the Tibetan Lama Sogyal Rinpoché in "Raum 3" at the Kunstakademie Düsseldorf.

June 10: The day before a state visit in Bonn by U.S. president Ronald Reagan, Beuys leads a protest against the military dictatorship in Turkey. That evening, he appeared as a singer for the rock group BAP, the most popular German band at the time in front of Bonn's main train station. Before a crowd of 30,000 people, he sang *Sonne statt Reagan* (*Sun not Reagan/Rain*), a song playing on the German word for rain: Regen. He also appeared the next day in front of 500,000 people during a peace demonstration on the Bonn Rhine shores.

June 19–September 28: Documenta VII. For the opening, Beuys plants a first group of trees, the beginning of the long-term *7000 Oaks* project.

June 30: In front of the Museum Fridericianum in Kassel, Beuys melts a gold cast copy of the crown of Czar Ivan the Terrible into a symbol of peace, the *Hase mit Sonne* (*Hare with Sun*). The proceeds from the sale go toward the financing of a substantial part of *7000 Oaks*.

August 4–18: Journey to Australia for the installation of "Stripes from the house of the shaman" in the Australian National Gallery, Canberra.

October 16–January 16, 1983: Exhibition "ZEITGEIST," Martin-Gropius-Bau, Berlin, for which Beuys creates and installs from October 2 to the opening day the environment *Hirschdenkmäler (+-Wurst—Lehm—Werkstatt)* (*Stag Monuments [+- Sausage—Loam—Workshop]*), as well as the sculpture *Hirschdenkmal In Memoriam George Maciunas* (*Stag Monument for George Maciunas*).

October 27: Beuys has the opportunity to meet with the Dalai Lama on his visit to Germany.

December 23–January 4, 1983: Journey with his family to Greece.

1983

January 21: Beuys is elected the Bundestag candidate for Nordrhein-Westfalen for the Green Party during the federal assembly of the party in Hagen. He withdraws his candidacy a few days later, discontent with his low ranking on the list.

January 26–27: Beuys spends time in Vienna, where he meets with the Viennese activist Otto Muehl in the community Friedrichshof, and the following day with the Austrian chancellor Bruno Kreisky.

February 11–April 30: "Der Hang zum Gesamtkunstwerk—Europäische Utopien seit 1800" ("The Tendency Towards the Total Work of Art—European utopias since 1800"), Kunsthaus Zurich. For the second and third venue of the exhibition at the Kunsthalle and Kunstverein für die Rheinlande und Westfalen, Düsseldorf

(May 19–July 10) and Museum moderner Kunst, Vienna (September 10–November 13), Beuys installs *Das Ende Des zwanzigsten Jahrhundert* (*The End of the Twentieth Century*), the first version out of four.

> *This is the end of the Twentieth Century. That is the old world, on which I impress the stamp of the new world. Look, the plugs, they are like plants from a stone age. I have drilled their funnel shapes with a lot of effort out of the basalt and then placed them back into their holes with felt and clay, so that they wouldn't hurt as much and stay warm. There is something moving, eruptive, living in this stiffened mass—just as the basalt itself was pressed once out if the interior of the earth.*[82]

April 22–May 21: "Joseph Beuys: Drawings." City Art Gallery in Leeds. The exhibition is also on view at the Kettle's Yard Gallery, Cambridge (May 29–July 3), the Victoria and Albert Museum, London (July 27–October 2), The Harvard University Art Museums, The Busch-Reisinger Museum, Cambridge, Massachusetts (April 17–June 17, 1984), and the Guinness Visitors Centre, Dublin (August 24–November 17, 1984). Beuys holds several conferences in conjunction with the exhibition.

August/September: The "Initiative Brücke Ost-West" ("Initiative Bridge East-West"), an activist group supported by Beuys, examines the possibility of incorporating the public opinion poll in the constitution.

September 9–October 15: "Joseph Beuys–12 Vitrines, Forms of the Sixties," the first exhibition dedicated to vitrines only, opens at Anthony d'Offay Gallery, London.

November 17–January 3, 1984: "Joseph Beuys–Zeichnungen Dessins," Musée Cantonal des Beaux-Arts, Lausanne. The exhibition travels to the Kunstmuseum Winterthur (January 21–March 11, 1984), Musée des Beaux-Arts, Calais (March 24–June 4, 1984), Musée d'Art et d'Industrie, St. Etienne (June 20–September, 1984), Neue Galerie der Stadt Linz (November 8, 1984–January 5, 1985), Musée Cantini, Marseille (January–February 1985), and to the Sonja Henies og Niels Onstads Stiftelser, Oslo (March–April 1985).

December 11–February 1984[83]: "Joseph Beuys—*hinter dem Knochen wird gezählt/ SCHMERZRAUM 1941–1983*" ("Joseph Beuys—*Counting Behind the Bone/ PAIN ROOM 1941–1983*"), Galerie Konrad Fischer, Düsseldorf.

1984

January 1: Nam June Paik realizes, in collaboration with Beuys and others, the Action *Good Morning, Mister Orwell*, a multimedia Action broadcast worldwide, which takes place simultaneously in Paris at the Centre Georges Pompidou, and in New York in the studios of PBS, Channel 13. Beuys and his daugther Jessyka both wear jeans with a round hole at the back of the knees. While Jessyka slowly turns around, Beuys recites the following text:

> *This is the Orwell leg, the trousers of the 21st century. Everybody in the world should make these trousers... to struggle against worldwide materialism and repression especially on the young... Look! How beautiful it looks on a girl! How beautiful it is on a girl.*

May 11–14: On his sixty-third birthday Beuys starts to plant 400 trees and bushes in the community Bolognano under the auspices of Baron Giuseppe Durini who wants to establish a nature reserve of plants original to the region. On March 13, the gallery Lucrezia de Domizi organizes "J. Beuys—Difesa della natura," including a planting Action. Beuys is made honorary citizen of Bolognano.

May 22–24: Extension and reinstallation of *Block Beuys* in the Hessisches Landesmuseum, Darmstadt.[84]

June 2–July 2: "Joseph Beuys: An Exhibition Based on The Ulbricht Collection," The Seibu Museum of Art, Tokyo. In conjunction with the exhibition, Beuys performs the concert *Coyote III* with Nam June Paik, on June 2 at the Sogetsu Hall, Tokyo.

July 24: The senate of the city of Hamburg rejects the environmental project that Beuys conceived for the redevelopment of an area in Altenwerden, where toxic mud threatens to destroy the surrounding vegetation. He is approached in March 1983 by the cultural authorities of the city to develop a concept for the competition "art in public places." Beuys suggests reviving that zone by planting trees and marking them with basalt steles from *The End of the Twentieth Century*. The mayor of Hamburg dismisses this suggestion with the argument that it lacks artistic character.

September 8–October 28: "Joseph Beuys Ölfarben 1949–1967" ("Joseph Beuys Oilcolors 1949–67"), Kunsthalle Tübingen. The exhibition travels to Kunstverein Hamburg (February 16–March 31), Stadtmuseum Ratingen (May–June 30, 1985), and the Kunsthaus Zurich (September 6–November 3, 1985).

November 10–22: "MENSCHENBILD–CHRISTUSBILD / 4. Ausstellung JOSEPH BEUYS" ("Image of Man–Image of Christ / 4th Exhibition Joseph Beuys"), Sankt Markus Nied, Frankfurt am Main.

December 13–16: For the opening of the Museo d'Arte Contemporanea di Rivoli near Turin, Beuys creates and installs the room *Olivestones*, an environment composed of nineteenth-century sandstones, which had been used to decant olive oil.

1985

January 12: *Global-Art-Fusion*. Beuys, Andy Warhol, and Kaii Higashiyama collaborate in the creation of a transatlantic peace symbol. At noon local time Beuys faxes from Düsseldorf his drawing *der Stein der Weisen* (*The Wise Men's Stone*) to Warhol in New York, who adds his peace symbol and sends it to Higashiyama in Tokyo, who, after completing the peace message, faxes it half an hour later to the Museum moderner Kunst Wien, its final destination.

March 2–April 14: "7000 Eichen–34 Künstler stiften eine Arbeit für die Aktion von Joseph Beuys." ("7000 Oaks–34 Artists Donate a Work of Art for the Action by Joseph Beuys"), Kunsthalle Tübingen. It travels to the Kunsthalle Bielefeld (June 2–August 11) and the Orangerie, Kassel (August 25–September 22). On view are works by artists who donate work to support Beuys's goal of "Stadtverwaldung" (Urban Afforestation).

March 19: Contract between Beuys and the company Dentsu-Young & Rubicam K.K. Tokyo. Beuys agrees to appear with the slogan "Joseph Beuys appeared here to support his ecological undertakings" in advertisements for Nikka Whisky, and in return receives DM 400,000 to finance the rest of the ongoing project *7000 Oaks*.

End of May: Beuys falls ill with interstitial pneumonia.

August 11–September 29: Exhibition "Kreuz + Zeichen, Religiöse Grundlagen im Werk von Joseph Beuys" (Cross + Symbol, Religious Foundations in the Work of Joseph Beuys), Suermondt-Ludwig-Museum, Aachen.

September 3–18: Recreation vacation in Naples and on Capri.

October 8–November 16: "Joseph Beuys: Sculpture and Works on Paper 1958–85," Anthony d'Offay Gallery, London.

October 11–December 22: "German Art in the Twentieth Century, Painting and Sculpture 1905–1985," Royal Academy of Arts, London. The exhibition travels to Staatsgalerie Stuttgart, February 7–April 22, 1986.

October 24–December 1: "Joseph Beuys–Dibujos," Fundacion Caja de Pensiones, Sala de Exposiciones, Madrid. Traveled to Sara Hildénin Taidmuseo Tampere, Tampere, January 13–February 9, 1986; Städtisches Museum Abteiberg, Mönchengladbach, February 23–April 20, 1986.

November 20: Beuys delivers his famous speech "Talking about one's own country" at the theater Kammerspiele in Munich as part of a series by the same name.

November 29: Simultaneous piano concert performed by Henning Christiansen and Nam June Paik at the Hochschule für Bildende Künste, Hamburg. Beuys, already too weak to travel, joins in via telephone from Düsseldorf. Friend and collector Wolfgang Feelisch acts in Beuys place, following the instructions given to him over the phone. As a result Beuys creates the sculpture 'Klavier–Oxygen' (Piano–Oxygen). The concert is realized after an idea by Robert Filliou "Zugehend auf eine Biennale des Friedens" (Approaching a Biennial of Peace) on the occasion of an exhibition at the René Block gallery from December 1 to January 12, 1986.

December 23–May 31, 1986: "Joseph Beuys–Palazzo Regale", 1985 at the Museo di Capodimonte, Naples (in collaboration with the Fondazione Amelio). Beuys creates his last environment consisting of two brass-framed glass vitrines containing relics from actions and souvenirs, and seven large brass boards covered with golddust and varnish.

> *I don't care about power in the institutional sense, or, even worse, about a monar-chist concept, which means anything which has to do with the Palazzo Regale, with the idea of stately power. The palace, which we need to conquer and inhabit with dignity, is man's head, our head. … The symbolic aspect of this work is very high, because I wanted to emphasize two components of my work, which I believe that they should be present in all actions of the human being: the celebration of self-determination of one's own life and gestures, as well as the modesty of our actions and our work in every moment. But this whole is expressed without much ado, in a very quiet manner.*

1986

January 12: Beuys is awarded the Wilhelm-Lehmbruck-Preises 1986 of the City Duisburg at the Wilhelm-Lehmbruck Museum, Duisburg.

January 23: Beuys' physical condition deteriorates increasingly due to his yearlong lung disease. He dies in his studio in Düsseldorf-Oberkassel following a heart attack.

March 21–June 14: Kunstmuseum Bern.

March 23–April 4: "Joseph Beuys, Enzo Cucchi, Anselm Kiefer, Jannis Kounellis," Kunsthalle Basel, Basel.

July 16–November 2: "Beuys zu Ehren," Städtische Galerie im Lenbachhaus, Munich.

1987

May 24–September 6: "Brennpunkt Düsseldorf: Joseph Beuys—Die Akademie—Der Allgemeine Aufbruch 1962–1987," Kunstmuseum Düsseldorf. Travels to Lijevalchs Konsthall (December 4, 1987–January 24, 1988) and the Centro Cultural de la Fondació Caixa de Pensions, Barcelona (April 18–May 22, 1988).

June 5–July 3: "Beuys, Klein, Rothko: Transformation and Prophecy," Anthony d'Offay Gallery, London. Travels to Sala de la Fondación Caja de Pensiones, Madrid (September 17–November 8).

June 19–August 16: "Warhol/Beuys/Polke," Milwaukee Art Museum. Travels to Contemporary Arts Museum, Houston (September 12–November 15).

October 9, 1987–June 19, 1988: "Joseph Beuys: Fond Sculptures, Codices Madrid Drawings (1974), and *700 Oaks*, a permanent installation furthering Beuys' Documenta VII project," Dia Art Foundation, New York.

November 18–December 23, 1989: "Bits and Pieces," Ronald Feldman Fine Arts, New York. Exhibition originated at Richard Demarco Gallery, Edinburgh, as "Bits and Pieces: A Collection of Works by Joseph Beuys from 1957 to 1985," assembled by Beuys for Caroline Tisdall.

1988

February 20–May 1: "Joseph Beuys: Skulpturen und Objekte," and "Joseph Beuys: The Secret Block for a Secret Person in Ireland (Zeichnungen)," Martin-Gropius-Bau, West Berlin. The latter exhibition travels to Kunsthalle Tübingen (May 14–July 10); Kunsthalle Bielefeld (December 11, 1988–February 26, 1989).

1990

June 28, 1990–January 6, 1991: "Joseph Beuys: Work from the Dia Art Foundation," The Menil Collection, Houston.

June 22–August 14: "The End of the Twentieth Century," Anthony d'Offay Gallery, London.

July 20–September 16: "Joseph Beuys: Eine innere Mongolei: Dschingis Khan, Schamanen Aktricen (Ölfarben, Wasserfarben und Bleistiftzeichnungen aus de Sammlung van der Grinten)," Kestner Gesellschaft, Hannover. The exhibition travels to Fundació Joan Miró, Barcelona (September 27–November 18); Bayerische Akademie der Schönen Künste, Munich (November 29, 1990–January 27, 199); Kunstakademie des Kanton Thurgau, Kartause, Ittigen (April 29–June 30, 1991); The State Russian Museum, St. Petersburg (June 25–July 28); and the Pushkin Museum of Fine Art, Moscow (August 5–September 6, 1992).

October 7–January 6, 1991: "Joseph Beuys: Plastische Bilder 1947–1970," Galerie der Stadt Kronwestheim, Kronwestheim. The exhibition travels to Hessisches Landesmuseum, Darmstadt through May 7, 1991.

1991

February 21–March 20: "Beuys: Manresa; Zeichnungen, Fotos, Materialien zu einer FLUXUS-Demonstration; 25 Jahre MANRESA, 50o Jahre Ignatius," Kunst-Station Sankt Peter, Cologne.

April 21–June 9: "Joseph Beuys," Städtisches Museum Haus Koekokkoek, Kleve.

May 19–June 30: "Brennpunkt 2, Düsseldorf 1970–1991, Die Siebziger Jahre, Entwürfe, Joseph Beuys zum 70. Geburtstag," Kunstmuseum Düsseldorf.

November 17–February 16, 1992: "Transit: Joseph Beuys: Plastische Arbeiten 1947–1977; Joseph Beuys: Zeichnungen 1947–1977; Joseph Beuys: Barraque d'Dull Odde: 1961–1967," Kaiser Wilhelm Museum, Krefeld.

November 30–February 9, 1992: "Joseph Beuys: Natur, Materie, Form," Kunstsammlung Nordrhein-Westfalen, Düsseldorf.

1992
January 23–April 4, 1993: "Joseph Beuys: Arena—Where Would I Have Got If I Had Been Intelligent! (1970–1972)," Dia Art Foundation, New York. The exhibition travels to Öffentliche Kunstsammlung Basel (February 13–June 26 1994).

1993
February 21-May 4: "Thinking Is Form: The Drawings of Joseph Beuys." This first major presentation in the U.S. of Beuys's drawings is shown at The Museum of Modern Art, New York, The Museum of Contemporary Art, Los Angeles (June 6–August 15), Philadelphia Museum of Art (October 10– January 2, 1994), and The Art Institute of Chicago (February 19–April 24, 1994).

April 7– January 3, 1994: "Joseph Beuys: The Revolution is Us," Tate Gallery, Liverpool.

November 26–February 20, 1994: "Joseph Beuys," Kunsthaus Zurich, is the first major traveling exhibition of Beuys's sculptural work after his death. After Zurich, it is shown in Madrid, at the Museo nacional Centro de arte Reina Sofia (March 15–June 6, 1994), and in Paris, at the Centre Georges Pompidou (June 30–October 3, 1994).

1997
May 24: Opening of Museum Schloss Moyland in Bedburg-Hau, home to the collection assembled by the brothers Franz Joseph and Hans van der Grinten, and the Joseph Beuys Archive. About 5,000 works form the core of the permanent collection.

June 7–July 12: "Joseph Beuys and Wilhelm Lehmbruck," at Michael Werner, Cologne.

September 14–January 4, 1998: "Joseph Beuys: Multiples," Walker Art Center in Minneapolis. The exhibition celebrates the acquisitions of more than 300 multiples.

1998
September 10–June 13, 1999: "Joseph Beuys: Drawings after the Codices Madrid of Leonardo da Vinci, and Sculpture," Dia Foundation for the Arts, New York.

1999
July 22–September 16: "Joseph Beuys: The Secret Block for a Secret Person in Ireland," Royal Academy of Art, London.

2001
June 10–November 4: 49th Venice Biennale, Venice. Exhibition of Beuys's environments.

2003
September 10–November 15: "Joseph Beuys: Works from the Speck-Collection," Gagosian Galleries, London and New York, February 14, 2004.

Notes

1. For the most comprehensive chronologies / biographies of Beuys life and work see: Götz Adriani, Winfried Konnertz, and Karin Thomas, *Joseph Beuys* (Cologne: DuMont, 1994), originally published in 1973, trans. Patricia Lech, *Joseph Beuys: Life and Works* (Woodbury, New York: Barron's Educational Series, 1979); Marion Hohlfeldt, *Joseph Beuys* (Paris: Centre Georges Pompidou, 1994); Heiner Stachelhaus, *Joseph Beuys* (Munich: Heyne 1987), trans. David Britt (New York: Abbeville Press, 1991). All three publications are the basis of this chronology and have informed the individual entries which remain unannotated if the sources are in agreement. Discrepancies are footnoted, so are sources of additional information. For additional exhibitions see also histories in Hohlfeldt, 1994, pp. 385-389 and Ann Temkin and Bernice Rose, *Thinking Is Form: The Drawings of Joseph Beuys* (Philadelphia and New York: Philadelphia Museum of Art and The Museum of Modern Art, 1993).

2. Beuys in Caroline Tisdall, *Joseph Beuys* (New York: Solomon R. Guggenheim Museum, 1979), p. 14.

3. In 1936, adherence to the Hitler Youth was enforced by law. See Hohlfeldt, 1994, p. 247.

4. Dating, according to Hohlfeldt, 1994, p. 247; Adriani, Konnertz, Thomas, 1994, p. 13 date this encounter to between 1934 and 1939, without giving an exact date.

5. Adriani, Konnertz, Thomas, 1994 doesn't mention this escapade; Stachelhaus, 1991 and Hohlfeldt, 1994 do.

6. Beuys in Hans van der Grinten, *Joseph Beuys –Tagung: Basel 1.-4. Mai 1991* (Basel: Wiese Verlag, 1991), p. 9.

7. See Frank Giseke and Albert Markart *Flieger Fitz und Vaterland: Eine erweiterte Beuys Biografie* (Berlin: Elefanten Press, 1996) pp. 38–39, Beuys recalled having rescued several books and catalogues from a book burning at his school. Giseke/Markart argue that there was no book burning in Kleve in 1938, but only in 1933, however, although there is no record of a state-ordered book burning in 1938, this does not exclude the possibility of smaller, local book burnings taking place alongside those of the National Socialist order. The book Beuys is referring to is probably August Hoff, *Wilhelm Lehmbruck, seine Sendung und sein Werk* (Berlin: Rembrandt-Verlag, 1936). See Pamela Kort, "Of Song and Silence", in Galerie Micahel Werner, *Lehmbruck / Beuys* (New York and Cologne: Galerie Michael Werner, 1997), footnote 10.

8. Joseph Beuys, "Dank an Wilhelm Lehmbruck," in Christoph Brockhaus, ed. Joseph Beuys: *Wilhelm-Lehmbruck-Preis 1986* (Duisburg: Wilhelm-Lehmbruck-Museum, 1986), unpaginated, reprinted in *Lehmbruck / Beuys*, 1997.

9. "Ich verdanke ihm [Lehmbruck] die Entscheidung, mich mit Plastik zu befassen. Als ich in meiner Jugend ganz zufällig einmal ein Heftchen mit Lehmbruck-Figuren in die Hände bekam, habe ich ganz spontan gesehen, dass so etwas mein Beruf sein würde. Diese einfachen Bilder von Lehmbruck-Plastiken sagten mir, mit der Plastik kann man alles, man kann etwas Umfassendes machen. Das ist deine Sache . . . Seine [Lehmbrucks] Skulpturen [werden] zu Dingen des Hörens, des inneren Hörens oder des Gedankens: Also Sinnbilder für etwas andeutet, dass die Zukunft der Skulptur sich im Zeitlichen vollzieht, also auch dem Werden und Vergehen ausgesetzt ist . . ." (author's translation) Beuys in an interview with Erhard Kluge, "Ich will gestalten, also verändern," *Vorwärts*, no. 5 (February 1, 1986), p. 19, reprinted in Adriani, Konnertz, Thomas, 1994, p. 203.

10. Hohlfeldt dates this visit to 1941.

11. See F. J. Verspohl, in "Beuys," *Saur, Allgemeines Künstlerlexikon*, (Munich and Leipzig: K.G. Saur Verlag, 1995), p. 295.

12. For a detailed analysis of the actual circumstances and the conflicting accounts surrounding the crash, see Peter Nisbet, "CRASH COURSE: Remarks on a Beuys Story," in Gene Ray, ed., *Joseph Beuys: Mapping the Legacy* (New York and Sarasota, Florida: D.A.P. and The John and Mable Ringling Museum of Art, 2001), pp. 5–17.

13. Beuys in Tisdall, 1979, p. 16.

14. The information in the logbook and on the certificate vary. See: Adriani, Konnertz, Thomas, 1994, footnote 15, p. 207.

15. According to Adriani, Konnertz, Thomas, 1994, Beuys joined the league in 1946 but as Kort's research proves, it was only reactivated in 1947. See Pamela Kort, "Beuys: The Profile of a Successor," in *Mapping*, 2001, p.22.

16. *Ibid.*, p. 20. According to Hohlfeldt Beuys continued to exhibit there until 1955. See Hohlfeldt, 1994, p. 250.

17. Adriani, Konnertz, Thomas date this encouter to 1950. Nevertheless, the date 1946 has been confirmed by the Stiftung Schloss Moyland.

18. Beuys in video, *Jeder Mensch ist ein Künstler*, realized by Werner Krüger, quoted in Hohlfeldt, 1994, p. 250.

19. *Tierbegegnungen* and *Hirschkuhs* Adriani, Konnertz, Thomas, 1994, p. 26 note that the van der Grintens bought a drawing and a woodcut, but according to the records of the Stiftung Schloss Moyland, Sammlung van der Grinten the first acquisition was indeed two woodcuts.

20. The date of the Ulysses drawings remains unclear; the Estate lists it as undated. The above dates are probable. See "Joseph Beuys," *Heft 11* (Darmstadt: Hessisches Landesmuseum Darmstadt, Graphische Sammlung, 1997) footnote 3.

21. The official title authorized by the Estate reads: *Joseph Beuys verlängert im Auftrag von James Joyce den Ulysses um sechs weitere Kapitel*. See discussion Darmstadt, 1997, foonote 1.

22. Hohlfeldt dates the move to 1961. See Hohlfeldt, 1994, p. 266.

23. Participants are Beuys, Brecht, Hansen, Higgins, Klintberg, Kopcke, La Monte Young, Maciunas, MacLow, Paik, Patterson, Schmit, Spoerri, Vostell, Watts, and Williams.

24. Beuys translated in Adriani, Konnertz, Thomas, New York, 1979, pp. 91-92.

25. Beuys in Tisdall, 1979, pp. 87-88.

26. *Piano Action*, 1963 and *Kukei / akopee-No! / Brown Cross / Fat Corners / Model Fat Corners*, 1964. See entries below.

27. See Joan Rothfuss, "Joseph Beuys: Echoes in America," in *Mapping*, 2001, p. 43.

28. Beuys in Tisdall, 1979, p. 87.

29. "Was die Materialien angeht, so habe ich eigentlich gar nichts Neues verwendet, sondern nur versucht, sie materiell umzusetzen." (author's translation) Beuys in Adriani, Konnertz, Thomas, 1994, p. 58.

30. Hohlfeldt gives Oct. 28 as opening date, Hohlfeldt, 1994, p. 272.

31. Participants listed on the poster announcing the event coorganized by Valdis Abolins and Tomas Schmit are: Eric Andersen, Joseph Beuys, Bazon Brock, Stanley Brouwn, Henning Christiansen, Robert Filliou, Ludwig Gosewitz, Arthur Koepke, Tomas Schmit, Ben Vautier, Wolf Vostell, and Emmet Williams.

32. Beuys in *Jürgen Becker and Wolf Vostell: Happenings / Fluxus / Pop Art / Nouveau Réalisme* (Reinbeck: Rowohlt, 1965), trans. in Tisdall, New York, 1979, p. 90.

33. Beuys in Stachelhaus, New York, 1991, p. 131.

34. Beuys in Tisdall, New York, 1979, p. 95.

35. Beuys in *Joseph Beuys, 1 1947–59*, (Cologne: Schirmer & Mosel, 1972), p. 10, translated in *Ibid.*, p. 101.

36. *Ibid.*, p. 105.

37. *Ibid.* Beuys explains the symbolism of the hare as follows: "The hare has things in common with the stag but has very different specialization in matters of the blood. While the stag's province is from the middle of the body up to the head, the hare relates more to the lower part of the body, so in particular he has a strong affinity to women, to birth, and to menstruation, and generally to chemical transformation of blood. That's what the hare demonstrates to us all when he hollows out his form: the movement of incarnation. The hare incarnates himself into the earth, which is what we human beings can only radically achieve with our thinking: he rubs, pushes, digs himself into Materia (earth); finally penetrates (rabbit) its laws, and through this work his thinking is sharpened then transformed, and becomes revolutionary." Beuys in *Joseph Beuys Zeichnungen* 1972, p. 10, translated in *ibid.*, p. 101.

38. *Thinking Is Form*, 1993, p. 267 lists closing date as January 30, 1966.

39. See Per Kirkeby, *2.15 (an extract)* (Kopenhagen: 1966), pp. 108–109. Hohlfeldt wrongfully states that this journey effectively took place, Hohlfeldt, 1994, p. 277.

40. *Thinking Is Form*, 1993 and Hohlfeldt, 1994 wrongly date the opening of the exhibition to the June 18; Adriani, Konnetz and Thomas list the 17th as the opening date. The 17th has been confirmed with René Block.

41. "Die Aula war vollkommen freigeräumt, ein grosser Saal, und an einer bestimmten Stelle der Zeit wurde das Piano reingeschoben – das eingenähte Biest da, und mit Reinschieben des Pianos, also dieser Sache mit den beiden roten Kreuzen, lief unten her mit der Bewegung die Spielzeugente und ein kleines Ambulanzauto, was auch ein rotes Kreuz hatte. Das wurde dann einfach in die Mitte gestellt. ...Also der grösste Komponist ist derjenige der leidet. Der überhaupt nichts mehr machen kann... Viele Menschen sind zwar schlau und intelligent, manche sind auch schön und können sehr schnell laufen, manche sind auch fähig zu grossen äusseren Werken, aber was ist denn mit den Menschen, die das alles nicht äussern können, wenn sie ein Schicksal antreffen, das sie an dieser Art von Produktion hindert. Das war die Idee, und das Contergan war genau das Datum." (author's translation). Beuys in Georg Jappe, "Am Klavier Joseph Beuys. Auskünfte anlässlich zweier Konzerte mit Nam June Paik," *Kunst Nachrichten*, vol. 21, no. 3 (May 1995), pp. 73–74.

42. It is unclear if the title should read 32nd or 34th movement. Troels Andesron, *Billedkunst*, no. 1 (1967), p. 52, speaks of the 34th movement, so does the Documenta V catalogue from 1972, and *Thinking Is Form*, 1993. Schneede in his catalogue raisonnée of the actions discusses both versions of the action under the title of the 32nd movement, suggesting that the renaming in the Documenta

catalogue might have been a mistake. See Uwe M. Schneede, *Joseph Beuys, die Aktionen: Kommentiertes werkverzeichnis mit fotografischen Dokumentation* (Ostfildern-Ruit bei Stuttgart: G. Hatje, 1994), p. 126, and footnote 1.

43. Beuys in Tisdall, 1979, pp. 106, 108.

44. "Der Hase ist das Element der Bewegung, der Aktion, die den starren Kunstbegriff ändert. Dann ein Bewohner von Eurasien, der über alle Grenzen hinweggeht und sogar mit der Berliner Mauer fertig wird. Damit hängt die Idee der Grossen Einheit zusammen, die von Mitteleuropa ausgeht. Der Hase ist ein altes germanisches Symbol: Sein Osterei bedeutete Neubeginn, Frühling, Auferstehung. Er steht als alchemistisches Zeichen für Umwandlung." (author's translation) Beuys in Schneede, 1994, p.129.

45. *Thinking Is Form*, 1993, p. 267, lists opening date as November 2nd and title as "Zeichnungen."

46. Beuys in Tisdall, 1979, p. 146.

47. DSP founding declaration protocol "Die Partei, die sich zum Grundgesetz in seiner reinen Form bekennt und grundsätzlich für die Menschenrechte eintritt, arbeitet für die notwendige Erweiterung des Bewusstseins mit geistigen, vernünftigen Methoden, also fortschrittlich für den Fortschritt, also menschlich, und betont deshalb die Radikalität ihrer Forderungen nach grundlegender Erneuerung aller herkömmlichen Formen in Leben und Denken der Menschen." (author's translation) in Adriani, Konnertz, Thomas, 1994, p. 88.

48. Beuys quoted in Lukas Beckmann, "The Causes Lie in the Future," in *Mapping*, 2001, p. 98.

49. Tisdall, 1979, p.108.

50. *Thinking Is Form*, 1993 and Hohlfeldt, 1994 use the alternate title *Bildkopf-Bewegkopf (Eurasienstab), Parallelprozess 2, Der Grosse Generator (Image-Head—Mover-Head [Eurasian Staff] Parallel Process 2, The Moving Insulator)* based on Adriani, Konnertz, Thomas, 1979. But Adriani, Konnertz, Thomas, 1994, p. 92, lists the action again as cited above.

51. Beuys in Tisdall, 1979, p. 114.

52. Professors Bobaschik, Bobek, Bretzer, Grote, Götz, Hoehme, Kricke, Sackenheim, Siefer.

53. Adriani, Konnertz, Thomas, 1979, p. 179.

54. Beuys in Georg Jappe, *Frankfurter Allgemeine Zeitung*, (February 11, 1969), translated in Stachelhaus, 1991, p. 157.

55. This is according to Adriani, Konnertz, Thomas, 1994. Hohlfeldt, 1993, pp. 312, 315 states that this organisation replaces Fluxus Zone West.

56. According to Adriani, Konnertz, Thomas, 1994, p. 108, this was April 1, but the Masson exhibition only opened May 1.

57. "On the trip to Edingburgh, I had absolutely no idea of what I was going to give a concert there. I had ordered film, a piano, and many other things. I did not know what had arrived. I only knew that I was to give a concert. I prepared myself inwardly. Upon my arrival, I saw am axe in a store, which I bought; I might be able to make use of that too. I brought the axe, and even though I didn't use it, it was good that it stood there . . . Then I began. I looked around the room and began to touch everything a little and to develop the appropriate symbols and to form a time plan. Then Henning Christiansen came. We simply began . . ." Beuys in Adriani, Konnertz, Thomas, 1979, p. 202.

58. ". . . lernt der Mensch, sich selbst und den Weltinhalt zu bestimmen. Nur aus diesem Punkt heraus geht die Selbstbestimmungskraft, die freie Selbstbestimmungs des Menschen hervor, und insofern sehe ich diesen Kunstbegriff als einen revolutionären an in seiner erstmals totalen Erweiterung, in seiner Totalität. Dann bin ich bereit zu spezialisieren und zu unterscheiden und zu sagen: Erst in einem bestimmten Punkt der menschlichen Biographie muß ja jeder Mensch zu einem Spezialisten in der arbeitsteiligen Gesellschaft werden . . . Bevor aber eine solche Entscheidung zum Spezialistentum erfolgt, muss ja der Mensch in diesem Begriff entwickelt sein, der der totale Kunstbegriff ist, das heißt, wie kann man aus den menschlichen Kräften des Denkens, Fühlens und Wollens heraus einen Menschen schaffen, der etwas bestimmen kann." (author's translation) Beuys interviewed by Peter Holtfreder, Susanne Ebert, Manfred König, Eberhard Schweigert. *Kommunikation Nr.1*, (Düsseldorf: Staatliche Kunstakademie 1973), reprinted in Adriani, Konnertz, Thomas, 1994, pp. 113–114.

59. "Der ganze Aktionscharakter und die Idee der Aktion ist ja die Idee einer Transformation, aus einem tradierten Kunstbegriff auszubrechen, also die Grenzscheide zu markieren zwischen einer tradierten, traditionellen Kunst, wobei die Moderne mit eingeschlossen ist, und einer anthropologischen Kunst, einer auf den Menschen generell ausgerichteten Kunst, die naturlich einen viel höheren Begriff von sich hat. . . . Also ist die Aktion das Transformierende in sich selbst und auch als Transformationsgang dargestellt." (author's translation) Beuys in Mario Kramer, *Joseph Beuys: Das Kapital Raum 1970–1977*, (Heidelberg: Edition Staeck, 1991), p. 10.

60. See discussion in Adrinai, Konnertz, Thomas, 1994, pp. 117–119.

61. Beuys in Adriani, Konnertz, Thomas, New York, 1979, p. 231. Original document in the archives of the Joseph Beuys Estate, Düsseldorf.

62. The exact date is questioned by Adriani, Konnertz, Thomas, 1994, p. 120.

63. According to Schneede, entries in Beuys's personal calender and expense report suggest this date. The location given by Schneede, namely a bog on the way from Düsseldorf to Eindhoven, close to Eindhoven, is in contradiction with Beuys's indication, the Zuider Zee in nearby Ostende—a topographical impossibility from which Schneede concludes that Ostende serves as a metaphor. Schneede, 1994, pp. 312–313.

64. Beuys in Tisdall, 1979, p. 39.

65. "Der Titel von diesem Werk gibt nicht direkt wieder, was wir sehen. Es stellt sich die Frage, was dort zu sehen ist." (author's translation) reprinted in Adriani, Konnertz, Thomas, 1994, p. 121.

66. Beuys in Adriani, Konnertz, Thomas, New York, 1979, p. 244.

67. Hohlfeldt, 1994, p. 320, dates this action to June 10. According to Schneede, 1994. p. 318 and Adriani, Konnertz, Thomas, 1994, p. 137 the Action takes place on June 15.

68. Beuys in Adriani, Konnertz, Thomas, New York, 1979, p. 128.

69. "Beuys Sieger durch Punkte für direkte Demokratie Treffer." translated in *ibid.*, p. 129.

70. *Thinking Is Form*, 1993, p. 268 and Hohlfledt, 1994, p. 285; the 1974 exhibition, "Collected Editions II" however, is not in the *Thinking Is Form* exhibition history.

71. Brutvan, Cheryl, "A Blackboard by Joseph Beuys," *Apollo* (London, England) vol. 157 (May 2003), pp. 32-33.

72. See Caroline Tisdall, "Beuys in America, or The Energy Plan for the Western Man," in *Joseph Beuys in America* (New York: Four Walls Eight Windows, 1990), p.8.

73. Ronald Feldman talks at length about Beuys's relationship with America and vice versa in an unpublished interview with Mark Rosenthal. See also Joan Rothfuss, "Joseph Beuys: Echoes in America," in *Mapping*, 2001, p. 51.

74. See Schneede, 1994, p. 325.

75. Beuys in Stachelhaus, 1991, p. 173.

76. "Kreativität ist nicht auf jene beschränkt, die eine der herkömmlichen Künste ausüben, und selbst bei diesen ist sie nicht auf die Ausübung ihrer Kunst beschränkt. Es gibt bei allen ein Kreativitätspotential, das durch Konkurrenz- und Erfolgsaggression verdeckt wird. Dieses Potential zu entdecken, zu erforschen und zu entwickeln, soll Aufgabe der Schule sein. . . . Es soll nicht Sinn der Schule sein, neue politische oder kulturelle Richtungen zu schaffen, Stile zu entwickeln, industriell und kommerziell verwendbare Modelle zu liefern; ihr Hauptziel ist die Ermutigung, Entdeckung und Förderung des demokratischen Potentials, dem Ausdruck verliehen werden soll. In einer mehr und mehr durch Werbung, politische Propaganda, durch Kulturbetrieb und Presse gesteuerten Welt sollte nicht Namen, sondern der Namenlosigkeit Forum geboten werden." (author's translation) Beuys in Adrinai, Konnertz, Thomas, 1994, pp. 139–40. Original manifest owned by the Joseph Beuys Estate.

77. Beuys in ibid., p. 140.

78. See Hohlfeldt, 1994, p. 341.

79. According to Adriani, Konnertz, Thomas 1994, p. 162 the exhibition opens on the 13th. The exhibition catalogue of "Tracce in Italia" doesn't indicate the dates, but both Hohlfeldt, 1994 and *Thinking Is Form*, 1993 list the exhibition as opening on the 17th.

80. Beuys in Adriani, Konnertz, Thomas, 1994, p. 169.

81. See Hohlfeldt, Paris, 1993, p. 348

82. "Das ist das Ende des XX. Jahrhunderts. Das ist die alte Welt, der ich den Stempel der neuen Welt aufdrücke. Schauen Sie, die Stöpsel, die kommen wie Pflanzen aus der Steinzeit. Ich habe sie mühsam trichterförmig aus dem Basalt gebohrt und dann wieder mit Filz und Ton in die Höhlung eingebettet, damit sie sich nicht so weh tun und es warm haben. Das ist etwas Bewegliches, Eruptives, Lebendiges in dieser erstarrten Masse— so wie auch der Basalt selbst einst aus dem Erdinnerern herausgepresst wurde." (author's translation) Beuys in Peter M. Bode, "Wie die Steine ein Gesicht bekommen," *Münchner Abendzeitung*, (February 16, 1984).

83. Hohlfeldt gives as a closing date January 15, 1984, see Hohlfeldt, 1993, p. 360.

84. Works added are an important number of drawings and the sculptures and installations *Aggregat (Aggregate)*, 1958, *The End of the Twentieth Century*, 1982/83, and *Kleines Kraftwerk (Small Power Station)*, 1984.

Bibliography

Selected Monographs and Exhibition Catalogues

Aachen, Suermondt-Ludwig-Museum und Museumsverein. *Kreuz + Zeichen: religiöse Grundlagen im Werk von Joseph Beuys.* Aachen, 1985.

Adriani, Götz, Winfried Konnertz, and Karin Thomas, *Joseph Beuys.* Cologne: DuMont, 1994. Originally published in 1973 and translated into English by Patricia Lech in 1979 and published as *Joseph Beuys: Life and Works.* Woodbury, N.Y.: Barron's Educational Series.

Adriani, Götz. *Joseph Beuys. Zeichnungen zu den beiden 1965 wiederentdeckten Skizzenbüchern 'Codices Madrid' von Leonardo da Vinci.* Stuttgart, 1975.

Arbeitskreis Block Beuys Darmstadt im Verein der Freunde und Förderer des Hessischen Landesmuseums in Darmstadt e.V. Vorträge zum Werk von Joseph Beuys. Darmstadt: J. Häusser, 1995.

Altenberg, Theo and Oswald Oberhuber, eds. *Gespräche mit Beuys: Joseph Beuys in Wien und am Friedrichshof.* Klagenfurt: Ritter, 1988.

Am Ende, Johannes. *Joseph Beuys und die Fettecke: eine Dokumentation zur Zerstörung der Fettecke in der Kunstakademie Düsseldorf.* Heidelberg: Edition Staeck, 1987.

Angerbauer-Rau, Monika. *Beuys Kompass: ein Lexikon zu den Gesprächen von Joseph Beuys.* Cologne: DuMont, c1998.

Antwerpen, Galerie Anny De Decker. *Joseph Beuys: Eurasienstab.* With texts by Antje von Graevenitz et. al. Antwerp, 1987.

Basel, Kunstmuseum. *Joseph Beuys: Werke aus der Sammlung Ströher.* Basel, 1969.

———. *Joseph Beuys. The secret block for a secret person in Ireland.* Basel, 1977.

Bastian, Heiner. Tod im Leben. *Gedicht für Joseph Beuys.* Munich: Hanser 1972.

———. *Joseph Beuys. Joseph Beuys. Strassenbahnhaltestelle.* Berlin, 1980.

———. *Joseph Beuys. Joseph Beuys. Kunst-Kapital.* Munich, 1980.

———. *Joseph Beuys Zeichnungen. Dessins.* Bern: Benteli Verlag, 1984.

———. *7000 Eichen.* Bern: Benteli Verlag, in association with Kunsthalle Tübingen, 1985.

———. *Abschied von Joseph Beuys: Noch steht Nichts geschrieben.* Cologne: Verlag der Buchhandlung Walther König, 1986.

———. *Joseph Beuys im Wilhelm-Lehmbruck-Museum Duisburg.* Bern: Benteli, 1987.

———. *Joseph Beuys: Skulpturen und Objekte.* Texts by Götz Adriani et al. Munich: Schirmer/Mosel, 1988.

———. *Joseph Beuys: The secret block for a secret person in Ireland.* Text by Dieter Koepplin; catalogue by Céline Bastian. Munich: Schirmer/Mosel, 1988.

———. *Joseph Beuys, Editionen: Sammlung Schlegel.* Berlin: Nationalgalerie, 1999.

Bedburg-Hau, Förderverein Museum Schloss Moyland. *Joseph Beuys. Kleine Zeichnungen aus dem Bestand der Stiftung Museum Schloss Moyland, Sammlung van der Grinten, Joseph-Beuys-Archiv des Landes Nordrhein-Westfalen.* Bedburg-Hau, 1995.

Bedburg-Hau, Förderverein Museum Schloss Moyland e.V. in collaboration with Stiftung Museum Schloss Moyland, Sammlung van der Grinten, Joseph-Beuys-Archiv des Landes Nordrhein-Westfalen. *Joseph-Beuys-Symposium, Kranenburg 1995.* Bedburg-Hau and Basel: Wiese-Verlag, 1996.

Bedburg-Hau, Förderverein Museum Schloss Moyland. *The Schloss Moyland Museum. Museum Schloss Moyland Foundation, Van der Grinten Collection, Joseph Beuys Archive of the Federal State of North Rhine-Westphalia.* Translated by Elizabeth Clegg. Munich; New York: Prestel, 1997.

Berlin, Galerie René Block in collaboration with Ronald Feldman Gallery, New York. *Aus Berlin: Neues vom Kojoten.* Berlin, 1979. 2nd ed. Berlin, 1981.

Berlin, Nationalgalerie. *Joseph Beuys: Zeichnungen. Tekeningen, Drawings.* Texts by Heiner Bastian and Jeannot Simmen. Berlin, 1979.

Beuys, Eva, Wenzel Beuys, and Jessyka Beuys. *Joseph Beuys: Block Beuys.* Photographs by Claudio Abate. Munich, Paris, London: Schirmer/Mosel, 1997.

Beuys, Eva, ed. *Das Geheimnis der Knospe zarter Hülle: Joseph Beuys Texte 1941-1986.* Munich: Schirmer/Mosel, 2000.

Beuys, Joseph. *1a gebratene Fischgräte.* Berlin: Hundertmark, 1972.

———. *Joseph Beuys, Fluxus, aus der Sammlung van der Grinten. Stallausstellung im Hause van der Grinten.* Kranenburg, Niederrhein. Kleve: G.W. Bösmann, 1963.

———. *Joseph Beuys, Zeichnungen 1947-59.* With a conversation between Joseph Beuys and Hagen Lieberknecht. Cologne: Schirmer Verlag, 1972.

Beuys, Wenzel. *Blitzschlag mit Lichtschein auf Hirsch: 1958-1985 von Joseph Beuys.* Heidelberg: Edition Staeck, 1987.

Bleyl, Matthias, ed. *Joseph Beuys: Der erweiterte Kunstbegriff*. Darmstadt: G. Büchner, 1989.

Blöss, Willi. *Joseph Beuys der lachende Schamane*. Michelsberg, Okandukaseibe, Namibia: Museum für das Unbewusststein, 1998.

Bodenmann-Ritter, Clara. *Joseph Beuys: Jeder Mensch ein Künstler. Gespräche auf der Documenta 5, 1972*. Frankfurt am Main; Vienna: Ullstein, 1975.

Bojescul, Wilhelm. *Zum Kunstbegriff des Joseph Beuys*. 2nd ed. Essen: Die Blaue Eule, 1987.

Bonn, Galerie Klein. *Joseph Beuys: Multiples, Bücher und Kataloge*. Bonn, 1973.

Borer, Alain. *The Essential Joseph Beuys*. Munich: Lothar Schirmer; London: Thames and Hudson, 1996. Authorized American edition Cambridge, Mass.: MIT Press, 1997.

Bremerhafen, Kunstverein Bremerhafen. *Joseph Beuys. Zeichnungen und Objekte*. Bremerhafe, 1978.

Brockhaus, Christoph, ed. *Reden zur Verleihung des Wilhelm-Lehmbruck-Preises der Stadt Duisburg 1986 an Joseph Beuys*. Duisburg: Wilhelm-Lehmbruck-Museum der Stadt Duisburg, 1986.

Brouns, Rieja. *Joseph Beuys: Strassenbahnhaltestelle*. Otterlo: Kröller-Müller Museum, 1994.

Bunting, Victoria. *Fat, sulphur, chocolate and blood: storage, preservation and a condition survey for a large collection of works by Joseph Beuys*. 1996.

Burckhardt, Jacqueline, ed. *Ein Gespräch / Una discussione: Joseph Beuys, Jannis Kounellis, Anselm Kiefer, Enzo Cucchi*, 2nd ed. Zurich, 1988.

Burgbacher-Krupka, Ingrid. *Prophete rechts, Prophete links—Joseph Beuys*. Nürnberg: Edition für moderne Kunst im Belser Verlag, 1977.

———. *Strukturen zeitgenössischer Kunst: eine empirische Untersuchung zur Rezeption der Werke von Beuys, Darboven, Flavin, Long, Walther*. Stuttgart Enke, 1979.

Buschkühle, Carl-Peter. *Wärmezeit: zur Kunst als Kunstpädagogik bei Joseph Beuys*. Frankfurt am Main; New York: P. Lang, 1997.

Celant, Germano. *Beuys tracce in italia*. Essays by Heiner Bastian, Achille Bonito Oliva, Caroline Tisdall et al. Naples: Amelio Editore, 1978.

Cologne, Galerie und Verlag Heinz Holtmann. *Joseph Beuys: Zeichnungen, Skulptur, Objekte, Multiples. Mit einem Beitrag zum Thema des Hasen bei Beuys*. Cologne, 1989.

Cooke, Lynn and Karen Kelly, eds. *Joseph Beuys. Arena: where would I have got if I had been intelligent!* New York: Dia Art Foundation and Distributed Art Publishers, 1994.

———. *Joseph Beuys: Drawings After the Codices Madrid of Leonardo da Vinci*. New York: Dia Art Foundation, in association with Richter Verlag, Düsseldorf, 1998.

Darmstadt, Hessisches Landesmuseum. *Joseph Beuys verlängert in Auftrag von James Joyce den Ulysses um sechs weitere Kapitel, 6 Heft*. Bonn: VG Bild-Kunst, 1997.

De Domizio Durini, Lucrezia. *The Felt Hat: Joseph Beuys A Life Told*. Translated by Howard Rodger Mac Lean. Milan: Edizioni Charta, 1997, 1st ed. 1979.

De Domizio Durini, Lucrezia, Buby Durini, and Italo Tomassoni, eds. *Incontro con Beuys*. Pescara, 1984.

De Domizio Durini, Lucrezia. *Olivestone: Joseph Beuys*. Zurich: Kunsthaus; Rome:

Edizione Carte segrete, 1992.

De Domizio Durini, Lucrezia, Italo Tomassoni, and Giorgio Bonomi. *Joseph Beuys: difesa della natura: diary of Seychelles*. Milan: Charta, 1996.

De Domizio Durini, Lucrezia. *Joseph Beuys. Sculptor of Souls: Olivestone*. Cinisello Balsamo, Milan: Silvana, 2001.

———. *La spiritualita di Joseph Beuys*. Cinisello Balsamo Milan: Silvana, 2002.

———. *Joseph Beuys Grassello: Ca (OH)2 + H20: difesa della natura*. Milan: Silvana, 2002.

Devolder, Eddy. *Joseph Beuys: social sculpture, invisible sculpture, alternative society, free international university: Conversation with Eddy Devolder*. Gerpinnes: Editions Tandem, 1988.

Düsseldorf, Kunstmuseum. *Joseph Beuys, Multiplizierte Kunst 1965-1980: Sammlung Ulbricht*. Düsseldorf, 1980.

———. *Joseph Beuys—Wasserfarben, Aquarelle und aquarellierte Zeichnungen, 1936—1976*. Düsseldorf, 1986.

Ende, Michael. *Kunst und Politik: Ein Gespräch. Joseph Beuys and Michael Ende*. Freie Volkshochschule Argental, Düsseldorf: Wangen, 1987.

Elsen, Beate. *Studien zu den Prinzipien der Installationen von Joseph Beuys: ein Beitrag zur Gegenstandssicherung*. Bonn: Rheinische Friedrichs Universität, 1992.

Gold, Helmut, Margaret Baumann, and Doris Hensch. *"Wer nicht denken will fliegt raus": Joseph Beuys Postkarten: Sammlung Neuhaus*. Heidelberg: Edition Braus, 1998.

Fabo, Sabine. *Joyce und Beuys: ein intermedialer Dialog*. Heidelberg: Winter, 1997.

Fauth-Lange, Barbara. *Joseph Beuys: Richtkräfte einer neuen Gesellschaft: der Mythos vom Künstler als Gesellschaftsreformer*. Berlin: Reimer, 1999.

Fischer, Knut and Walter Smerling. *Joseph Beuys im Gespräch mit Knut Fischer und Walter Smerling*. Cologne: Kiepenheuer & Witsch, 1989.

Frankfurt, Städtische Galerie im Städel. *Joseph Beuys. Bergkönig, 1958-61*. Frankfurt, 1983.

Free International University, Kassel. *Die unsichtbare Skulptur: Zum erweiterten Kunstbegriff von Joseph Beuys*. Stuttgart, 1989.

Gallwitz, Klaus, et al. *Beuys vor Beuys: Frühe Arbeiten aus der Sammlung van der Grinten: Zeichnungen, Aquarelle, Ölstudien, Collagen*. Bonn: Ministerium für Bundesangelegenheiten des Landes Nordrhein-Westfalen, 1987.

———. *Joseph Beuys. Blitzschlag mit Lichtschein auf Hirsch. Lightning with Stag in Its Glare: 1958-1985*. Text by Heiner Bastian. Translation by David Galloway and Christian Sabisch. 1st ed. 1986. Bern: Benteli, 1989.

Geisenberger, Jürgen. *Joseph Beuys und die Musik*. Marburg: Tectum-Verlag, 1999.

Gelsenkirchen, Städtisches Museum Gelsenkirchen. *Mensch, Natur und Kosmos: die Schöpfung im Frühwerk von Joseph Beuys. Eine Ausstellung aus der Stiftung Museum Schloss Moyland, Sammlung van der Grinten / Joseph Beuys Archiv des Landes Nordrhein-Westfalen zum internationalen Kongress der Europäischen Märchengesellschaft*. Gelsenkirchen, 1992.

Gieseke, Frank and Albert Markert. *Flieger, Filz und Vaterland. Eine erweiterte Beuys Biografie*. Berlin: Elefanten Press, 1996.

Goslar, Mönchehaus Museum fur Moderne Kunst. *Joseph Beuys, Zeichnungen und Objekte*. Goslar: Heinz Holtmann 1979.

Grenoble, Centre National d'Art Contemporain. *Joseph Beuys: Peintures a l'eau: aquarelles et dessins aquarelles: 1936-1976*. Grenoble, 1986.

Grigoteit, Ariane. *Joseph Beuys: Wasserfarbe auf Papier 1936-1984/85*. Frankfurt am Main: Kunstgeschichtliches Institut der Johann-Wolfgang-Goethe-Universität, 1992.

Grinten, Franz Joseph van der and Hans van der Grinten. *Joseph Beuys: Bleistiftzeichnungen aus den Jahren 1946-1964*. Berlin: Propyläen-Verlag, 1973.

———. *Joseph Beuys Wasserfarben / Watercolors: 1936-1963*. Translated by Theresa Margherita with the assistance of Pat Grayson. 1st. ed. Frankfurt am Main: Propyläen, 1975.

———. *Joseph Beuys: Ölfarben / Oilcolors 1936-1965*. Translated by John Gabriel. Munich: Prestel-Verlag, 1981.

Grinten, Frank Joseph van der. *Joseph Beuys. Plastische Bilder 1947-1970*. Stuttgart: Gerd Hatje, 1990.

Grinten, Frank Joseph van der und Friedhelm Mennekes. *Menschenbild—Christusbild*. Stuttgart, 1984.

Groener Fernando, and Rose-Maria Kandler, eds. *7000 Eichen: Joseph Beuys*. Essays by Joseph Beuys, Richard Demarco, Johannes Stüttgen, Rhea Thönges-Stringaris et al. Cologne, 1987.

Haenlein, Carl, ed. *Joseph Beuys. Eine innere Mongolei: Dschingis Khan, Schamanen, Aktricen. Ölfarben, Wasserfarben und Bleistiftzeichnungen aus der Sammlung van der Grinten*. Hannover: Kestner-Gesellschaft, 1990.

Harlan, Volker, Rainer Rappmann, and Peter Schata. *Soziale Plastik: Materialien zu Joseph Beuys*. 3rd ed. Achberg: Achberger Verlagsanstalt, 1984.

Harlan, Volker. *Was ist Kunst? Werkstattgespräch mit Beuys*. 4th ed. Stuttgart: Urachhaus, 1992.

Harlan, Volker, Dieter Koepplin, and Rudolf Velhagen. *Joseph Beuys - Tagung, Basel 1.—4. Mai 1991*. Basel: Wiese, 1991.

Hergott, Fabrice, and Marion Hohlfeldt. *Joseph Beuys*. Paris: Musée national d'art moderne. Centre de création industrielle, Centre Georges Pompidou, 1994.

Hülbusch, Karl Heinrich. *Joseph Beuys: 7000 Eichen zur Documenta 7 in Kassel: "Stadtverwaldung statt Stadtverwaltung": Ein Erlebnis- und gärtnerischer Erfahrungsbericht*. Kassel: Kasseler Verlag, 1984.

Janik, Jadwiga. *Polentransport 1981: opere di Joseph Beuys dal Muzeum Sztuki di Lodz. Works by Joseph Beuys from the Muzeum Sztuki in Lodz*. Milan: Mazzotta, 1993.

Jappe, Georg. *Beuys packen: Dokumente 1968-1996*. Regensburg: Lindinger and Schmid, 1996.

Joachimides, Christos M. *Joseph Beuys: Richtkräfte*. Berlin: Nationalgalerie, Staatliche Museen Preussischer Kulturbesitz, 1977.

Kaldewei, Gerhard et al. *Getlinger photographiert Beuys, 1950-1963*. Kalkar: Städtisches Museum; Cologne: DuMont, 1990.

Kleve, Städtisches Museum Haus Koekkoek *Joseph Beuys: Zeichnungen, Aquarelle, Ölbilder, plastische Bilder aus der Sammlung van der Grinten*. Kleve, 1961.

Klophaus, Ute. *Sein und bleiben: Photographie zu Joseph Beuys*. Texts by Laszlo Glozer and Margarethe Jochimsen. Bonn: Bonner Kunstverein, 1986.

———. *Wandlungen. Photographien zu den Aktionen von Joseph Beuys 'Iphigenie / Titus Andronicus'*. Munich, 1993.

Kleve, Freundeskreis Museum Kurhaus und Koekkoek-Haus Kleve e.V. *Joseph Beuys "Strassenbahnhaltestelle": ein Monument für die Zukunft*. Kleve, 2000.

Koepplin, Dieter. *Museumskunst und 'soziale Plastik': Joseph Beuys*. Sarbrücken: Funkkolleg moderne Kunst, 1990.

Kotte, Wouter and Ursula Mildner. *Das Kreuz als Universalzeichen bei Joseph Beuys: ein Requiem*. Stuttgart: Verlag Urachhaus, 1986.

Kramer, Mario. *Klang & Skulptur: der musikalische Aspekt im Werk von Joseph Beuys*. Darmstadt: Häusser, 1995.

———. *Joseph Beuys "Das Kapital Raum 1970-1977."* Heidelberg: Edition Staeck, 1991.

Kranenburg, Joseph-Beuys-Archiv des Landes Nordrhein-Westfalen. *Joseph Beuys. Multiplikationen: Druckgraphik und Serienobjekte aus der Sammlung van der Grinten*. Kranenburg, 1992.

Krenkers, Brigitte and Johannes Stüttgen. *Aktion Ost / West: Omnibus für direkte Demokratie im Deutschland*. Wangen: Freie Volkshochschule Argental, 1991.

Kuoni, Carin, ed. *Energy Plan for the Western Man: Joseph Beuys in America*. New York: Four Walls Eight Windows, 1990.

Lamarche-Vadel, Bernard. *Is it about a bicycle?* Paris: Marval, 1985.

Lauf, Cornelia. *Joseph Beuys: the pedagogue as persona*. Ph.D. diss. Columbia University, New York, 1992.

Leppien, Helmut Rudolf. *Joseph Beuys in der Hamburger Kunsthalle*. Hamburg: Kunsthalle, 1991.

Levin, Kim. *Joseph Beuys*. New York: Abbeville Press, 1986.

Liechtenstein, Staatliche Kunstsammlung. *Joseph Beuys. Späte Druckgraphik*. Liechtenstein, in association with Bern: Benteli-Verlag, 1996.

Liverpool, Tate Gallery. *Joseph Beuys: the revolution is us*. Liverpool, 1993.

Loers, Veit and Pia Witzmann. *Joseph Beuys: Documenta Arbeit*. Stuttgart: Edition Cantz; Kassel: Museum Fridericianum, 1993.

London, Anthony d'Offay. *Joseph Beuys: words which can hear*. London, 1981.

London, Institute for Contemporary Arts. *Art into Society—Society into Art*. Texts by Norman Rosenthal, Christos M. Joachimides, Joseph Beuys. London, 1974.

London, Victoria and Albert Museum, *Joseph Beuys: Drawings*. Text by Anne Seymour. London, 1983.

London, Royal Academy of Arts. *Joseph Beuys. The secret block for a secret person in Ireland*. London, 1999.

London and New York, Gagosian Gallery. *Joseph Beuys: Just Hit the Mark*. London and New York, 2003.

Luckow, Dirk. *Joseph Beuys und die amerikanische Anti Form-Kunst*. Berlin: Gebr. Mann Verlag, 1998.

Mennekes, Friedhelm. *Beuys zu Christus: Eine Position im Gespäch / Beuys on Christ: a position in dialogue*. Translation by Lesa Mason and Jon Boles. Stuttgart: Verlag Katholisches Bibelwerk, 1989.

———. *Joseph Beuys Manresa: eine Fluxus-Demonstration als geistliche Übung zu Ignatius von Loyola*. Frankfurt am Main: Insel, 1992.

———. *Joseph Beuys: Christus denken / thinking Christ*. Stuttgart: Verlag Katholisches Bibelwerk, 1996.

Meyer, Hans, Margarete Mitscherlich-Nileson, and Albert Schönherr. *Joseph Beuys: Reden über das eigene Land. Deutschland 3*. Munich: C. Bertelsmann, 1985.

Moffitt, John F. *Occultism in Avant-Garde Art: The Case of Joseph Beuys*. Ann Arbor, Mich.: UMI Research Press, 1988.

Mönchengladbach, Museumsverein Mönchengladbach, and Städtisches Museum Abteiberg Mönchengladbach. *7 Vorträge zu Joseph Beuys 1986*. Texts by Heiner Bastian, Johannes Cladders, Hans van der Grinten, Jonas Hafner, Johannes Stüttgen, Theodora Vischer, Armin Zweite. Cologne, 1986.

Müller, Martin. *Wie man dem toten Hasen die Bilder erklärt: Schamanismus und Erkenntnis im Werk von Joseph Beuys*. Alfter: Verlag und Datenbank für Geisteswissenschaften, 1993.

Münster, Westfälisches Landesmuseum für Kunst und Kulturgeschichte. *Joseph Beuys. Braunkreuz*. 2nd ed. Münster: Landschaftsverband Westfalen-Lippe, 1985.

Munich, A11 Artforum. *Joseph Beuys: a private collection*. Munich, 1990.

Munich, Schellmann and Klüser. *Joseph Beuys: Zeige deine Wunde*. 2 vols. Munich, 1976.

————. *Joseph Beuys, Zeichnungen: Teil I, 17 Zeichnungen "Gespräch mit Hagen Lieberknecht," 1972. Teil II, Zeichnungen, 1946-1974*. Munich, 1977.

Murken, Axel Hinrich. *Joseph Beuys und die Medizin*. Münster: Coppenrath, 1979.

New York, Dia Art Foundation. *Joseph Beuys*. New York, 1987.

New York, Marisa del Re Gallery. *Joseph Beuys: Is it about a bicycle?* New York, 1986.

New York, Hirschl & Adler Modern. *Joseph Beuys: Ideas and Actions*. New York, 1988.

New York, Michael Werner Gallery. *Joseph Beuys*. Text by Mark Rosenthal. New York, 1999.

New York, Michael Werner. *Joseph Beuys: Doppelaggregat, Bergkönig*, New York, 1999.

Nisbet, Peter. *Joseph Beuys Drawings*. Cambridge, Mass.: Harvard University Art Museums, 1984.

Oltmann, Antje. *"Der Weltstoff letzendlich ist… neu zu bilden": Joseph Beuys für und wider die Moderne*. Ostfildern: Tertium, 1994.

Oman, Hiltrud. *Die Kunst auf dem Weg zum Leben: Joseph Beuys*. Text by Lukas Beckmann. Weinheim: Quadriga, 1988.

Osterwold, Tillman and Thomas Knubben. *Joseph Beuys: Wasserfarben 1942-1963 aus dem Bestand der Stiftung Museum Schloss Moyland, Sammlung van der Grinten, Joseph Beuys Archiv des Landes Nordrhein-Westfalen*. Ostfildern-Ruit: Hatje, 1998.

Oxford, Museum of Modern Art. *Joseph Beuys. The secret block for a secret person in Ireland*. Texts by Caroline Tisdall, Joseph Beuys. Oxford, 1974.

Paik, Nam June. *Beuys Vox 1961–86*. Seoul, 1986.

Rappmann, Rainer E. *Kunst=Kapital: Achberger Vorträge*. Wangen: FIU-Verlag, 1992.

Raussmüller-Sauer, Christel. *Joseph Beuys und das Kapital: Vier Vorträge zum Verständnis von Joseph Beuys und seiner Rauminstallation "Das Kapital Raum 1970-77" in den Hallen für Neue Kunst, Schaffhausen, ergänzt durch Erläuterungen von Joseph Beuys und seinen "Aufruf zur Alternative."* Schaffhausen: Hallen für Neue Kunst, 1988.

Ray, Gene. *The use and abuse of the sublime: Joseph Beuys and art after Auschwitz*. Ph.D. diss. Universtity of Miami, 1997.

Ray, Gene, ed., *Mapping the Legacy*, New York and Sarasota: Distributed Art Publishers and The John and Mable Ringling Museum of Art, 2001.

Reithmann, Max. *Joseph Beuys. Par la présente, je n'appartiens plus à l'art*. Translated by Olivier Mannoni and Pierre Borassa. Paris: L'Arche, 1988.

Renn, Wendelin. *Joseph Beuys: Pflanze, Tier und Mensch. Aus dem Bestand der Stiftung Museum Schloss Moyland, Sammlung van der Grinten, Joseph Beuys Archiv des Landes Nordrhein-Westfalen*. Cologne: DuMont, 2000

Riedl, Peter Anselm. *Joseph Beuys, Zirkulationszeit*. Worms: Werner'sche Verlagsgesellschaft, 1982.

Romain, Lothar and Rolf Wedewer. *Über Beuys*. Düsseldorf, 1972.

Rönneper, Joachim, ed. *Kleider machen Leute. Joseph Beuys im Gespräch*. Cologne: Edition Fundamental, 1990.

Rosenthal, Mark. Joseph Beuys. B*litzschlag mit Lichtschein auf Hirsch*. Frankfurt am Main: Museum für Moderne Kunst, 1991.

Rywelski, Helmut. *Joseph Beuys. Heute ist Jeder Mensch Sonnenkönig*. Cologne: Art Intermedia, 1970.

Schade, Werner. *Joseph Beuys: Frühe Aquarelle / Early Watercolors*. Translated by Paul Kremmel. Munich: Schirmer Art Books, 1998.

————. *Joseph Beuys: Frühe Zeichnungen / Early Drawings*. Munich: Schirmer, 1998.

Schellmann, Jörg, ed. *Joseph Beuys. The Multiples*. 8th ed. (first full English-language edition), Munich and New York: Edition Schellmann and Distributed Art Publishers, 1997. Originally published as *Beuys, Mulitplizierte Kunst*, Jörg Schellmann and Bernd Klüser, eds. Munich: Schellmann & Klüser, 1971.

Schalhorn, Andreas. *Joseph Beuys: Das Ende des 20. Jahrhunderts*. Münster, 1995.

Schneede, Uwe M., ed. *Joseph Beuys in der Hamburger Kunsthalle*. Essay by Helmut Leppien. Hamburg, 1991.

Schneede, Uwe M. *Joseph Beuys: Die Aktionen*. Stuttgart: Gerd Hatje, 1994.

Schulz, Heribert. *Plazentavorstellung von Joseph Beuys: eine sythetische Anatomie*. Cologne: Salon Verlag, 1997.

————. *Pulsschlag: Herz-und Kreislaufkonzepte von Joseph Beuys*. Düsseldorf: Richter, 2003.

Stachelhaus, Heiner. *Joseph Beuys*. Translated in 1991 by David Britt and published by New York: Abbeville Press. Originally published Düsseldorf: Claassen, 1987.

Staeck, Klaus, ed. *Ohne die Rose tun wir's nicht. Für Joseph Beuys*. Heidelberg: Edition Staeck, 1986.

Staeck, Klaus and Gerhard Steidl. *Das Wirtschaftswertprinzip Joseph Beuys*. Essay by Jan von Hoet. Translation by S. Visser & Co. Heidelberg: Edition Staeck, 1990.

Staeck, Klaus, ed. *Joseph Beuys, "mit dummen Fragen fängt jede Revolution an": Die Sammlung Staeck*. Göttingen: Steidl, 1996.

Staeck, Klaus, and Gerhard Steidl. *Beuys in America*. Heidelberg: Edition Staeck, 1997.

Staeck, Klaus, ed. *Honey is flowing in all directions*. Photographs by Gerhard Steidl. Heidelberg: Edition Staeck and Göttingen: Steidel, 1997.

Stemmler, Dierk. *Zu den Multiples von Joseph Beuys*. Bonn: 1977.

———. *Joseph Beuys: Objekte, Zeichnungen, Multiples*. Bonn: Kunstmuseum, 1981.

Storck, Gerbard, et el. *Transit: Joseph Beuys*. Krefeld: Kaiser Wilhelm Museum, 1991.

Stuttgart, Institute for Foreign Cultural Relations. *Joseph Beuys: drawings, objects, and prints*. Stuttgart, 1989.

Stüttgen, Johannes. *Joseph Beuys. 7000 Eichen: Beschreibung eines Kunstwerks*. Düsseldorf: Free International University, 1982.

———. *Professor lag der Länge nach in Margarine*. Düsseldorf: Free International University, 1983.

———. *Über Joseph Beuys und jeden Menschen, das Erdtelephon und zwei Wolkenkratzer, über 7000 Eichen, 7000 Steine und ein schwarzes Loch*. Düsseldorf: Free International University, 1985.

———. *Freie Internationale Universität. Organ des erweiterten Kunstbegriffs für die Soziale Skulptur*. Wangen: Freie Volkshochschule Argental, 1987. 1st edition: Düsseldorf: Free International University, 1984.

———. *Der Fehler. (Ein Briefwechsel)*. Heidelberg, 1987.

———. *Zeitstau: im Kraftfeld des erweiterten Kunstbegriffs von Joseph Beuys: Sieben Vorträge im Todesjahr von Joseph Beuys*. Stuttgart: Urachhaus, 1988.

———. *Fettecke. Die Geschichte der Fettecke von Joseph Beuys in Raum 3*. Düsseldorf: Staatliche Kunstakademie, 1989.

———. *Der erweiterte Kunstbegriff und Joseph Beuys' Idee der Stiftung*. Cologne: Heinrich-Böll-Stiftung, 1990.

———. *Dann schneiden Sie mal ein Stück davon ab, dann ist sie nicht mehr ganz*. Cologne, 1991.

Szeemann, Harald and Tobia Bezzola. *Joseph Beuys*. Zurich: Kunsthaus, 1993.

Szeemann, Harald. *Beuysnobiscum*. Amsterdam; Dresden: Verlag der Kunst, 1997.

Temkin, Ann, and Bernice Rose. *Thinking Is Form: The Drawings of Joseph Beuys*. Philadelphia and New York: Philadelphia Museum of Art and The Museum of Modern Art; and London: Thames and Hudson, 1993.

Theewen, Gerhard. *Joseph Beuys Vitrinen: Ein Verzeichnis*. Cologne: Verlag der Buchhandlung Walther König, 1993.

Thönges-Stringaris, Rhea. *Letzter Raum: Joseph Beuys, dernier espace avec introspecteur*. Stuttgart: Verlag Freies Geistesleben, 1986.

———. *Je länger aber das Ereignis sich entfernt: zu Joseph Beuys und Peter Handke*. Wangen: FIU-Verlag, 2002.

Thistlewood, David. *Joseph Beuys: Diverging Critiques*. Liverpool: Liverpool University Press; Tate Gallery, 1995.

Tisdall, Caroline. *Joseph Beuys Coyote*. Munich: Schirmer/Mosel, 1976.

———. *Report to the European Economic Community on the feasibility of founding a 'Free International University for Creativity and Interdisciplinary Research' in Dublin*. Dublin: Free University Press, 1975.

———. *Joseph Beuys Coyote*. Munich: Schirmer/Mosel, 1976. 3rd edition 1988.

———. *Joseph Beuys*. New York: Solomon R. Guggenheim Museum, 1979.

———. *Joseph Beuys: dernier espace avec introspecteur, 1964-1982*. London: Anthony d'Offay Gallery, 1982.

———. *Bits & pieces: a collection of work by Joseph Beuys from 1957-1985*. Edinburgh: Richard Demarco Gallery, in association with Red Lion House and the Arnolfini Gallery, Bristol, 1987.

———. *Joseph Beuys: we go this way*. London: Violette Editions, 1998.

Verspohl, Franz-Joachim. *Joseph Beuys, das Kapital Raum 1970-77: Strategien zur Reaktivierung der Sinne*. Photographed by Ute Klophaus. Frankfurt am Main: Fischer Taschenbuch, 1984.

Verspohl, Franz-Joachim. *Plastik = Alles. Zu den 4 Büchern aus: "Projekt Westmensch" von Joseph Beuys*. Munich, New York: Schellmann, 1992.

Vierneisel, Klaus. *Hauptstrom Jupiter: Beuys und die Antike: aus dem Museum Schloss Moyland, Sammlung van der Grinten*. Munich: Schirmer/Mosel, 1993.

Vischer, Theodora. *Joseph Beuys: die Einheit des Werkes : Zeichnungen, Aktionen, plastische Arbeiten, soziale Skulptur*. Cologne: Verlag Walter König, 1991.

Vischer, Theodora. *Beuys und die Romantik: individuelle Ikonographie, individuelle Mythologie?* Cologne: Verlag Walter König, 1983.

Wangen, Free International University. *Joseph Beuys. Aktive Neutralität: Die Überwindung von Kapitalismus und Kommunismus.* Wangen, 1987.

Weber, Christa. *Vom "erweiterten Kunstbegriff" zum "erweiterten Pädagogikbegriff": Versuch einer Standortbestimmung von Joseph Beuys.* Frankfurt: Verlag für Interkulturelle Kommunikation, 1991.

Westermann-Angerhausen, Hiltrud, and Dagmar Täube. *Joseph Beuys und das Mittelalter.* Cologne: Schnütgen-Museum and Cantz Verlag, 1997.

Wiegand, Wilfried, et al. *Joseph Beuys: In Memorium, Joseph Beuys: Obituaries, Essays, Speeches.* Translated by Timothy Nevill. Bonn: Inter Nationes, 1986.

Wijers, Louwrien. *Schreiben als Plastik, 1978-1987.* Translation revised by Eva Beuys. Berlin: Ernst & Sohn; London: Academy Editions, 1992.

Wilp, Charles. Joseph Beuys. *Naturerfahrung in Afrika.* Fankfurt am Main: Qumran, 1980.

———. Jospeh Beuys. *Sandzeichnungen in Diani.* Frankfurt am Main: Qumran, 1981.

Wuppertal, Von der Heydt-Museum. *Joseph Beuys: Objekte und Zeichnungen aus der Sammlung van der Grinten.* Wuppertal, 1971.

Zumdick, Wolfgang. *Über das Denken bei Joseph Beuys und Rudolf Steiner.* Basel: Wiese, 1995.

Zurich, Galerie & Edition Schlegl. *Joseph Beuys: auch wenn ich meinen Namen schreibe zeichne ich.* Zurich, 1989.

Zweite, Armin. *Joseph Beuys: Zeige Deine Wunde.* Munich: Schellman and Klüser, 1980.

———. *Joseph Beuys. Arbeiten aus Münchener Sammlungen.* Munich: Städtische Galerie im Lenbachhaus, 1981.

———. *Beuys zu Ehren.* Translated by John Ormrod. Munich: Städtische Galerie im Lenbachhaus 1986.

———. *Joseph Beuys: Natur, Materie, Form.* Munich: Schirmer/Mosel 1991.

———. *Joseph Beuys. Palazzo Regale.* Berlin: Kulturstiftung der Länder; Düsseldorf: Stiftung Kunst und Kultur des Landes Nordrhein-Westfalen, 1992.

———. *Joseph Beuys: Werke aus der Sammlung Ulbricht.* Texts by Zweite und Bernd Finkeldey. Cologne: DuMont, 1993.

Selected Periodicals

"Itinerary: Joseph Beuys in the United States." *Arts Magazine*, vol. 8, no. 48 (May 1974), pp. 50–3.

"Prepare ye the way of the beuys. A beuys crying in the wilderness?" *Three*, no. 3, vol. 1 (1974), p. 1.

"Beuys. Tracce in Italia." *Flash Art*, 84/85 (1978), p. 4.

"Obituary." *Artweek*, vol. 17 (February 22, 1986), p. 7.

"I'm right and you're wrong! No, I'm right and you're wrong!." Interviews with Heiner Bastian and Julius Hummel. *Art Newspaper*, vol. 5 (July/September 1994), pp. 5–6.

"A slippery matter. The Case of Joseph Beuys's Olivestone: what determines value in conceptual art." *Art Newspaper*, vol. 7 (January 1997), p. 20.

Adams, Brooks. "Landscape Drawings of Joseph Beuys." *The Print Collector's Newsletter* (New York), vol. 10 (November/December 1979), pp. 148–53.

Adams, Brooks. "Joseph Beuys." *Arts Magazine* (New York), vol. 54, no. 5 (January 1980), p. 21.

Adams, Brooks. "Panel Discussion with Joseph Beuys." *Artforum*, vol. 7, no. 18 (March 1980), pp. 72–73.

Adams, David. "Joseph Beuys: Pioneer of a Radical Ecology." *Art Journal*, vol. 2, no. 51 (Summer 1992), pp. 26–34.

Ammann, Jean-Christophe. "A Talk Joseph Beuys, Jannis Kounellis, Anselm Kiefer, Enzo Cucchi." *Flash Art* (International Edition), no. 128 (May/June 1986), pp. 36–39.

Ashbery, John. "Crowd Teasers: Beuys and Warhol." *New York*, no. 49, vol. 12 (1979), p. 169.

Ak, Edit de, and Walter Robinson. "Beuys: Art Encagé." *Art in America*, vol. 6, no. 62 (November–December 1974), pp. 76–79.

Baker, George and Christian Philipp Muller. "A balancing act." *October* (Cambridge, Mass.), no. 82 (Fall 1997), pp. 94–118.

Belz, Carl. "Joseph Beuys's American Debut." *Art in America*, vol. 5, no. 60 (September/October 1972), pp. 102–3.

Benjamin, Andrew. "Repeating Themes: Notes on Haacke, Kiefer, Beuys." *Art and Design*, vol. 5, nos. 9/10 (1989), pp. 35–38.

Bell, J. "Joseph Beuys." *Art News*, vol. 85, no. 4 (1986), pp. 68–76.

Bird, Michael. "Joseph Beuys Works From the Speck Collection." *Modern Painters*, vol. 16 no.4 (Winter 2003), pp. 120–21.

Bonami, Francesco. "Every artist can be a man: the silence of Beuys is understandable." *Parkett*, no. 59 (2000) pp. 60–73.

Briers, David. "Some Notes on the Relation of Photography-Performance." *Creative Camera*, no. 240 (December 1984), pp. 167–69.

Briers, David. "Sense and incense." *Art Monthly*, no. 229 (September 1999), pp. 46–47.

Broner, K. "Joseph Beuys. Social Sculpture." *Taide*, no. 2, vol. 21 (1980), pp. 26–31.

Brutvan, Cheryl. "A Blackboard by Joseph Beuys." *Apollo* (London), vol. 157 (May 2003), pp. 32–33.

Buchloh, B.H.D., R. Krauss, and A. Michelson. "Joseph Beuys at the Guggenheim." *October*, no. 12 (Spring 1980), pp. 3–21.

Buchloh, Benjamin H.D., "Beuys: The Twilight of the Idol." *Artforum*, vol. 5, no. 18 (January 1980), pp. 35–43.

Bürgi, Bernhard. "Joseph Beuys. Sand Drawings in Diani." *Arena International Art*, January 1989, pp. 75–86.

Burnham, J. "Beuys. Götterdämmerung at the Guggenheim." *New Art Examiner*, no. 7 (March 1979), pp. 169+.

Carry, Rickey. "Joseph Beuys. Ronald Feldman Fine Arts." *Artforum*, no. 6 (1980), p. 95.

Cavaliere, B. "Joseph Beuys." *Art Magazine*, vol. 54, no. 6 (1980), p. 34.

Christ, William and Barbara Mueller. "Recollections of Joseph Beuys." *New Art Examiner*, vol. 8, no. 13 (1986), pp. 26+.

Coetzee, C.L., "Liberty, Art and fraternity. Joseph Beuys and the symphonic education of post-war Europe." *South Africa*, no. 3 (1989).

Codognato, Mario. "Joseph Beuys." *Flash Art* (International Edition), no. 125 (December/January 1985–86), p. 48.

Cooke, Lynne, "Beuys. Dernier espace avec introspecteur." *Art Monthly*, no. 56 (1982), pp. 11+.

———. "Joseph Beuys." *The Burlington Magazine*, vol. 127 (December 1985), pp. 921–22.

———. "Joseph Beuys." *The Burlington Magazine*, vol. 130 (July 1988), pp. 557–58.

———. "Critical constructions: the interpretation of the contemporary visual arts. (On recreating a site-specific installation by Joseph Beuys)." *Kunst & Museumjournal*, vol. 6, no. 5 (1995), pp. 52–57.

Crist, William, and Barbara Muelle. "Recollection of Joseph Beuys." *New Art Examiner*, vol. 13 (April 1986), pp. 26–27.

Crow, Thomas. "The Graying of Criticism." *Artforum*, vol. 1, no. 32 (September 1993), pp. 185, 187–88.

D'Arcy, David. "Beuys takes notes on Leonardo." *Art Newspaper*, vol. 10, no. 90 (March 1999) p. 23.

Davvetas, Démosthènes. "Joseph Beuys—Man is Sculpture." *Art and Design*, vol. 5, nos. 9/10 (1989), pp. 14–27.

Demarco, Richard. "Richard Demarco interviews Joseph Beuys." *Studio International*, vol. 195, no. 996 (September 1982), pp. 46–47.

Demarco, Richard. "Memories of Joseph Beuys." *Studio International*, vol. 199, no. 1012 (March 1986), pp. 54–55.

Dimitrijavic, Nena. "Joseph Beuys. Drawings." *Flash Art*, no. 114 (1983), p. 71.

Dornberg, John. "Where's the grease?" *Art News*, vol. 3, no. 87 (March 1988), p. 13.

———. "Beuys butter battle." *Art News*, vol. 4, no. 88 (1989), p. 23.

———. "The Loved ones in the castle. *Art News*, vol. 93 (April 1994), pp. 154–57.

Douglas, David. "Pied Piper." *Newsweek*, no. 18 (1972), p. 53.

Duve, Thierry de. "Joseph Beuys, or the Last of the Proletarians." *October*, no. 45 (Summer 1988), pp. 47–62.

———, "Marcel Duchamp, or the 'Phynancier' of Modern Life." *October*, no. 52 (Spring 1990), pp. 60–75.

Ellmann, L. "Jospeh Beuys. Anthony d'Offay, London." *Arts Review*, vol. 32, no. 17, pp. 374+.

Faxon, Alicia. "Newport Art Museum/Newport: Joseph Beuys, selected prints and multiples." *Art New England*, vol. 17 (August/September 1996), pp. 49–50.

Flood, Richard. "Wagner's Head." *Artforum*, vol. 1, no. 21 (September 1982), pp. 68–70.

Frackman, Nol. "Joseph Beuys." *Arts Magazine*, vol. 10, no. 49 (1974), p. 23.

Francklan, Catherine. "Joseph Beuys, a spotless retrospective." *Art Press*, no. 194 (September 1994) p. 20–22.

———. "Joseph Beuys: the Most Fascinating of Enigmas." *Art News*, no. 4, vol. 72 (April 1973), p. 51.

Franzke, Andreas. "New German Sculpture: The Legacy of Beuys." *Art and Design*, vol 5, nos. 9/10 (1989), pp. 28–34.

Furlong, Anthony. "Plight. Interview with Joseph Beuys." *Art Monthly*, no. 112 (December 1987/January 1988), pp. 7–8.

Gale, P. "Explaining Pictures to a dead air: The Robertson/Beuys Admixture." *Parachute*, no. 14 (1979), pp. 4-8.

Galloway, David. "Beuys and Warhol: Aftershocks." *Art in America*, vol. 7, no. 76 (July 1988), pp. 112–23.

Germer, Stefan. "Haacke, Broodthaers, Beuys." *October*, no. 45 (1988), pp. 63–75.

Gleadell, Colin. "New beginnings: developments in the Beuys market." *Art Monthly*, no. 129 (September 1989), pp. 40–47.

Godfrey, Tony. "Joseph Beuys: drawings and water-colours." *The Burlington Magazine*, vol. 133 (March 1991), pp. 209–10.

Glozer, Laszlo. "On Blinky Palermo: A Conversation with Joseph Beuys." *Arts Magazine*, vol. 7, no. 64 (March 1990), pp. 60–65.

Goodman, Jonathan. "Joseph Beuys: drawings after the Codices Madrid of Leonardo da Vinci." *Art On Paper*, vol. 3, no. 5 (May/June 1999), pp. 62–63.

Goodrow, Gerard A. "Beuys: voting right is voting left." *Art News*, vol. 90 (October 1991), pp. 50+.

Gowing, Lawrence. "Introducing Mr. Beuys." *The Sunday Times Magazine*, August 17, 1980, p. 26.

———. "In Search of Beuys." *London Magazine*, vols. 11/12, no. 20 (February/March 1981), pp. 39—49.

Giuliano, Charles. "More Beuys." *Art New England*, vol. 18 (April/May 1997), pp. 82+.

Hall, James. "The Art Market: Joseph Beuys: Fat Profits." *Apollo*, vol. 129, no. 328 (June 1989), pp. 406-8.

Hatton, Brian. "Conference report—Joseph Beuys: then and now." (Tate Gallery, Liverpool), *Art Monthly*, no. 172 (December 1993/January 1994), p. 34.

Haxthausen, Charles Werner. "Thinking as form: the drawings of Joseph Beuys." *The Burlington Magazine*, vol. 136 (January 1994), pp. 53–54.

Hayes, Christa-Maria Lerm. "Joseph Beuys Extends James Joyce's Work." *Circa* (Belfast, Northern Ireland), no.104 (Summer 2003), pp. 35–39.

Horsefield, Kate. "On Art and Artists: Joseph Beuys." *Profile*, no. 1 (1981), p. 5.

Hukkila, K. "Beuys, Honey and the Golden Age." *Taide*, vol. 4, no. 27 (1986), pp. 14–21.

Hübl, M. "Joseph Beuys." *Art News*, vol. 87, no. 6 (1988), p. 207.

Jappe, Georg, "A Joseph Beuys Primer." *Studio International*, vol. 183, no. 936 (September 1971), p. 65.

———. "The Beuys Example." *Studio International*, vol. 184, no. 950 (December 1972), pp. 228–29.

———. "Not just a few are called, but everyone." *Studio International*, vol. 184, no. 950 (December 1972), pp. 226–28.

Jeffreys, David. "London: Joseph Beuys." *The Burlington Magazine*, vol. 141, no. 1158 (September 1999), p. 561.

Kirk, M., "Joseph Beuys at the Australian National Gallery." *Art and Australia*, vol. 22 (March 1985), pp. 375–77.

Kletke, Daniel. "Beuys in the Schloss." *On Paper*, vol. 2 (September/October 1997), p. 4.

Knight, Graham. "The Secret Block for a Secret Person in Ireland." *Southern Arts Magazine*, May 1974, p. 22.

Krupka, I., and U. Meyer. "Joseph Beuys: I Speak for the Hares." *Print Collector's Newsletter*, vol. 4, no. 6 (September–October 1973), pp. 73–76.

Kuester, K. "Robert Irwin and Joseph Beuys. Creative Transformation and the New Age Artist." *New Art Examiner*, no. 8 (February 1980), p.10.

Kuspit, Donald B. "Beuys: Fat, Felt and Alchemy." *Art in America*, no. 5, vol. 68 (May 1980), pp. 78–89.

———. "Beuys or Warhol?" *C Magazine*, no. 15 (Fall 1987), pp. 26–27.

———. "Joseph Beuys." *Artforum*, vol. 27, no. 6 (1989), pp. 127+.

———. "Joseph Beuys: the Body of the Artist." *Artforum*, vol. 10, no. 29 (Summer 1991), pp. 80—86.

———. "Cabinet of wonders." *On Paper*, vol. 2 (March/April 1998), pp. 4–7.

Lamb, Robert. "How to explain Joseph Beuys to Peter Fuller." *Modern Painters*, vol. 8 (Winter 1995), pp. 58–61.

Larson, Kay. "Joseph Beuys: Shaman, Sham, or Brilliant Artist?" *Art News*, vol. 4, no. 79 (April 1980), pp. 126–27.

Larson, Philip. "Joseph Beuys." *On Paper*, vol. 2 (November/December 1997), pp. 43–44.

Latham, John, and Richard Hamilton. "Joseph Beuys (1921—1986)." *Art Monthly*, no. 94 (March 1986), pp. 9–11.

Lauf, Cornelia. "Beuys, Knoebel and Palermo: changing the guard at Dia." *Arts Magazine*, vol. 9, no. 62 (May 1988), pp. 70–73.

———— "The Word that Produces all Images: Reading the Drawings of Joseph Beuys." *Arts Magazine*, vol. 7, no. 64 (March 1990), pp. 66–71.

Levin, Kim. "Joseph Beuys: The New Order." *Arts Magazine*, vol. 8, no. 54 (April 1980), pp. 154–57.

Lloyd, Jill. "German Sculpture since Beuys: Disrupting Consumerist Culture." *Art International*, vol. 6, no. 33 (Spring 1989), pp. 8–16.

Mandel, C. "Joseph Beuys at the York University Art Gallery." *Arts Magazine*, no. 12 (1981), p. 68.

Maestri, B. "Joseph Beuys." *Artforum*, vol. 24, no. 9 (1986), p. 150.

Marzorati, Gerald. "Beuys will be Beuys. Portrait of the Artist." *SoHo*, vol. 7, no. 5 (November 1979).

MacAdam, Barbara. "Beuys will be Beuys." *Art News*, vol. 92 (March 1993), p. 22.

———. "Thinking is form, the drawings of Joseph Beuys." *Art News*, vol. 92 (May 1993), p. 131.

———. "Wilhelm Lehmbruck, Joseph Beuys." *Art News*, vol. 97 (February 1998), p. 118.

McEvilley, Thomas. "Art in the Dark." *Artforum*, vol. 10, no. 21 (June 1983), pp. 62–71.

———. "Hic Jacet Beuys." *Artforum*, vol. 9, no. 24 (May 1986), pp. 130–31.

Macmillan, D. "Joseph Beuys in Edinburgh." *Arts Review*, vol. 20, no. 32 (1980), p. 456.

McKintosh, Alistair. "Beuys in Edingburgh." *Art and Artists*, vol. 5 (1970), p. 10.

MacRitchie, Lynn. "Joseph Beuys." *Performance Magazine*, vol. 25 (August/September 1983), pp. 8–11.

Maila, Katriina, and Vikkari Tuominen. "The Man Behind the Myth: Joseph Beuys, an Account by Heiner Bastian." *Taide*, vol. 5, no. 27 (1986), pp. 51–53.

Mesch, Claudia. "Joseph Beuys multiples." *Sculpture* (Washington, D.C.), vol. 17, no. 2 (February 1998), pp. 64–65.

Meyer, Ursula. "How to Explain Pictures to a Dead Hare." *Art News*, vol. 68, no. 9 (1970), pp. 54+.

———. "Joseph Beuys. I speak for the Hares." *The Print Collector's Newsletter*, vol. 4 (1973), pp. 7+.

Michaud, Eric. "The End of Art according to Beuys." *October*, vol. 45 (Summer 1988), pp. 37–46.

Morgan, Robert C. "Who was Joseph Beuys?" *High Performance*, vol. 1, no. 9 (1986), pp. 20–26.

———. "Joseph Beuys: ideas and actions." *Arts Magazine*, vol. 63 (March 1989), pp. 100–101.

Morgan, Stuart. "Joseph Beuys, Anthony d'Offay Gallery, London." *Artforum*, vol. 20, no. 10 (1982), p. 95.

———. "Letters to a Wound." *Artscribe International*, no. 55 (December 1985–January 1986), pp. 32–37.

———. "On the canonisation of Joseph Beuys." *Art Monthly*, no. 155 (April 1992), pp. 22–23.

Morris, Lynda. "The Beuys Affair." *Studio International*, vol. 184, no. 950 (December 1972), p. 226.

Neugass, Fritz. "Artists and Students Rally to Beuys." *Art News*, no. 2, vol. 72 (February 1973), p. 77.

Ottmann, Klaus. "The World According to …Byars, Beuys, Dokoupil." *Flash Art*, no. 125 (December 1985/January 1986), pp. 55–56.

Ottmann, Klaus. "Heidegger, Beuys and the Consequences." *Flash Art*, no. 154 (October 1990), pp. 123–24.

Parcellin, Paul. "Joseph Beuys at the Busch-Reisinger Museum." *Art New England*, vol. 22, no. 2 (February/March 2001), pp. 18–19, 87.

Phillips, Christopher. "Court fight over Beuys resale royalties." *Art in America*, vol. 80 (July 1992), p. 29.

———. "Back to Beuys." *Art in America*, no. 9, vol. 81 (September 1993), pp. 88—93.

———. "Beuys fakes?" *Art in America*, vol. 7, no. 81 (July 1993), p. 29.

———. "Joseph Beuys." *Art News*, vol. 8, no. 4 (1982).

Plouffe, Paul-Albert. "Joseph Beuys: Avers et Revers." *Parachute*, vol. 21 (Winter 1980), pp. 32–41.

Politi, Giancarlo. "Joseph Beuys: la rivoluzione siamo noi, we are the revolution." *Flash Art* (International Edition), no. 169 (March/April 1993).

Price, Jonathan, "Listening to Joseph Beuys: A Parable of Dialogue." *Art News*, no. 6, vol. 73 (Summer 1974), pp. 50, 52.

Raetzo, D. "Kunst und Gesellschaft. Joseph Beuys im Gespräch mit Bruno Kreisky." *Du*, no. 5, (1983), p. 90.

Rainbird, Sean. "Joseph Beuys, works on paper." *The Burlington Magazine*, vol. 130 (June 1988), pp. 487–88.

Rein, Ingrid. "Hommage a Beuys." *Artforum International*, vol. 25 (December 1986), pp. 128–29.

Reinke, Klaus U. "Düsseldorf Academy of Art." *Studio International*, no. 183 (1972), pp. 84–85.

Risaliti, Sergio. "Interview with Harald Szeemann." *Flash Art* (International Edition), no. 175 (March/April 1994).

Robinson, Walter. Obituary. *Art in America*, vol. 74 (March 1986), p. 182.

Rohan, M., "New Thoughts on Joseph Beuys' Early Development." *Dumb Ox*, no. 8 (Winter 1979), pp. 22–23, 42–48.

Rosenthal, Mark. "Beuys will be Beuys." *Contemporeana 8*, June 1989, pp. 56–63.

———. "Le dialogue de Joseph Beuys avec la geometrie a l'ecart du minimalisme americain." *Revue de l'Art*, no. 113 (1996), pp. 74–85.

———. "German shepherd." *Art News*, vol. 98 no. 5 (May 1999), p. 128.

Rothfuss, Joan. "Joseph Beuys." *The Burlington Magazine*, vol. 136 (June 1994), pp. 400–401.

Russell, John. "The Shaman as Artist." The *New York Times Magazine*, October 28, 1979, p. 38.

Salvioni, Daniela. "Beuys, Knoebel, Palermo." *Flash Art* (International Edition), no. 138 (January/February 1988), p. 120.

Scharp, Willoughby. "An Interview with Joseph Beuys." *Artforum* (December 1969), pp. 40–47.

Schindler, Richard A. "Democracy is fun! Joseph Beuys and the aesthetics of activism." *New Art Examiner*, vol. 24 (October 1996), pp. 20–25.

Schwartz, Sanford. "Anselm Kiefer, Joseph Beuys and the Ghosts of the Fatherland." *New Criterion*, no. 7, vol. 1 (1983), pp.1–9.

Seidel, Miriam. "Lines of force," *New Art Examiner*, vol. 21 (January 1994), pp. 24–27.

Siegel, Katy. "Joseph Beuys." *Artforum International*, vol. 36, no. 8 (April 1998), pp. 121–22.

Silberman, Robert. "Minneapolis: Joseph Beuys multiples." *The Burlington Magazine*, vol. 140 (March 1998), pp. 225–27.

Spens, Michael. "Joseph Beuys, 1921–1986." *Studio International*, vol. 199, no. 1012 (March 1986), p. 2.

Steinberg, Ellen. "Joseph Beuys." *New Art Examiner*, vol. 21 (May 1994), p. 42.

Stevens, Mark. "Art's Medicine Man." *Newsweek*, November 12, 1979, p. 76.

———. "The Witch Doctor of German Art." *Vanity Fair*, February 1993, pp. 120–25.

Storr, Robert. "Beuys's boys." *Art in America*, vol. 3, no. 76 (March 1988), pp. 96–103, 167.

Strauss, David Levi. "American Beuys: 'I like America and America likes me.'" *Parkett*, vol. 26 (December 1991), pp. 124–36.

———. "American Beuys: 'I like America & America likes me." *Art Criticism*, vol. 1, no. 8 (1993), pp. 1–2.

Suquet, Annie. "Archaic thought and ritual in the work of Joseph Beuys," *Res* (Cambridge, Mass.), no. 28 (Autumn 1995), pp. 148–62.

Svan, L. "Joseph Beuys and his World of Ideas through his Watercolours." *Paletten*, vol. 1 (1979), p. 14.

Sviblova, Olga. "Beuys: Eastern front" *Art Press*, vol. 194 (September 1994), pp. 23–25.

Sylvester, David. "On Beuys." *Art in America*, vol. 87, no. 4 (April 1999), pp. 114–17.

Taylor, Paul. "Café Deutschland: Art after Beuys." *Art News*, vol. 4, no. 85 (1986), pp. 68–76.

Takalo-Eskola, Ikka-Juhani. "Did you feel the earthquake thoughts after the Beuys exhibition?" *Taide*, no. 3, vol. 28 (1987), pp. 56–61.

Thwaites, John Anthony, Alastair McKintosh. "The Ambiguity of Joseph Beuys. Proteus in Düsseldorf." *Art and Artists*, vol. 7, no. 6 (November 1971), pp. 22–23.

Tisdall, Caroline. "Joseph Beuys." *Arts Guardian*, (1972).

———. "Beuys: 'The Coyote'." *Art-Rite*, no. 6 (Summer 1974), pp. 6–7.

———. "Three Pots Action in the Poor House." *Lotta Poetica*, no. 46 (1975), p. 46.

———. "Beuys: 'Coyote'." *Studio International*, vol. 192, no. 982 (July/August 1976), pp. 36–40.

———. "Jimmy Boyle, Joseph Beuys. A Dialogue." *Studio International*, vol. 191, no. 980 (March/April 1976), pp. 36+.

———. "Beuys class (mit, neben, gegen): Kunstverein Frankfurt." *Studio International*, vol. 193, (1977), p. 29.

———. "Tram stop: Joseph Beuys's terminal memory." *Flash Art* (International Edition), vol. 169 (March/April 1993), p. 56.

Toole, B. "Joseph Beuys." *Parachute*, vol. 4 (1976), pp 20+.

Unger, Miles. "Busch-Reisinger Museum, Harvard University/Cambridge: Joseph Beuys: in/tuition." *Art New England*, vol. 19 (December 1997/January 1998), p. 54.

Walker, J.A. "Joseph Beuys. 'The Secret Block for a Secret Person in Ireland.' at the Museum of Modern Art Oxford." *Studio International*, vol. 87 (1974), p. 310.

Watson, Gray. "Beuys' line to Bond Street. Interview with Anthony d'Offay." *Performance Magazine*, vol. 46 (1987), pp. 10–14.

Watson, Scott. "The wound and the instrument. Joseph Beuys." *Vanguard*, vol. 3, no. 17 (1988), pp. 30–49.

Wechsler, Max. "Joseph Beuys/Enzo Cucchi/Anselm Kiefer/Jannis Kounellis." *Artforum International*, vol. 24 (Summer 1986), pp. 134–35.

Wullfen, Thomas. "Joseph Beuys: his death has yet to be assimilated." *Flash Art* (International Edition), vol. 140 (May/June 1988), p. 126.

Lenders to the Exhibition

Busch-Reisinger Museum, Harvard University Art Museums, Cambridge, Massachusetts

Ronald Feldman Fine Art, Inc., New York

Froehlich Foundation, Stuttgart

Collection Marguerite and Robert Hoffman

Centre Georges Pompidou, Paris, Musée national d'art moderne / Centre de création industrielle

Kröller-Müller Museum, Otterlo, The Netherlands

Museum am Ostwall, Dortmund

Museum of Fine Arts, Boston

Nationalgalerie im Hamburger Bahnhof, Museum für Gegenwart-Berlin (Joseph Beuys Medien-Archiv)

Öffentliche Kunstsammlung Basel, Kunstmuseum

Private collection, Antwerp

Private collection, Berlin

Private collection, Germany

Marshall and Cynthia Reid, Houston

Keith and Katherine Sachs

Scottish National Gallery of Modern Art

Solomon R. Guggenheim Museum, New York

Speck-Collection, Cologne

Staatliche Museen Kassel

Stedelijk-Museum Voor Actuele Kunst, Ghent

Tate, London

Collection Van Abbemuseum, Eindhoven, The Netherlands

Checklist of the Exhibition

Unless otherwise noted, all works shown at both Houston and London venues.

Action Films

1. *Kukei / akopee—Nein! / Braunkreuz / Fettecken / Modellfettecken* (*Kukei / akopee—No! / Brown Cross / Fat Corners / Model Fat Corners*), July 20, 1964, Aachen
Production: West German Broadcast, Cologne, 1968
Plates 1–2
Checklist nos. 1–5 and 7
Joseph Beuys Medien-Archiv, Nationalgalerie im Hamburger Bahnhof Museum für Gegenwart-Berlin
Houston only

2. *wie man dem toten Hasen die Bilder erklärt* (*How to Explain Pictures to a Dead Hare*), 1965, Düsseldorf, Galerie Schmela
Sequences from two television reports:
 Sequences one–three
 Happening—Bewegung in der Bundesrepublik (Ausschnitt) (*Happening—Movement in the Federal Republic [detail]*), January 24, 1966
 Production: West German Broadcast, Cologne, 1966
 Sequence four
 How to Explain Pictures to a Dead Hare, December 7, 1968, Düsseldorf
 Production: West German Broadcast, Cologne, 1968

3. *Kunst und Ketchup. Ein Bericht über Pop-Art und Happening* (*Art and Ketchup. A report about Pop art and Happening*), February 14, 1966
Director: Elmar Hügler; Cinematographers: Dieter Mährlen, Kurt Hirschel; Sound-recorders: Albrecht Müller, Manfred Müller; Editor: Heike Prasuhn; Voiceover: Charles Wirths; Composer: Dave Hildinger
Production: South German Broadcast, Stuttgart, 1966

4. *Eurasienstab* (*Eurasian Staff*), 1967/68
Sound-recorder: Henning Christiansen
Plate 45

5. *Celtic + ~~~*, 1971
Cinematographer: Bernd Klüser
Appeared as a multiple, Schellmann & Klüser, Munich, 1971
Edition: Jörg Schellmann, Munich, 1971

6. *Three Blackboards*, February 26, 1972, London
Selection from Seven Exhibitions, 1968–75
Production: Tate Modern, London
London only
Plate 128

7. *I Like America and America Likes Me*, New York, 1974
Director: Helmut Wietz; Cinematographer: Helmut Wietz; Contributors: Ursula Block, Ernst Mitzka, Caroline Tisdall, and Irene von Zahn
Production: René Block Gallery, Ltd.
Plates 3-10

Action Objects

8. *Fluxusobjekt* (*Fluxus Object*), 1962
Cardboard, fat, small broom, rubber band, metal toy
21 ¼ x 26 x 33 ½ inches (54 x 66 x 85 cm)
Collection Marguerite and Robert Hoffman
Houston only
Plates 18–19

9. *Rostecke* (*Iron Corner*), 1963
Iron, ferric oxide, lacquer
19 ¾ x 19 ¾ x 19 ¾ inches (50 x 50 x 50 cm)
Museum am Ostwall, Dortmund
Houston only
Plate 33

10. *Eurasienstab* (*Eurasian Staff*), 1967/68
Felt, four wooden rods, one copper staff
168 ⅛ x 5 ½ x 5 ½ inches (427 x 14 x 14 cm)
Private collection, Antwerp
Houston only
Plate 44

11. *Schlitten* (*Sled*), 1969
Wooden sled, felt, straps, flashlight, fat, stamped in oil
13 ¾ x 35 ½ x 13 ¾ inches (35 x 90 x 35 cm)
Busch-Reisinger Museum, The Willy and Charlotte Reber Collection, The Jorie Marshall Waterman '96 and Gwendolyn Dunaway Waterman '93 Fund, 1995.220
Houston only
Plate 34
(Photo used as Plate 34 is another from this edition, in the Collection Walker Art Center, Minneapolis. Alfred and Marie Greisinger Collection, Walker Art Center T.B. Walker Acquisition Fund, 1992. 1992.218)

12. *Filzanzug* (*Felt Suit*), 1970
Felt, sewn; stamped
67 x 39 ⅜ inches (170 x 100 cm)
Collection Marguerite and Robert Hoffman
Houston only
Plate 31

13. *Erdtelephon* (*Earth Telephone*), 1968–71
Telephone, earth, straw, glass and wood
7 ⅞ x 30 x 19 ¼ inches (20 x 76 x 49 cm)
Keith and Katherine Sachs
Houston only
Plate 42

14. *Dürer, ich führe persönlich Baader + Meinhof durch die Dokumenta V* (*Dürer, I personally conduct Baader + Meinhof through Documenta V*), 1972
Two boards, two wooden slats, two felt slippers, rose stems, fat
80 ¾ x 63 x 13 ⅜ inches (204 x 160 x 35 cm)
Speck-Collection, Cologne
Houston only
Plate 43

15. *La rivoluzione siamo Noi*
(*We are the Revolution*), 1972
Silkscreen on polyester sheet with handwritten text and stamped
75 ⅛ x 40 ⅛ inches (191 x 102 cm)
Marshall and Cynthia Reid, Houston
Houston only
Plate 41
(Photo used as Plate 41 is another from this edition, in the collection of The Museum of Fine Arts, Houston)

16. *Untitled* (*Three Blackboards*), 1972
Chalk on blackboard
47 ⅞ x 36 x ¾ inches (121.6 x 91.4 x 1.8 cm)
Tate. TO3594
London only
Plate 128

17. *Rose für direkte Demokratie*
(*Rose for Direct Democracy*), 1973
Graduated glass cylinder, with inscription; printed certificate on paper
Diameter of cylinder:
13 ½ x 2 inches (35.5 x 5 cm)
Courtesy Ronald Feldman Fine Art, Inc., New York
Houston only
Plate 40

18. *Ohne Titel* (*Untitled*), 1973
White and colored chalks on blackboard with wooden frame
41 ½ x 53 ½ inches (105.4 x 135.9 cm)
Museum of Fine Arts, Boston. Catherine and Paul Buttenwieser Fund. 2000.979
Houston only
Plate 38

19. *Three Pots for the Poorhouse—Action Object*, 1974
Two blackboards, chalk, three cast iron pots, cord
35 ½ x 43 ⅜ inches (90 x 110 cm)
Scottish National Gallery of Modern Art. GMA 1318
Houston only
Plate 32

20. *Tafel I (Geist—Recht—Wirtschaft)*
(*Board I [Spirit—Law—Economics]*), 1978
Chalk, blackboard
35 ⅜ x 43 ¼ inches (90 x 110 cm)
Lent by the Froehlich Foundation, Stuttgart
2000. L02223
London only
Plate 35

21. *Tafel II (Jeder Mensch ist ein Künstler)*
(*Board II [Everyone is an Artist]*), 1978
Chalk, blackboard
35 ⅜ x 43 ¼ inches (90 x 110 cm)
Lent by the Froehlich Foundation, Stuttgart
2000. L02224
London only
Plate 36

22. *Tafel III (Kapital = Kunst)*
(*Board III [Capital = Art]*), 1978
Chalk, blackboard
35 ⅜ x 43 ¼ inches (90 x 110 cm)
Lent by the Froehlich Foundation, Stuttgart
2000. L02225
London only
Plate 37

23. *Jungfrau* (*Virgin*), 1979
Chalk, tempera, wood, soap, blackboard
33 ⅛ x 49 ⅜ inches (84.2 x 125.3 cm)
Solomon R. Guggenheim Museum, New York. 94.4264
Houston only
Plate 39

Vitrines

24. *Ausfegen* (*Sweeping Up*), 1972/85
Vitrine containing sand, stone, paper, garbage, and broom with red bristles, with Beuys pamphlets printed on plastic bags
79 ½ x 91 ¾ x 24 ¼ inches
(202 x 233 x 61.5 cm)
René Block Collection in deposit of Neues Museum in Nürnberg
Plate 47

25. *Doppelobjekte* (*Double Objects*), 1974–79
Vitrine containing *Ohne Titel* (*Untitled*): battery cells; *Telefon* (*Telephone*), 1974: metal, string, brown paint; *Ohne Titel* (*Untitled*): Syberian Symphony gramophone records, bone; *Ohne Titel* (*Untitled*): glass jars, brown cross (oil paint); *Ohne Titel* (*Untitled*), 1977: enamel bowls, soap; *Ohne Titel* (*Untitled*):
two X-ray photographs, metal clips, brown cross paint; *Irish Energies:* peat brickettes with butter, coal
81 x 86 ⅝ x 19 ½ inches
(205.7 x 220 x 49.5 cm)
Collection Marguerite and Robert Hoffman
Plate 61, frontispiece

26. *Kartoffelkraut und Fluxusstaubbild* (*Potato Plant and Dust Image*), 1962/82
Vitrine containing *Fluxusstaubbild* (*Fluxus Dust Image*), 1962–81: cardboard, dust image of objects and titles; plastic object for *Sibirische Symphonie* (*Siberian Symphony*), 1962; *2x Braunkreuz* (*2x Brown Cross*), 1963; *Kartoffelkrautskulptur* (*Potato Plant Sculpture*), 1977: dried potato plant grown in West Berlin, Schaperstrasse 11 (planted March 15, 1977, harvested October 19, 1977); soil, bone, knife; placed by Beuys in vitrine in 1981
79 ½ x 91 ¾ x 24 ¼ inches
(202 x 233 x 61.5 cm)
Private collection, Berlin
Plate 51

Checklist nos. 27–33 intended to be shown together
Plate 62

27. *Athener Mondeule* (*Athenian Moon Owl*), 1970/82
Vitrine addition for checklist nos. 28–32; hung at the left edge of the group
Blast furnace slag and zinc box
10 x 7 x 4 inches (25 x 17 x 11 cm)
Private collection, Germany
Plate 68

28. *Ohne Titel I* (*Untitled I*), 1962/81
Vitrine containing *Ohne Titel* (*Untitled*), 1962: dried meat, paint, chocolate, signed "Beuys/ 1962"; *Ohne Titel* (*Untitled*), ca. 1963: metal rod, wax, signed "Joseph Beuys/Untitled/ ~1963"; *Ohne Titel* (*Untitled*), 1964: wooden board, oil paint, laundry line, clothes pins, wax, toe nail, hair, fat, felt, tin can cover, tar, iron weight, signed "Beuys/64"; *Monumente / 4 Schokoladensprengungen* (*Monuments / 4 Chocolate Detonations*), ca. 1964: chocolate, signed "Monuments / 4 Chocolate Detonations/~64"; *Aktion Deutsche Studentenpartei* (*Action German Student Party*), 1968: printed paper, rosemary, essential oils; *Rose für direkte Demokratie* (*Rose for Direct Democracy*), 1973; *Ohne Titel* (*Untitled*), 1977: slate, signed "Beuys/1977"; *Hals* (*Neck*), 1981: stem of a plant, glass bottle, signed "Joseph Beuys/1981/Hals"
79 x 91 x 26 inches (201 x 232 x 67 cm)
Private collection, Germany
Plate 63

29. *Ohne Titel II* (*Untitled II*), 1956/75
Vitrine containing *Brücke der Verständigung* (*Bridges of Understanding*), 1956: bronze; *Gemeinschaftsspaten* (*Community Spade*), 1964: spade blade, two wooden sticks; *Filzanzug* (*Felt Suit*), 1970; *12.Mai 1971* (*May 12, 1971*), 1971: plastic can, spade stone, plastic bowl, paint, pine needles, rice, signed on bottom of plastic can "to bowl with garland and rice/Joseph Beuys /1971," on the bottom of the bowl "to turquoise col. can/Beuys 1971," and on extra paper "12 May 71"; *Ohne Titel (Partitur)* (*Untitled [Musical Score]*), ca. 1973: pencil, stamp on paper; *Pflasterstein* (*Cobble Stone*), 1975
79 x 91½ x 26 ½ inches (201 x 232 x 67 cm)
Private collection, Germany
Plate 64

30. *Ohne Titel III* (*Untitled III*), 1948/81
Vitrine containing *Schaf* (*Sheep*), 1948: brass, signed on the back "JB"; *Strassenbahn* (*Tram*), ca. 1956/57: sticky foil, linen, oil paint, and pencil in a shoe box, signed on left side "Tram/Joseph Beuys/~1956~57"; *Ohne Titel* (*Untitled*), 1958/59: plastic, fat, pencil, turning-fork, signed on the back "Beuys 1958/59"; *Königskopf* (*Kings Head*), 1962: zinc plate and stone, signed on back "Königskopf/Kings Head/1962"; *Ohne Titel* (*Untitled*), ca. 1964: bacon-rind, fabric, rubber band; *Konzert Mönchengladbach* (*Concert Mönchengladbach*), 1970; *Ohne Titel* (*Untitled*), 1972/81: fat, copper (five parts); *Ohne Titel* (*Untitled*), 1974: stamped board, two wooden blocks with pencil and ink, wooden boxes with honeycomb, white tin can with asphalt, signed below on the front "Joseph Beuys 74"; *Scheibe* (*Disc*), 1976: carton, oil paint, signed on back "Joseph Beuys/1976/Disc"
79 x 91½ x 26 ½ inches (201 x 232 x 67 cm)
Private collection, Germany
Plate 65

31. *Ohne Titel IV* (*Untitled IV*), 1964/78
Vitrine containing *Maschinenaggregat* (*Machine Aggregate*), 1964: poppy seeds, pine needles, machine parts, bees wax plate, shards of a mirror, fat in white tin can; *Plastik/medizinisch (Zinksalbe) behandelte Blutwurst* (*Plastic/Medicinal [Zinc Salve] containing Blood Sausage*), 1964: blood sausage, zinc salve, signed on extra paper "Plastic/~65"; *Gelatinekeil/programmiert* (*Gelatin Wedge/Programmed*), 1969: gelatin, chocolate, paper, signed on back of paper, "Joseph Beuys/Gelatin Wedge/Programmed"; *Ohne Titel (Beuysbräu)* (*Untitled [Beuys brew]*), 1970: bottle carrier, eighteen "Dötze bottles," gelatin, water glass, brown cross (oil paint); *Ohne Titel (Klischee für Vorzugsausgabe der Zeitschrift Interfunktionen, Heft 61)* (*Untitled [Proof for Special Edition of the Magazine Interfunktionen, 61]*), 1961: metal plate, oil paint; *Ohne Titel* (*Untitled*), 1973: Grass plant (Grass flower),

fat; *Substanzen (Substances)*, 1977: eleven samples from *Unschlitt / Tallow*, 1977, plastic box with fat, signed "Substance 1 / Joseph Beuys"; "Substance 2 / Joseph Beuys," inscribed on paper "tallow samples for Unschlitt / Tallow / 1977 Beuys"; *aus dem Maschineneraum (From the Machine Room)*, 1977/78
79 x 91 ½ x 26 ½ inches (201 x 232 x 67 cm)
Private collection, Germany
Plate 66

32. *Ohne Titel V (Untitled V)*, 1949/82
Vitrine containing *Corsett (Corset)*, 1949: bronze, fat, wax; *Ohne Titel (Untitled)*, ca. 1964: felt, chalk, and hare; *Zwei Fräulein mit leuchtendem Brot (Two Young Ladies with Luminous Bread)*, 1966; *Ohne Titel (Zuckerecke) (Untitled [Sugar Corner])*, 1967–68: hare bone, napkin, sugar, pieces of sulfur, cable, in cardboard box, water colors, inscribed on left side of box "Joseph Beuys 67–68"; *mit Schwefel überzogene Zinkkiste (tamponierte) Ecke (Zinc Box Covered with Sulfur [Tamponed Corner])*, 1970; *Ohne Titel (Brustwarze) (Untitled [Nipple])*, ca. 1970: wax, felt, sugar, in preserving jar, signed on extra paper 'around 1970;' *Ohne Titel (Untitled)*, 1974: chocolate, oil paint, on carton; inscribed on carton "Joseph Beuys 1974"; *Magnetischer Abfall (Magnetic Waste)*, 1975; *Mirror Piece*, 1975; *Ohne Titel (Untitled)*, 1978: baking form (two parts), oil paint, stamp print, and signed on back "Joseph Beuys / 1978"; *Ohne Titel (Untitled)*, 1982: ceramic object, potato plant
79 x 91 ½ x 26 ½ inches (201 x 232 x 67 cm)
Private collection, Germany
Plate 67

33. *Frau (Woman)*, 1971
Vitrine addition for checklist nos. 28–32, hung at the right edge of the group
Wood, nails, oil
9 ⅝ x 5 ⅛ x 3 ½ inches (24.4 x 12.8 x 9 cm)
Private collection, Germany
Plate 69

34. *Braunkreuz Haus (Brown Cross House)*, 1983
Vitrine containing *Ohne Titel (Untitled)*, early 1960s: marbleized paper file-box with metal fittings containing mice and rate bones, needle, and carbon; *Brown Cross House*, ca. 1962-64: brown cross (oil paint) on wood and cardboard with metal and wire joins
81 x 86 ½ x 19 ¼ inches
(205.7 x 219.7 x 49.5 cm)
Solomon R. Guggenheim Museum, New York. 91.3942
Plate 60

35. *Schlitten mit Filter (Sled with Filter)*, 1983
Vitrine containing *Fat Filter*, 1964: linen bag with fat, beeswax, carnauba wax, and bark; *Sled*, 1969, edition 5 / 50: brown cross (oil paint) on wooden sled with felt blanket, flashlight, wax, webbing bands, tape, and rope
81 x 86 ½ x 19 ½ inches
(205.7 x 219.7 x 49.5 cm)
Solomon R. Guggenheim Museum, New York. 91.3950
Plate 56

36. *Incontro con Beuys (Encounter with Beuys)*, 1984
Vitrine containing *Incontro con Beuys (Encounter with Beuys)*, 1974: felt, copper, fat, and cord
75 x 78 ⅝ x 23 ½ inches
(190.5 x 199.7 x 59.7 cm)
Solomon R. Guggenheim Museum, New York. Purchased with funds contributed by The Gerald E. Scofield Bequest, 1987. 87.3522
Plate 59

37. *Ohne Titel (Untitled)*, 1983
Vitrine containing *Vino FIU (FIU Wine)*, 1983: cardboard carton containing thirteen bottles of FIU red wine; *Rose für direkte Demokratie (Rose for Direct Democracy)*, 1973: glass measuring cylinder; *Ich kenne kein Weekend (I Know No Weekend)*, 1972: cardboard suitcase with plastic handle and metal fittings containing used paperback book (Emmanuel Kant's *Critique of Pure Reason*), Maggi Würze glass bottle; *Berry Seed Cake*, 1960s: red currant seeds, fruit pulp, felt; *Ohne Titel (Untitled)*: metal canteen with felt, leather, metal; *Luftschutzverbandkasten (Air-raid First Aid Kit)*, 1967: hinged metal box (painted), containing printed reproduction, Irish unsalted butter, copper rod, paper, metal parts; *Ohne Titel (Untitled)*, 1962: plastic receptacle containing linseed oil, fat, knife, ladle with painted lid, string; *Fontanadose (Fontana Tin)*, 1957 or 1967: slit tin can mounted on cardboard box lid
81 x 86 ½ x 19 ½ inches
(205.7 x 219.7 x 49.5 cm)
Solomon R. Guggenheim Museum, New York. 91.3943
Plate 58

38. *Ohne Titel (Untitled)*, 1983
Vitrine containing *Action Apron*, 1964: white cotton apron; *Angel*, 1983: beef drippings with Irish unsalted butter and two coffee spoons; *Ohne Titel (Untitled)*, ca. 1977: plastic tube with tape containing hare's blood; *Ohne Titel (Untitled)*, 1966: tin can with blood sausage remnants, thyme twig dipped in wax, string
81 x 86 ½ x 19 ½ inches
(205.7 x 219.7 x 49.5 cm)
Solomon R. Guggenheim Museum, New York. 91.3949
Plate 57

39. *Ohne Titel* (*Untitled*), 1984
Vitrine containing *Bett* (*Bed*), 1950: bronze
sculpture, purchased 1972, TO1542;
Badewanne für eine Heldin (*Bathtub for a Heroine*),
1950, cast 1984: bronze and electric water
heater wand (metal and plastic), presented by
the artist 1984, T03920; *Tierfrau* (*Animal
Woman*), 1949, cast 1984: bronze sculpture,
presented by the artist 1984, T03921;
Fettbatterie (*Fat Battery*), 1963: sculpture made
of felt, fat, tin, wood and board, presented
by EJ Power through the Friends of the Tate
Gallery 1984, T03919
81 x 86 ⅝ x 19 ½ inches
(205.7 x 220 x 49.5 cm)
Tate
Plate 48

40. *Ohne Titel* (*Untitled*), 1983
Felt, copper, steel, wood, and glass
(felt with razor blade attached, Samurai
sword, knife sheathed in felt, piece
of a tram rail, razor blade held upright
on magnetized plate, battery)
81 x 86 ⅝ x 19 ½ inches
(205.7 x 220 x 49.5 cm)
Tate. Purchased 1984. T03825
Plate 49

41. *Ohne Titel* (*Untitled*), 1983
Fat, beeswax, sealed preserving jar containing
pork dripping, thermometer; *Fettecke*
(*Fat Corner*), 1963: pork drippings; *Tiefstand*
(*Low Point*): zinc box, tallow from mutton
81 x 86 ⅝ x 19 ½ inches
(205.7 x 220 x 49.5 cm)
Tate. Purchased 1984. T03825
London only
Plate 50

Environments

(All overall dimensions are approximate)

42. *Das Rudel* (*The Pack*), 1969
Volkswagen bus with twenty wooden sleds,
each with felt, belts, flashlight, fat, rope,
and stamped with brown cross (oil paint)
Overall dimensions:
236 ¼ x 472 ½ inches (600 x 1200 cm)
Staatliche Museen Kassel
London only
Plate 75

43. *Voglio vedere le mie montagne*
(*Show Me My Mountain*), 1950/71
Environment consisting of twenty-nine
elements: armoire with mirror, inscribed on
the front left; wooden box; wooden chest,
bog oak, fabric, and bone, inscribed on
the side; three-legged stool made of wood,
iron, sulfur, mirror, and fat; bed with
net made of copper thread and photographs;
four copper rods; four copper plates; four
glasses containing gelatin; one lamp; one felt
disc; one rifle; two photographs
Overall dimensions:
165 ⅜ x 228 ⅜ x 307 ⅞ inches
(420 x 580 x 782 cm)
Collection Van Abbemuseum, Eindhoven,
The Netherlands
London only
Plate 88

44. *Strassenbahnhaltestelle* (*Tram Stop*), 1976
Environment consisting of iron, tramlines,
four cylinders, rods, pole
Overall dimensions:
29 x 97 x 330 inches
(74 x 246 x 837 cm)
Kröller-Müller Museum, Otterlo,
The Netherlands
Plates 73, 74, 122, 132, 133, 134

45. *Feuerstätte I und Feuerstätte II*
(*Hearth I and Hearth II*), 1968/74
and 1978–79
Environment consisting of twenty-nine
copper rods, iron, sixty-two felt suits,
chalk on blackboard, wood
Overall dimensions:
315 x 196 ⅞ inches (800 x 500 cm)
Öffentliche Kunstsammlung Basel,
Kunstmuseum
London only
Plate 85

46. *Wirtschaftswerte* (*Economic Values*), 1980
Environment consisting of iron shelves with
basic food and tools from the former GDR;
plaster block with pencil and fat; paintings
from the collection of the host museum
Overall dimensions:
114 ¼ x 157 ½ x 104 ⅜ inches
(290 x 400 x 265 cm)
Stedelijk-Museum Voor Actuele Kunst, Ghent
Plate 81

47. *Terremoto* (*Earthquake*), 1981
Environment consisting of typesetting
machine; Italian flag; felt; nine blackboards
with chalk drawings and diagrams; metal
container with fat and lead type; cassette
recorder with tape and brochure
Overall dimensions:
80 x 137 ¾ x 193 inches
(203 x 350 x 490 cm)
Solomon R. Guggenheim Museum, New York.
91.3960
Houston only
Plate 82

48. *FOND VII / 2*, 1967/84
Environment consisting of eight piles of felt;
copper plates
Each layer of felt: 50 x 34 ¼ inches
(127 x 87 cm), cut in angles of
14 ⅝ x 5 ⅛ inches (37 x 13 cm);
heights of the piles:
26 ¼ inches (66.5 cm);
55 ⅛ inches (140 cm);
53 ⅜ inches (136 cm);
54 ½ inches (138.5 cm);
56 inches (142 cm);
55 inches (139.5 cm);
54 ⅛ inches (137.5 cm);
77 ¼ inches (196 cm);
copper plates:
39 ⅝ x 50 inches (100.5 x 127 cm);
ribbon 98 ½ x ⅞ inches (250 x 2cm)
Overall dimensions:
77 ¼ x 179 ⅛ x 253 ⅛ inches
(196 x 455 x 643 cm)
Centre Georges Pompidou, Paris, Musée
national d'art moderne / Centre de création
industrielle. Inv. AM 1985-139
London only
Plate 77

49. *Das Ende des zwanzigsten Jahrhunderts*
(*The End of the Twentieth Century*), 1983–85
Environment consisting of thirty-one
basalt stones, each with truncated basalt
cones and elements of clay and felt
Overall dimensions:
393 ¾ x 275 ⅝ inches
(1000 x 700 cm)
Each ca. 73 ½ x 18 inches (186.6 x 47 cm)
Tate. Purchased with assistance from
Edwin C. Cohen and Echoing Green 1991.
T05855
Plates 86,125

Index of Plates by Artist